She's Got Handle

Best wishes. Enjoy!
Adam
1-11-02

She's Got Handle

The Story of Nicole Louden's Triumph Through Inner-City Basketball

Adam Zagoria

**Andrews McMeel
Publishing**

Kansas City

She's Got Handle copyright © 2001 by Adam Zagoria. All rights reserved. Printed in the United States of America. No part of this book may be used or reproduced in any manner whatsoever without written permission except in the case of reprints in the context of reviews. For information, write Andrews McMeel Publishing, an Andrews McMeel Universal company, 4520 Main Street, Kansas City, Missouri 64111.

01 02 03 04 05 QUF 10 9 8 7 6 5 4 3 2 1

Library of Congress Cataloging-in-Publication Data

Zagoria, Adam.
 She's got handle : the story of Nicole Louden's triumph through inner-city basketball / by Adam Zagoria.
 p. cm.
 ISBN 0-7407-1894-0
 1. Louden, Nicole, 1983– 2. Women basketball players—United States—Biography. 3. Basketball players—United States—Biography. I. Title.
GV884.L63 Z34 2001
796.323'092—dc21
[B]

 2001035870

BOOK DESIGN AND COMPOSITION BY KELLY & COMPANY

ATTENTION: SCHOOLS AND BUSINESSES

Andrews McMeel books are available at quantity discounts with bulk purchase for educational, business, or sales promotional use. For information, please write to: Special Sales Department, Andrews McMeel Publishing, 4520 Main Street, Kansas City, Missouri 64111.

To my mother and father

Contents

Foreword by Teresa Weatherspoon *ix*

Preface *xiii*

PROLOGUE
1999: Nike All-America Basketball Camp *1*

PART ONE
1996–99: Working Toward Nike Camp *11*

PART TWO
September 1999–June 2000: Junior Year *49*

PART THREE
Summer 2000: Recruitment *117*

PART FOUR
Fall 2000: Decisions, Decisions *169*

EPILOGUE
2000–1: Senior Season *223*

Acknowledgments *233*

Foreword

by Teresa Weatherspoon

A couple of years ago I was signing books for a group of people at Dumont High School in New Jersey when someone tapped me on the shoulder.

When I turned around, a young lady with an incredible basketball build asked me to play a game of one-on-one.

"Come on, please," she said.

"This girl's got some game," added an older woman, a friend of hers. "She might surprise you."

"Do you think you can win?" I asked.

"Yes," she said, exuding tremendous confidence.

That was good enough for me. Every day I hear guys say they want to play against me. But I haven't had very many girls challenge me. She was young and I'm a wise old veteran. And she wanted to play me. Anytime a kid walks up with the build she has and wants to play me, she can play.

I didn't play Nicole Louden that day because things were hectic during the book signing. But I knew she was for real. The voice, the walk, the asking, the believing—that was convincing.

I never really had anybody out there like that for me. It's different in this day and age because Nicole and our young ladies can turn on the television and see WNBA players they relate to. That's why *She's Got Handle* is a new kind of story, and what's happened to Nicole is a new kind of thing.

When I was growing up, I watched men on TV—Michael Jordan, Magic Johnson, Larry Bird, Isiah Thomas. I was always watching, implementing some of the things that they did, especially the mental attitude that Michael Jordan had. He had you beat mentally; you're done.

I had an opportunity to watch those things. But my mom was my role model. I've always said if I could endure all the pain, all the suffering that she has endured, I'll be successful.

We didn't have much. You have six kids you have to dress. You have six kids you have to feed. And you have all six of us eating like men. It was very hard living where we lived: Pineland, Texas, a town of 882 people. There were nights, man, you would go to bed hungry, nights you go to bed cold. I remember times when we just had cereal for dinner. When you talk about peanut butter and jelly, I know about that. There were mornings you would wake up in the same clothes. I'm the kid who knows about having holes in my shoes; I'm the kid who knows about having holes in my shirt; but I'm also a kid who knows about being loved.

My mom decided that she was going to be a registered nurse, and that's what she started doing. To make sure we were taken care of, she would go 14, 15 days straight, no days off. And she was burning herself out to make sure we were taken care of. It was amazing to see something like that. To see her come from bottom up was a triumph for all of us.

You want people to know that. You don't want anybody to think that you woke up one morning and everything was fine—that you woke up that morning and you were in the WNBA. No. It was all about what happened for me as a kid, what I remembered as a kid, and what I wanted—what my dreams were.

There were many nights I would lie down, look straight up, and say, "Man, we're having it tough. But one day, one day." There were times when I might be dreaming about dribbling the ball and say something like, "Pass the ball."

My sisters would say, "Teresa, you're talking in your sleep." I was waking them up because I was dreaming so vividly.

I'm sure those are the things that Nicole thinks about sometimes when she lies down, because I did. Will I get through that tunnel and find the light? Will someone give me an opportunity to fulfill my dream? All I want is an opportunity and it will happen.

Nicole and I both know that to make your dreams happen you have to work very hard. When everybody's sleeping, Teresa and Nicole are out working. When everybody's eating, Teresa and Nicole are out working.

And that's the difference. That means that your heart is much stronger; your will is much stronger; your power is much stronger.

Basketball has been tremendous to me. I got a chance to go overseas and play for eight years. We didn't have a WNBA. I had to make the sacrifice. I went to Italy for six years; I went to Russia for two. I got an opportunity to play all over Europe. I got an opportunity to see the world with that round ball. It's something that I'm very passionate about, something that I love, something that

I protect totally because it's something that means the world to me—it has given me the opportunity.

And I guess that's the one thing that I want Nicole and the other young ladies like her to know—that your dream is possible no matter how hard things might seem. When you look at the end of that tunnel, you might not see a light, but if you continue to work, the light will definitely be there.

I've been told that I'm cocky. I've been told that I'm very confident. Which one do I think I am? I'm very confident; I'm not cocky. There's a difference in the way you carry yourself.

Nicole is like that, too. She exudes confidence. Last year when I played on the weekends in New Jersey, one guy would come in buzzing about Nicole. He was like, "I went to see her play. She had forty-seven points."

If she continues to walk with that confidence, talk with that confidence, she'll have respect from all the people in the college rankings. And she'll see by the defense that they play against her.

I'm sure this kid is gonna wrap it up and do what she has to do because she's confident. And that's the key to whatever you want to do in life. Watch out for this kid. Spoon says watch out for this kid. She is mad.

May 2001

Preface

In early 2001 I finally got my mother to come see Nicole Louden play basketball. For more than three years as a sportswriter for Passaic County's *Herald News*, I had been covering Nicole, a senior at John F. Kennedy High School in Paterson, New Jersey, and one of the best high school basketball players in the nation. For months and months my mom had heard me tell tales about Nicole's great talents. She knew I was writing a book about Nicole, but she had never gotten around to attending a game. Finally, on a late Saturday afternoon in February, my mom and dad drove out to Wayne, New Jersey, to watch the semifinals of the Passaic County girls' basketball tournament. My mother couldn't believe her eyes.

When she had played basketball in New Jersey in the 1950s, long before Title IX was a reality, reportedly the girls wore tunics with blouses, belts, and tights stretching almost to the knees. They played six-on-six, with three players on offense and three on defense. Only the forwards were allowed to cross the midcourt line. Each player was allowed only one dribble, so passing was at a premium. The big girls dominated a painfully slow version of the game with bank and hook shots. They took their foul shots underhanded. Still, they were happy to be competing.

The game my mother played looked almost nothing like the matchup between Kennedy and Wayne Valley she was watching now. Both teams were playing a fast-paced, up-tempo brand of basketball, but Nicole, a 5'7" point guard, was clearly the star of the show. She dribbled equally well with her left and right hand, she moved the ball between her legs and behind her back with ease. With her hair in cornrows and her eyes focused like laser beams, she was more aware of the clock, her defenders, and the spacing on the floor than anyone else. On her first possession of the game, she drove into a sea of Wayne Valley defenders and, despite having a hand in her face, put up a shot that banked off the backboard

and through the net. Wayne Valley, an all-white team, double- and triple-teamed Nicole, but it was to no avail. She hit jump shots from almost everywhere on the court, including well beyond the 3-point arc. She drove past her defenders and, with only the narrowest of space beneath her feet, elevated up and over them for layups and short-range jump shots. By halftime she had piled up 34 of Kennedy's 44 points. She finished with 47 in a 73–48 victory. It was one of those nights when Nicole was hot, nobody could stop her, and everyone in the gym knew it.

I was glad my mom had come, creaky knees and all. It was a chance for her to see how much women's basketball had changed in the half century since she had competed. Before double knee-replacement surgery sidelined her, she liked to ski, play tennis, ride a bike, and go for long walks. She never became obsessed with team sports like basketball and baseball the way I did. But at that moment we were both enjoying the results of a revolution in women's sports.

"It has become a very exciting game and I love it for the young women," my mom said. "They're so lucky. It can make all the difference to your sense of yourself because you're performing and showing your skills."

The revolution in women's sports came on me less suddenly. I grew up on a dead-end street named Angela Drive in Crugers, New York, about an hour north of New York City. There were a dozen or so kids on my block, boys and girls, who loved games, and there were more like them in the neighborhood. One of my best friends was a blonde tomboy named Tricia Cole who lived across the street. When the neighborhood kids were engaged in kickball battles in the street in front of my house, Tricia could run, throw, and kick with the best of them. As we got older, Tricia and I went our separate ways and I spent most of my time playing games with the guys. When my friends and I weren't on the kickball "field," we played basketball on the blacktop in my driveway and softball and baseball in parks nearby. When cold weather and snow came, Steve, Matt, Teddy, Eric, Byron, and I turned to football for long hours until the sky grew purple or dark blue and it was time to trudge home—cold, wet, and tired—for hot chocolate in front of the fire.

The television images that left an indelible mark on my memory mostly had to do with men, too. I remember being at the local tennis club with my father the night Reggie Jackson hit three home runs in one game in the 1977 World Series. I watched on those July weekends when John McEnroe and Bjorn Borg staged their duels at Wimbledon in the early 1980s. And I vividly recall discovering college basketball the night in 1982 that a freshman named Michael Jordan hit the game-winning jump shot against Patrick Ewing's Georgetown team in the NCAA championship game.

But aside from Chris Evert and Martina Navratilova battling it out in what seemed like every Grand Slam final for a decade, women's sports weren't on TV. There were no women's basketball games on the networks (at least none that I noticed), no women capturing nationwide attention by pulling off their soccer jerseys in celebration, and certainly no professional women's basketball league being promoted during the NBA playoffs. Even though I had played basketball with girls growing up, I'm pretty sure I never even went to a girls' hoops game during my four years at Hendrick Hudson High School.

By my late twenties—a quarter of a century after President Nixon signed the Title IX legislation mandating equal federal funding for men's and women's sports—the revolution in women's sports was in full swing. In 1971, just 1 in 27 high school girls, or about 300,000, participated in sports. By the time Nicole was born, in 1983, almost 2 million were playing. By the start of her freshman year at Kennedy in 1997, more than 2.5 million girls competed in high school athletics, or about 1 in 3. Basketball was by far their No. 1 sport. Almost half a million high school girls played it during Nicole's freshman year.

* * *

It was about this time, during the mid-nineties, that I coached the women's Ultimate Frisbee team at Columbia University and experienced the cultural change firsthand. These Title IX babies had grown up in an era when it was commonplace for female athletes to run, dive, sweat, and bleed—and still be feminine. I had played Ultimate Frisbee with and against women for almost a decade. Now I learned that a lot more was involved in coaching them than I thought. Yelling didn't motivate them as it did guys. Generally speaking, the women were looking for a positive relationship with their teammates and coach, and shouting didn't help matters at all. But many were every bit as competitive as—if not more so than—the guys I had played with my entire life.

Also at about this time, 1995 to be exact, the University of Connecticut basketball team led by Rebecca Lobo and Jen Rizzotti went undefeated and captured the national championship. Suddenly, and especially in the Northeast, you started hearing more about women's college ball, the families and children who attended the U.Conn. games . . . and the differences between men's and women's basketball. How the women couldn't dunk but played a below-the-basket, more fundamentally sound game that emphasized passing, cutting, and moving without the ball. How they spent time after games signing autographs and mingling with fans. How they weren't having babies out of wedlock and leaving them for others to raise.

In the summer of 1996, when the U.S. Olympic Dream Team barnstormed the nation in preparation for the Atlanta Games, the names of stars like Lobo, Lisa Leslie, Sheryl Swoopes, and Teresa Edwards filtered into male-dominated sports pages and highlight reels.

The women's basketball medal games at that Olympics were oversubscribed a year ahead of time, at $133 a ticket. In Atlanta, American women captured attention winning gold medals in basketball, soccer, and softball. A record was set at those Games when 34 percent of all competing athletes—3,684—were women.

It wasn't long before Nike and Reebok put their marketing strategists to work, propelling women's basketball—and women's athletic shoes—into the American consciousness. The filmmaker Spike Lee directed a Nike ad featuring the Dream Teamers Leslie, Swoopes, and Dawn Staley in which the players took on men at a city playground. Reebok placed Niesha Butler and Aja Brown, New York high school stars, in another commercial (they were not paid; to do so would have violated NCAA regulations). No doubt aware that more women's athletic shoes than men's had been sold every year since 1992, Nike created the Air Swoopes, analogous to the Air Jordan.

Posters of Leslie, Lobo, and Swoopes papered the bedroom walls of young women across the nation. And everywhere these players went, crowds of girls—real live girls with ponytails and freckles—had real live athletes for role models.

As the Olympic softball pitcher Lisa Fernandez said, millions of people were able to watch women "be aggressive and bleed and play and dive for balls. And be respected."

These role models didn't have measurements of 36-24-36 and didn't boast cosmetically enhanced or virtually unattainable bodies. They started appearing on magazine covers in uniforms instead of bathing suits, and a generation of girls wanted to be like them.

I knew times had changed when I saw a high school girl wearing a T-shirt with a cartoon of two stick figures, one male and one female, whose caption read: SEE JANE DO A REVERSE IN YOUR FACE SLAM OVER DICK.

The success of the women's Dream Team, which went undefeated and drew record crowds en route to capturing the gold medal in Atlanta, spawned not one but two professional women's leagues, the American Basketball League (ABL) and the Women's National Basketball Association (WNBA). They weren't the first attempts at women's pro leagues in this country, but they would be the most successful.

Before the foundation of those leagues, female college basketball players had only two options upon graduation: quit or, like Cynthia Cooper, play overseas,

in places like Israel, Turkey or Italy, far away from friends and family. But now, the ABL and WNBA offered a chance for women to play for pay in the U.S.A. Reebok, a founding sponsor of the ABL, featured a television ad in which an ABL player said with determination, "This is our time. This is our league."

Though the ABL featured better talent and a longer schedule than the WNBA, it struggled from its inception to secure a major television contract, a factor that ultimately led to its demise in late 1998. The WNBA has yet to generate profits, but it has enjoyed remarkable success beginning with its inaugural season, the summer of 1997. With the marketing and organizational power of Commissioner David Stern's NBA behind it, the WNBA signed television deals with NBC, ESPN, and Lifetime TV. The league's president, Val Ackerman, and her colleagues had initially hoped for 4,000 fans per game. They averaged more than 10,000. Mostly girls, families, senior citizens, and single and gay women—everyone but the corporate suits who now dominate NBA games—attended an abbreviated summer schedule of 28 games per team in 1997.

During the league's inaugural season, I covered New York's team, the Liberty, for *The Star-Ledger* of Newark, New Jersey. Almost overnight, the team—led by the fiery point guard Teresa Weatherspoon, whose intensity filled the locker room—developed a powerful, emotional bond with its fans. And the fact that the Liberty was good only helped.

I traveled with the team to Phoenix and Houston for the WNBA playoffs, and saw that in those cities, fans of women's basketball were just as vocal, supportive, and plentiful as those at Madison Square Garden. The Liberty ultimately fell in a one-game championship to the Houston Comets. Houston's star, Cynthia Cooper, a product of the Watts section of Los Angeles, had competed in virtual anonymity in Italy and Spain for more than a decade before earning Most Valuable Player honors during the league's first year.

Against this backdrop, questions were being raised in sports pages and society at large. How long would it take for the women's salaries—the WNBA's average salary that year was about $30,000—to rival the over-the-top amounts the men earned? How long before a high school girl, badly in need of money to support her family, tried jumping directly to the pros? After all, hadn't it become almost commonplace for boys to make the jump in the wake of the phenomenal success of the NBA stars Kobe Bryant and Kevin Garnett?

And then, given this sudden shift in the landscape of the women's game, how long before women's college basketball went the way of men's, with street agents, under-the-table payments, and performance-enhancing drugs and steroids corrupting the process? Who was watching these pro games? And who were the young female stars appearing on playgrounds across America?

This last question intrigued me most of all. What was it like for a generation of young women who could now ostensibly look forward to going pro? Now that this door was open how would someone with sufficient talent be affected? What steps would she take, what obstacles would she overcome, to make it to the pros? And for someone growing up without great financial means, perhaps in an inner city the way Cynthia Cooper had, how might going that route change her life?

In the fall of 1997, I was hired at the *Herald News* and began to become acquainted with the rich sports tradition in the city of Paterson. In 1947, Paterson's Larry Doby followed Jackie Robinson to become the second African American baseball player in the major leagues and the first in the American League. Two decades later, Rubin "Hurricane" Carter challenged Joey Giardello for the world middleweight championship before spending 19 years in jail on a murder charge of which he was later acquitted. (Carter was later memorialized in song by Bob Dylan and a film starring Denzel Washington.) Doby and Carter were only two of the star athletes Paterson produced in baseball, boxing, football, and track.

But it is basketball that is truly king in Paterson. Basketball is to that city what Friday night football is to Texas—a spectacle, a religion, and a way to escape life's drudgery. For years, the rivalry between Kennedy and Eastside—between the two schools' boys' basketball teams in particular—divided the city along its version of the Mason-Dixon Line, Straight Street. Those who lived "up the hill" across the street went to Eastside; those who lived "down the hill" attended Kennedy. Years ago, they used to joke that if you were caught across the line, especially if boys were caught talking to girls across the line, you'd better have a good pair of sneakers for the run home. Even still, your parents might have to come visit you in St. Joseph's or Barnert Hospital. To this day, the two regular-season meetings between Kennedy and Eastside draw capacity crowds. Fans of each school take over a set of bleachers, dividing their energies between cheering their own and heckling the other side.

"If we had a tiddlywinks team and it was our tiddlywinks team against theirs, you take it to another level because they're your natural rival," Jim Ring, the Kennedy boys' basketball coach, says. For decades young boys dreamed of one day wearing the red-and-black basketball uniform of Kennedy or the orange-and-blue of Eastside, while older generations endlessly compared the current rising stars to the legends of the past.

"The shortest, the fattest, the skinniest guy in Paterson thinks he can play basketball," says Benjie Wimberly, the head of the Paterson Recreation Department. "I don't care how cold it is, or if it's raining, you can ride past any play-

ground in this city on any given day and you will find somebody out playing. People just love basketball." During the summer, the game might be at Montgomery Park one day, School 13 another, and the Alabama housing projects yet another. The game moves from court to court, with each location having a group of players who consider it a mortal sin to lose on their home turf. Those who win on somebody else's home court have bragging rights for a week; those who lose on their own turf suffer ridicule. During the winter the game moves inside to School 21 or the Paterson YMCA; in the old days the City Hall annex downtown was a hot spot.

Paterson has produced its share of talented players, and the few who went on to the pros, however briefly, hold a special place in city history. Ken Rohloff had an abbreviated stint in the NBA in the 1960s, Rory Sparrow enjoyed a solid career in the '80s and James Scott made a brief appearance in the '90s. Other Paterson street heroes like Tony Murphy, James Hargrove, and Kwan Johnson have flirted with NBA careers. They are revered to this day.

In 1997, a 6'10" forward named Tim Thomas, a graduate of Paterson Catholic High School, signed a three-year contract with the Philadelphia 76ers worth nearly $6 million after spending one year at Villanova University. Thomas grew up on Paterson's East Twenty-ninth Street, near Eastside, but attended Paterson Catholic because his mother, Dorothy, thought it would provide a safer, academically stronger environment. Murphy, Sparrow, and Scott all came out of Eastside, but Thomas was the first player from Paterson Catholic to make it to the pros. His success—and the subsequent collegiate success of his teammates Kevin Freeman, Donald Hand, and DeShaun Williams—now inspires a new generation of kids to dream of donning Paterson Catholic's colors instead of Kennedy's or Eastside's.

The drafting of Thomas was one of the proudest moments in Paterson's history, but people still debate whether the city's best ballplayer was LeMarvin "Bosco" Bell—and not Sparrow or Murphy, Scott or Thomas. Bell was a mythic local figure who could do anything with a basketball and who was known for running through local parks wearing a weighted jacked to improve his strength and stamina. He earned a scholarship to Seton Hall University, in South Orange, New Jersey, and many boys in the city looked forward to watching him on television on weekend mornings, or, if they could afford it, seeing him in person. But Bell got sidetracked by drugs.

"Paterson's full of guys like that," says one high school coach in the city. "Bosco could've had everything. Bosco was a legend before he even got to high school. It's a shame. You see him now, you wouldn't think he was that kind of ballplayer."

Women's basketball does not have as storied a tradition in Paterson. When I began at the *Herald News,* my job was to cover the WNBA and girls' high school sports. That was when I discovered that the names of the successful players and schools changed from autumn to winter, from soccer season to basketball season.

During the fall, girls with names like Jillian, Megan, and Lauren dominated the headlines for predominantly white, suburban schools. But when the basketball season arrived, Dakita, Delfiah, and Antoinette—girls from Paterson's predominantly African American inner-city schools—were my focus.

I soon realized I was uniquely positioned to view not only the adult women in the WNBA, but the girls who dreamed of one day following them. I was on the lookout for the next great female star who might seize this critical moment, earn a college scholarship, and possibly even make it to the pros.

In December 1997, when I was assembling a preview for the upcoming season, Donovan Jonah, then the Kennedy girls' coach, told me to check out 14-year-old Nicole Louden. She was something to see. She struck me immediately as an intelligent, thoughtful, focused kid intent on pursuing basketball seriously. The first day I met her at Kennedy she challenged one of her coaches to a game of one-on-one, and after beating him asked for a ride to the Paterson YMCA, where she spent an additional couple of hours playing ball against older men. It wasn't until about 9 P.M. that she headed home to do her homework.

It was clear she was fairly obsessed with basketball. As her high school career evolved, I spent more and more time at her games, her practices, and her home. By her senior year I became so captivated by her personality and talents, so interested in her story and what it symbolized, that I took a leave of absence from the paper to follow her on a full-time basis. For four years since the day I first met Nicole at a Kennedy practice, I have watched her grow into not only one of the most highly recruited players in the nation but also one of the most determined people I have ever known. The more time I spent with her, the more I wondered: What is it like for a young African American woman, who often could not afford lunch or admission to a basketball game, to be in possession of so little but on the brink of so much? And what has her journey been like for her family—proud, hardworking Jamaican immigrants struggling to build a life for themselves?

This book follows Nicole through triumphs and setbacks experienced during her high school years. Nicole Louden is the subject of this book, but it might as well be about any one of a hundred girls growing up with a crossover dribble and a dream.

Prologue
1999: Nike All-America Basketball Camp

On July 17, 1999, the first day of the 1999 Nike All-America Basketball Camp, Nicole Louden lopes down the stairs and into the lobby of the University Hotel in Indianapolis. She looks around anxiously at several dozen other girls milling about, chatting and stretching out on plush brown and orange chairs, waiting to be formally welcomed to the camp. Many of the girls seem to be old friends by the way they trade the latest news of their summer travels and college plans. Nicole doesn't recognize any of her fellow campers. She is one of only 11 rising juniors invited to this prestigious event, which hosts the 81 best female high school basketball players in the nation; the rest of the girls will start their senior year in the fall. Nicole, the lone representative from New Jersey, is a rookie on the national scene. Seven hundred and fifty miles from home, she is nervous, but eager to test her skills against the competition.

The Nike handbook Nicole has been given misspells her name "Nicole Loudon" and lists her as 5'8". She is closer to 5'7". The sinewy arms and sturdy legs on her 150-pound frame reveal the effects of continuous weightlifting; her body seems thicker and stronger than that of many of the other girls. She has a round face, bright brown eyes, an infectious smile. On this hot July day she had taken the plane to Indianapolis by herself, wearing a pair of tan short-shorts, a light-blue fitted spaghetti-strap tank top, a pair of small silver hoop earrings, and a necklace depicting a basketball falling through a hoop. She thought that the older man seated next to her on the plane was about to end their friendly conversation with a request for her phone number—until he discovered that she is

16. A Nike staffer picked Nicole up at the airport and drove her to her $200-a-night hotel room.

Her first move was to collect the bounty of gear Nike provides each girl in attendance: three T-shirts, two jerseys, two pairs of shorts, two pairs of socks, and one pair each of sneakers and sandals. Nicole and the other girls received everything the 217 boys at the camp the week before got, plus a sports bra. "They give you Nike everything," Nicole would later remark. "All you need is underwear." Back at John F. Kennedy High School in Paterson, where Nicole is the unquestioned star of the team, she wears the No. 11 jersey. Here the unfamiliar No. 72 adorns the blue-and-white jerseys she has been given. She will have to give the clothing and shoes back at camp's end in order to comply with the strict regulations of the National Collegiate Athletic Association (NCAA) concerning gifts.

While picking up her gear, Nicole saw the familiar face of Falisha Wright, who teased Nicole about the "length" of her shorts.

"Where'd you get those hoochie-mama clothes?" Wright asked.

"Mos bought 'em," Nicole said with a big smile.

"What Mos got you wearin'?" Wright teased.

Joann Mosley, or Mos, as the girls call her, has been a basketball coach for more than 30 years. She coached Falisha and her twin sister, Lakeysha, on the New Jersey Monarchs Amateur Athletic Union (AAU) team and became a sort of second mother to the twins after their own mother died in her early thirties of a brain aneurysm. In their mother's stead, Mos and the Monarchs' head coach, Karen Fuccello, known to her players as Fu, escorted the girls to center court to receive their "senior night" honors before their final game at San Diego State. A divorced mother with glasses and shoulder-length brown hair, Mos, who is white, now plays a similar role with Nicole. She is at once a provider, chauffeur, confidante, and friend.

Wright, who works for Nike in Portland, Oregon, was a star point guard at Kennedy a decade before Nicole assumed that role. There are similarities in their backgrounds as well. Ironically, Nicole was born in the same hospital as the Wright twins, exactly 10 years later, in 1983. Falisha Wright grew up in Paterson, not far from where Nicole spent much of her childhood on North Sixth Street. Nicole also lost a parent at a young age; her father died when she was 12.

As a freshman, Nicole saw the brown-and-gold "Athlete of the Week" plaques Falisha Wright had received from a local newspaper hanging prominently in the walls of Kennedy. She first met Wright her freshman year, when her team went to Philadelphia to watch the Kennedy alum compete in an American Basketball League game. It was then that Nicole realized that Wright wasn't some distant

image, some face appearing only on plaques in the halls of Kennedy. She was a real person who came from the same place she did. While watching Wright that day, it dawned on Nicole that she might follow in the older woman's footsteps. "Oh, hell no, Nicole," she thought to herself, "you know you could do it too."

Wright's presence at the Nike camp made Nicole feel more at ease. After chatting briefly with the former Kennedy standout, Nicole changed into the mandatory Nike gear: black shorts, T-shirt, and sneakers. She left the ankle brace she customarily wears on her right leg back in her room.

As Nicole enters the lobby once more, she takes stock of her fellow campers. They are a mixture of black and white, inner-city and suburban, tall and not as tall, each a star in her respective world. Tattoos and baggy shorts are all the rage. Thirty-two are 6'2" or taller, including the 6'7" Gillian Goring from Germantown Academy in Pennsylvania, the tallest player at the camp. Of the 10 players on Nicole's team, which was nicknamed "Swoopes" after the WNBA star Sheryl Swoopes, half a dozen are 6'1" or taller. A number have won state championships, something Nicole has never gotten close to. Still others describe themselves variously as the "first female black belt in South Carolina," or "nominated for Sports Woman of the Year." The big names entering the camp are the flashy 5'11" junior point guard Diana Taurasi of Chino, California, and the 6'4" junior center Ashley Robinson of Grand Prairie, Texas (Taurasi will eventually play for the University of Connecticut; Robinson will select Tennessee.)

Nicole's eyes soon settle on the one person in the lobby she recognizes, Rutgers University's 5'6" point guard, Tasha Pointer. Nicole got to know Pointer the past two summers at the C. Vivian Stringer basketball camp at Rutgers; Stringer is Pointer's coach. When Nicole wasn't dominating the opposing high school girls, she competed against Pointer and other college and pro players during lunchtime and evening games. Nicole impressed the others so much with her crossover dribble and defensive quickness that she was often mistaken for a collegian. Tasha's teammate Usha Gilmore dubbed her "Killa Cole," a nickname Nicole proudly placed in large black letters on her bedroom door. Like Wright, Pointer is a role model for Nicole. The previous March, as a sophomore, Pointer led the Scarlet Knights to an appearance in the Sweet 16 of the NCAA Tournament.

Nicole approaches Pointer. "Hey Tasha."

"Hey Nicole," Pointer replies. "How was your flight? What team you playing for?"

"It was good, I'm on 'Swoopes.'"

"All right, you on my team!" says Pointer, who is scheduled to be Nicole's assistant coach.

An alumnus of the first Nike girls' camp in 1996 and a veteran of the women's basketball scene, Pointer knows a lot of people at the camp. Soon, she notices her friend Cappie Pondexter, who grew up near Pointer in Chicago and had played for the same AAU team. The two possess the same sort of street smarts and favor the same kind of city ball. When they were younger, Pointer would call Cappie whenever she went out to play at the nearby courts.

Pointer and Nicole go over to Cappie.

"What's up?" Pointer asks. She and Cappie launch into a discussion of friends in the old neighborhood, including their old AAU coach.

Cappie is perhaps an inch or two taller than Nicole. Like Nicole, she is a sophomore and comes from an inner-city school. She has already won a state championship at Marshall Metro High School, a nationally known basketball powerhouse that was featured in the film *Hoop Dreams*, and is considered one of the top players in the class of 2001. She isn't lacking confidence, either. When she was asked to describe herself in three words for the camp handbook, she wrote, "Beautiful, smart, unique."

Like any two teenagers meeting for the first time, Nicole and Cappie feel each other out, asking where the other is from and what their high school teams are like. Pretty soon, Cappie is emboldened enough to ask, "Yo, you got handle?"

In basketball terms, handle essentially means the ability to control the ball like a yo-yo while deceiving your opponent, making him or her look foolish if possible. Bob Cousy had handle, and Walt Frazier and Magic Johnson after him. Allen Iverson and Kobe Bryant are currently idolized on playgrounds across the world because of their ankle-breaking, head-faking ball-control skills. By the very nature of their job, which includes controlling the offensive flow, setting up plays, and serving as an extension of the coach on the floor, point guards must have handle. For forwards and centers it is considered a bonus, although the game more and more favors agile big players who can do a combination of things—run, shoot, handle the ball, and play defense on a number of different-sized players.

"Yeah, I got handle," Nicole says, somewhat annoyed. She does not say it, but thinks to herself, "I'm here just like you, so what do you think? If you're a point guard, what are you supposed to have, post-up moves?"

"Because you know you're nothing without a handle," Cappie adds.

"We'll see when we play," Nicole says before the two part company.

* * *

Soon Nicole, Cappie, and the other girls are ushered into the auditorium to hear Felicia Hall, the Nike camp director, give her introductory remarks. Hall

stands on a stage at the front of the room while Nicole and the others listen attentively in rows facing her. A former forward at the University of Iowa, Hall immediately strikes Nicole as a no-nonsense lady. She welcomes the girls and then launches into an explanation of the tremendous number of opportunities available to Nicole and her fellow campers, Nike's role in supporting women's basketball, a brief history of Title IX, and a rundown of the rules for the week.

"Contrary to popular beliefs, life is still not a playground for women athletes," Hall says. "But as a result of Title IX and Title IX babies like Mia Hamm, Cynthia Cooper, and Chamique Holdsclaw, many more opportunities have been made available. You girls are on center stage right now. You have a chance to do something that Cynthia Cooper couldn't do at her age." Cooper, the star of the Houston Comets, never had the chance to play at the Nike camp because it didn't exist when she was growing up.

Hall proclaims that the camp teaches the girls valuable off-the-court skills and also teaches them how to use basketball as an avenue to better their lives. Beginning tomorrow, Sunday, the girls will spend three hours each morning in classes covering nontraditional sports subjects such as dealing with anger, assertive communication, values clarification, and interviewing.

"The leadership training is the best thing we do here," Hall later tells reporters. "It's more important than the basketball. Any business wants to establish relationships, but it's more important to have them become future leaders. The relationship we establish is one of trust."

Nike's motives aren't entirely altruistic, though. Hall is a marketing representative for Nike and underscores the importance of wearing the Swoosh.

"Since Nike is sponsoring the camp that you are attending for the next few days, let's show some respect for the brand," she tells the girls. "Anyone wearing anything other than Nike will be asked to change."

Because she doesn't have any friends at the camp, Nicole spends the evening reading in her room. She enjoys Patricia Cornwell mysteries, horror novels, and books on the history of slavery. In the space in the camp handbook where campers were asked to write three words to describe themselves, Nicole put "leader, competitor, studious." Under "hobbies," she wrote, "reading, swimming, writing," but because her *W*'s sometimes looked like *H*'s, the Nike people interpreted "writing" as "hiking." Being from the city, she doesn't get a chance to do much hiking. Swimming is a part of her daily routine at the Paterson YMCA.

Nicole's roommate, Kelly Mazzante, is white and comes from an entirely different world. A 5'11" guard from Montoursville, Pennsylvania, Mazzante lists her hobbies as tennis, fishing, and friends; she has already made a verbal commitment to attend Penn State. Mazzante teases Nicole about being a "bookworm"

when she stays in the room to read. Despite their differences, the girls get along fine. Nicole pronounces her roommate "cool."

The next morning Nicole and her fellow campers descend from the hotel, through a walkway with a clear ceiling, into the cavernous gym at the National Fitness Center on the campus of Indiana University/Purdue University at Indianapolis (IUPUI). The arena is divided into three full-sized courts, each with shiny blond wood surfaces. Giant banners bearing likenesses of the Nike basketball stars Chamique Holdsclaw, Sheryl Swoopes, and Lisa Leslie hang on the walls.

Nicole sits on a training table so that a Nike staffer can tape the painful shin splints that have bothered her for some time now. The injury, which she first experienced during track season last spring, makes Nicole feel as though someone had jammed her shins with a shoehorn; sometimes it hurts just to walk. Because she participates in sports year-round—track, volleyball, and basketball—Nicole rarely gives her body a rest. Mos and Fu, Nicole's AAU coaches, have repeatedly told her to rest after the high school season, and to take time off after her AAU season in August too. But asking Nicole to stop playing basketball is like asking her to stop breathing.

In an ideal world, she would rest during the summer months instead of heading out on a recruiting circuit that this year has included several AAU tournaments, the Rutgers camp, AAU Nationals in Tennessee, and now Nike. But Nicole, and all the other girls as well, are in a double bind. If they don't attend AAUs and Nike, they will not be ranked by the recruiting services, noticed by the armada of coaches, and recruited to the top schools. If they do attend these camps and tournaments, they risk serious wear and tear on their bodies and, in some cases, irreparable physical damage.

Now the woman places strips of white tape in a weave pattern up Nicole's foot, and then covers the tape with a thin stretchy cover called a Stockinett to keep it in place. Nicole likes the job the woman has done taping her shins and feels ready to go.

* * *

A murmur builds inside the gym as dozens upon dozens of college coaches slowly file in for the first of four days of games. There is Geno Auriemma, the straight-talking coach who led U.Conn. to an undefeated season and the national championship in 1995. There is Tara Van Derveer, the Stanford coach who guided the U.S. Olympic team to the gold medal in 1996. There is Vivian Stringer, who is working on leading her third school to the NCAA Final Four and whom Nicole knows from the Rutgers camp. Nicole tries to play it cool, but some of

the sights at the camp overwhelm her, like a child seeing the ocean for the first time. At one point in between games, she looks across the court and notices one of her fellow campers, the 6'5" Kara Braxton, one of two girls in camp known to have dunked, staring at one coach in absolute amazement. Nicole is staring at the same face.

"I bet you can't believe that Coach Summitt is sitting there," Nicole shouts, motioning to the renowned Tennessee coach Pat Summitt, winner of six national championships during her career.

"No, I can't," Braxton says, looking down on her shorter acquaintance. Most coaches are dressed in shirts or sweaters prominently displaying the names of their schools, but Summitt, known for her work ethic and raging intensity, is dressed in light-colored shorts and a sweater. Everyone knows who she is.

The coaches have entered the arena on the opposite side of the players so as to avoid contact, according to NCAA regulations. For them, the event is essentially a one-stop shopping location, a giant meat market of basketball talent. The sounds of cell phones ringing and a hundred separate conversations fill the room. Bleachers are cordoned off to divide parents from coaches. Players must be accompanied by a Nike representative even to the bathroom, where coaches might try to recruit them. Yellow-shirted security guards are stationed at every corner of the court. Those same security guards patrol the hotel hallways at night to enforce the 11 P.M. curfew.

The college coaching fraternity is a tight-knit one, and players develop reputations quickly. "Nice pass," one will say after games have begun on three courts inside the arena. "I don't know if she'll qualify [academically]," another will add. Coaches stand up and move around, all in an effort to be noticed by their targeted players, players they will bombard with letters and phone calls until the early signing period in November. They call it "babysitting."

* * *

For girls like Nicole, this camp, the crown jewel of the summer recruiting circuit, represents the single best opportunity to receive a scholarship to a Division I institution. Unlike some of the other players, Nicole has the academic record to compete at a high-profile college or university. She just doesn't have the money.

Her dream, though, is to play in the WNBA. Though the Nike camp has been in existence only four years, its alums have gone on to play for all the major women's college programs. Those schools in turn produce a disproportionate number of athletes in the WNBA. Simply by being invited to this camp,

Nicole is already on the right track for her dream. She doesn't have to prove that she can play college ball just yet because she still has another year to hone her game.

She is nervous at first, and it shows in her play. A missed shot here, a turnover there cause Nicole to furrow her brow and shake her head in frustration. Nicole has extremely high personal expectations, and when she doesn't meet them, it is difficult for her to view anything positively.

"She's so young," Pointer says later. "If she works harder on her weaknesses, then she could become one of the great point guards. If she gets with the right coaches in college as well as high school, she could be extremely successful. She's still a baby."

Pointer advises Nicole to focus on her defense. "The college coaches love defense," she says. "So even if you can't score, play defense."

As the games move along, Pointer notices Nicole gaining confidence, showing some of the moves that made her a star at the Rutgers camp, where she just earned Most Valuable Player honors for the second year in a row. Her normally tenacious defense begins to pay off, as she makes a number of steals—"rips," as she likes to call them. Offensively she displays a full repertoire. She pulls up and shoots off the dribble, a skill prized by college coaches. She steps back from her defender and hits 3-pointers. She penetrates the paint and passes the ball to open teammates inside.

Up in the stands, the coaches are taking notice. The Auburn University assistant coach, MaChelle Joseph, notes in her handbook that Nicole is a "big-time scoring machine." For Joseph, who doesn't follow New Jersey basketball closely, this is her first real look at the Paterson player. The Rutgers assistant coach Jolette Law, who knows Nicole's game intimately and who, along with Falisha Wright, recommended her to the camp director, Felicia Hall, draws a star next to Nicole's name in her book. But she knows the secret is out.

Nicole is generally regarded as a point guard by the scouts, a job for someone who is fundamentally strong, whose primary emphasis is distributing the ball and being selfless, as opposed to a shooting guard, whose job is to score. Though she views herself as a pure point guard, Nicole has had to take on a different role ever since the beginning of last season, her sophomore year at Kennedy. That was when the Lady Knights lost two thirds of a trio many had hoped would restore the program to the glory years of an earlier decade.

During the late 1980s and early '90s Falisha Wright and her teammates won five straight league and Passaic County championships, captured the prestigious New Jersey Tournament of Champions in 1990, and were ranked among the Top 25 teams in the nation by *USA Today* and other national publications. But just

before the previous season, two girls who were highly regarded left Kennedy for other programs, leaving Nicole to shoulder the scoring burden.

Possessed by a singular desire to win, Nicole met the challenge, averaging a state-best 29 points per game and garnering all-state honors in the process. In one outing that stirred great controversy, she scored 60 points, rewriting a Passaic County record held by Falisha Wright. She has already piled up more than 1,000 career points, a benchmark many girls can envision achieving only over a four-year span.

But there is a danger to such prolific scoring. Already there are whispers among Kennedy's opponents that Nicole shoots too much, that she hogs the ball. Scouts at Nike recognize that many of these girls are head and shoulders above their teammates and competitors at home, but still, those whispers can become part of a player's permanent file. These scouts aren't looking for players who shoot all the time, or who feel they must do everything alone. They are looking for athletes who can take advice and fit into a team concept.

By the time for the showdown with Cappie's team, Nicole is ready. She thinks back to that conversation in which Cappie asked whether she had handle—doubted it, it seemed more like. Nicole does her best to ignore her shin splints; the tape job that cushioned the pain for the first game is now virtually useless.

Nicole's team sets up in a zone and she watches as Cappie comes downcourt and makes a series of in and out dribbles on the wing in front of her. Nicole shadows Cappie on the court, observing her midsection so that she can tell which way she intends to move. A natural defender, Nicole learned early to anticipate her opponent's movements, to use angles to her advantage, to step into passing lanes and intercept the ball, to shadow the other team's ball handler wherever she went, harrassing and wearing her down. Suddenly, the ball appears right in front of Nicole's face and she senses a tremendous opportunity. She leans in and rips the ball out of Cappie's hand like a cat snatching a piece of string.

As Nicole races in the other direction with the stolen property, she says to herself, "You better not miss this layup." She remains calm and collected enough to sink the basket on the other end and feels relieved. In the stands, a splattering of "ohs" and "ahs" can be heard from the college coaches. When she trots to the sideline, Nicole asks Pointer with a sly smile, "You saw how I ripped Cappie?"

Cappie has seen Nicole's handle, has felt its wrath. And so have all the major college coaches in America. In the end, Nicole wasn't entirely happy with her play at the camp, but this move remained one of her best and lasting memories from her first Nike All-America Basketball Camp.

Before the camp is over, Nicole gives Felicia Hall a thank-you note saying how happy she was to be invited and how much she has learned while there.

Like most people who meet Nicole, Hall is impressed by her maturity and earnestness. "She's a class act," Hall says.

When Nike camp ends, Nicole has gone from being known by only a handful of coaches to being one of the most sought after young players in the nation. Within a week after the Nike camp, Nicole receives almost 100 questionnaires from Division I schools. There is so much mail that Mos, Nicole's friend and AAU coach, goes to Cost Cutters and buys her a giant plastic container to hold all of it. On the box Nicole tapes trading cards of her favorite WNBA players—Lisa Leslie, Teresa Weatherspoon, Cynthia Cooper, and Dawn Staley.

When the fall rankings come out, Mike Flynn's Blue Star Report, a nationally recognized recruiting service, has positioned Nicole as the fourteenth best guard in the nation and the No. 1 guard in the class of 2001. Mike White's All-Star Girls Report ranks Nicole as the thirteenth best junior in the country. Joe Smith's Women's Basketball News Service ranks Nicole as the twenty-ninth best junior in the country. *Street & Smith's,* the prestigious national sports magazine, lists Nicole as an Honorable Mention All-America. High praise for someone who didn't even own an invitation to Nike just a couple of weeks before the tournament began.

The college coaches aren't the only ones impressed with Nicole, either. In October, Nicole attends the Sheryl Swoopes Basketball Camp in Piscataway, New Jersey. There, while she is shooting baskets one day, Swoopes's agent strikes up a conversation with her, hands her his card, and says, "Call me as soon as you get out of college."

Part One

*1996–99:
Working Toward
Nike Camp*

Chapter 1

Nicole positions her feet behind the foul line, gazes intently at the rim, and lets loose a free throw as if nothing else in the world exists but the net 15 feet away. All around her, her Kennedy High School teammates engage in loosely organized shoot-arounds and games of one-on-one. The squeaking of sneakers and the chatter of children on the verge of adulthood fills the air. Within the confines of the Kennedy High School gymnasium, Nicole is an island of concentration in a sea of distraction.

The 14-year-old freshman's focus isn't the only thing that sets her apart. The other players warm up in red-and-black Kennedy T-shirts and sweats; Nicole wears a white shirt neatly tucked into her black athletic shorts. It advertises the nascent WNBA and its catchphrase, WE GOT NEXT. Standing 5'6" and weighing a solid 145 pounds, Nicole has straight brown hair ending above her shoulders. Her skin glistens with sweat.

On this late afternoon in January 1998, Nicole and her fellow Lady Knights are preparing for their next game against Eastside High School, Kennedy's archrival on the other side of Paterson. Kennedy has won four of its first seven games, and Nicole has led the team in scoring in each victory. Already she has piled up 31 points on two occasions, a fairly remarkable feat considering that many high school girls' teams struggle to score 50 or 60 points in a game. Before the season began just a couple of weeks ago, Nicole was just another freshman walking the halls. Now, people stop her in the hallway and ask, "How many points you gonna score this game?" With good reason, Kennedy's coach, Donovan Jonah, hopes that Nicole might help restore Kennedy to its glory years when it was one of the best teams not only in New Jersey but in the nation.

The Kennedy gymnasium is two or three times the size of many other high school gyms. The words KENNEDY KNIGHTS appear in red in two places on the wooden basketball court. A red circle sits at its center; two red knights, like chess pieces, adorn either side of the floor. Giant movable dividers separate the gym

into sections, one for today's girls' practice and one for the boys. In the area in which Nicole and her teammates are working out, large red-and-black banners depicting the success of the Lady Knights during the late 1980s and early '90s are visible on the gym wall; they stand opposite similar banners highlighting the triumphs of the boys' team. The Lady Knights didn't always draw capacity crowds as the boys did back then, but there was no doubting their talent. Under Lou Bonora, Coach Jonah's predecessor, all five starters from the 1990 squad earned Division I scholarships. Led by Falisha Wright, the star of the team, all five scored 1,000 career points, a testament to its tremendous balance.

When Nicole has a moment for a break from practice, she sits down on the bleachers to give her first extended interview. She immediately comes off as a self-assured, confident kid with a sense of humor. Whereas many high school athletes look away or down when answering questions, stumbling and stammering in their speech, Nicole looks people straight in the eyes, generally coming up with measured, thoughtful answers.

She explains how she enjoys writing poems and raps, and was inspired by a Langston Hughes composition she read in the fifth grade.

"At first I started writing about love," she says with a chuckle. "I don't know why. I was in the sixth grade. I didn't know anything about love." She doodles in a series of notebooks she keeps in her room, writing potential rhymes in the margins. For one poem, entitled "Striving for Success," about her desire to overcome the challenges of the inner city and make something of herself, she won an award in junior high school.

* * *

All of this basketball business got started only after she dabbled in softball and track, where she specialized in sprinting. "I only started playing sports to lose weight," she says with a shy smile. During fifth grade, she played basketball with a Paterson midget league team called the Knights composed primarily of boys. Her dribbling and shooting were fairly strong at that age, even if she couldn't control the ball very effectively with her left hand. Still, she quit basketball after that year because she "wasn't feeling it." She didn't have the passion for the game. One fall day a year later when she was walking home from the library, she saw one of her friends playing basketball outdoors with a girls' city league team called the Trojans. The friend pestered Nicole to join, saying, "Come on, Nicole. You're gonna have fun." Finally, Nicole relented. That same day she called her mother and asked for permission to join the basketball team. Almost

immediately she was out on the street with her Trojan teammates asking for donations—a fund-raising process known as "tagging."

Her basketball career didn't have a stellar start. As a sixth-grader playing for the Trojans in a city league game, Nicole scored the first two points of her career with a scoop shot along the baseline. She was thrilled until her teammates started yelling at her because she had put the ball in the wrong basket. She broke down and cried in front of everyone. If her coach, Ronald McLaurin, hadn't convinced her to stay, her career might have ended right there in city league.

Nicole didn't see much playing time back then—she didn't get much "burn," as the players say—and was happy for the two or three minutes she spent on the floor each game. She wished she could play like Dakita and Delfiah, Chocolate and Buffy, the stars of the league.

When Nicole did play, it was at center because she was often bigger than the other girls, and knew how to play the post, or forward, position. She studied the lithe, graceful movements of Lisa Leslie, the 6'5" star center of the U.S. Olympic team, and learned everything she could about her: her birthday, and how Leslie's mother, a truck driver, used to take her children with her on road trips all over the country. It was clear that Nicole was not bound to be a lead-footed, stocky center, though. Her coaches all said she worked harder, and listened more attentively, than anyone else.

Soon Nicole began playing basketball on Paterson's outdoor courts. After finishing her homework, she would often leave her house, passing the drug dealers who congregated out front on North Sixth Street, walk down the hill along Temple Street, and meet her friend Dakita Trapp at the Christopher Columbus Housing Development.

A dark-skinned girl with a solid, compact body and sleepy eyes, the 5'2" Dakita had been friendly to Nicole when she first arrived at the Trojan practices, showing her how to shoot a layup. She and her family live in the hulking seven-building 498-unit public housing project that sits on Matlock Street and was built during the urban renewal movement of the 1950s and '60s. Nicole and Dakita would sometimes meet Delfiah Gray, a shy, quiet girl who, at 5'9", can leap almost to the rim. She also lives in the Christopher Columbus Project, known in Paterson simply as the CCP.

Because the CCP is only a short walk to Kennedy, hundreds of students from the project attend that school. Both Dakita and Delfiah, in fact, are on the current Kennedy roster along with Nicole.

The girls would head out to play ball on the hallowed, graffiti-covered basketball courts opposite the buildings. The court at CCP features many current and past Kennedy players, who spend countless hours playing pickup games, or

competing in tournaments against one another. When it gets too cold to play outside, they sometimes retreat to the recreation center next door for games.

Nicole, Dakita, and Delfiah were often the only females on the court; many of the other girls at the project were busy jumping rope or perfecting dance steps. Others were taking care of chores at home, caring for siblings or babies they had made as teenagers. The guys would tease Nicole, Dakita, and Delfiah, saying, "You're trying to be a boy," "You can't play basketball," or "You're a girl. You're supposed to go jump rope."

Nicole didn't often get into full-court games with the men. Instead, she and her friends played three-on-three, or shooting games like 21. When she got a chance to compete against the men at CCP, Nicole loved the challenge.

"My main thing was to score a basket," she recalls. "That's all, just one basket. That one basket meant more to me than anything." She often stayed at the CCP courts until it grew dark, running up the hill to get home before her grandmother scolded her for being out too late.

Dakita and Delfiah had grown up playing ball together on those courts long before Nicole first joined them. Carzell Collins, a powerful rebounding forward on the Kennedy boys' team and the best friend of Dakita's older brother Danny, would often come to Danny's window late at night with a ball, and say, "Yo, Trapp, come downstairs."

"What's up?" Danny would ask as he laced up his ankle braces.

"Come on, let's go to the courts." At two or three in the morning, with only the streetlights to see by, the two boys would play one-on-one and work on improving each other's games.

During the day, Dakita would follow Danny to the court, while Delfiah shadowed her older brother, Rondell. Dakita developed a deadly jump shot. But when she was on defense, the guys would say, "I'm just gonna back you up," meaning they were planning on posting her up under the basket to take advantage of her height. Other times, they would make Danny defend her, forcing her to learn how to get around her brother to drive to the hoop.

When faced with verbal assaults from the men, Delfiah would take her ball and dribble or shoot by herself at the opposite end or at the secondary court below the main one. Eventually, when the guys needed an extra player, they would look over, notice that Delfiah had a decent shot, and ask her to play.

In those hours on the court, competing against the best players in Paterson, Nicole, Dakita, and Delfiah forged themselves into tough, unrelenting competitors who could dominate most girls they met.

They did it because they loved basketball, Dakita and Delfiah especially because they needed an outlet from the disturbing, violent surroundings in

which they lived. Dakita and Danny's mother, Delores, and Delfiah's mother, Rhonda, had lived in the projects for most of their lives. Dakita's father had been around to teach Danny and his other sons about basketball before moving to Florida when Dakita was young; he still stays in touch with the family and supports them financially. Delfiah's dad moved out when she was five. She still sees him around Paterson, using drugs.

Mrs. Trapp and Mrs. Gray remember the days when they were young and CCP was a nice place to live. They recall green lawns, working playground swings, carefully trimmed trees; hallway floors shined; doors left unlocked so people could move easily between apartments; drugs being sold discreetly, by relatively clean-cut guys in gabardine slacks and alligator shoes. Even the dealers looked out for one another.

"It was more like a family," says Carmela Crawford, a Kennedy basketball star in the early 1980s who returned to become the assistant coach at Kennedy in 1998. "Everybody would watch out for everybody. If you did something wrong, somebody would take care of you and then take you to your mother and tell her, 'Look, I saw your child throwing a rock,' or 'I saw your child spit on somebody.'"

That child might then get two or three beatings aimed at preventing a repeat offense—one from the person who caught him in the street and at least one from a parent.

But in recent years, things began to degenerate around CCP. Dealers began to sell drugs more openly, and some paid residents' rent in exchange for stashing large amounts of drugs in their apartments. Users shot up in the hallways and stairwells and maintenance crews stopped cleaning away urine, human feces, and crack vials that littered the property. Graffiti covered buildings inside and out. Garbage bins overflowed with waste. Playground equipment was rendered useless. In just a matter of years, dealers and users took entire buildings hostage, making life dangerous for law-abiding tenants. Mrs. Trapp got so used to the gunshots that she would routinely duck in the middle of her second-floor apartment.

Dakita became so jaded by the drug use around her that she didn't think life would be that much different outside the projects.

"A lot of people moved to other places or whatever thinking it was gonna be okay," she says. "But it's the same thing everywhere. It's drugs everywhere. Everywhere you go, it's gonna be drugs. It's not like it's just the projects."

Still, Dakita tried to steer clear of the drugs and the violence by watching television or inline-skating when she wasn't playing basketball. Her mother encouraged Dakita to play basketball because it kept her daughter out of trouble.

"[Other girls] start getting grown, being out with the crowd and stuff," Mrs. Trapp said. "I ain't never had that problem because . . . Dakita's mind was all into

basketball. She ain't have time to get into with the girls or boys or nothing because she was into basketball. That's why I thank God for that."

Delfiah was a deeply introspective girl who sometimes had trouble verbalizing her thoughts. She wanted out of the violent life in the projects, but knew no other way of life.

"You see people get killed, beat up, cops every day," Delfiah recalls. "You see drugs being sold to parents, young people, old people, pregnant people, stuff that ain't right. And it's like, you keep your mind on it, you might follow up and start doing stupid stuff too. So I had to do something to clear my mind and keep my conscience right and stay focused. If I don't get involved, then no one can put nothing on me. If I stay over here for five minutes and let them argue and fight, then when the police come, they gonna get in trouble, and not me. So if I just isolate myself, I'll stay out of trouble and I'll be living to see tomorrow when someone else might not be."

Delfiah played organized basketball on and off in city league, but she didn't have the staying power of Nicole and Dakita. She quit teams because she felt she wasn't touching the ball often enough. One day, Carmela Crawford, a former Kennedy basketball star who grew up at CCP, discovered Delfiah shooting baskets at the projects and persuaded her to join an AAU team co-run by her friend Debbie Tillman.

By the time Nicole was in seventh grade and Dakita and Delfiah were in eighth, all three were competing for Tillman's AAU team, the Pioneers. Throughout the spring and summer, the Pioneers practiced and traveled to tournaments in Massachusetts and Virginia and on Long Island. For the girls it was a chance not only to measure their skills against those of other select traveling teams but also to get out of Paterson, to leave the inner city and be exposed to other parts of the country, other types of people, and other ways of life. The team did well, twice qualifying for the state AAU tournament. The trio of Nicole, Dakita, and Delfiah contributed to much of the Pioneers' success. "They all clicked," one coach said. "They always knew what the other one was gonna do."

For Dakita, the AAU team led to a more stable life. She became so attached to "Coach Debbie" that she always wanted to stay in her coach's hotel room during tournaments. Even when she wasn't on the road, she would stay with Tillman, who lives with her husband in a residential part of Paterson. Tillman eventually became Dakita's godmother. In Tillman's view, it is not too much to say of both Dakita and Delfiah that "basketball saved their lives."

During the week, Nicole looked forward to the weekend AAU trips, to the team camaraderie and the chance to contribute to a winning unit. But as a seventh-grader she was devastated when she wasn't chosen for the Pioneers' 16-and-

under team headed to Florida to compete in a tournament. Nicole desperately wanted to go, but Dakita and Delfiah were selected instead. Nicole was 12 at the time, and probably wouldn't have played much anyway. But that didn't matter then.

"We had tryouts and I didn't get picked. I kept crying and crying and crying. I cried for a couple of days. That was one of the things that I wanted most in my life."

Perhaps that's what set it off. Rejection can be an awfully strong motivator. After that incident her interest in the sport grew into a full-blown obsession. She compared it to an addict's desire to feed his drug habit.

After that, Nicole played as much basketball as she could. She was so obsessed that at one time she played for three teams. On top of playing for the Trojans during the winter in city league and the Pioneers during the spring and summer, she competed for her school team, the School 4 Bulldogs. When time permitted, she also practiced with the Kennedy varsity team. Nicole's two-years-older cousin, Jody Foote, would sometimes bring Nicole along to practice. Nicole simply couldn't get enough. In seventh grade she got a glimpse of the recruiting madness she would later experience at the Nike camp. She received her first letter of interest from a college. Florida State sent Nicole what would be the first of many recruiting letters.

* * *

Now that she is enrolled at Kennedy and has witnessed the tremendous success of the WNBA during its first season in 1997, her obsession with the game has not abated. She keeps her mother up at night bouncing a basketball off of her bedroom wall. "She annoys me," Andrea Richman says. "Even at like two o'clock in the morning, she's bouncing balls." Now that Nicole has seen Falisha Wright, a former Kennedy point guard, make it to the ABL, she has big dreams.

As she sits in the bleachers on this January day, she imagines where basketball might take her eventually. And with only the slightest shred of self-doubt, as if communicating the thought for the first time, she says: "I see myself playing pro ball. Hopefully, I'll be there someday. I hope the girls on the team feel the same way. I don't know what they want to do or where they want to go with their life. But for me, I want to play pro."

Chapter 2

Colonel Alexander Hamilton first got the idea to harness the power of the Passaic River's majestic 77-foot-high Great Falls for industrial use in 1778, while having a picnic lunch with General George Washington at its base. Founded with Hamilton's aid as the nation's first planned industrial city in 1792, Paterson, New Jersey, was over the decades variously heralded as "the Silk City," "the Cotton City," and "the Aviation City." The abundance of jobs in the city's red-brick mills offered employment for generations of Germans, Poles, Irish, Italians, and Jews. During the nineteenth century, Paterson, located just to the west of New York City, grew faster than any other city on the Eastern Seaboard.

Up through the 1930s and '40s, Paterson continued to offer the hope of a better life for new waves of migrants. By World War II, there were 35,000 Jews in the city. Buoyed by the availability of jobs at Wright Aeronautical Company, Paterson's largest employer and the nation's largest manufacturer of airplane engines, thousands of southern blacks moved to Paterson as well. While World War II raged, Paterson's African American population more than tripled, increasing to almost 14,000.

But since the 1960s and '70s, white—and industrial—flight and urban decline have given Nicole's hometown a different appearance. Gone is the former abundance of industrial jobs in the city's now aged red-brick mills. Corporations, seeking cheaper labor pools, moved steadily to the South and overseas until Paterson's factories were abandoned. Gone are the stylish department stores, theaters, and movie houses that once made Paterson's downtown a vibrant center of activity. In their place are multipurpose suburban shopping centers like the Willowbrook and Bergen malls. The city's main streets now feature mostly bargain clothing outlets, fast-food restaurants, check-cashing storefronts, liquor stores, nail- and hair-care establishments, and that old standard, the U.S. Army, whose recruiting office sign reminds passers-by WE'RE STILL HIRING.

Gone also is much of the middle-class population, white and otherwise, to neighboring towns—the Jewish residents to suburbs like Wayne, Fair Lawn, Pompton Lakes, Franklin Lakes, and Wyckoff, so that now there are fewer than 1,000 Jews left in the city. Seeking better schools and safer living areas, many Italians moved to West Paterson, Totowa, and Wayne, while Poles, Irish, and Germans left for Clifton and other neighboring cities. Paterson's newcomers are Dominicans, Puerto Ricans, and Arabs, who seek affordable housing and a way of life better than that at home. Paterson today is 33 percent black, 31 percent white, 28 percent "other," and 6 percent Indian. Half of the city's population identifies itself as Hispanic.

"Everything that could happen to a city happened to Paterson," said Francis X. Graves, Jr., a former mayor. "Everyone who could afford to leave, did." When asked, two weeks after his reelection in 1986, whether he thought he would live long enough to see things turn around, Graves replied, "Hey, I'm only sixty."

Violent crime, gangs, drugs, teenage pregnancy, and prostitution are daily features of city life. Even as hardworking, determined, goodhearted people go about their lives, many are understandably uneasy about their city. The census shows that Paterson is one of the poorest cities in the nation. Nearly one in five of its 149,000 residents lives in poverty, and about 15 percent receive public assistance. The city's per capita income is under $11,000. Unemployment is high, more than twice the state's average. Affordable, adequate housing remains in short supply, with the exception of the city's less-than-desirable public housing projects.

Perhaps nothing better illustrates the ills of Paterson than two large housing projects: the Alexander Hamilton Housing Development on Alabama Avenue on the city's east side, and the Christopher Columbus Project, where Nicole and her friends play basketball, on the city's west side. Both developments have been ravaged by drug abuse and drug-related violence. By the mid-1980s, crack became the drug of choice in inner cities like Paterson, largely because it was cheaper and more accessible to low-income people than other drugs. About this time, Jim Ring, the coach of the Kennedy boys' basketball team, began hearing comments from the stands about players faring badly because they were "on the pipe." Ring didn't know what it meant until his players explained, "That's the crack pipe, Coach." Soon the kids were saying that "half of Paterson is on dope and the other half is selling it."

Both inside and outside of the projects, selling drugs became an easy way to make money. James Lattimore is a lanky, talented basketball player who grew up at CCP and became the star point guard of the Kennedy boys' team beginning in his sophomore year in 1997; he led the Knights to three straight Passaic championships and proudly wears a varsity jacket that proves it. A year older

than Nicole, he once said that if basketball didn't take up most of his time, "I probably be in an orange jumpsuit in the county jail. All my friends were selling drugs and doing all types of stuff—robbing people. Most of us came from poor families. That was the only way to make money—sell drugs."

With the drugs comes violence. Drug dealers conceal guns in fire-hose cabinets and nooks and crannies all around the project's buildings. At CCP, gunshots are heard at all hours of the night; Danny and Dakita Trapp say people sometimes shoot in the air just for the fun of it. At Alabama, where Nicole's older sister Lorna and her two young sons, Junior and Kadeem, have lived since the early 1990s, packs of young men who hang out in front of the project shoot at the outdoor lights so that the police can't observe their activities. Lorna's building features graffiti promoting one of the local gangs, the AHP (Alabama Housing Project) Boys, and is considered one of the most marked in her development. It is covered with graffiti.

"People shouldn't have to live the way they are living up there," Paterson's mayor, Marty Barnes, said of the Alabama project. "As we speak, we've got significant [police] representation up there, and we're going to hold that in place to get the development straightened out and cleaned up."

The Paterson Housing Authority recently initiated a Gun Buyback Program that paid $100 cash for working guns and $50 for nonworking ones. In what was considered a resounding success in the first buyback, 54 weapons were turned into the police department at three sites.

Many children have become desensitized to the violence and despair around them. The children who are allowed to play outside at CCP do so in areas that feature more glass and graffiti than grass. One game played by CCP kids is called "pit bull": the kids get on all fours, form a circle, and snarl and bark at each other while two kids wrestle in the center of the circle.

Robert Buttersworth, a clinical psychologist who studies the effects of violence on children in housing projects, was interviewed by a reporter from the *Herald News*. For 15 years, Buttersworth has been asking children to complete the sentence, "My biggest fear is . . ." "Fifteen years ago, children living in the projects would answer that question with something imaginary, like the bogey man or a monster," Buttersworth said. "But that's all changed. Nowadays kids come back with responses like, 'My biggest fear is getting shot,' or 'My biggest fear is that my mom and dad will get killed.' The constant violence around them is really affecting them."

Nicole is lucky. Her family has never lived in the projects. Her grandmother, Euphemia Richman, the family's matriarch, instead moves her clan around from house to house, searching for the best possible location depending on how many

of her relatives are in Paterson at a given time. Before Nicole entered Kennedy, she spent much of her childhood with her mother and younger brother Alex in a narrow, blue-painted three-family house on North Sixth Street, a residential street not far from the CCP.

At that time Euphemia Richman lived across the street with her husband, Kenneth, and several of Nicole's aunts and cousins. Euphemia never liked the neighborhood. Junkies lived downstairs, local dealers stored drugs outside the house, and police cruisers regularly looked to arrest the kids selling drugs. Groups of boisterous men would buy ice and booze and sit on the stoop in front of Euphemia's house until all hours of the morning making noise. Every night Euphemia would come out and say, "Get out of in front of my house. Don't you live somewhere? I'm calling the police." Sometimes they would listen, other times they would ignore her. Nicole's cousin, Kesha Young, who lived in the house with her mother, Nicole's aunt Joan, and two sons, Ricky and Daniel, joked that when the family left Jamaica, it had "moved out of the hood to come back to the hood."

Euphemia may not have liked the dealers on North Sixth, but not everyone was bothered by the surroundings.

"Nobody really messed with us," Nicole's mother recalls. "If you don't pay attention to them, they don't pay attention to you, unless you're buying your drugs or whatever." The dealers never bothered Nicole because they knew she was a kid with a purpose; they often saw her leaving the house with a basketball. Sometimes they would even buy her food if she was hungry.

Still, Euphemia has reason to be apprehensive. Her son Daniel was shot and killed on his way to watch Bob Marley's funeral on a large screen in a New York City park in 1981, and she worries that Paterson, a place she had thought was safe when she first arrived, is becoming more and more dangerous.

"When I came here, Paterson was Paterson," she says. "But man it got so delapidated, all the houses burned down and mashed up. Paterson is no more Paterson. Paterson is going to the dogs."

* * *

John F. Kennedy High School is a massive gray-brick, bowtie-shaped building on the corner of Totowa and Preakness Avenues in Paterson's Westside Park. Completed in 1965, the school was built to accommodate the overflow of students from the old Central High downtown and the westward growth of the city, which filled its last open spaces after World War II. Before Kennedy was built,

the nearly 5,000 public high school students in Paterson were attending classes in split sessions instead of full-time. The then-mayor, Francis X. Graves, Jr., called Kennedy "the most significant building erected in the City of Paterson in our generation." Graves noted that the school would open with 2,800 students, had 102 classrooms, and featured the largest cafeteria in the city.

In the 35 years since, Paterson has changed dramatically, and so, too, has Kennedy High. If a member of the graduating class from, say, 1967 were able to go "back to the future" and visit Kennedy, he would be hard-pressed to recognize his own school. The first page of the 1967 yearbook depicts seven students, all smiling, and all white, wearing cowboy hats and standing in front of the building. One girl holds a guitar, another sits on a horse. "Mr. and Mrs. JFK," pictured later in the book, are both white, as are most of the students, teachers, and administrators. Only a small percentage of students is African American.

Today, the horse and students in cowboy hats have been replaced by four armed, uniformed officers from the Paterson Police Department, who man the entrance to the building on a daily basis. The white faces among the students have given way to black and brown ones belonging to Dominicans, Puerto Ricans, Arabs, Caribbean Islanders, and a vastly increased African American population. Seventeen different languages are spoken in their homes. Spanish is spoken in so many of them—60 percent—that the school report card prepared by the state appears in both English and Spanish.

Eastside, Kennedy's crosstown rival and the alma mater of Allen Ginsberg, first became known in the 1970s for its crime, vandalism, turnover rate among principals, and its students' poor academic performance. Unlike Kennedy, which is relatively secluded on the western edge of the city near a park, Eastside sits in the center of a busy downtown section on Park Avenue. In those days, anyone walking past the school, especially anyone looking to deal drugs or exact retribution for a fight, had a relatively easy time getting into the building through one of its many doors.

However, in 1982 the Board of Education named Joe Clark principal at Eastside. The controversial Clark made national headlines in the mid-1980s when he used a bullhorn and a baseball bat as his main props for restoring order and cracking down on lateness, absenteeism, student apathy, and poor academic performance.

He was ultimately made world famous by the 1989 movie *Lean on Me*, starring Morgan Freeman, which was based on his autocratic style of governing Eastside. In his book, *Laying Down the Law*, he spelled out, in often bombastic terms, the problems he saw in schools like Eastside. "Most people generally know that inner-city schools in the United States are in bad shape, but they don't know how bad," Clark wrote. "These schools are constant Bedlam. There are fights

every day. There is widespread incompetence, wanton destruction of property, and constant vile language. Prostitution is rampant. Violence is extolled. Weapons are prized, and used. Drugs are king. The major role model for the inner-city youth is the rich drug dealer. The main point of distribution is the school."

Clark believed that the ills of the inner city would grow until they spilled "outwards into more affluent areas, bringing drugs, crime and pitiable want." The solution, he argued, was an investment in education, a realization by the entire country that the nation's children, all of its children, held the key to the future health of the country.

"The cure for ignorance is education," he wrote. "But our schools, especially our inner-city schools, have broken down. This is a crisis in education." At a time when the federal government was cutting back on funding for education, Clark drew praise from Ronald Reagan's secretary of education, William Bennett, and from Reagan himself.

Clark earned criticism from other quarters. "It's interesting. A media star comes on the horizon, and all of a sudden Eastside High School becomes this bastion of education," Peter Tirri, the president of the Paterson Education Association, told a local newspaper at the time.

As Clark made national news at Eastside, many at Kennedy felt ignored. There had always been a rivalry between the two schools, a competition that extended from the basketball court to the Board of Education offices, where the schools vied for funding and the latest resources and technology.

Though Kennedy more or less stayed out of the spotlight during Clark's tenure, by the mid-1990s it had surpassed Eastside in the eyes of the police as the most dangerous school in Paterson. In one incident, some Kennedy white students, some of the brightest in the school, were practicing a form of witchcraft, spending their lunchtime conducting seances down by the Passaic River. One girl told a boy he was going to die the following Halloween. The police intervened in time to head off the threat.

At the same time, attacks on teachers and sexual assaults on female students were being reported in increasing numbers. Fights in the cafeteria in which tables were flipped were commonplace. Students were routinely found with knives, some with guns. One day, authorities confiscated a machete from a kid. Any time a fight broke out on a Friday or Saturday night, a student would open one of Kennedy's more than 100 doors during school the following week in order to let in older buddies from CCP. Nineteen-, twenty-, twenty-one-year-old guys would then walk the halls looking to pull someone out of a classroom in retaliation. Unarmed security guards, limited in their training, could do only so much in response.

Finally, in February 1996, when Nicole was in seventh grade, six uniformed and armed police officers were hired by the school district in response to a cluster of brawls between black and Dominican students. Two years later, police were stationed at Eastside as well. The primary job of the police was—and remains—to stop nonstudents from entering the school and inciting violence.

The officers at Kennedy weren't greeted with open arms. Some students shouted "No pork in our forts," and "We don't need no Five-O here." Others said JFK stood for "Jail for Kids." "You feel like you're in a prison," one of Nicole's teammates says. "I feel if something's gonna happen, it's gonna happen regardless of whether they're here or not. It's already been proven with all the fights."

The teachers, on the other hand, are generally supportive of the police presence.

"It's much better with the police here because [incidents are] handled quickly and instigators can be taken out of the school," one teacher explains.

Despite the police presence, ethnic violence still flares outside the school. In October 1996, one year before Nicole entered Kennedy, a group of Arab students walking toward the corner of Market and Main streets to catch a bus to South Paterson clashed with a group of Dominicans, who had followed them. Store windows were shattered as more than 300 youths fought with knives, bats, and sticks. On other occasions, students have gotten into massive brawls using sticks, bottles, and knives in the parking lot behind the school.

"We just don't like them," Joel, a Dominican student involved in the downtown brawl, said of the Arabs. "They think they are better than us. They think they are all that and that we are nothing." In an effort to diffuse the ethnic tensions, the district conducted conflict-resolution meetings bringing students, community leaders, and school officials together.

Still, all sorts of potentially dangerous occurrences take place. In Nicole's first three months at Kennedy, police responded to 21 incidents at the school, ranging from assault to disorderly conduct and trespassing. Within a four-block radius of the school, officials arrested four alleged drug dealers and 10 alleged drug buyers.

Most of the students simply go about their business while a minority of troublemakers create problems and headlines. Still, there are 14 security guards from an outside agency, four from the Board of Education, and four full-time police officers stationed at Kennedy. The Paterson Board of Education spends approximately $340,000 annually on security at Kennedy and Eastside.

Kennedy teachers, coaches, and administrators are well aware of the school's challenges. But the majority are welcoming and hardworking. They are trying to make a difference. They do not seem daunted by the overwhelming task.

"I heard a lot of things about Paterson and gangs and I was afraid to come here," says Nicole's guidance counselor, Alberta Rollins, who is African American. "[But] I love it here. I wouldn't go anyplace else."

Even though the state took over the Paterson school district in 1991 and has earmarked emergency funds for its schools, scores on the High School Proficiency Test are still below standard. At Kennedy, 28 percent of students passed the HSPT during the 1997–98 school year, Nicole's freshman year; the state average was 75 percent. Only 10 schools in the state had a worse percentage than Kennedy, and one of those was Eastside. The mobility rate, or percent of students who entered or left the school during that year, was 36.7 percent, almost three times the state average. Kennedy also had a 20.2 percent dropout rate that year. Paterson has many immigrants moving in and out, and the students can be adversely affected by this. Educators say students have a difficult time learning when their environment continually changes.

In response, Kennedy's principal, Richard Roberto, a Vietnam veteran who has spent virtually his entire adult life living and teaching in Paterson, has spearheaded an effort to improve HSPT scores by introducing after-school, Saturday, and summer programs offering extra help to students. The school has also instituted a number of theme-based curricular programs ranging from the Government, Law, and Social Change Academy to the Science, Technology, Engineering, and Math Academy (STEM), in which Nicole is enrolled.

Roberto and many of the teachers and students at both Kennedy and Eastside are sensitive about the media. At Kennedy they believe the school is targeted for sensationalized stories because it is an inner-city school. At Eastside these feelings are especially acute because anyone who saw *Lean on Me* has the idea that the school is simply a zoo. But Roberto also understands that Paterson's problems are similar to those in many other American inner cities.

"School is not just a place where students come for an education," he says. "We deal with the health and social issues of the students. Their problems and issues hinder a really solid education. There's more of that now than there was in the eighties or the seventies. Sometimes it's disturbing to see the results [of the tests], but it means you just gotta work a little harder. You know, that's an inspiration. You lose a game. What are you gonna do? You win the next one. So it lights a fire under you. What do we have to improve? What do we have to work on? How can we change the mind-set of the kids?"

Chapter 3

By the time she was ready for high school in the fall of 1997, Nicole was such a good basketball player that she had become the subject of a local turf war. Nicole had initially hoped to attend Paterson Catholic, the lone parochial school in the city, the alma mater of Tim Thomas, now with the NBA team the Philadelphia 76ers, and a school with an emerging girls' basketball program.

A couple of years earlier, the football coach had come around offering her cousin Dameon a full scholarship, filling his head with dreams of glory. When the coach was fired a year later, tuition bills for thousands of dollars started coming to the house. The family was shocked. They simply couldn't pay and had never thought they would have to. Euphemia, Nicole's grandmother, pulled Dameon out of PC and enrolled him at Kennedy. After that experience, there was no way she was going to let Nicole enter Paterson Catholic.

Nicole's second choice was Eastside. Her older sisters, Karen and Lorna, had both graduated from Eastside in the early 1990s, but Nicole's primary motivation for wanting to go there was Ed Black, Eastside's coach. He gained respect for her as soon as he discovered she liked to read books and was an A student. He didn't know whether she could play basketball or not, but he knew she would be a good influence on his basketball team. They soon developed a relationship, playing games of one-on-one and occasionally going out to eat. Nicole liked Black and decided she wanted to play for him, even though her family lived on the city's west side—Kennedy's side of town. So what if she had to temporarily use Lorna's address at the Alabama projects to claim that she lived on the east side? Kids in Paterson did it all the time.

But Coach Donovan Jonah—a stout, compact Jamaican with a strong will—knew full well that Nicole actually lived within Kennedy's district on North Sixth Street; her cousins Jody, Kesha, Kaara, and Dameon all lived on North Sixth and were enrolled at Kennedy. Donovan wasn't about to let her talents go to his

archrival. Eastside and Kennedy had fought like the Hatfields and McCoys over lesser players than Nicole. Donovan was shocked when he discovered that Nicole was switching her allegiance. After all, she had been practicing with the Kennedy girls since the seventh grade. When he returned from a vacation in Florida, he couldn't believe what had happened.

"I found out that Mr. Black wined and dined her and took her everywhere, and talked her into coming to Eastside," he would later say. According to Nicole, Black hadn't really wined and dined her as much as he had earned her trust. In any event, Donovan went to Nicole's house and threatened to sue Black and Eastside unless Nicole enrolled at Kennedy or, depending on whom you believe, simply expressed interest in having her under his tutelage.

Whatever the case, after spending a couple of days at Eastside, Nicole showed up outside Jonah's office at Kennedy, ready to be a Lady Knight. Her mother and grandmother had told her it had to be that way. Nicole was angry as a result of what happened, and Jonah knew he wasn't her first choice.

Nicole learned a valuable lesson during that period about the double-edged sword of being coveted. On the one hand, it reinforced her ego to see coaches taking extraordinary measures to get her into their school colors; on the other, there were emotional costs involved with being in the crosshairs of several coaches; there were sacrifices attached to whatever decisions she made—or was obliged to make.

As the 1997–98 season takes off, both Nicole and Coach Jonah are optimistic about the team's chances. In the world of girls' high school basketball, any team in possession of one genuine star has an immediate advantage over most opponents. Because the pool of quality girls is still catching up to that of boys, the gap between a legitimate scorer and the rest of the players is likely to be substantial. Any team that boasts two quality players is almost certain to be a contender for league and county titles, as long as the supporting cast can hold its own. And any club fortunate enough to have three skilled players, each of whom poses a threat to score, is a rare and dangerous entity indeed.

The sky is the limit for Coach Jonah's club, for he now has not one, not two, but three players who present serious matchup problems for most opposing teams. Dakita, a sophomore, is the team's combustible but prolific shooting guard. She often has trouble focusing in class and her mischievous nature leads to trouble with teachers and frequent suspensions from school and from the basketball team. She often gets into arguments with Coach Jonah and the other players. When she was a freshman, Jonah described her as a "wild bronco," because she was so difficult to control. Still, when Dakita does play, she is a major force. As a freshman, she was named all-county and averaged 17 points per game. Kennedy also returns Delfiah, a raw but lithe and nimble forward

who averaged 10 points and 10 rebounds as a freshman. Dakita and Delfiah are the established stars. One local paper calls them "super sophs" and devotes one simple line to the freshman: "Nicole Louden is a player to watch."

Jonah was an assistant under Lou Bonora when Falisha and Lakeysha Wright led the nationally ranked Kennedy teams a decade earlier. He took over the heralded program in 1993, after Bonora decided he wanted to spend more time with his young daughters. During his tenure, Jonah has enjoyed mixed results, but he senses that once Dakita and Delfiah have a chance to play with Nicole anything is possible.

"I had a feeling that when Dakita and Delfiah were seniors and Nicole would be a junior, I had the capability of winning the state Group Four championship, if not moving on even further," he said. "I needed a big girl and I was going to these eighth-grade games and I had my eye on several people." Another promising young guard named Trenee Douglas, who grew up playing with Dakita, Delfiah, and Nicole, is also planning on coming to Kennedy next year. "The future is looking good," Jonah tells himself.

Nicole and Dakita were pretty close before high school, but now that Nicole is at Kennedy the dynamic between the two girls is beginning to change. In two of her first three games in a Kennedy uniform, Nicole scored 31 points, garnering headlines, praise, and jealousy in the process.

The girls insist that it isn't a problem, but it is clear that the team, and Dakita in particular, feels somewhat threatened by Nicole's arrival.

"We're a one-two punch," Dakita says. "I'm one, she's two."

In reality, Nicole is fast becoming the main attraction by sheer force of will and commitment to improving. When Nicole scores a season-high 35 points against Barringer High School in mid-January, it marks the seventh time in the team's first 10 games that Nicole leads the team in scoring. Dakita scores 19 points in that game and is playing well, but she is starting to hear things at school.

James Lattimore and other members of the boys' team, classmates at school, and even the assistant coaches are fomenting division by choosing sides, with some saying Nicole is the best player on the team, and others saying Dakita is.

"The reason I was going with Nicole was Kita had an attitude problem," Lattimore would later say. "Nicole never talked back. Nicole was like, 'I ain't in competition with you.' Dakita wasn't setting goals on winning counties and [making] the team better. She was worried about Nicole getting more points. Nicole was only a freshman, dropping thirty, thirty-five points."

Meanwhile, Delfiah, who shows hints of amazing athleticism, feels like a third wheel. At one point she tells Dakita and Nicole she wants more touches on the ball, and so they oblige, feeding her the ball down low every chance they

get. But Delfiah repeatedly has trouble converting the layups, much to the annoyance of Nicole and the others.

"I feel like I'm part of them," Delfiah says. "I'm one of the three. It's not just them two. It could be one, two, three. I think people take it too far as in them being the stars. You can't always depend on them."

Nicole in turn is becoming offended by what she perceives as Dakita's immature and sometimes wild behavior. On several occasions, Dakita jogs during team runs instead of running at full speed. One day she splashes water on an assistant coach (claiming it is an accident). She tells teammates and coaches alike, "Go fuck yourself."

And Nicole just can't stand this. She grew up in Euphemia's strong household, with plenty of love and family support. There are always aunts and uncles and cousins around to guide her, and Euphemia doesn't brook much fooling around. The sort of behavior Dakita is exhibiting simply wouldn't go over in Euphemia's house.

When Dakita and other players repeatedly act up, Nicole feels Coach Jonah should discipline them, or kick them off the team.

"I feel like you shouldn't keep making excuses for people who continue to do the wrong thing," she would later say. "You think society's gonna feel bad for them? No, you can only do so much for a person. You can only make so many excuses because if you don't nip the problem in the bud, it's gonna continue. I just lost so much respect for Jonah. It made me so mad how the kids treated an adult like that. It wasn't that they were treating him like garbage, it was that he wasn't doing anything about it."

Things reach a head between Nicole and Coach Jonah on January 24. When Nicole arrives late on a city bus for the team trip to Passaic High School, Jonah benches her for the start of the game. When Nicole finally gets in, she receives a pass from Dakita on a fast break right under the basket but chooses to dribble back out and take a jump shot—which she misses—instead of banking in the layup. She is angry at Coach Jonah and wants to show him up. Nicole sits the bench for the remainder of the game, finishing with 13 assists, many to Dakita, and just two points. Dakita winds up scoring a season-high 40 points. To Nicole and many outsiders, it appears that under Jonah there are two sets of rules: one for Nicole and one for Dakita. The coach stands by Dakita, making excuses for her even when she makes mistakes. It is Nicole whom he perceives as the real troublemaker.

Perhaps Jonah has higher expectations for Nicole and holds her to a higher standard, but he and Nicole also have diametrically opposed philosophies about handling these situations. Whereas Nicole feels little sympathy for girls who

behave badly, Jonah wants desperately to reach out to them. Having come to the United States from Jamaica and grown up in a tough part of Newark, he knows how difficult it is for kids from the inner city. With Dakita Jonah tries the tough-love approach. He believes basketball can save her, despite her rambunctious personality. Oftentimes before a game he is off in a hallway or corner lecturing Dakita, emerging with a frustrated, anguished look on his face.

"Morals and values were not something these kids were given as a framework to survive in this society," he would later say. "What they were given is, you go out there and get your hustle on. The morals and values that these kids need as a framework to make it in society were not instilled in them at a young age. [But] you see the diamond that's sitting there that needs to be chiseled out because the talent is there. The talent is waiting in the school and the streets have gotten them, have taken them away from the athletic program. When I say the street, I'm talking about the impoverished life of these kids. Certain people you can yell and scream at. Certain people you got to put your arms around. Dakita's the kind of kid you put your arms around. You had to be stern but loving. I told her whenever she screwed up, I don't care who she disrespected, a teammate, assistant coach or me, I was gonna sit her."

Over the course of the season, Jonah benches Dakita for about half a dozen games. When she isn't in the lineup, the Lady Knights often lose. That is probably partly because they miss her scoring capability, and partly because they are thrown off by the distraction these incidents cause.

While these subplots play out behind the scenes, Jonah is full of praise for Nicole in public. When asked for a quote for a newspaper story on Nicole, he says: "During the pre-season, when everybody complains about going outside and running, she'll come down on her lunch period and lift. She'll go down to the gym and run. She's just an unbelievable kid."

Toward the end of the season, Nicole is advised by an adult at the school to write Jonah a letter expressing her feelings about the lack of order on the team, which she does. The letter criticizes him for his inability to control the situation, and he says it goes so far as to say that she "hates" him for making her attend Kennedy.

Nicole does hate the fact that her mother and grandmother made her come to Kennedy, a program she sensed was lacking in discipline from the beginning. Before her freshman year, she told her mother, "I'm on my hands and knees; don't send me there."

So disturbed is Jonah by the note that he takes it to the school principal, the athletic director, and Nicole's mother, all in hopes of finding some way of addressing the situation.

"I was forty years old and the letter made me cry," he says.

Meanwhile, the team dynamic drives a wedge between Jonah and assistant coaches John Zisa and Maria Colon, who seem awed by Nicole's work ethic and openly use her as a point of comparison for other, older players.

"It's amazing to me that a girl fourteen years old knows as much about basketball as she does," Zisa says one day. "With her, it's not one day she works hard, one day she takes off. She works hard every day. She has a good effect on the seniors and the older kids because they see that and become competitive. They see her working hard and they say, 'Hey, she can do it, we can do it, too.'"

But that's not how things are playing out. Whereas guys can generally fight and verbally assault one another yet still play together without much problem, jealousy and anger among girls can lead to more far-reaching problems. Indeed, there is a standard line among the coaches and teachers at Kennedy that they would sooner break up a fight between two boys than two girls. The boys, they say, are inclined to stop when someone steps in. The girls are not.

Though no one on the girls' basketball team has thrown a punch, loyalties soon splinter as Coach Jonah feels that his assistants keep things from him and pamper Nicole at the expense of the others. Zisa sometimes drives Nicole to the YMCA to work out after practice, a habit that Jonah says he hasn't learned about until late in the season, but according to Nicole, Jonah himself drove her to the Y at times.

* * *

On the court, the team has its ups and downs. The Lady Knights reach the second round of the state tournament. Kennedy is involved in a tight game with North Bergen when chaos erupts. When Jonah tells the team to play a man-to-man defense, Nicole asks who will cover one of the North Bergen players within that scheme. Furious at her for questioning his authority, Jonah interprets her question to mean, "I don't feel like playing man today, Coach."

At another point, one of the girls yells at Coach Jonah, prompting assistant coach Maria Colon to yell at her. Jonah, unable to control the situation, proceeds to shout at Colon and throw his clipboard down. Meanwhile, the Kennedy fans—including several coaches, teachers, and administrators—are aghast that such a scene is going on at a game of such importance.

The game devolves into an every-girl-for-herself situation, and by the third quarter Kennedy is down by almost 30 points. Nicole finishes with 10 points, while Dakita scores 25. It ends with finger-pointing all around and turns out to be Jonah's last game as head coach. Nicole later says, "I was totally in the wrong

for that. You don't tell a coach what to do." But by then it is too late. Jonah is blamed for the team's internal squabbles and his perceived lack of control. He is fired after 10 years with the program, but remains at the school as a health and physical education teacher. So distraught is he that he goes to visit his mother in Florida, staying inside for five of the seven days there, asking her to give it all some meaning. He shows her the letter Kennedy sent him informing him of his dismissal, his own letter of grievance asking for an explanation, and Nicole's letter sent earlier in the year. But that last letter he doesn't save. He burns it.

"I burned it like everything of her," he says one day, his voice raising in anger. "My memory of her is gone. Everybody's gonna say, 'Well, she's a child, Jonah. You have to forgive her because she was young.' I forgive her, but I didn't forgive the adults who stabbed me in the back because of her."

As if all of this weren't bad enough, a local newspaper prints an article saying Jonah has been fired, but failing to offer any sort of explanation. The next day in school, everyone assumes the worst—that he somehow behaved improperly with the girls.

"I went through two years of people looking at me like I'm some kind of pervert, some kind of child molester because it wasn't explained why I was dismissed," he would later say. "Not only did I have to go through the disgrace of losing a program, I had to go through the disgrace of people suspicious of me. I had no way of saying it's not true."

Even when Nicole's senior year comes to a close, she and Jonah do not speak when their paths cross in the hallways and classrooms at Kennedy.

* * *

The tension between Nicole and Coach Jonah isn't the only drama Nicole experiences during her freshman year. In one game against Montclair, Nicole makes a steal and is pushed from behind while driving to the basket for a layup. She crumbles to the floor faceup as the girl she has just robbed falls on top of her. Nicole's face contorts and she screams in anguish, but stays in the game to shoot foul shots. Her knee "hurts like a mother"; she injured that same knee when she and her mother were involved in a car accident the year before. With Nicole sitting in the backseat, a car door slammed into the knee.

The day after the Montclair game she reports the injury to Laura Judge, the Kennedy athletic trainer. Judge is a young woman with an open, friendly face who has come to Kennedy just this year. She calls the office of Dr. Vincent McInerney, director of sports medicine at St. Joseph's Hospital and Medical Center in Paterson. McInerney has an excellent reputation as both a doctor and

a people person. If a student athlete does not have insurance, McInerney has been known to see him or her in the emergency room.

Nicole visits McInerney in his office at NorthLands Orthopedic & Sports Medicine Associates in Clifton, New Jersey. The third-floor office has a large waiting room with many chairs and several multicolored abstract paintings on the walls; like many offices it is often stuffy.

McInerney diagnoses a hyperextended medial collateral ligament (MCL) and recommends that Nicole wear a knee brace and undergo rehabilitation. The news is not devastating, but knee injuries are no small matter in women's sports. For a variety of reasons, ranging from biomechanical and hormonal differences to discrepancies in strength and conditioning, women are five to 10 times more likely to suffer anterior cruciate ligament (ACL) injuries than men. In one recent high school soccer game in Passaic County, three girls went down with damaged ligaments. Luckily for Nicole, her injury is not a ligament tear.

Euphemia and Nicole's sister Karen chip in for the $200 it costs to buy a giant ugly black knee brace with large metal hinges. Nicole wears it for the rest of the season and it seems to dramatically ease the pain. Several days a week Nicole's mother or someone else drives her to St. Joseph's to perform various rehabilitation exercises on her knee. It is not uncommon for her to go to practice, then the hospital, and then finish up her day by lifting weights or playing more basketball at the YMCA, thereby putting extra stress on her body. She loves the game too much, and is too young and fearless, to think any better. It doesn't occur to her that resting her knee now would benefit her in the long run.

Despite the injury, Nicole, along with Dakita, is named all-county when the selections are made in March. One local newspaper's summaries of the two girls reveals a lot about how the season went. Of Nicole it writes: "Clearly the most dazzling freshman to come along in years, Louden displayed all the signs of greatness to lead the Knights in several categories. The 5'8" guard, who scored 30-plus points four times [it was actually five], pumped in 21.3 points a game while averaging about seven rebounds and four steals. Her knifing moves to the basket, coupled with an accurate perimeter shot, make her a candidate to earn All-State recognition before her career ends." Dakita's season was described as "bittersweet for the gifted guard" because she missed seven games. Still, it pointed out that Dakita is on pace to score 1,000 career points, a lofty number for any high school player. Despite their incredible year together, Kennedy's two all-county girls will never play on the same team again.

The following fall, in 1998, Dakita transfers to nearby Passaic County Technical Institute because she and those close to her feel she needs more discipline and a change.

"It is a better place, a different atmosphere," Dakita says later. "At Kennedy, I did what I wanna do. Since I was one of the star players, they let me walk the halls and get passes. Now [at Tech], teachers I don't even know make me do my homework, ask how I am doing. I feel like they protect me more than at Kennedy." Her mother wonders if Dakita ever would have graduated had she stayed at Kennedy.

"A lot of times they let you get away with murder because you play a sport," Delores Trapp says. "[At Tech], they was all for her grades. They made it known from the door that they was all about her education."

Meanwhile, Meticia Watson has been hired to replace Donovan Jonah, establishing a sort of continuity within the program. A decade earlier, sporting a modified afro, the 5'10" Meticia played alongside the Wright twins and was an important element in Kennedy teams that won five straight county titles and two Group 4 state championships and owned a remarkable 58-game winning streak. She was no stranger to the recruiting process either. Known as Lottie to her friends, Watson had been heavily recruited before ultimately accepting a full scholarship to George Mason University, where she spent an injury-plagued four years.

Upon returning to Paterson (with her hair closely cropped), she simultaneously pursued a teaching degree and had hopes of joining the WNBA. She tried unsuccessfully to make the Liberty during the league's inaugural season. Hired at Kennedy in 1998, she still works out regularly with Nicole at the Paterson YMCA in the hopes of rekindling her career.

A soft-spoken but firm, friendly and intelligent woman, Watson wants to teach the game to Kennedy's young players, and she also badly wants to return Kennedy to its glory years. On more than one occasion, she inquires about restoring a missing banner to the gym wall.

Watson's hopes of winning more banners seem to take a giant step out the door when another star vanishes from the program. Delfiah mysteriously leaves Paterson early in her junior year, the beginning of Nicole's sophomore season. She leaves home with an unidentified older woman and winds up with her grandmother in Nansemond, Virginia. During that time, the police come looking for Carmela Crawford, whom Watson had brought in as an assistant coach, because she vaguely fits the description of the woman Delfiah left with. Watson spends several weeks on the phone with Delfiah's family trying to ascertain what the situation is, but Delfiah is gone for the year. Delfiah and her mother were not always the closest, but no one, including Delfiah, has ever said why she left. Something terrible evidently happened to her in Paterson.

"I was living in a violent environment, so I had to get away from that," she would later say.

Nicole must now soldier on on her own. She must adjust to her second coach in two years, and she will have to carry the load at Kennedy mostly by herself. She responds to Watson's arrival and Delfiah's departure by redoubling her efforts. Watson works the Lady Knights hard, much to Nicole's liking; she shoots 500 to 700 extra shots per day in the gym.

During Nicole's sophomore year, Kennedy qualifies for the state tournament and finishes 15–9, an improvement over the year before despite the loss of two-thirds of the heralded trio. Nicole emerges as one of the best players in New Jersey, averaging a state-best 29.3 points per game and garnering all-state honors and headlines in the process. SUPER SOPHOMORE NETS 1,000TH reads one headline after Nicole scores her thousandth career point. KENNEDY SOPH AN ALL-STATER says another. PERFECT COMBINATION: KENNEDY'S LOUDEN AND A BASKETBALL reads still another.

Nicole is now recognized all over Paterson. Girls point at her on the streets, whispering her name and smiling as if they have seen a celebrity. Boys, respectful but brash, crack jokes, challenging her to games of one-on-one, and asking her when she will make it to the WNBA.

Nicole has quickly developed a reputation as one of the hardest-working high school athletes in the state. Her obsession with the game drives her to spend hour upon hour in the Kennedy gym and the Paterson YMCA. Nicole does extremely well in school, and finds times for track, volleyball, and extracurricular activities, but those around her wonder whether all of this basketball is such a good thing. On more than one occasion Watson has left Nicole shooting baskets in the gym while she went out to eat, only to find Nicole right where she left her when she returns.

"She's the ultimate gym rat, a basketball freak," Watson tells a reporter. "Sometimes I have to tell her to give it a break and relax. It's almost scary."

Chapter 4

In the weeks leading up to Nicole's first experience at the Nike All-America Basketball Camp, in July 1999, she has a full schedule of summer basketball activities.

Today, June 30, under a hot midsummer sun, on a concrete basketball court not far from the Rutgers Athletic Center, Nicole is having her way with an opposing team that simply can't keep up. On this afternoon, the 16-year-old is outfitted in three-quarter-high black Nike sneakers, mesh shorts, and a white T-shirt.

Nicole's five opponents, as well as her four teammates, appear to be moving in slow motion while she conducts her own private high-speed ballet. On one play she steals the ball from a rival at midcourt and races in the other direction for an uncontested layup. On another, trying desperately to get her inexperienced teammates involved, she dribbles the ball on the perimeter, yelling, "Motion, ladies, motion." On the defensive end, she muscles her way through the opposition like a bully at the beach, grabs a rebound, and races toward the basket for a layup as a couple of foes trail helplessly behind.

Soon, Nicole substitutes out for one of her teammates and joins her friend, Colleen McCann, and several other girls behind one of the baskets.

"What's up, man?" asks McCann, a 30-something woman with freckles and long, red curly hair, wearing tan khakis, a green tank top, and sneakers. A former basketball player at Rowan University in nearby Glassboro, New Jersey, Colleen is working this week as a trainer at the Rutgers campus.

"I feel good playing against the big girls," Nicole says as she wipes the sweat from her brow and grabs a drink of water from a bottle. "I hate shooting so much. I want to get everyone involved. But you have to do what you have to do."

Nicole's personality and talent have driven McCann to get involved, much as Mos was drawn to Nicole. McCann met Nicole at the Rutgers camp a year earlier and has since become her sponsor and friend. She especially liked the way Nicole was so polite after beating her soundly in one-on-one. She thinks Nicole

can eventually play in the WNBA, if given the proper support. On one occasion, McCann and Nicole attended a book signing for the Liberty point guard Teresa Weatherspoon. Nicole was excited about meeting the WNBA star and even challenged her to a game of one-on-on. Weatherspoon was impressed with Nicole, with her size, strength, and confidence. She reminded her of herself at that age, but she declined the offer.

McCann helps Nicole out financially when she can. She sent Nicole $40 in the mail once during her sophomore year, and she asked the Rutgers staff to deduct Nicole's $370 tuition out of her $525 weekly salary, having made sure to clear it with Nicole's mother and the NCAA first. Andrea works the graveyard shift at a remittance processing center, standing for four and five hours over a machine that processes credit card and utility bills. She faces the same financial crunch as many people in Paterson. She doesn't have the money to send Nicole to basketball camps or tournaments and relies primarily on what Nicole can raise and on the donations of others.

"She's not caught up in any of the bad stuff," McCann says of Nicole. "Her surroundings and her behavior don't mix. From where she's from she should be caught up in all kinds of problems. She could be easily swayed by drugs and stuff, but she stays focused. There's always one golden child, and she's it."

Nicole is one of about 400 girls between the ages of eight and 17 at Rutgers' camp, run by coach Vivian Stringer. A revered fixture in the women's coaching ranks, Vivian Stringer has already led Pennsylvania's Cheyney State and the University of Iowa to the NCAA Final Four. Now she hopes to guide Rutgers there too. Stringer is highly respected in the world of women's basketball not only because of her success, but because of the way she has handled tragedy with dignity.

Her daughter Nina was confined to a wheelchair with spinal meningitis as a child; she has never spoken or walked. Her husband, William, suffered a fatal heart attack on the night before Thanksgiving in 1992. Shortly thereafter, Stringer left Iowa for a fresh start at Rutgers. In November 1998, her son, David, a football player at North Carolina State, was one of six student athletes charged in connection with the shooting death of a classmate; his involvement was judged peripheral, and as a first-time offender, he received probation and community service for what were deemed misdemeanor offenses. (Later, in September of 2000, her son Justin was involved in an automobile accident that left him in a coma and clinging to life support for two days. He made a miraculous recovery.)

Through all of this, basketball remained Stringer's life raft. "Sports is a celebration of life," she says. "Basketball keeps everything in balance for me." Players like the point guard Tasha Pointer chose to play for Stringer because they

bonded with her and shared her vision of what Rutgers could become. In an era when the Rutgers football team struggled mightily to be competitive and the men's basketball team was not nationally ranked, Stringer became the school's highest-paid coach. Her first recruiting class at Rutgers helped the Scarlet Knights reach the Elite Eight—the quarterfinals—of the 1999 NCAA championship. Possessing a keen eye for talent, Stringer knows it is never too early to start connecting with skilled young players.

After Nicole's freshman year at Kennedy, when she dominated opponents at the 1998 Rutgers camp and was named its Most Valuable Player, Nicole caught the attention of the Rutgers coach and staff. That year the college and pro counselors at the camp, the "big girls," as Nicole called them, were impressed enough with Nicole's skills that they asked her to join their lunchtime game. The campers were all on their way to the cafeteria when Nicole, walking past a pickup game involving current and former college players, heard a voice say, "Hey you, girl, you wanna run?"

Even though the voice belonged to Nadine Domond, the New York Liberty's second-round draft pick, Nicole kept on walking. After all, she thought to herself, "My name is not 'Hey you girl.'"

Finally, Tomora Young, a Rutgers player who had seen Nicole dazzle opponents and onlookers throughout the camp, asked Nicole to join her team.

"Sure," Nicole said. She was supposed to be wearing her knee brace because of the injury she had sustained the previous season, but her knee was feeling much better now, and besides, she didn't want any coaches or college players seeing her walking around in that big bulky brace. She proceeded to fake out Domond with a crossover dribble, steal the ball from another player, and score several baskets. Later, Domond, a former Iowa star, got even by emphatically blocking Nicole's attempted layup and warning the kid, "Don't come in here no more"—which meant, "Don't try to drive down the lane against me again," not "You can't play with the big girls."

It was during those lunchtime and evening games, as she struck up friendships with world-class collegiate players, that Nicole's star began to rise. Competing against other high school kids was one thing, but battling college and pro players earned her a reputation as a warrior with no fear.

Ironically, Nicole's reputation as a competitor was enhanced after her team lost the camp championship. So devastated was she by the loss that she sat to the side crying when awards were presented to the winners.

"Nicole, what's wrong?" Domond asked.

"Nothing," Nicole said, the loss eating her up inside as if she had just blown the WNBA championship.

"C'mon you can talk to me. You know you can talk to me."

"Nothing!"

"Come on, Nicole, I know there's something wrong."

"I can't believe I didn't win this championship," Nicole finally admitted.

Domond looked her in the face, and asked, "Nicole, are you kidding me? Don't cry over something like this. You will have games that are twenty times bigger in your life than this little thing. Don't you realize that you're gonna be one of the top players in the country?"

"No, I'm not," Nicole said, fixated upon the defeat she had just endured. "I'm not gonna be no top player in the country."

"Nicole, I wouldn't lie to you. You're gonna be one of the top players in the country."

Slowly, as time went on, Domond's words began to sway Nicole. After all, here was a woman whom Nicole had seen talk smack to Chamique Holdsclaw, the two-time collegiate Player of the Year at Tennessee. And if she was good enough to do that, Nicole reasoned, she must know what she was talking about. That winter, when Nicole was outside dribbling the ball until her hands became numb, she often thought about that conversation, dreaming of one day playing big-time Division I basketball.

* * *

Nicole's exploits this week at the 1999 camp haven't done anything to erode her faith in herself or the belief of others that she is something special. She has resumed her extracurricular games with the college and pro counselors and is sometimes mistaken for a collegian herself. Already she has won campwide competitions in one-on-one, three-on-three, and knockout, a game that pits players against each other in a test of shooting. She has been so dominant that when she failed to win the 3-point shooting contest in the Rutgers Athletic Center, the other girls, the "playa haters," as Nicole calls them, began clapping and cheering. Cheering at her misfortune! Nicole could not believe it.

"Instead of cheering a sister on, you are so envious," she thought to herself. "They are probably sick of me winning, but I wouldn't go clap that they lost."

Nicole's presence at this camp seems unfair to many of these girls, most of whom are average players here to spend a few days living away from home in the dorms and working on their games. None has been named all-state like Nicole this past spring. None has drawn statewide attention by scoring 60 points in a single game, rewriting the Passaic County record book. And none of them has spent the past two years at the camp forgoing lunch and dinner to play

full-court games with Domond and other "big girls" like Pointer and Shawnetta Stewart of Rutgers.

Despite two new injuries, Nicole continues to measure herself against the college players. During her freshman year her knee was the problem; now it is shin splints and a hip problem that continually plague her. Nicole adopted a pigeon-toed gait early in life—modeled after an older player she thought looked cool—meaning that her ankles are more likely to roll when she runs because her feet are angled inward. On top of that, she has unusually flat feet. All of that, as her doctors and trainers have observed over the years, contributes to greater force loads up her legs and, ultimately, to shin splints, tendinitis in her knees, and pain in her hips. Ever since Nicole's freshman year, Laura Judge, the Kennedy athletic trainer, has urged Nicole to buy orthotics, custom-made shoe inserts that cost $300 and up and put the foot in a better-balanced position, lessening the impact of jarring movements like jumping. When Nicole discovered how much they cost, she did not even ask her mother for the money. She knew it was not there.

Consequently, the pain in her shins is sometimes so bad it overcomes her when she is sitting in class. The knee injury was nothing "compared to the damn shin splints," Nicole says. Judge has felt tenderness along both of Nicole's shins, although the left one bothers her more than the right. To Nicole's amazement, Judge got her in to see Dr. McInerney, the local specialist, without an appointment.

Nicole cut past a waiting room full of people to see Dr. McInerney, who felt the same tenderness as Judge. Dr. McInerney, like Judge before him, explained that the way to alleviate the problem was through a combination of ice, rest, stretching, and therapy.

Now, Nicole is following the advice, with mixed success. She regularly applies ice after games. Here at Rutgers she wraps her shins in sleeves full of ice between games. She stretches whenever possible. When she can get a ride to St. Joseph's Hospital, she uses various therapeutic techniques, including a slant board that requires her to slide down, bending her knees, and push herself back up. But the rest is problematic. Because of her busy schedule, Nicole can rarely take a sustained period of time off to rest.

Her right hip is another matter altogether. The pain there comes and goes like the wind; Nicole can never predict when it will flare up. When it does, it hurts to walk. Nicole continually stretches it, extending her hip out to alleviate the pain. At other times, she bangs on it, as if that will somehow make the hurt go away.

Despite these ailments, Nicole had little trouble dominating the camp All-Star game the previous evening. With Coach Stringer, assistant coach Jolette

Law of Rutgers, and various players watching, Nicole pulled up and drained seemingly effortless 3-pointers from the top of the key. She put the ball through her legs before making a crossover dribble to the basket, leaving a helpless defender standing in her wake. Every time she touched the ball, the coaches and counselors were riveted to see what would happen next.

On one play, Nicole broke out her "Shamgod" move, a variation of the crossover dribble that just about brought the house down. The move was named after the former Providence star God Shamgod, and the move works like this: As Nicole dribbles down the court on a fast break, she rolls the ball out with her left hand, making it appear as if she has lost control, thus encouraging her defender to lunge for the ball. But just as the defender reaches in and commits to one side, Nicole pulls the ball back in with her right hand and darts the other way toward the basket.

So viciously did Nicole fake out her defender that Law fell off her chair laughing and onto the scorer's table. Like anyone with an effective crossover dribble in the post–Michael Jordan era, Nicole repeatedly gets away with carrying the ball without a referee's call. But to those who watched, that mattered not at all. Nikki Thompkins, a counselor at the camp who also played professionally in Israel, was so impressed she sought Nicole out after the game and asked her to teach her the move. To everyone but Nicole, it hardly mattered that her white team lost to the red team by five points. Before the night was through, she had racked up more than 30 points, overwhelmed her opponents both physically and tactically, and created some memories that might stay with the onlookers forever.

Everyone agrees that Nicole still has weaknesses in her game. Denise Duncan, the former Cleveland State women's coach and the coach of Nicole's team at the camp, the Lynx, says she must get stronger—but not at the expense of losing speed—and develop a medium-range jump shot in order to compete in college. She must work on remaining calm and composed in the face of adversity, for instance when her bullet passes go flying through the hands of unsuspecting teammates.

But Duncan and the others all agree Nicole is a unique talent.

"Right now, she's the best overall player at the camp," Duncan said. "I think Nicole has the potential to be special."

Like anyone with a healthy ego, Nicole enjoys the attention from the coaching staff, and the competition with the older players she admires. But getting her second Most Valuable Player award in two years signifies that she has outgrown Stringer's camp. It has become like a comfortable old sweater that you pull excitedly from the closet on the first cold day of the year, only to find that it no

longer fits. She needs something bigger, something more suited to her current abilities.

Behind the scenes, McCann is working on getting Nicole called up to the big leagues, to the Nike All-America Basketball Camp in Indianapolis later this summer. The 80 best players in the nation, and every major Division I coach in the land, will convene at the camp for the biggest recruiting event of the summer. The camp is generally dominated by rising seniors, and Nicole is going into her junior year of high school. But McCann is determined to get Nicole invited.

"I call people," McCann says. "We're working on it. She should be there. At this camp, it's sleepy-time for her. She's just jogging to the ball. Next year, I swear to God she'll be at the Nike camp."

* * *

For the playoffs Nicole's team at the Rutgers camp must do without its best player. In May, her current AAU team, the New Jersey Monarchs, captured the state tournament in both the under-17 and under-15 age brackets. Nicole hopes to play with both teams at national tournaments in Dallas and Oklahoma City in July. On the last day of the Rutgers camp, Joann Mosley, or Mos, picks Nicole up early so that they can fly to Dallas.

Nicole joined the Monarchs during the spring of her freshman year, in 1998. Mos, the Monarchs' assistant coach, had approached Nicole after Kennedy's loss in the Passaic County Tournament in February 1998. Mos, also the girls' basketball coach at nearby Wayne Valley High School, had been following Nicole in the newspapers throughout the season. She and Karen Fuccello, the Monarchs' head coach, known as Fu, were in the market for a penetrating guard for their 14-and-under team. Mos figured Nicole would be an excellent fit. The Pioneers, Nicole's previous AAU organization, weren't organizing a team that year, but Nicole drew interest from at least one other local AAU program.

Jeff Horohonich, coach of the Bergen Jazz, scouted Nicole on several occasions during her freshman year. He considered her one of the top five freshmen in northern New Jersey, and he especially liked the way she passed the ball into the post. "That's a lost art," he said. "Guards don't pass the ball into the post. She handles the ball with both hands. She can attack. She can shoot from the outside." Nicole went to a couple of Horohonich's practices, but eventually landed with the Monarchs after her mother attended one of their practices and liked the way Fu and Mos operated. Andrea Richman doesn't generally involve herself in Nicole's basketball decisions because she doesn't know the game that well. But on this occasion, she just felt more comfortable with the Monarch program.

Nicole liked the Monarchs because of the reputation the team had acquired under Coach Fu. Fu had coached girls' basketball for 30 years and had seen just about everything there is to see. The Monarchs had won more than 40 state championships in various age groups during Fu's tenure, and had placed as high as second in the country in AAU Nationals. Five of her former players had gone on to play professionally, including Falisha Wright and Tamecka Dixon, who now played for the Los Angeles Sparks of the WNBA. Nicole figured that if Fu and Mos could help those players, they could help her too. She knew that competing with the Monarchs would allow her to travel, meet new people, and compete in the highest level tournaments.

During the summer of 1998, Nicole started practicing twice a week with the Monarchs on top of playing an average of four games per weekend in about 15 tournaments. She also competed twice a week with her Kennedy teammates in a summer league in Jersey City. At other times she was at the Paterson YMCA playing pickup and training. "I play basketball every day," she said that summer. "I have to. It's like a need."

At many tournaments that year, Nicole led the Monarchs in scoring and rebounding, prompting other AAU coaches to point her out as a big-time Division I prospect. "Nicole Louden has all the things that these Division I coaches are looking for—speed, skill, they're looking for that knowledge that maybe only the urban playgrounds can teach," one coach said. "She's only a baby. She's got tremendous upside. They're ga-ga already about her. By the time she's a junior, the major colleges will be looking at that kid. The Tennessee types, Connecticut, Rutgers."

When Nicole joined the Monarchs, Mos became more and more prominent in her life. Mos drove Nicole to and from Monarchs practice because Nicole was too young to drive and her mother worked at night. Mos also took an active role in making sure Nicole ate properly. During her freshman year, Nicole had stopped eating the cafeteria lunch provided by the federal Free and Reduced Lunch Program after she noticed a cockroach scurrying across the floor in her Algebra I class. When they could afford it, Nicole's mother and grandmother gave her money to buy lunch, but eventually Nicole simply stopped eating lunch altogether. During her sophomore year, Beverley Kovach, a physical education teacher at Kennedy, noticed that Nicole seemed tired and listless during games. Eventually she approached Mos and asked, "What the hell's wrong with Nicole?" Mos explained that Nicole was a fussy eater and had stopped eating lunch. Sometimes she had trouble finding something to eat at home as well.

From that day on, Kovach prepared Nicole's lunch every day and left it in the gym office in a lunchbox. She made one lunch for her son each morning, so

now she simply made two. During the spring and fall, Kovach generally made Nicole salads, but during basketball season the menu expanded to include Nicole's favorite sandwich, turkey on whole-wheat bread with a little bit of mayonnaise. Kovach often added raisins, baby carrots, or yogurt and juice or Snapple as well. At first Nicole was embarrassed by the arrangement because other teachers and students found out about it. "But then after I got lunch every day, I forgot about it," she recalled.

Aware that Nicole often could not afford to eat properly, Mos had her over for homecooked meals on occasion. There, in Mos's suburban Wayne home, she and Nicole discussed everything from school to recruiting to life. Nicole respected Mos's sometimes brutal honesty and Mos in turn liked Nicole for her vivacious personality, unquenchable drive, and sensitivity. She thought Nicole could go far in life, given the right support.

"I'm trying to keep her off the streets," Mos said. "I don't know why I do it. I just do it."

* * *

Now, as Nicole heads to the AAU Nationals, she can't wait to test herself against top competition. But upon her arrival, she learns that she can't compete in nationals in two age brackets. She will have to play only for the Monarchs' under-15 team at the tournament scheduled for the following week in Oklahoma City. Nicole is relegated to the role of team manager, which basically means carrying the balls. Meanwhile, every coach from Vivian Stringer to Pat Summitt to Tara VanDerveer evaluates talent at the 17-and-under event.

"I wanted to play," she says. "There were like a million scouts there. I felt awful. I know they're probably gonna come to our [under-15] tournament. But I know I could play well with those [older] girls."

As she moves on to Oklahoma City, where the Monarchs are seeded seventh of 75 teams, Nicole is fully aware what may be at stake. She knows her mother simply cannot afford to pay for college, and that the only way for her to attend a Division I college will be on a basketball scholarship.

"I'm very excited to show the scouts what our team can do, as well as what I can do because it's my ticket to college," she says. "So I have to do my thing."

Though things in Texas don't turn out as she had hoped, people are at work behind the scenes trying to make things break Nicole's way. There are still three spots open for the 1999 Nike camp, and Jolette Law and Colleen McCann are pushing to get her invited to the big event in Indianapolis.

Law, a former Iowa point guard now considered one of the top recruiters in the nation at Rutgers, has been teasing Felicia Hall, manager of Nike women's basketball, that the camp failed to recognize players from New Jersey. She tells Hall that there is a gem of a ballplayer in the Garden State worth checking out.

Hall then learns more about Nicole from Falisha Wright, who has been living in Portland and working at Nike since the ABL went bankrupt and her pro career was put on hold. Hall had hoped to see Nicole in Texas, but now decides to fly to Oklahoma City to watch Nicole and a handful of other girls she feels might have the potential to be Nike all-Americans. Once there, Ohio State's coach, Beth Burns, who had coached Falisha Wright and her sister Lakeysha at San Diego State, further bolsters Nicole's resume by telling Hall how fond she is of her game.

Hall is at the tournament for just one day, long enough to watch two of Nicole's games. That's all it takes. Nicole is in rare form in Oklahoma City, averaging almost 30 points per game. She is still polishing her game, but the hard work she has recently put in developing her left hand is evident. Nicole can now handle the ball equally well with both hands, if not even better with her left. She now makes gorgeous no-look bounce passes with her left hand—a talent some professionals do not possess.

"Either you're there or you're not there," Hall says of Nicole's play at the tournament. "And you have to stand above the rest. I don't need kids who blend in with everyone else. I need kids who rise to the top."

When Nicole learns she is one of just 11 sophomores in the nation who will attend the Nike camp, she tries to play it cool, but she is overwhelmed. McCann arranges a plane ticket so Nicole can fly directly from the AAU Nationals in Oklahoma City to the Nike camp in Indianapolis. There will be no time for Nicole to go home and see her family, no time to trade in sweaty, smelly clothes for fresh ones. But at this point, Nicole couldn't care less.

"You do not know the feeling," she says later. "I mean these are the top eighty players in the country and I was invited."

* * *

According to NCAA regulations, college coaches can watch prospects only at limited times during the school year. But for several designated weeks in the summer, including the AAU Nationals, Nike, and the U.S. Junior Nationals, in July, they can "evaluate" recruits as often as possible.

The recruiting process for girls was far less intense before the early- to mid-1990s. It evolved during the 1980s, when Title IX began to have a noticeable

impact on girls' and women's basketball. In fits and starts, coaches' salaries improved, schedules became more competitive, equipment was upgraded, practice time grew more equitable, recruiting budgets increased, and transportation and accommodations on the road slowly began to improve. Eventually, the women garnered television contracts as well.

As women's college games have become televised on CBS and ESPN, the money and the pressure to perform have exploded. Big-name coaches like Pat Summitt and Vivian Stringer earn salaries well into the six figures. Geno Auriemma reportedly earns close to $1,000,000 per year. All of them are expected to provide winning seasons, and championships, in return.

The importance of recruiting has become magnified.

"Now, everybody is out there trying to build a championship team," Auriemma told *Sports Illustrated* in 1998. And the pressure to land the upper-echelon players is intense. The pool of the top 100 players in the country during any given year is much deeper than it was 10 or 15 years ago. Still, each year the premier programs in the nation—U.Conn., Tennessee, Rutgers, Georgia, Penn State, Stanford, Purdue, Duke, Notre Dame, and a handful of others—engage in trench warfare to obtain the best of the best.

"The dropoff in talent between the twentieth-best player and the fiftieth is huge," Auriemma says.

It is not unheard of for a Top 25 team to charter a plane so its recruiters can jet to the backwoods of South Carolina or wherever on a moment's notice. Coaches don't limit themselves to U.S. talent, either; any program worth its salt sends scouts to tournaments in Europe—sometimes Russia, South America, and Australia, too. Top Division I programs spend a couple of thousand dollars annually just for the opinions of four or five recruiting experts, who attend the summer tournaments with the coaches. The top schools have annual recruiting budgets of over $50,000.

Mike Flynn's Blue Star Report notes that his information is used to assist in the picking of *Street & Smith's* preseason All-America team and *USA Today's* preseason list of America's Top 25 players. Since his own Blue Star camps were eclipsed by Nike when it launched its girls' camp in 1996, Flynn has become an adviser to the shoe giant, helping to determine who gets invited to its camp.

Mike White's All-Star Girls Report promises those who read it "the kind of information that can only be obtained from our staff who have seen each player perform on a consistent basis over time." White is associated with Adidas and runs a variety of camps sponsored by that company.

When the hectic summer recruiting period subsides, both men rank the top players in the graduating class. These rankings are posted on the Internet. Dozens

of recruiting experts, on-line services, and magazines publish other lists ranking the best of the best.

Schools have been known to do some crazy things to motivate kids to wear their colors. Krista Gingrich, a highly recruited point guard from Lewiston, Pennsylvania, was profiled in *Sports Illustrated* because of her experience. Before selecting Duke, Gingrich had narrowed her list to Duke, Notre Dame, and Penn State when the Fighting Irish coaching staff sent her a card with the middle cut out and told her to hold it against a mirror and have a look at Notre Dame's next All-America. The school followed that up with a mock press release from the Associated Press dated 2002. The release read in part, "Krista Gingrich, who just led Notre Dame to the NCAA National Championship, will play for the Atlanta Glory of the American Basketball League. Atlanta, who will pay Gingrich a reported $650,000 a year, said all along that she was their number one choice."

No team in the ABL ever paid anyone a salary close to that amount because the league ended up declaring bankruptcy, but the message was not lost on Gingrich.

"I think I realized a long time ago that this is a business," she told the magazine.

Part Two

September 1999–June 2000: Junior Year

Chapter 5

During her freshman year, Nicole and her family moved from North Sixth Street to part of a rented three-family house on Paterson's East Twenty-sixth Street. It is perhaps the quietest house they have occupied in Paterson. The tree-lined block is home to predominantly working-class black families, many of whom have young children. Two blocks away are several liquor stores and Jamaican food shops offering specialties like beef patties and curried chicken. The neighborhood is not exempt from drug dealers, though. On the corner of Tenth Avenue and East Twenty-sixth, young men congregate at night, selling drugs to anyone interested. Much of their business is with whites, some of whom come to Paterson from towns in New York and Pennsylvania as far as 90 miles away, others from nearby suburbs. "Yo, yo, what up?" they inquire to passers-by they think might be interested in purchasing something.

Andrea misses the action and feeling of the west side.

"It's too quiet for me," she says. "I'm used to the noise and the ghetto. I'm used to that. But as you grow older, you need a little peace and quiet in your life."

The move from the west side to the east side means that technically Nicole is supposed to attend Eastside High School. But because she has already enrolled at Kennedy, the school's administrators agree to let her stay there, on the condition that she passes all of her classes.

* * *

Late on a Thursday morning, Nicole is asleep on her living room couch when she is awakened by the postman opening the screen door nearby. Nicole frequently sleeps downstairs in the living room these days. The upstairs bedroom that she shares with her mother and her little brother, Alex, now eight, is too crowded, especially for a teenage girl. But she has no choice. Her home has three bedrooms. Kenneth, her grandfather, is ill with diabetes and shares one

room with Euphemia and a host of pill bottles and medical supplies. Nicole's great-aunt and -uncle occupy a second room. They help take care of Kenneth while they look for their own home in Paterson. That leaves the upstairs for Andrea, Alex, and Nicole.

Wearing burgundy-and-black Calvin Klein boxer shorts and a T-shirt, Nicole groggily opens the living-room door, the door that faces the street. She cannot believe her eyes. Dozens upon dozens of letters and packages come tumbling into the house on this bright sunny morning. "Why in the world are they sending me all this mail?" she asks herself. By the second or third trip to lug the correspondence to the living-room table, it dawns on her, "Oh, it's after September first of my junior year!"

September 1 is a magical date for college coaches. It is the day they can begin sending recruiting materials to juniors, everything from handwritten letters to media guides to impressive-looking summaries of a program's basketball accomplishments. Nicole has been receiving a steady stream of questionnaires asking for basic information up through this past summer, and especially after Nike camp. One day last year, Nicole's best friend, Justine Baker, helped her fill out 100 questionnaires in one three-hour sitting. By the end, they were so bored and annoyed that Justine wrote her name and address on several forms as a prank; on others, they simply made up names. Nicole has known Justine, a pretty girl with smooth, caramel skin, since the second grade, when Justine, a veteran of the gifted and talented program at School 4, befriended Nicole, who was crying because she didn't know anyone else in the program. More than anyone else, Justine brings out the silly side in Nicole. Nicole likes to ask, "Whose butt is bigger? Hers or mine?" to which Justine will respond, "Nicole, you act like you got a little butt."

Justine had filled out forms to schools that Nicole had absolutely no interest in attending. Now the colleges are sending real letters of interest, not just questionnaires. All the packages piled on the living-room table is quite a sight. Dozens of multicolored media guides stare up at her.

The room itself is a virtual shrine to religion, family, and the family's athletic and academic achievements. On the main wall near the kitchen, framed pictures of smiling family members hang next to a portrait of the Last Supper and a couple of Martin Luther King, Jr. Numerous trophies, plaques, and framed certificates attest to Nicole's success in the classroom and on the volleyball and basketball courts. Others showcase the achievements of Nicole's cousin Dameon, a standout football player during his time at Kennedy.

Standing with one knee on a chair next to the table, Nicole begins tearing through the packages, scattering them randomly on the table. They come from

every major program in the country—the defending national champion, Purdue, Tennessee, Rutgers, Georgia, Texas Tech, Pittsburgh, and on and on. "This is crazy," she thinks. "How do all these schools know my name?"

"We want you at Rutgers," reads a letter from Jolette Law, the Scarlet Knights assistant. "What number you want?" Generally, the notes are accompanied by some sort of inspiring quote or phrase. "Nicole Louden and the Tennessee Lady Vols," reads the note from the six-time national champions, which goes on to quote Jules Jusserano. "The future is not in the hands of fate, but in ours."

These letters excite Nicole, but the one package that grabs her attention like a giant Christmas present is the huge media guide from the University of Connecticut. "Nicole," reads the penned letter from Connecticut's Coach Geno Auriemma. "Hope you are doing well—I saw you play at Nike camp and I thought you were terrific. Hope you enjoy the reading material—I'm sure you'll have some questions, so please call me. Take care. Coach Auriemma."

Can this be happening? Nicole has dreamed of playing for U.Conn. ever since the seventh grade, when she watched wide-eyed on television as a former Huskie star, Nykesha Sales, torched an opponent for about 30 points. When her mother came home that day and found Nicole watching the game, Nicole pronounced, "That's where I'm gonna go to college."

Nicole waits until her mother has awakened to tell her the news. A sleepy Andrea, fresh off a graveyard shift at her job, descends the stairs and enters the living room wearing a long white T-shirt whose caption reads, BOO-BOO BEE-DOOP. Euphemia got it for her in England while visiting her brother. The oldest of Euphemia's seven children, Andrea is a stocky woman with closely cropped, curly brown hair and a ready smile. Early in life, one of her brothers nicknamed her May and it stuck. Like her family, she has an easygoing attitude toward life, but she is fiercely protective of her children. Once, when Nicole was a freshman, a teacher at Kennedy suggested that Nicole take algebra tutoring in the afternoon instead of the morning because she thought the afternoon teachers were more qualified. When Nicole said she preferred the morning because she had basketball practice in the afternoon, the teacher told her that she had to prepare for life through academics, and not count on a pro basketball career. Andrea, furious at the teacher's comments, told her she had broken Nicole's heart. "Don't tell my daughter she can't do this," Andrea said. Eventually, the situation was settled when Coach Jonah told Nicole she could come to practice late, after the tutoring sessions.

Andrea notices the table littered with letters and packages.

"You got all this mail," she says, sounding as amazed as her daughter. "Where'd you get this mail from?"

"Look, Mommy, UConn sent me some stuff!" Nicole says excitedly. Years ago, when Andrea first began driving Nicole to School 9 for city league basketball games, she never imagined it might lead to this. Andrea never followed basketball closely and still doesn't understand all the rules. On one occasion, she thought that because a player had stepped on the 3-point line while shooting, the shooter would receive no points instead of 2, an interpretation that resulted in ruthless teasing from her daughter. Andrea doesn't comprehend the complexities of the recruiting process, either, preferring to leave these decisions up to Nicole.

When representatives from the Nike camp first telephoned Andrea at work, asking whether Nicole might be available to attend, Andrea asked to call them back. She wanted to speak with her sister Joan first to see if she knew what it was all about. "Are you crazy?" Joan screamed into the phone. "Those people are asking Nicole to be a Nike All-American!" Slowly, it dawned on Andrea that a four-year scholarship for her daughter was a real possibility, a tremendous reward for Nicole's devotion to the game. Andrea has always been extremely proud of Nicole's achievements, but her primary concerns are her daughter's grades and health. Now that all of these letters have arrived, it seems like a scholarship is almost a foregone conclusion. Andrea, who struggles simply to pay the bills and feed her family, thinks, "That will be a big help for me."

When school starts a week later, Nicole continues to be bombarded with letters and packages even at Kennedy. School security guards regularly notify Nicole that she has recruiting mail to pick up in one of the offices.

"It makes me feel special," she says. "It's pretty nice."

The recruiting mail makes Nicole stand out even more at Kennedy. She already defies the odds. Nicole was the valedictorian of her junior high school, and was recommended for Kennedy's advanced Science, Technology, Engineering and Math Academy (STEM), a college preparatory science program. Her GPA is regularly above a 3.5 and she is one of the most talkative and inquisitive students in her class. The 900 she scored on the Scholastic Assessment Test is about 100 points higher than the average score at Kennedy, but still not high enough for her stringent standards.

But she is no nerd; she skillfully balances academics, athletics, and membership in several extracurricular groups. She moves easily between athletes and bookworms, adults and children. She can shift from speaking Jamaican patois with her family to Ebonics with her friends to "white English" with reporters and teachers. Nicole's confidence and verbal skills are so strong that some have suggested that she may want to consider a career in broadcasting later in life.

She travels from class to class within the STEM program with a select group of about 50 students, 15 of whom are black and 12 of whom are Bengali; whereas

only about half of all Kennedy students in any given year plan on attending a two- or four-year college, virtually all of the STEM students go on to four-year colleges. Because STEM is a self-contained group, Nicole doesn't intermingle with many of the students outside her program, other than those on the sports teams.

She spends most of her time at school with Justine and her other best friend, Sakina Gillespie. The trio often meets at the School Based Youth Services Program office in the afternoon. Located in the Kennedy basement, not far from the gym, School Based is an in-house counseling agency that provides services for Paterson teenagers; it offers everything from tutoring to family counseling to field trips. The program is run by Raheem Smallwood, Sakina's father and the man who helped coordinate the conflict-resolution sessions among Dominican, Arab, and black leaders after ethnic tensions flared up.

In Justine, and later Sakina, Nicole has found girls who aren't afraid to use their minds or become involved in school and community affairs. Sakina, a thoughtful girl with her father's long, narrow face, met Nicole during their freshman year at Kennedy. Sakina only started paying attention to Nicole one day when Sakina was about to get into a fight with a female classmate, and Nicole said, "Sakina, she's not worth it. She's not worth getting suspended for."

"And I didn't even beat her up just because Nicole said that," Sakina recalls. "I'm happy she did, though. I hate violence."

Soon all three girls began working together on school projects. Nicole was still just getting to know Sakina when Sakina told her she was pregnant. Sakina, 16, gave birth to her daughter, Jalea, amidst a storm of gossip. Because Raheem spends much of his time educating young women about pregnancy, it was more than a little ironic to outsiders when his own daughter became pregnant.

"You can think you're providing all the answers and still find yourself in this situation," he says.

Sakina's pregnancy tested her family's strength, but it didn't derail her goals. She still attends school, works and devotes time to serving on the Mayor's Task Force as a youth representative advising on drugs and violence. One day she dreams of reforming the system.

"Being a teen parent is not the worst thing in life, but you have to realize that your life doesn't stop," she says. "You can't stop your goals and dreams. You still can become a lawyer or a doctor. You got to lace up your boots."

Sakina and Justine provide a balance with the heavy basketball orientation in Nicole's life. Nicole found that once her basketball career took off, a whole new group of people suddenly started being friendly toward her, asking her questions, mostly about basketball. But with Justine and Sakina, Nicole doesn't

have to think or talk about sports. She knows she can trust them because they have known her since before she was a "ghetto superstar."

"Sometimes I'm sick of talking about basketball," Nicole says. "[And] I love being around them. You surround yourself with people that have similar interests or that have the same mind-set as you. Justine and Sakina, they keep it real. You can't do that with just anyone without them letting your business out on the street."

The School-Based room serves as a meeting place for the three girls, their friends, and the clubs they are involved with, including the Environmental Club; a peer counseling program that mediates conflicts between students; and UMOJA, an all-female group promoting sisterhood, pride, and self-esteem. Posters on the wall warn against the dangers of drug use and teenage pregnancy. The room is equipped with several couches, chairs, and board games, to say nothing of a refrigerator semiregularly stocked with sandwiches and soda.

When Nicole isn't in school or playing basketball in the Kennedy gym, she can almost always be found at one of these locations: at home listening to music or watching basketball on television; at her aunt Joan's house checking her e-mail; at Mos's home studying or eating; or at the Paterson YMCA working out. She rarely goes to parties and never hangs out on the street. Her world is so regimented and insulated from the goings-on in Paterson that she rarely comes into contact with the violence surrounding her. Her routine and the people she associates with because of it keep her on a relatively straight and narrow track, away from the troubles other students sometimes experience. She confesses to being naïve about the activities of the gangs at Kennedy, and she has little tolerance for those who are not making something of themselves.

"If you have a drive or a need to be successful, you will be," she says. "Stop blaming everything on everyone else. If you have to work or get a job or help out at home or you have a baby, that's different. But just to say, 'Because I'm born in the inner city, that means I'm not gonna be successful,' that's stupid. Why would you ever say that? Some of [these girls] just settle. Their life just plateaus on some level. Not me, man. Stay away from those fast boys and get out of Paterson. Get a college education and do whatever it takes."

Consciously or not, Nicole has used basketball as a technique for shielding herself from the dangers and distractions that surround her. Basketball is not only her passion and her one true love, but her fortress as well.

"I never see her doing nothing negative," James Lattimore once said of Nicole with a touch of awe. "I guess that's how she was brought up. Everybody wasn't brought up that way."

Chapter 6

Laura Judge's office is a small space just off the Kennedy gym. On one of its brown doors hangs a plaque that reads ATHLETIC TRAINING ROOM, LAURA JUDGE, ATC. A desk stands in one corner, opposite two padded training tables, one black and one brown. A giant metal ice-making machine, a whirlpool, and a sink take up space in the back. Track lights hang overhead. The walls are covered with health-related posters. One depicts the human skeletal system. Another shows various athletic trainers helping injured football and basketball players off the field. Still another describes how to treat sprained ankles.

Since Judge arrived at Kennedy when Nicole was a freshman, she and Nicole have developed a real fondness for each other. Nicole generally enjoys confiding in adults more than in people her own age, and she especially likes talking to Judge. During her free period in the afternoon, Nicole often plops down on one of the trainer's tables in the office and shoots the breeze about school, boys, basketball, whatever is on her mind that day. During their office chats and when they pass each other in the hallways during school, Judge frequently asks Nicole how she is feeling.

Nicole's answers vary depending upon how much her shin splints hurt. Sometimes "It feels better than yesterday." Sometimes "I can't really run on it." And if her shins are particularly bad, she will say, "Aw, they were killing me last night!"

"What did you do?" Judge asks.

"I took some painkillers," Nicole says, Tylenol or Advil.

Judge is particularly worried as September moves along. Except for a brief period in August, when Nicole and her brother went to visit their older sister Karen, a U.S. Army recruiter stationed on Long Island, and took time off for the beach, shopping, and video games, Nicole's life has been nonstop sports. At the end of the summer AAU season, Mos and Fu, the Monarch coaches, told the girls to stop playing basketball for a month, to play tennis or swim, something

that would allow their bodies to rest and regenerate. Nicole followed their advice for a couple of weeks at most.

Now that school has started, she picks up where she left off—working out and playing pickup basketball regularly at the YMCA and competing for the Kennedy volleyball team. As a sophomore, Nicole was named second-team all-county in volleyball. Charlie Bell, who coaches volleyball and also keeps the clock during girls' basketball games, values Nicole for the same attributes that make her stand out on the basketball court: jumping, blocking, and leadership. Though the volleyball team is not tremendously successful, Nicole's presence often means the difference between losing and winning a match.

Given Nicole's shin splints, Judge was ambivalent about letting her play volleyball. She felt caught in the middle because of Bell's desire to have her play—and Nicole's own interest in competing. Who could blame Bell? Nicole is the best player he has had in half a dozen years of coaching. As the season unfolds, Judge voices her concerns to Bell, asking, "What can we do to reduce the risks of anything further happening with her shins?"

Eventually, Bell, Judge, and Nicole strike an informal agreement.

Nicole will limit her practice time. If she needs to ice or stretch in Judge's room during practice, she will; instead of diving or sprinting at practice, she will conduct a light workout. During games, Bell will play her up front so that she can block and spike, but rotate her out when she gets to the back, thereby limiting her running and diving. Judge hoped she wouldn't run at all. "You can go, as long as there's no running," she told her. Nicole's teammates and others at the school also worry about Nicole. Some of the other volleyball players tell Bell, "It's good that Nicole's playing, but we don't want to see her get hurt." Jim Ring, the boys' basketball coach, has a conversation with Bell along the same lines

Before each match, Judge tapes Nicole's shins the way the trainer at the Nike camp did. Afterward, she gives Nicole plastic ice bags to soothe the pain. She tells Nicole repeatedly that the only way to solve the problem is through ice, rest, stretching, and orthotics.

Judge isn't the only trainer Nicole sees. Sometimes on a weekend, or when Judge is inaccessible, Mos takes Nicole to see her friend Nancy Keil, the trainer at nearby Wayne Valley High School, where Mos teaches gym and coached girls' basketball. Nicole explains that sometimes the pain is so bad it overcomes her when she is sitting in class; sometimes it hurts just to stand or walk. Keil says many of the same things Judge does. It isn't so much the volleyball or the pickup games at the Y as the combination of all of Nicole's activities that contribute to her pain. She encourages Nicole to get in the pool or ride a bike at the Y, or simply shoot, instead of playing games all the time. She again counsels Nicole on the

benefits of ice, stretching, and other techniques aimed at minimizing the wear and tear on her legs. Keil has seen Nicole's type before.

"It's the makeup of athletes who are trying to take it to the next level," she says. "It's a common mentality. You see it with soccer kids, football kids. It's in their personality to push through things, it's mind over matter. They are conditioned by society that they must do something every day; they don't understand the recovery aspect of the body. Some of it is immaturity, where they are age-wise." She is right about Nicole. At 16, she thinks she is invincible.

By late September, both Judge and Keil are concerned that Nicole's condition might be something more serious than shin splints. Judge tells Coach Bell that Nicole's shins are not responding to the normal treatments. She and Keil worry that Nicole's condition might lead to stress fractures, microfractures in the bone that result from repetitive pounding. Once a stress fracture occurs, there is no option but rest. On October 1, after again feeling tenderness along both of Nicole's shins, Judge calls Dr. McInerney's office to make an appointment for a magnetic resonance imaging exam (MRI). At Kennedy, if a student has no health insurance, he or she is automatically covered by Bollinger Inc., the school's insurance company. Sometimes Andrea's health insurance does not cover Nicole—or limits the care she can get—so Judge goes out of her way by helping Nicole fill out a Bollinger claim form. Ultimately Bollinger will end up with an extensive file on Nicole's shin, ankle, and back problems. The more Judge learns about Nicole's situation, the more she does for her. She incurs large bills making calls on behalf of student athletes, but it is Nicole whom she cares for the most often.

Nicole has to wait a few weeks before she can see the doctor. Sometimes Nicole cannot get a ride to the doctor's office. Sometimes she forgets that Judge has made the appointment for her. It is a pattern Judge has seen before, and it frustrates her because she knows Nicole needs immediate help. In the meantime, Nicole sits out four volleyball matches during October. Coach Bell wishes she could play, but understands the situation. Nicole has never complained about the pain in her legs, but he has seen her grimace after making a spike or block. His own daughter has played basketball and he knows that Nicole's future is in that sport, not volleyball. "This kid has one hundred thousand dollars' worth of education looking at her," he tells Judge and other coaches at the school. "I don't want the newspaper to say, 'Volleyball coach makes player play.' I don't want to be the one responsible for [ending her career]." As volleyball season comes to a close, Nicole tells Bell that she really wants to compete against Eastside. The coach lets her play, but only for one of the three games in the match.

When Nicole finally sees McInerney on November 11, several weeks after Judge made the appointment, he warns her of the potential danger of stress fractures. He and Nicole get along well and he knows full well that she is a high-level athlete hopeful of earning a college scholarship. He explains that her bones are similar to paper clips that keep getting bent back and forth. Over time, they will finally break. If that happens, they will have to be immoblized for two months. McInerney orders an X ray and a bone scan of Nicole's shins and tells her to stay away from sports for several weeks to allow the shins to heal themselves. In the meantime, he gives her anti-inflammatory pills and advises her to get involved in a strengthening program. In a couple of weeks, she will come back for the test results.

Meanwhile, Judge files a claim form so that Nicole can obtain physical therapy in November and December at St. Joseph's Hospital. Nicole goes for the therapy when she can get a ride, but she isn't too worried about the potential for stress fractures. "I knew if I took the pills and didn't do anything too stressful, I'd be all right," she said later.

But those around the basketball team worry that if the results of the bone scan come up positive, she might not be able to play for some time. Jim Ring, the boys' basketball coach, says Nicole might have to "shut down" for the entire season. If that happens, it not only will be a devastating blow to the Kennedy team, but to Nicole's recruiting hopes. If she is forced to miss the entire season, there is no telling how many college coaches might back off for good.

Even if she is able to play, she will have to do more work than anyone else on the team, which continues to experience tremendous turnover. Of the eight freshmen and sophomores on the Kennedy varsity roster in 1997, when Nicole was a freshman, she is the only one still playing at the start of the 1999–2000 season. One girl had a baby, one could not play because she was too old to compete in interscholastic activities, and one, Nicole says, quit the team because she was a "smoker" with "no ambition." Two others, Dakita and Delfiah, transferred schools.

This turnover is not unusual at an inner-city school. Girls sometimes move out of town with their families, or across town to live with another family member. Others quit teams because they must help with child care at home, or can't accustom themselves to rigid practice and game schedules. Still others become pregnant.

According to the Paterson School District, 145 girls in the city's three public high schools—Kennedy, Eastside, and Rosa Parks—became pregnant during the 1998–99 school year, or about 6 percent of the female student population. That number was down slightly from 161 the year before. More than 60 percent of the births to teens in Passaic County in 1998 occurred in Paterson.

Coach Jonah, who was the Kennedy basketball coach until 1998, says, "During my five years as coach, we had at least one kid every year leaving the team, whether it's pregnancy or the parents moving to another state or city. We go through that every year."

Without Dakita and Delfiah, Kennedy went 15–9 under Meticia Watson and qualified for the state tournament during Nicole's sophomore year. Nicole emerged as one of the best players in New Jersey, averaging a state-best 29 points per game and garnering all-state honors. But as Nicole continued to improve, the gap between her and her teammates grew wider.

Shantay Brown, a taciturn point guard with braids hanging down her back, is the team's only other reliable ball handler. She can create her own opportunities, has a decent jump, and averages about 10–12 points per game. Antoinette Johnson, a quiet junior with shorter braids, has limited handle, but possesses a streaky outside set shot that sometimes results in three or four 3-pointers a game. Other times she disappears from the scoring column. Litza Roman, a Puerto Rican sophomore with a long black ponytail, does much of the team's unheralded work—gathering rebounds, hustling after loose balls, and playing defense—but is not a prolific scorer. The other members of the team are more suited to a junior varsity club, and rarely shoot.

Nicole doesn't mind so much that her teammates aren't as gifted as she is, but it frustrates her no end that some of them appear not even to respect the game, not to care about it. Antoinette, for example, works about 20 hours a week at Pizza Hut and does her best to attend as many Kennedy practices as possible, but basketball is not her only priority. Where Nicole plays all year long in an effort to better herself, some of her teammates compete only in a Jersey City summer league at the request of the coach. Others barely pick up a ball until the season begins.

"It just hurts when I go out there and kill myself to win and the other girls are taking it easy," Nicole says.

* * *

When volleyball season ends, Nicole is named all-county, adding yet another plaque to her living-room wall. As basketball season draws nearer, Nicole is cleared by Dr. McInerney to play, much to her and Meticia Watson's relief. Now that Nicole has attended Nike and been named one of the best players in the nation, she feels even more pressure to play like one. Nicole has a lot invested in Kennedy. She hates to lose and has poured her heart and body into the team

for two years now. She wants badly to contend for county and state championships the way Falisha Wright and Watson did.

Although her primary motivation is winning, she also knows that it will benefit her recruiting if the team does well. College coaches love players who are winners. It is no coincidence that the Tennessees and UConns of the world recruit players who have won county and state championships.

The school and community have a lot invested in Nicole too. She is the best Kennedy player in a decade and she gives almost everyone associated with the team a reason to be proud. So Nicole doesn't think twice about risking injury—or exacerbating already existing injuries—just to give her team a chance to win. Deep down, Nicole planned on playing regardless of what McInerney said. Of course, that could have been a disastrous decision. Had she played with shin splints, the bones in her legs could have shifted and become displaced. That might have necessitated an operation such as the one the former NBA star Bill Walton underwent. After spending the entire 1987–88 regular season recovering from major surgery on his right foot, Walton tried to return to practice, but the pain was too great. He was forced to retire.

* * *

No sooner is the shin splints crisis averted than another controversy arises. A couple of weeks before the season is scheduled to begin in December, Delfiah Gray returns to Paterson—just as suddenly as she left. Her arrival in the city after a one-year absence during which she played basketball while living with her grandmother in Virginia provides all sorts of interesting subplots to the upcoming basketball season.

Delfiah apparently called Watson a couple of weeks before coming home, telling her she was looking forward to returning to Kennedy. But when Delfiah showed up to live with her mother, she found that Rhonda Lyde had moved out of the CCP project and into an apartment on the city's Eastside. The apartment is set on a tree-lined street and features a front porch, diamond-cut parquet floors, and 10-foot ceilings. Rhonda got the apartment in the housing lottery for CCP residents, who were being relocated. CCP had become so infested with drug abuse and violence that the federal government decided it was better to raze it in early 2000 as part of a $70 million HOPE VI program than attempt to reclaim it.

"I wouldn't trade it for anything," Rhonda says of her new apartment. "When we lived in CCP, I wouldn't even let my girls out of the house unless I was with them. It was like prison. They went to school, then they came home and stayed in the apartment most of the time. Now I let them out to play and I

don't even worry about them. Plus now they're seeing the difference between how people from the projects live and how people who own houses live."

Because Delfiah now lives on the other side of town, she shows up outside Coach Black's door at Eastside instead of Watson's. Black is, of course, overjoyed. Eastside is a decent team, but with Delfiah there is no telling how good it can be.

"I certainly was happy to see her and I was very happy to get her on the team," Black says. Eastside, like Kennedy, has depleted ranks, and he desperately needs someone who can handle the ball. Already the Ghosts lost one player for "personal reasons"—the code for pregnancy—and another one who decided to pursue a rap career.

Though he does not say it, Black must feel some satisfaction in getting a former Kennedy player. After all, a decade earlier he lost Watson when she chose to play for Kennedy instead of Eastside while studying at Rosa Parks, a high school specializing in fine and performing arts but without a basketball team. Later, he watched as Nicole spent a few days at Eastside before being sent back to Kennedy.

When word gets out that Delfiah has switched schools, Watson and assistant coach Carmela Crawford are especially frustrated. Here is a former Kennedy star wearing a blue-and-orange Ghosts uniform instead of a red-and-black Lady Knights one.

"She don't belong at Eastside," Crawford says. "She wanted to be at Kennedy. I think we'd be unstoppable with Delfiah in the paint and Nicole outside."

Not only do Crawford and Watson want Delfiah on their team, but they know they will have trouble defending against her during the two regular-season games between Kennedy and Eastside.

"We didn't have a kid that could jump with her, that could even match up with her," Carmela would later say. "I mean, Nicole's a guard, Delfiah's a forward."

* * *

Kennedy's first game with Eastside is not scheduled until January 11, so everyone will have to wait until after the dawn of the new millennium to see the first Nicole-versus-Delfiah showdown. The Lady Knights are set to open their 1999 season at home against Belleville, a fellow league member.

With Watson suffering from bronchitis, Crawford assumes control for the first game of the season. A vivacious, talkative, full-figured woman, Crawford was Kennedy's first female 1,000-point scorer back in the 1980s and earned a full scholarship to St. Peter's College. She now works as an accountant for a

medical publishing firm and has been associated off and on with her alma mater for the last several years. Her size (5'8") and propensity to yell at individual players during games lends her an aura of toughness, but she is really a friendly, funny person.

Carmela Crawford just missed the glory years of the Wright twins, and felt a spiritual bond with Nicole because she also had to carry the load virtually by herself.

"I can relate to [Nicole's] frustration, to her impatience sometimes," she says. "I can relate to the whole thing that she's going through. Being the best player on the team, you have to carry the whole weight on your shoulders or you feel that way, it's tough. You're going over the same things or the coach is hollering at the same kid for the same thing. And instead of them getting better, it seems like they're just staying at that same level and it's not making you any better because you don't have no competition in practice. I played point guard, I played forward. I played everything. I had a mess with me." Crawford now tries to teach the other girls lessons about responsibility and punctuality, but she and Nicole are almost equals. It is probably a combination of their shared experience and their similarly outgoing personalities that has forged such a tight bond between the two women. Nicole affectionately calls Crawford "Carmy Carm," and likes to ask when she will take her out clubbing.

"You too young to hang out with me," Crawford says. "You got to wait till you get at least twenty-one until you go out with me."

Kennedy's games generally start at 4 P.M., and for this one, the crowd in the Kennedy gym numbers only a few dozen people, including the half dozen cheerleaders dressed in black skirts and red-and-white tops and Nicole's extended family: Mos, Andrea, Joan, Kesha, now 22, and Ricky and Daniel, Kesha's sons. After his shift, Nicole's old city league coach, Ronald McLaurin, a groundskeeper at nearby William Paterson University, often sits in the stands in his gray uniform and blue baseball hat; he makes it a point to watch Dakita and Delfiah play whenever he can as well. Most high school athletes are fortunate to have one relative in the stands, but Nicole regularly has an entourage. The family makes a point of attending every one of Nicole's games. Because her knowledge of basketball is limited, Andrea is generally reserved, limiting her cheers to "Let's go, Knights," and, when Kennedy is on defense, "Take that ball away." But Nicole loves having her mother in the stands. Upon seeing Andrea enter the gym, Nicole has been known to say proudly, "Here comes my mommy. I love my mommy."

Nicole's aunt Joan is a well-built, lively woman with the strongest Jamaican accent of the bunch and is more talkative than her sister. It is often hard to miss

her booming voice in the stands, especially if she is unhappy with the referees. "You wicked, terrible man," she has been known to yell at a white referee she feels is discriminating against her niece. Fortunately for her, her Jamaican accent can be so thick the referees may not understand what she is saying. She and Kesha like to sit near the top of the stands, often surrounded by a group of the family's young children, videotaping each game and adding the tapes to a vast library that Joan keeps in a drawer in her bedroom. She says she isn't able to properly focus on games while taping them, so she lies in bed and watches the day's tape that night. Sometimes during the offseason when she is bored she pulls out old tapes and watches them.

Euphemia, who is not present for this game, has taken to betting her granddaughter about the number of points she will score in a given game, in order to motivate her. For every 10 points Nicole scores, Euphemia pays her a dollar. Eventually, when the deal becomes prohibitively expensive, Euphemia changes the rules so that 20 points earns a dollar. "It was too much," she will say, "so I had to cut it down."

For the game, Nicole wears a plastic mouthpiece, white socks pulled up just below her knees, and her No. 11 white jersey with KENNEDY across the front in black letters. As the game begins, Belleville, an all-white team with a reputation as a fair but not excellent squad, streaks out ahead 14–8 after the first quarter. Nicole makes only two of her first nine field-goal attempts.

Slowly Nicole starts to warm up her shot, entertaining the small crowd that has come to watch. When she pulls up and buries a 3-pointer to open the second period, Charlie Bell, Nicole's volleyball coach who is seated courtside keeping the clock, offers some mock advice to the Belleville coach. "It's easy, Coach. You put three on her and hope the others don't kill you."

Nicole has such range from beyond the 3-point arc that the joke around North Jersey goes like this: "When do you pick up Nicole Louden? When she enters the gym." Nicole makes her next two baskets, both 3-pointers, and draws Kennedy within reach to 26–21. By halftime, she has 20 of her team's points as Belleville leads 35–32.

During the halftime break, when the team congregates in a nearby classroom, Crawford gives her team some sound, basic advice.

"Put a lot of pressure on the ball: we're still in the game," she says. "And be there to help Nicole out."

During the third quarter, Nicole starts to dominate, giving the Lady Knights the lead when she scores seven unanswered points—a pull-up jump shot in traffic, a layup and a foul shot, and a putback off of one of Shantay's misses—to give Kennedy a 42–40 lead. Her repertoire includes a change of speeds on the

dribble, slow to fast and back to slow again, a process that allows her to glide past defenders after appearing to hesitate. Nicole can also dribble behind her back and pass with either hand, skills that no one else on the court has mastered. She has worked so hard on her left hand that it is now her dominant dribbling hand. After scoring 11 consecutive points herself, Nicole turns a 40–35 deficit into a 46–43 lead after three quarters.

Behind the Kennedy bench stands Athletic Director Bob Gut, a tall, stout man with a ruddy face and a head full of gray hair. He has been at Kennedy since it was known as Central High in the 1960s. Near him is Lou Bonora, the former coach. A short, squat man with a smile so big it almost matches his passions for sports and Italian food, Bonora walks over near the scorer's table and begins discussing the latest gossip—Delfiah's move to Eastside—with Bell.

"It's a shame," he says while watching Nicole play. "The two of them together would've made some noise."

Out on the court, Nicole has simply taken over the game on both ends of the floor. She is doing virtually everything from grabbing most of her team's rebounds to stealing the ball to streaking downcourt and feeding Shantay for open shots at the basket. When Antoinette bobbles a pass, allowing the ball to roll out of bounds, Nicole rolls her eyes in disbelief.

Kennedy ends up winning 62–53 and Nicole finishes with 38 points on 15-of-36 shooting. She also has 12 rebounds, four assists, and three steals.

Afterward, as she catches her breath near her family in the stands, she seems businesslike as usual, but a little overwhelmed by the lack of support.

"It was mentally tough for me because right now I'm battling injuries. My shins and my right ankle aren't that strong, so I had to dig down deep and try to pull out the victory. This is the opening game. This sets the tone for the rest of the season, so I was just trying to pull out the W [win] and that's what inspired me to work harder."

Shantay scored 11 points, benefiting from several nice passes from Nicole. Nicole obviously would like to have her teammates help out in the scoring column.

"Shantay could be the second leading scorer on this team, it could be A.J.," she says in reference to Antoinette. "It would be better if we could have balanced scoring each night. If we could each come out and get fifteen points apiece, that would be great too."

For the Belleville players, dealing with Nicole was more than enough.

"It's extremely frustrating to know that you're all going out and trying to play defense as a team and she just kind of breaks that all away with her moves, her speed, her ability," Dana Lopreato, a Belleville senior, says.

Over the years, opposing coaches have used every defense imaginable to attempt to contain Nicole: the box-and-one, the triangle-and-two, zones, extremely physical man-to-man. She has seen everything except the defense where the opposing coach comes off the sideline to trip her. Some schemes work better than others, but, in the end, rivals generally concede that Nicole will score her 30 points; they concern themselves with making sure one of her teammates doesn't have a big game to complement hers.

"One girl can't do it all," Belleville's coach, Cheryl Marion, adds after the game, as if trying to deny what her eyes had just seen, "but [Nicole] turned it on in the second [half] when she was hot. You can't do anything about somebody shooting the ball and any shot they take is going in."

* * *

The day after the Belleville game, Delfiah makes her Eastside debut, scoring a team-high 14 points in a loss to a tough Montclair team. A couple of days later, she and her teammates are watching a tape of the game in Coach Black's office at Eastside. On one play, Delfiah glides down the lane, puts the ball all the way around her back, and then puts it in the basket for a layup. The move draws rave reviews from her teammates. It was a bit of showmanship, but it is clear that Delfiah's game has evolved a great deal from when she was a sophomore at Kennedy. The tape also shows her sinking a couple of 3-pointers, something she rarely did at Kennedy.

It is clear she has matured as a person as well. She seems to have grown an inch or two, and she now carries herself as if she wants to be a leader on her new team.

"The hardest part [of moving away] was leaving my team," she says. "I learned from my journey to stay committed to a team. You don't just drop off. So while I'm here, I'm gonna try to show my team leadership and [give them] the courage that they can do it because some may think that they can't do it and get upset."

Over at Kennedy, Watson, Crawford, and the Lady Knight boosters cannot help but wonder how the season will play out now that Delfiah and Nicole are on different teams. How good will Kennedy be with a somewhat injured Nicole leading the way again? How good can Delfiah make Eastside? And what would have happened if they had been teamed together?

* * *

At first it seems that Delfiah experiences some separation anxiety from her old team. Over the Christmas break, she travels on the Kennedy bus when the Lady Knights attend a Christmas tournament at Marist High School in Bayonne. Two years before at this tournament, Dakita and Delfiah were both on the Kennedy roster, and Delfiah played well enough to earn all-tournament honors. But on this late December day as Nicole walks diagonally across the floor toward the Kennedy bench and the scorekeeper's table, her bag slung across her shoulders, Delfiah remains in the bleachers wearing jeans and Timberland boots, a touch of sadness in her normally stoic face.

"I coulda helped y'all out today if I had been up here and on the team and playing with you guys instead of where I'm at," Delfiah tells Crawford, who is sitting nearby. "Ain't too many people at our level," she adds, looking at Nicole. "Kennedy, they got Nicole. Tech, they got Dakita. And Eastside, they got me. If you think about it, we coulda been a good team. Now it's hard to watch your teammate take over a good team while you leave."

As the season moves along and Delfiah becomes accustomed to life at Eastside, she identifies more and more with the orange and blue of the Ghosts, less and less with the black and red of Kennedy. Kennedy gets its first taste of the revamped Eastside team on January 11, 2000. The game, originally scheduled for four o'clock is pushed back to seven. Nicole has come to Eastside for the early start time, but is on her way out when she sees Delfiah in the gym. The two have always been friendly, but never particularly close. They played together for only one season; Nicole spent much more time with Dakita when they were all growing up.

"Where you getting ready to go?" Delfiah asks her old teammate near the door.

"I'm going to get my ankle wrapped," Nicole says.

"We got a trainer here, why can't you let our trainer do it?"

"I want my trainer to do it," says Nicole, who plans to head back to Kennedy so Judge can tape her right ankle.

"Okay," Delfiah says. "See you later. Good luck tonight."

"Good luck, too," Nicole says as she goes out the door.

When it comes time for the game, Nicole's shot is not particularly on. As usual, her teammates aren't much help. Delfiah, on the other hand, has a strong supporting cast, a mix of big girls who dominate the smaller Kennedy players on the boards and a number of quick guards who can score from outside. Nicole ends up scoring 26 of Kennedy's 35 points; the rest of her teammates combine for only nine. Playing point guard for Eastside, Delfiah brings the ball upcourt on nearly every possession. Her quickness enables her to drive past the Kennedy defenders on several occasions, and her height allows her to jump over

her defenders for easy layups and putbacks. She finishes with 16 points to lead Eastside to a 41–35 victory.

Eleven days later, on January 22, things start to turn even worse for Nicole. It seems like the entire season may be cursed. On this Saturday, Nicole takes the Scholastic Assessment Test (SAT) for a third time (she got a 460 on the math section, upping her combined total to a 910.) Most of her teammates are younger, so none of them take the test on this day. At about 1 P.M., Mos drives Nicole straight from the test to Kennedy's home game against Clifton; tipoff is scheduled for 1 P.M. for Saturday games. The Mustangs have never beaten Kennedy during Nicole's tenure, but they are still a decent league opponent.

By the time she comes running into the gym in jeans and sneakers, Clifton is already leading 8–2 halfway through the first quarter. Shantay had been suspended for the game after missing a practice, so the team has almost no one who can reliably put the ball in the basket. Nicole winces at the score and suits up for the game without warming up.

She quickly scores two baskets and assists on a third to her teammate Litza Roman to tie the game at 10–10 near the end of the first period. But as the first-quarter clock winds down, she hoists a 3-point attempt, and then falls awkwardly on her right ankle as a defender attempts to stop the shot. Crying and in obvious pain, she lies on the floor for several seconds before a teammate, Jennifer Esteves, and Judge help her off the floor.

On the sideline, Coach Watson wipes the tears from Nicole's red and puffy face, but Nicole is determined to get back onto the court as soon as possible. Judge begins wrapping Nicole's ankle in thick white athletic tape, hoping to stabilize what is clearly a bad sprain. Meanwhile, without their best player, the Lady Knights are helpless. Clifton outscores Kennedy 17–4 and takes a 27–14 lead into halftime.

During the break, Judge tests Nicole's strength in a hallway just off the gym. As Andrea, Athletic Director Bob Gut, and several friends look on, Judge scrutinizes Nicole as she gingerly jogs up and down the hallway.

"Be honest with yourself," Judge says. "You'll be all right for Tuesday, but if you hurt it further you won't be."

"Yeah," Nicole mumbles, her eyes still moist from pain.

"You all right, Nicole?" Andrea asks her daughter in a quiet, hopeful tone. Nicole's mother worries whenever Nicole gets injured, and has often told her that if it was up to her, she wouldn't be playing basketball.

"You just passed zero speed," Judge remarks as Nicole continues to run. "Now you're at [a speed of] one. Gimme half [speed]."

"It's all right," Nicole insists, even though it is painfully obvious to everyone that it isn't.

"Give me three quarters," Judge instructs. "Give me full speed, maybe this will be half."

"Full speed?" Nicole asks. "I don't think I can do that."

"Give me as much as you can give me then."

As the second half starts, Nicole remains on the bench and Clifton continues to pour it on, taking a virtually insurmountable 39–16 lead midway through the third quarter.

Finally, toward the end of the third quarter, Watson allows Nicole to hobble back into the game. She hits a 3-pointer and scores Kennedy's next 9 points, but it is clear that the game is lost. During one timeout, Nicole stands with her head cast downward in the huddle. She can't believe what is happening.

Clifton ends up winning 53–30. Despite missing almost half of the game, Nicole, remarkably, is still the game's leading scorer with 15 points.

When it is over, she sits dejectedly in the stands near her family members.

"Frustrating is an understatement," she says, her voice rising in anguish. "There's not even a word to describe how I feel. The season is going downhill and it's just like injury after injury for me. It never ends. Last year it was my knees. This year it's my shins, my ankles. But I just gotta suck it up and keep on playing."

Nicole didn't even seriously consider sitting out the remainder of the game. She felt she had to go back on the court.

"Part of me wants to [sit it out]," she says. "We have to qualify for states. So I was just thinking, 'Win, win, win' while I was playing hurt, hurt, hurt. I just pray it doesn't get any worse, man. It hurts like hell."

Perhaps if Shantay had been there it would have been different, but Nicole knows her team is a glorified junior varsity club without her.

"My team, they need to learn to play without me," she adds. "That really annoys me. I mean, we lost to Clifton. That's rock bottom."

So frustrated and angry is Nicole that she mentions transferring to Eastside, where she spent those few days at the beginning of her freshman year.

"If this was my freshman year and I had to transfer, I would. Just being here bothers me. Since I've been here three years, it's kind of sad to say that."

The Mustangs could not have known the extent of Nicole's feelings, but they know the victory is a hollow one.

"This is a good Kennedy team, but without Louden, it's tough," Clifton coach Alan Carline says. "I'd prefer to beat a Kennedy team with her at full strength, but we'll take the win."

Clifton senior forward Mary Rosado, the team's best player, adds: "Today, we weren't too happy about the victory. It isn't a big thing without Louden in the game.... After she got out, it was nothing."

While Nicole worries about her injury and the future of her season, others can only focus on whether she is still on pace to score 2,000 points for her career—a feat accomplished by only two girls in the history of the county. At the end of the game, Nicole's career total is up to 1,577, tenth on the all-time Passaic County list.

In the parking lot, Maria Colon, who was an assistant coach during Nicole's freshman year, yells to Judge: "Gotta get her better, Laura. Gotta get her better. She gotta get that two thousand this year. I gotta make sure I can back up what I say."

"She'll be all right," Judge answers. "She's getting there."

Chapter 7

Six days after Nicole's ankle injury, on January 28, 2000, Joan and Kesha have moved all of the furniture from the two large common rooms in their home on North Sixth Street to create space for the disc jockey and the dance floor. Nicole's family has planned a joint party celebrating Nicole's seventeenth birthday and her cousin Kesha's twenty-third. The room that features the music equipment is where Nicole often goes after school to use the computer and send e-mails to friends and college coaches under her various screen names. She has so many, it is hard to keep track. There is "Dark Delight," "African Honey," "A Different Beat." Eventually, she ends up with about eight different screen names, all on various servers.

Every two weeks, and especially on the eve of a big trip or event, Nicole goes to her cousin's house so that Kesha, who has a certificate in cosmetology, can give her a $45 hair styling for free. The night before the birthday party, Kesha gave Nicole a ponytailed bob free of charge. "Man, I've had a trillion styles in my hair," Nicole says.

By 10:30 P.M., Nicole looks quite elegant, wearing a simple black dress, several silver bracelets, and her hair up. It is a rare sight indeed. Usually she wears either jeans and a T-shirt or athletic gear.

The house is pulsating with music and warmth on this frigid winter night. On the wall in the living room hangs a poster that reads HAPPY BIRTHDAY NICOLE. In front of that is the King Agony disc jockey setup, a turntable, microphone, keyboard, and speakers. Ricky, otherwise known as King Agony, is the father of Kesha's children. The two maintain a relationship, but it is strained. Also at the party is an uncle of Nicole's, clad in a red hat, matching sweatshirt, and giant gold cross necklace. He says he is a rap artist in Jamaica by the name of Major Damage. Later, at almost two in the morning, Damage regales the crowd with some Jamaican rap before letting Nicole, Alex, and others take the mike.

Although the house is beginning to fill up with various friends and family members, only two of Nicole's Kennedy teammates have been asked.

"To tell you the truth, I don't really like many of my teammates that much," Nicole says. Still, she is overjoyed that her best friends, Justine and Sakina, are there. While Nicole, Sakina, and Justine are up front at the party playing spades, listening to music, and talking to a few friends from the STEM program, Andrea, Joan, and Esther, Andrea and Joan's sister, are watching cartoons on a television perched atop the refrigerator in the kitchen, waiting for Euphemia to come from church to bless the food. Nothing starts in this family without Euphemia, and this party is no exception.

Arrayed in aluminum containers on the kitchen table are lasagna, rice, fried chicken, salad, and two Jamaican specialties, jerked chicken and curried goat. Friends and relatives, smelling the wafting odors, move in and out of the kitchen, anxious for food and some sign that the party is ready to kick off.

"Mama said she getting out of church at nine," Joan says. "Now it's eleven, and mom ain't even here yet."

"I'm ready to start," Kesha adds. "The people are hungry."

While the guests wait for Euphemia to arrive, Joan pulls out a master list of the points Nicole has scored in every single game of her high school career. Joan has missed only one or two of those games, and is trying to figure out the discrepancy between Nicole's reported point total in two area newspapers. Nicole is closing in not only on 2,000 career points, but on the all-time scoring record for girls in Passaic County, and Joan has calculated how many points she needs for each milestone.

Joan has always been a sports enthusiast. Upon her arrival in America in 1986, she started watching basketball on television, and became a big fan of Magic Johnson and the Showtime Lakers. When she and Andrea learned that Patrick Ewing was Jamaican, they added the Knicks to their list of favorite teams. Once the WNBA formed, Joan began going by herself to Madison Square Garden to watch Liberty games. During the NBA season, after a long day at work, she enjoys lying in bed and watching the Knicks in the darkness of her bedroom. But she follows Nicole's career the closest. Joan's office at the Passaic County Board of Social Services is essentially the Nicole Louden Museum. The divider in her cubicle is covered with photocopies of articles documenting Nicole's career. Coworkers sometimes ask Joan for Nicole's autograph.

Because of the extreme pride she takes in her niece, Joan is often mistaken for Nicole's mother. Recruiters see her as a way to get to Nicole. On more than one occasion, Joan has been woken up at three or four in the morning by a coach hoping to curry favor with her niece.

It is almost eleven o'clock when Nicole's 66-year-old grandmother arrives from the Church of Jesus Christ Apostolic, where the members had been making plans for the upcoming year. She wears a blue dress and a black hat, and glasses frame her smiling face.

She moves to the living room and takes the microphone from King Agony in order to bless the food, and Nicole and Kesha.

"Let us pray," she says. "As we come and pray tonight, let us, Lord Jesus, partake with love, with unity, with strength. Oh, God, as these two have their birthday tonight, Lord, we ask you to bless them. And may they live to see many more birthdays while we give you thanks for them and each and every one that are here tonight in the name of Jesus. Amen."

"Amen," the crowd says

With that, the music and dancing start and Euphemia retreats to the kitchen. There, as she sits in a chair and eats, she talks about her family's history, and the importance of family to her.

"[Nicole] could be on the street, but we love each other and we have togetherness, so she doesn't need that," Euphemia says in her soft, strong voice tinged with a Jamaican accent. "She can come home and get the same love as from friends, but better."

Nicole's grandmother is fond of saying that when she first came to America she was like a "blind Bartimaeus," the beggar to whom Jesus restored sight. Euphemia didn't know much about where she was going or what she would do away from her native Jamaica. When she got off the plane that February day in 1977, all she knew was that her brother and his wife were already here—and that America offered a better life.

"I was excited to be someplace new," she says. "I didn't know the place, but I was excited to be in America. I was just curious. I love my country, but it's better here money-wise."

Euphemia was 43 years old at the time. Her little-old-lady glasses and medium-sized frame belied her tremendous determination and spirit. Deciding that America was the best option for her family, she left her job cleaning and maintaining laboratory equipment at St. Hughes High School in Allman Town, a quarter in the Jamaican capital of Kingston. She set off without her husband, Kenneth, a fisherman with a sense of humor whom she had met at the Mizpah Spiritual Healing Mission in nearby Torrington Bridge. And she left behind her seven children.

Soon after her Air Jamaica flight touched down at Kennedy Airport, Euphemia joined her brother Theophelous and his wife, Clarice, at their home on Paterson's East Twenty-first Street. Before long, she found work as a domestic for a

well-to-do white Metuchen, New Jersey, family. She cooked and cleaned and took care of their children, all the while saving money to finance building her family's new home in Nannyville, Jamaica, a home the Richmans would own instead of rent. Meanwhile, she petitioned the American government to allow her, slowly but surely, to bring her family over.

For six years, she lived away from her husband and children, visiting them only on rare occasions like Christmas. She got her green card in 1983 and later became a naturalized citizen. To this day she proudly displays the certificates of naturalization awarded both her and Kenneth, along with a framed picture of Bill Clinton on top of a smaller picture of herself smiling in the corner. The truth is, she has a little crush on Clinton. "I love that guy," she says of the man then in the White House. "I just love that guy, man."

Beginning in the early 1980s, she brought her family to Paterson in groups of two and three and four, paying a $60 fee each time a new person arrived. First Kenneth and their daughter Jackie and grandson Dameon came, followed by waves of children and grandchildren. Eventually, Euphemia would have 7 children, 19 grandchildren, and 8 great-grandchildren in the States. She even paid the way for Kenneth's daughter Prudence, whom he had fathered with another woman.

"I have a whole army," she likes to say.

Andrea, the oldest of Euphemia's children, initially came to the United States not only to be with Euphemia but also because the father of her children, Orlando Louden, was here. "I think mostly because he was here," she once said with a laugh.

Orlando, a thin, handsome man with a beard and well-defined features, and Andrea were sweethearts at Kingston Senior School in Jamaica. He ran track and played soccer, and she competed in relay races and the high jump. They lived a bicycle ride away from each other, Orlando in Fletchers Land and Andrea in Allman Town.

Growing up, Andrea wanted to be a nurse, and attended Wilmar College for several years before leaving to concentrate on her daughters, Karen and Lorna, who were born a year apart in the early 1970s.

"It just didn't work out for me," she says of her dream of becoming a nurse. "So, after that I just concentrate on my kids." Eventually, she found work as a waitress and cashier at the Western Farms restaurant in nearby Half Way Tree.

As Orlando grew older, he wanted to stretch his wings and come to America. He left Andrea and the children behind and moved to Brooklyn, where several of his family members had already migrated. In 1979, not long after, Andrea quit her job at the restaurant and followed, leaving Joan in charge of her daughters in Jamaica.

She joined Euphemia in Paterson and soon found work as a housekeeper and child caretaker for a white family in Dix Hills, Long Island. On Fridays, Andrea took a taxi, a train, and a bus back to Paterson for the weekends. Then she would sometimes visit with Orlando.

She kept that job right up until she was in the ninth month of her pregnancy with Nicole. Still, despite the birth of their third child, Andrea and Orlando had a volatile relationship. They never married. He wanted to live near his family in Brooklyn, and she wanted to stay near hers in Paterson.

"That was our conflict," she says. "He used to say that over here was 'country' and I said I just wanna go [to New York to visit] and leave. He was stubborn and I was stubborn." For a brief period of time, after Karen and Lorna came to New Jersey in the mid-1980s, Andrea, Orlando, and the girls lived together in an apartment in Paterson. For the most part Nicole's father stayed in Brooklyn. In 1995, when Nicole was 12 years old, Orlando died of causes never fully explained to Andrea or her children. They believe it was a disease of some kind, but say they were never fully informed because Andrea was not legally married to Orlando. The family doesn't volunteer anything more than that. Nicole's recollections of her father are limited but she recalls him cooking, joking, and, perhaps most of all, wanting to keep her inside the house, off the street.

In Paterson, Euphemia was forced to look for a bigger house as more and more family members arrived. She eventually found one on Jefferson Street that sat atop a bar, and was so dirty, cockroach-infested, and crammed with garbage that the owner couldn't show it at first. Euphemia's family got the place fumigated and pitched in and made it a home. No matter how tidy they kept the house, though, the roaches wouldn't go away. But what really bothered Euphemia was living above that house of sin. She was a churchgoing woman and she didn't like all the music and carrying on below. It often kept the children up at night. Euphemia especially didn't like having to pay the bar's electricity bill, an unwanted feature of living in the apartment.

Kenneth had found work maintaining boilers at the Elmwood Park Housing Complex, but it was Euphemia who did the bulk of work around the house—cooking, cleaning, shopping, and supervising children. Despite her job and domestic chores, she found time to take classes. Though she had never attended high school, she enrolled at Passaic County Community College and spent two years studying liberal arts, accumulating 36 credits before withdrawing to take care of her husband, who was in and out of the hospital suffering from diabetes. "My husband was so sick, I had to go to the hospital every day and come home," she recalls. "It was hectic for me to continue."

Still, she obtained her home health aid and homemaker certificates, and got a job working for Home Care Option caring for the elderly.

When the apartment on Jefferson Street got too crowded, the family moved to an apartment on North Main Street. There the group got even bigger as Euphemia's two sons, Prince and Joshua, and Nicole's sister Lorna came. More than a dozen of them shared a two-bedroom apartment, sleeping three or four to a bed and on the couches in the living room.

"They had to bunk together," Euphemia says. "I couldn't find a place to fit all of them."

Eventually, as Euphemia's children and grandchildren got on their feet in their new country, they began to move out. Her daughters Esther and Jackie established themselves in their own homes in Paterson. Joshua moved to be with a woman in town. Meanwhile, the original group splintered and migrated from house to house.

Back in Allman Town, the Richman clan had been respected because Euphemia was a member of the choir and active in the affairs of St. Matthew's Church. The children had their father, Kenneth, wrapped around their collective finger, but it was a different story with Euphemia. She laid down the law. She would make sure all seven of her children appeared clean and tidy when they went to church on Sunday. At dinner, the children sat at a long table in front of seven plates, and they never went hungry.

"We were happy," Andrea recalls. "My mom provided for us. We weren't rich, but we were making it."

In America Euphemia retained her position as head of the family. And her children were accustomed to that. Even though her daughters were around, Euphemia raised her grandchildren just as she had her own children back in Jamaica. The whole family calls her Mama.

"Mama is everything," Andrea says. "She's like the backbone of us."

As the size of Euphemia's family in the United States increased, so too did her responsibilities. She worried about her young granddaughters amid the temptations of the inner city. She immediately sensed a difference between her immigrant family and the American blacks in Paterson.

"They are different in actions, in moods," Euphemia says. "What these kids do in this country, we couldn't do in Jamaica. [There] they respect teachers and respect people. They are respectful. They're not as rude as these kids [who] carry guns in school, knives in school." At the end of Nicole's sophomore year, in June 1999, a 17-year-old Kennedy freshman was arrested after students saw him putting a 9mm Smith & Wesson semiautomatic handgun in his locker. The student did not threaten anyone with the gun, but it was loaded with 14 rounds.

Four days later, the police were notified that another student had a .38 caliber Smith & Wesson revolver loaded with six bullets in his knapsack. Both students were remanded to the Passaic County Youth Juvenile Center.

"No, no we don't have that," Euphemia says. "We have a different environment. [My grandchildren] were taught how to behave. My kids didn't get involved with what's going on with these kids. They were already versed in how to behave."

When Lorna came to Paterson and began spending a lot of time with a young man from next door who was several years older, Euphemia warned Andrea to "watch that girl."

"Boys are trouble for young girls," Euphemia is fond of saying. "They trouble, man. They mess up young girls, then they run away and leave them. They only looking for one thing. They get that, you never see them again."

Andrea was busy working to put food on the table and couldn't stop Lorna from associating with him or ultimately from getting pregnant when she was 14. Euphemia was so upset with her granddaughter that she stopped speaking to her, and Andrea and Lorna had to move out. (Nicole split her time between Euphemia's house and Andrea's.) Lorna believes that she was Euphemia's favorite grandchild and that her grandmother simply couldn't take what happened.

"It was tough, I wasn't looking for that," Euphemia says. "I wasn't looking for that. But it happens, what could I do? What's done is done." Andrea has similar feelings.

"I really didn't like that it happened, but I really can't do anything about it," Andrea says. "Everybody pitched in and helped."

Once Lorna's son, Junior, was born, Euphemia resumed speaking to her granddaughter. Lorna, meanwhile, continued her schooling, and raised her son with help from her extended family. She has held a number of jobs, most recently as a cashier at a local supermarket. Though she never lived with Junior's father, Lorna said he was around to help. "My baby's father was there for four years," she recalls. But, Junior says, "I don't know my father." Because he is having trouble coping with school and his environment, Lorna has lately decided to let Karen take Junior with her when she transfers to an Army base in Georgia. Perhaps new surroundings will make things better for him, Lorna reasons.

Four years after Junior was born, Lorna gave birth to another son, Kadeem, and soon thereafter, another of Euphemia's granddaughters, Kesha, became pregnant with her first son, Ricardo, known as Ricky. Like Lorna, Kesha was 14 when she had the baby. Later, Kesha gave birth to Daniel. Euphemia was so angry when Ricky was born, she didn't speak to her granddaughter for some time. "She had high hopes for all her grandkids," Joan says. "She don't like to

see them mess up their lives. And with them becoming pregnant so young, they are messing up their lives. She wants them to become something."

Kesha, a friendly, open woman, went on to receive a certificate in cosmetology from a school in Pittsburgh. One day, she hopes to return to the nearby Capri Institute, a cosmetology training center, and eventually open her own hair salon. Meanwhile, her mother has helped raise Ricky and Daniel, as has Kesha's boyfriend, Mark, though he is not their father.

Amid all of this, it is probably no surprise that Karen and Nicole developed a healthy skepticism concerning boys, especially many of those from the inner city. When the situation with Lorna and Euphemia exploded, Karen said, "I was scared of guys after that." Nicole is a decade younger than her sisters, but as she has gotten old enough to date, she remains wary. "Nicole knows better," Lorna says. "She doesn't want to disappoint my grandmother."

Except for a brief relationship during her freshman year, Nicole has never had a boyfriend during her time in high school.

"I just can't talk to boys from Paterson," she said once. "A lot of them wanna go smoke and drink. Nicole don't play that. Besides, I don't want my mom to kill me."

It isn't that the boys aren't interested. Many members of the boys' basketball team are attracted to Nicole, and they joke in the locker room about which one of them will go out with her first. She is, after all, in great shape, she is attractive, smart, and funny. But she doesn't want to give herself to just anyone.

"I want somebody who's decent," she says. "It's so hard to find somebody who's decent."

At times, she blames her lack of a social life on her rising stardom and need for independence. James Lattimore, the point guard on the boys' team, thinks she is a better player than some of the boys on his team. Nicole frequently appears in the newspapers because of her basketball feats, and she doesn't wear tight clothes and makeup like many female classmates.

"I think guys are intimidated by me," she said one day. "I'm a regular teenager. I like to go to the movies and eat junk food. I like to have a social life, too."

Andrea has expressed relief that Nicole has avoided getting pregnant at a young age. "I'm just grateful," she says. "I pray to God that it don't happen. I'm really grateful for that."

* * *

Even as the family moved several times, winding up in a series of rented houses on North Sixth Street, Euphemia forged a tight-knit clan that is completely self-sufficient socially. Given all that has happened, its leader is even dis-

missive of outsiders. Euphemia normally speaks in soft, measured, polite tones, but when she is annoyed, her voice rises an octave or two and you know she means business. When other kids came to the house to play with her grandchildren, she would ask those other children in a high-pitched, scolding tone, "You don't live somewhere? You don't have parents?" To this day her grandchildren laugh as they recall how other kids would just run when they saw Euphemia coming home from work.

At night, Euphemia often cooks a Jamaican staple such as curried chicken or curried goat for the entire family. She likes to go to the slaughterhouse and buy an entire goat and then strip and clean it for cooking. She uses the head, the belly, and the forefeet to make a type of soup known as mannish water. "When you cook that mannish water, man, it's so good," she likes to say. She cuts up the rest of the goat and stores it in bags in the freezer, cooking parts here and there.

Nicole and her cousins, Dameon, Jody, Kesha, and Kaara, often got hungry, really hungry, before Euphemia came home from work to make dinner. They never had much money, and the only place to eat around there was a bodega on the corner known as Angel's Liquor & Grocery. Nicole and her cousins would take turns asking their aunts for quarters so they could go to Angel's and get veggie sandwiches—which basically consist of lettuce, tomato, vinegar, cheese and mayonnaise wrapped in a roll. "If you wanted meat, that called for more money," Nicole says. For another quarter, she could buy a container of juice, and that had to hold her until dinner.

The family was struggling financially, but Euphemia did the best she could. Once in a while, she would take the group out to dinner at Sizzler's, the International House of Pancakes, or a nearby Chinese restaurant. Nicole couldn't afford to wear name-brand sneakers, so she wore shoes from Payless, something that still sticks with her to this day when she receives complimentary Nikes from her sister or others.

Hunger and living without the latest Nikes weren't the only hazards of life on North Sixth. Once, when Lorna was braiding Nicole's hair in their upstairs apartment, a massive electrical fire that had started at a neighbor's spread through a window, sending Nicole, her brother Alex, and cousin Kadeem running across the street to their grandmother's. Lorna couldn't run because she had broken both her hips and her left leg in a terrible car accident and was using a walker. She managed to get the walker and move to the front of the house, and a fireman picked her up and carried her out. Much of the family's clothing and furniture were destroyed. They were lucky that the flames were contained on one side of the house.

"If it was coming up both ways, we'd a been dead," Nicole recalls.

Through all of these struggles, Euphemia created a remarkably strong matriarchy, a clan whose members were tighter and more supportive of each other than those in plenty of more traditional families.

Euphemia has an immensely optimistic view of life, a belief that education, hard work, self-confidence, and faith in God can get you almost anywhere in life. Evidence of Euphemia's faith is everywhere. The tapestry on her and Kenneth's headboard reads BLESS THIS HOUSE WITH LOVE. During those years when she lived away from her family, saving every dime to bring them over, she never doubted herself. "No siree," she says, "never doubt myself yet. Always have confidence. Always have confidence in myself." Through her own example, she has taught her family a simple message: Work hard and be successful. Then you will achieve what you want to achieve.

One element of success is education. When her grandchildren were young, she picked up all of their report cards at school and accompanied her daughters during parent-teacher conferences. Thus, even while Lorna was pregnant with Junior, she remained in school until a tutor began coming to the house.

"She kept our academics straight," Kesha says. "You couldn't play any sports without the grades. Don't bring home no D's to Mama, boy." "One C is acceptable, but no D's or F's. If you bring home a D, you better sleep out that night." And because sports were so important to the children, they knew they had to do well in school if they hoped to compete.

Nicole's mother and aunts had been avid athletes growing up and their children were no different. Back in Jamaica, Joan and her sister Esther specialized in netball, a seven-on-seven game based on basketball and played primarily by women. The game is played on a court about the size of a tennis court and the object is to get the ball in the opposing hoop as many times as possible throughout a 60-minute match. Several days before Joan left for the United States, her club team, Walgrovian Sports Club, beat Esther's team, Hampshire Sports Club, in the finals of a local tournament. Today, Joan's knees bother her and prevent her from playing; Esther still competes in Queens. But Joan fondly recalls how she left Jamaica as a champion.

Nicole and her sisters and cousins never caught the Netball spirit, preferring other sports instead. Karen played softball and tennis at Eastside, while Lorna specialized in volleyball. Meanwhile, the younger Richmans took up football and basketball. When Dameon, the only boy among his cousins, played football on the street with his friends, Nicole would sometimes say, "I wanna play." The neighborhood boys would tell Nicole and Jody, "Y'all are girls, you can't play with us," but Dameon would invite them into the games anyway. He always thought of Nicole as a tomboy because of the way she measured herself

against him. One time Nicole and Jody were competing against two of their uncle Prince's friends by shooting a basketball into a garbage can. When the girls started beating the grown men in front of a small crowd, the guys challenged them to a real game of two-on-two. Everyone jumped in their cars and headed to School 28, where Jody and Nicole beat the men so badly they only scored one basket.

"It's because I got a corn," Uncle Prince's friend said, giving Nicole a taste of the excuses men would use for losing to her when she got older.

Eventually, Dameon became a football star at Kennedy, earning "athlete of the week" honors from the *Record*, of Hackensack, New Jersey, and a full scholarship to the College of New Jersey. Nicole and Jody turned to basketball. Two years older than Nicole, Jody would already be on the Kennedy varsity when Nicole arrived.

Now that Nicole's great-aunt and -uncle have moved out of the house on East Twenty-sixth Street, Nicole has turned her room into a basketball shrine. The door bears her nickname, KILLA COLE, in giant black letters. The plastic box overflowing with recruiting letters, Federal Express packages, and media guides stands two feet high in the corner. The walls are covered with newspaper and magazine photographs and posters of players, an autograph from Teresa Weatherspoon, and handwritten letters and cards from coaches. "Happy Birthday," reads one card from the Connecticut coaching staff. "Wishing you all the best on your special day. Nicole, all the best—Coach Auriemma." The card doesn't fail to mention that the team was the "1995 National Champions."

Chapter 8

Paterson has no movie theaters, no teen centers, and no mall. About the closest thing to a refuge from the streets a teenager can find is the YMCA. Where some of Nicole's classmates struggle to find activities after school and others fill their time with drugs, sex, or delinquency, Nicole returns to the Y, day after day after day, to lift weights and work on her game. She carries into the Y a duffel bag holding a pair of shorts, a tank top, a sports bra, her knee brace, and an orange Wilson basketball that says JFK. She is fond of quoting the rapper Notorious B.I.G.: "Either you sling crack rock or you get a mean jump shot." Nicole has opted for the latter.

The current version of the Paterson Y is a brownstone structure built in 1929. A blue-and-white banner reading "YMCA" hangs along the side of the building on Ward Street, but no one in Paterson needs a sign to tell them that this is the place for some of the best basketball in the city.

In many ways, the Y is a microcosm showing the changes that Paterson has undergone in the last half century. Once a segregated institution whose bowling alley, pool tables, and cafeteria were off limits to blacks, the Y now houses, employs, and serves an overwhelmingly African American population. Once a sort of hotel for factory workers, the Y is now a federally subsidized shelter for the homeless, the disabled, and those on welfare.

"Like elsewhere in the northeast, when the industries went south, the cities went south with them," says Larry Gutlerner, who has served as the executive director of the Y for a dozen years. "When the factories left, within a couple of years, those [factory workers] were no longer here and the need for housing was for people on welfare, and that translated into the homeless." Some of the residents spend their days sitting listlessly in a downstairs lobby equipped only with a few ragged couches and broken-down chairs. Some spend the income they receive from the federal government on drugs.

The residents live on the upper floors of the eight-story building, and the second and third floors are devoted to athletic facilities: a free weight room, a Nautilus room, a swimming pool, and the two small basketball courts that constitute basketball heaven to the ballplayers of Paterson.

* * *

Every morning, Milton Evans wakes up in his apartment across the street from the Y—it simply says MILTON on the buzzer outside—and looks forward to training Nicole. Forty-eight years old, Evans no longer works because of the injuries he suffered from a major car accident years earlier. He lives off $800 a month in Social Security payments. His children are grown and his second wife lives halfway across the country.

Nicole gives meaning to Evans's life. Through her, he can play the game he himself hasn't been able to enjoy in more than a decade. He can teach her all of the things he has learned on playgrounds and in gyms over the years. He can mold her into a tough, skilled woman who can do battle with any female in the country—and many men, too. And in Nicole, unlike the son and stepdaughters he drove to the brink of hating the game, he has a subject willing to absorb his abuse and heed his advice because she wants more than anything else to be the best player she can be.

Six-foot-five and 240 pounds, Evans has a long, angular face, a patchy beard covering his brown skin, and intense eyes that can be childlike or downright frightening—depending on his mood. Though he cannot extend his left arm and now walks with a limp that tilts his body to the right, he can still emit a dangerous air, a coiled, predatory presence.

In his prime, Evans possessed a brutish, physical style of play that his friends later compared to that of the former Detroit Piston Rick Mahorn. Like Mahorn, Evans was never a great player, but served as the enforcer and rebounder who passed the ball to the shooters. His best tool was his mouth. He liked to bark out plays and strategies to his teammates and wild threats to opponents.

"You don't have the game," Evans would tell the opposition. "You should be ashamed to be playing basketball out here with us."

Back when all the big ballplayers in Paterson competed in traveling leagues, Evans played for a Catholic Community Center team called Mean Machine—#1 Gunners. Once when the Gunners were being physically overwhelmed by an older team in a basement gym in Harlem, Evans told one opponent, "If you come down the middle again, you'll be picking up teeth. You just don't be runnin' through here like that."

When the guy drove the lane again, Evans blocked his shot with such force the man had trouble picking himself up off the floor.

Another time, at Don Bosco Tech High School in Paterson, Evans gathered in a rebound and elbowed an opponent so strongly that the man left the gym on a stretcher. Evans never apologized for what he said or did because he saw basketball as war.

But everything changed when he was 35 years old. In September 1987 he was driving a friend to Trenton, going about 80 or 85 miles an hour, when a 19-year-old driver crossed a grass median and three lanes, hit Evans's car, and flipped it five times, leaving him and his friend bleeding and unconscious in a ditch.

"I never saw him coming," Evans says.

Milton Evans, that indestructible trash talker his stepdaughter Erica thought of as Superman, was left with a detached retina, a hole in his aorta, a ruptured spleen, broken ribs all along his left side, several teeth knocked out, and the entire left side of his body completely altered. He had no use of his leg, and his elbow was destroyed. He required 11 hours of surgery. His wife, Veronica, didn't expect him to make it.

But it would take more than a car accident to kill Evans.

"A lot of motherfuckers are dead and in their grave," he likes to say. "I'm not one of them."

He spent four months in the hospital, and lost more than 100 pounds. It took eight more months before he could eat properly and his weight returned to normal. Doctors attached his elbow to his chest via a temporary flap that allowed blood to flow to the elbow. A series of operations left him with a network of thick dark scars called keloids across his chest and body. To this day he takes Percoset and Benadryl to reduce the pain and itching caused by those scars. He later discovered that he had contracted diabetes as a result of trauma to his spleen.

As tragic as the crash was, Evans and those close to him believe that it may actually have saved his life. Arthur Lowery, a lanky fellow basketball player who remains one of Evans's best friends, thinks so. He remembers more than a few times when Evans would hit people for no reason, or provoke other men by talking to their women.

"It stopped him from being the rambunctious, sometimes brutal person that he was," says Lowery, who now handles front desk duties at the Y. "He had a propensity toward violence. More than likely [the accident] saved his life. Somebody probably would have shot him."

For two years after the accident, Evans stayed with Veronica and her daughters, Erica and Del, in their apartment on Prince Street. He couldn't do much but go back and forth to hospitals, collect insurance money, and watch movies while

Veronica and the girls cared for him. During his stay in the hospital, Evans became addicted to morphine and Percoset, so when he signed himself out after four months, sick and tired of his hospital bed, he needed a substitute. He turned to street drugs. On one occasion, Erica watched Evans and another man using crack. She didn't know what to do or say, and she began to wonder what kind of life he was living. When he started stealing from the family to buy drugs, Del and Veronica grew weary and resentful too.

As Evans emerged from his injury-induced isolation, he began wandering across the street to watch his son, Kwan Johnson, and his two stepdaughters play basketball. Evans was unable to use his left arm and often had his friend Charles "Wiz" Richardson, a slight, compassionate man with glasses and crooked teeth, help the children. Soon Evans was putting his children through a rigid regimen, making them shoot hundreds of baskets from every conceivable angle, taking them out on the playground in the dark to work on their "night vision," and encouraging the girls to compete against boys. Evans was still addicted and in awful pain, but somehow coaching the kids eased the discomfort. He sat them down and told them that he wanted them to have a better life than he did, that basketball was their ticket to college, and that, sometimes, you had to live out your dreams through your kids.

Of the three children, Kwan showed the most potential. An athletic leaper, he eventually grew almost to his father's height, 6'4". He dunked for the first time as a 13-year-old at Paterson's Montgomery Park, and soon became known throughout the city for his ferocious dunking ability. Pretty soon, Kwan was either in the Y or at Montgomery Park most days. Instead of hanging out with friends, some of whom were selling crack or weed, Kwan played basketball every day after school. Occasionally, he skipped classes to play ball at the park.

Kwan's career almost came to an end in 1990, during his sophomore year at Eastside. An opponent undercut him while he was lifting off for a dunk, causing Kwan's knee cap to pop out and split. He ended up in the hospital with three screws in his knee, scared, angry, and confused. Evans was almost more hurt by the accident than Kwan. First the game had been taken from him, and now the same doctor who had worked on him was saying it could be taken from his son. Evans wasn't going to let that happen.

Under his guidance, Kwan agreed to put his faith in God and to dedicate himself to recovering, with the aim of getting back on the basketball court. But Evans's techniques proved too much even for Kwan. One hot August day when Kwan was recovering from his knee injury, his father worked him especially hard, telling his son that he wasn't following through on his jump shot. Kwan, hot and fatigued, told his father he was too tired to continue.

"If you can't do what we want you to do, then run, goddammit," Evans barked. "I know you can do that." Then he pointed to the wall on the opposite side of the gym and said, "You know what, run and touch that wall down there and then come back here and touch this wall down here until *I* get tired." While Kwan ran up and down the floor, Milton berated him even more.

Sometimes Evans would wake his son up at two or three in the morning and order him to do squats, knee-bends, push-ups, or sit-ups, because he felt Kwan needed that intensity if he was ever going to play college basketball.

Eventually, Kwan became a dominant player in Paterson. As a junior in 1991, Kwan teamed with the future NBA guard James Scott to lead Eastside to the second of its back-to-back Passaic County championships. By Kwan's senior year, he was the go-to player, and Evans had him believing that he could score 30 points a game. He ended up averaging more than 28 points per game.

Still, Evans let Kwan know whenever he wasn't performing up to his, Evans's, standards. One time at Eastside, when Evans felt his son was playing below his potential, he said to him as he was about to take the ball out, "What the fuck is wrong with you? Ain't nobody out there can play you. What the fuck are you doing? Do you know I'm in this gym? Are you trying to embarrass me? Get your ass out there and play like you capable of."

Eventually, this behavior got to Kwan the same way it did his sisters. In Kwan's eyes, Evans had gone from being a coach to a dictator. So he turned his father's own attitude back on him and started shutting him out. When Kwan discovered his father was abusing drugs, their relationship suffered even more.

"When you look up to somebody like I was looking up to Milton and then you find a chink in the armor, it's hard to deal with," Kwan says.

Still, Kwan's crossover dribble, his behind-the-back move, and his dunks became so celebrated that white kids from nearby Wayne would ask him to show them how it was done. One boy in particular wanted to do everything Kwan did.

"Just go and see my father at the Y," he told boys like this. "He'll show you."

So, in groups of two and three they would come, white kids with their suburban game, to the heart of Paterson to learn the inner-city game.

"Basketball is a funny game because it depends on where you learn it," Evans says. "A lot of white kids are taught the slowdown game. Black children are taught helter-skelter speed, style, but they don't have no fundamentals." For Evans, the fundamentals include dribbling and shooting skills, awareness of the court and teammates, defensive anticipation, and a passion for the game.

He and Wiz Richardson worked on the fundamentals with the black kids, and speed and style with the white ones. When they mixed the two, "it makes them a star."

But few kids, white or black, had the staying power to commit to the regimented program Richardson and Evans believed in. Many made cameo appearances at the Y and then went back to their own courts, where the work wasn't as hard.

* * *

The summer before her freshman year, Nicole got her first look at Kwan's workouts at the Y. Kwan had let a smooth-talking agent convince him to leave the University of New Orleans for the Atlantic City Seagulls of the United States Basketball League (USBL). But when Kwan ended up sitting on the bench, angry and frustrated over the politics that he believed cost him a starting job, he left the team and came home. Word then spread that Kwan was working out at the Y, and people started coming there just to see him play.

One of Nicole's former teachers became aware that Nicole was developing an obsession for basketball. The teacher, a French-speaking woman raised in the African country of Malawi, knew that her hairdresser, Mamissa Mwenentanda, had played basketball for Zaïre at the Atlanta Games in 1996 and was working out at the Y. She asked Mwenentanda if she could bring Nicole by the shop one day.

"You like to play basketball?" 19-year-old Mwenentanda, home from Old Dominion University for the summer, asked in her West African accent. "You ever been to the YMCA?"

"No," Nicole replied.

"You wanna come?"

"Yes, but I don't have any money."

"Don't worry about it, you're with me."

That same day, around four o'clock, Nicole ventured into the Y for the first time, entering for free because Evans, who had taken Mwenentanda under his wing, was now working part-time at the front desk. The two women shot baskets in the gym, and Nicole got her first taste of the macho, testosterone-filled world she would eventually come to love.

"So you like to play basketball?" asked Evans, who keeps an oversized stopwatch around his neck even though he has no official certification to coach or train.

"I love basketball," she replied.

"Do you want to be really good, where people walk down the street and talk about you?"

"Yeah."

"Are you willing to work to get better?"

"Yeah. No matter what, I wanna get better."

Satisfied that he might have a new student, Evans told Nicole he would have to get permission from her mother. But he left Nicole with instructions: "Get on the track and do two miles." He wanted to make her as tired as possible to see if she would come back.

Nicole didn't hesitate. She walked up to the track above the court and ran two miles. Fifty laps. Then she came back and asked, "What's next?"

What's next turned out to be a whole lot of drills. Wiz Richardson, who by now was program director at the Y, worked on Nicole's physical game, while Evans "developed" her mental toughness. One day it was an hour of dribbling around and through dirty old chairs or soda cans Richardson had set up on the court (he later introduced orange cones to the drill). First right-handed while looking down at the floor, then right-handed looking up. Then left-handed both ways. Through the legs front and back. Behind the back. Crossover right. Crossover left. All the while staying low to the ground to maximize explosiveness.

The next day it was shooting drills. One hundred jump shots without a dribble. One hundred with a dribble. Then run, catch, and shoot. Then run, catch, dribble, and shoot. Then 25 foul shots. Then 50 layups right-handed, 50 left-handed, and 50 down the middle. Then knee bends and sit-ups. Then more foul shots so she could practice shooting while she was tired. As she got stronger, the dribbling and shooting drills were combined in a day's workout. Evans would never let Nicole leave the gym without taking 1,000 shots.

Richardson and Evans devoted themselves to perfecting Nicole's jab step, a move that allows her the triple threat of cutting right, or left, or shooting a jump shot, depending on the position of the defender. They taught her to throw a head and shoulder fake to set up the move. They taught Nicole to analyze the game and think ahead. "If you're a person who always reacts," Evans would say, "that means you're always a step behind." They encouraged her to anticipate her opponent's movements, to cut down passing angles, thereby making the court in effect smaller.

Throughout all of these drills, Evans would whisper in Nicole's ear, "You're mother's no good," or "You're a little nigger who can't play, "You're nothing but a girl." At the end, he would hug her and tell her he loved her.

Evans's experience had taught him that Nicole would have to play games in hostile, mostly white gyms, where it was sometimes seven against five (including the referees)—and he didn't want Nicole getting flustered.

Nicole, like Erica, Del, and Kwan before her, didn't especially like Evans's tactics, but she used them as motivation. "It either makes you stronger or it breaks you," she says of Evans's strategy. "I just opted to stay on the positive side."

Richardson and Evans also introduced Nicole to weightlifting, explaining that she needed to bulk up to compete at the higher levels. One year after Nicole first met Milton, the Y was renovated and a new state-of-the-art weight room was introduced.

Still too young to drive, Nicole had someone take her to the Y whenever possible. During the summer before her freshman year, she sometimes entered in the morning, leaving only for a slice of pizza at lunch, and then returned until 10 or 11 at night. During the basketball season, she often goes after practice, meaning that by the end of the day she has worked out in one form or another for five, six, or seven hours. As a minor, she was supposed to be out of the Y by seven at night, but because Richardson was in charge, he often allowed her to stay until well beyond that, when he or Evans would drive her home. Nicole became such a regular at the Y that no one even asked her for the five-dollar daily fee anymore. Not that she could have afforded it anyway.

Meanwhile, Evans explained that playing basketball could eventually translate into a full athletic scholarship.

"Do you realize what this basketball will do for you?" he asked one day while holding up a ball. "This basketball will give you four years of education free. But you got to work. If you don't hit the books, there's no need you coming here because it's a waste of time." If Euphemia and Andrea hadn't made the value of an education clear enough to Nicole, Evans did.

* * *

At first, Kwan didn't think much about Nicole, other than noticing that she had a decent outside shot and sure looked determined. As he went through his drills, Nicole would pester him, trying to jump in and do everything he did, including his patented crossover dribble that left opponents standing on the perimeter while he exploded to the basket.

"Hold up, show me how you did that," Nicole would ask.

Kwan would take the time to show her, figuring she'd never learn it. But then he'd come back a few days later, and here would come Nicole with the crossover. She had trouble dribbling with her left hand, but she was learning.

Pretty soon, Kwan and Nicole were teaming up, playing two-on-two against guys in the Y. He noticed that she didn't get scared or worried about having her shot blocked by bigger men. She stood tough, and together they won a lot of games.

Meanwhile, Evans, in his continuing effort to toughen Nicole, would whisper to the boys in the Y, "You can't beat Nicole. You can't beat Nicole." He wanted

her to be faced with competition whenever she walked through the doors. As her profile rose and as Evans continued to challenge boys, it wasn't uncommon for Nicole to walk down the street and hear a boy yell at her, "I'll whup your ass, Nicole."

On some occasions, she got more than she bargained for. One day during her junior year, a man in his twenties named Nick was shooting baskets in the Y when Evans and Arthur Lowery started toying with him.

"You can't beat Arthur," Evans said. "You can't beat Wiz. You're game isn't up to par. I think on a scale of one to ten, your game is zero."

"Pick somebody for me to play, pick somebody for me to play," Nick said.

Pointing to Nicole at the other end of the floor, Evans answered, "You can't even beat that girl down there."

"If she play me, I'll beat her, but she won't even play me."

"You must be crazy. That's one of my students. She ain't scared to play nobody."

As Nicole came up the court dribbling her personal ball, Evans said, "Nicole, will you play him?"

"Yeah, I'll play him," she said, thinking she could probably win.

"You're gonna have to play him because he's out to prove a point."

When the game started, Nicole faked one way and took her crossover dribble the other, leaving Nick standing outside. Then she made a layup, followed by a couple of jumpers in his face. By the time Nick realized he had taken on somebody who could really play, he was behind and it was too late. When he felt his manhood was in danger, he got frustrated and tried to push her into the wall.

"C'mon, man, what you doing?" a disbelieving Nicole asked.

"You have to cut that shit out," added Evans, who had been standing on the sideline with Lowery laughing the whole time. "Don't get mad because she's doing you. You wanna play basketball, play basketball."

"Oh, no girl can't beat me. I'll kick your ass," Nick said.

"Listen," Nicole added, "we playing basketball, we're not playing bully-ball."

When she finally beat him, she said: "I'm a girl and you're a guy. You just can't stand the fact that I beat you."

"All right, let's play for some money," he said, reaching into his pocket. "I'll bet a hundred."

"I got it," Lowery said. "She could play you. I got it covered."

Despite the offer, Lowery and Evans weren't about to let Nick play Nicole for money, because then the stakes would have been much higher and Nicole might have gotten hurt.

"When you playing for money," Nicole says, "whether it's five dollars or a hundred, you gonna be ballin' it up."

With that, the battle ended. Another guy had become a victim of Nicole Louden. Funny thing about it, Nick had tried to get her phone number a few days before. But she wasn't interested.

* * *

In September 1997, Kwan earned a tryout with the Denver Nuggets, but a severe ankle injury sidelined his dream of competing in the NBA. He returned to Paterson briefly. Since then, Kwan has pursued a career in the NBA through a variety of fringe leagues that have taken him from Wilkes Barre, Pennsylvania, to the Philippines to Tampa Bay. When he comes home, he and Evans spend time together. Once in a while, Erica or Del will come from Michigan, where they now live, to visit. Evans also fills his time with visits to his grandchildren in Passaic. But Nicole is the only basketball protégée he has left.

* * *

By the time recruiting has stepped up during Nicole's junior season, she and Milton have formed a bond of friendship in addition to their coach-athlete relationship. One of her biggest fans, he frequently attends her games at Kennedy. Sitting in the front row of the stands so he can simultaneously shout advice to Nicole and heckle the referees, he experiences that same tingle he felt when he used to watch Kwan hit a jump shot or lose somebody with a crossover dribble. He also feels Nicole's frustration at having to do most of the work at Kennedy. After games, he and Nicole often huddle courtside. Her presence brings a smile to his face, and his to hers, but he likes to tease her anyway. "Don't touch me," he will say when she attempts to hug him, trying to hide a smile, "people think I know you." Then he will launch into an analysis of the game.

"Give your best effort no matter what your teammates are doing," he tells her. "Don't let them bring you down. Don't ever let them bring you down."

Evans tries to give Nicole the benefit of all his experience. To him, she isn't just one player. She is a composite of all the people he has played with and against in Paterson over the years—Art Lowery, Wiz Richardson, the great Bosco Bell. He tries to take a little bit from each of them and give it to Nicole.

"When she plays, she has all of us in her," he says. "Nicole is the community. It's not just Nicole Louden. That's Paterson."

Chapter 9

As Nicole's junior season progresses, she continues to be flooded with FedEx and Priority Mail packages from schools. "They'll waste one of those FedEx packages just to say hello," Nicole says. Sometimes the letters and media guides are sent to her home, sometimes to school. Some continue to misspell her name "Nicole Loudon," or the city of Paterson "Patterson." Others are mailed to the attention of Meticia Watson, and still others to Nicole's guidance counselor, Alberta Rollins. Whereas Nicole once answered every questionnaire sent her way, now she is more selective. "If it's handwritten, I'll read it," she says. "If it's not, I won't."

A good recruiter knows what schools a player is interested in. If your school isn't among a kid's top five or 10 choices, why waste time and energy contacting her? Top recruiters also pride themselves on knowing who is involved in helping a player make her decision. How much influence does the high school coach have? The AAU coach? The mother, the father, the boyfriend? And any recruiter worth his or her salt keeps abreast of what is going on in a student's life. How is her team doing? What kind of year is she having? Has she suffered any injuries recently?

About the time of Nicole's seventeenth birthday, January 28, 2000, Mickie DeMoss, an assistant coach at Tennessee, considered one of the best recruiters in the nation, sends Nicole a note, a note that ends up on Nicole's bedroom wall next to the birthday card from coach Geno Auriemma of UConn. DeMoss's note reads: "Nicole, I spoke with your coach today and she says that you are having a very good year—shooting the ball really well. We are really excited about you and I'm planning on coming up there in February. Hope your ankle gets better and you are full speed before too long. We need to sign a guard from your class—you would be coming in at a great time. Hope you will think seriously about Tennessee. Would love to have you at camp this summer. Mickie."

Despite Tennessee's six national championships and the larger-than-life reputation of Coach Pat Summitt, Nicole has never been particularly enamored of Tennessee. She prefers to stay closer to home, possibly playing in the Big East Conference, which includes, among other schools, Rutgers. Not all the schools she is interested in are in that conference, but several are near home. One of them is UConn.

Playing for UConn has long been her dream, but Nicole is aware that the Huskies are loaded at her position. Sue Bird, a highly regarded point guard, will be a senior when Nicole is a freshman in college.

"I know I'm not getting a lot of playing time behind Sue Bird," Nicole says. "When I get there, she'll be a senior. I don't want to wait a whole year. That kind of sounds selfish, but that's the truth." The Huskies also have Point Guard Diana Taurasi waiting in the wings. Taurasi, just one year older than Nicole, was the star of the 1999 Nike camp.

Another possibility is Rutgers. It is nearby, only about an hour or so from Paterson, so her family could watch her anytime. The program is on the rise, as evidenced by its appearance in the NCAA Elite Eight the previous spring. Nicole likes what Rutgers point guard Tasha Pointer and a few other players have told her about Coach Vivian Stringer—that she cares for them as people as well as athletes. That all sounds pretty good to Nicole.

"I think I want a coach like that," she says. "And just about my whole life I've been coached by women, so to be coached by a man, I don't know how that would affect me."

Tasha Pointer will have graduated by the time Nicole is ready for college, but Rutgers has already fortified itself at the guard position during the early signing period in November. The Scarlet Knights signed three outstanding guards from the class of 2000: Dawn McCullouch of Long Beach, California, averaged 22.5 points during her junior year in high school. Nikki Jett of Columbia, South Carolina, was a four-time all-state player and a 1999 *Street & Smith* All-America. Mandakova Clark of Pikesville, Maryland, averaged 26.4 points as a junior. She was Nicole's teammate at Nike. Though Nicole does not say much in November, as time goes by, these signings irk her. After all, if Coach Stringer and her staff really want Nicole, the star of their summer camps, why have they gone ahead and signed these other guards?

Still another school that intrigues Nicole is Georgia, a perennial contender for the national championship. Lately its coaches have been sending packages to Nicole at home, faxing notes to Meticia Watson at school, and mailing correspondence to Nicole's guidance counselor asking for her GPA and SAT scores. By the time Nicole is ready for college, the Georgia Bulldogs will have graduated

their starting backcourt, the twins Kelly and Coco Miller. They are in the market for a point guard. One package they send Nicole includes facts about the Georgia program: "Did you know . . . That Georgia ranks seventh in the nation in athletes receiving NCAA post-graduate academic scholarships with 40? In fact, 19 of those scholarships were awarded to female athletes since 1983." It also reminded Nicole that the Bulldogs had reached the NCAA Final Four five times during Coach Andy Landers's tenure. And it included pictures of Georgia's best-known female basketball stars, Teresa Edwards, Saudia Roundtree, Katrina McLean, and Janet Harris. The attached note read, "If someone says you run like a girl, ask them which girl."

Penn State and Purdue, both topnotch programs, are two other schools Nicole likes. Penn State has had its eye on her for some time. Assistant Coach Michael Peck watched her in December 1999 at the Marist Christmas Tournament in Bayonne, New Jersey. Kennedy lost that game and Nicole emerged from the locker room with teary eyes. She scored 27 points, but had an off night shooting. That day she had spent several hours at the YMCA working on her crossover dribble with Evans and Richardson. Then, she ate only a few slices of pizza for dinner, and her stomach was slightly upset. Later, in January, Penn State's head coach, Rene Portland, took in Kennedy's game with Eastside—another loss. Coach Portland has a history with players from Paterson, having recruited the former Eastside star Vanessa Paynter, who will later return to Paterson to rejuvenate the YMCA.

Sometimes it takes only a single player on a college team for Nicole to identify with a program. That is the case with Purdue, located in West Lafayette, Indiana, the 1999 NCAA champions. Nicole likes Guard Ukari Figgs, selected the Most Outstanding Player at the 1999 Final Four before she was drafted into the WNBA.

As Nicole sorts through her feelings about these schools, she has developed a network of touchstones. One of them is Mos, who went through the recruiting process with Falisha and Lakeysha Wright a decade earlier. Once a week Nicole has dinner at Mos's house, generally with a handful of athletes and coaches Mos knows from Wayne Valley High School. These dinners are an opportunity for Nicole to get a square meal. Her favorite is lamb and broccoli, both of which she dips in ranch dressing. But the dinners also represent an opportunity for Nicole to discuss recruiting with Mos and sometimes with other former basketball players who have been through the process.

Mos knows that Nicole dreams of attending UConn, but she isn't entirely in favor of that program. She met Coach Auriemma in the early 1990s, when UConn was on the rise and he made a home visit to recruit the Wright twins. Because

they were estranged from their father and their mother had died, Auriemma met the twins at Mos's house. Mos found him arrogant. She doesn't tell Nicole that straight out, saying instead that the UConn campus is "not that great," and that Nicole should make a visit there herself.

Mos also keeps Nicole in touch with Falisha Wright, who she thinks has the best perspective. Sometimes when Wright comes back to Paterson, she joins Nicole at Mos's house for dinner. Other times, Nicole and Wright speak on the phone. Wright does not tell Nicole where to go or where not to go, but she can relate to everything Nicole is going through. She warns Nicole that there will be plenty of people trying to influence her decision in the coming months, coaches promising this and that if she attends their school. She encourages Nicole to think for herself, to choose a place that has both good academic and good athletic reputations.

Wright learned the recruiting ropes from Coach Bonora, the former Kennedy coach. Bonora and his wife, Linda, would host college coaches interested in the Wright twins, Meticia Watson, and the other Kennedy stars. A visit with Lou Bonora was a chance for a college coach to recruit two or three players at once. A veteran coach with experience in high school football, baseball, and basketball, Bonora knew what questions to ask. He knew how to protect his players. Most of all, he knew that scouts often came on like used-car salesmen.

Nicole also draws on Watson's experience. Though she was not as highly recruited as Falisha Wright, she still knows a great deal. Each day when Nicole arrives at school, she comes to the physical education offices and checks in with Watson.

"Hey, Coach," Nicole says, putting her bag of athletic gear under her coach's desk.

"What's up, Nic Dog?" Watson responds. She then updates Nicole on the lunch left her by Beverley Kovach, the gym teacher. Later in the morning, Nicole returns to the gym office to eat lunch, work on her homework, and hang out with Watson. The conversations inevitably turn to recruiting. College coaches are not permitted to contact players directly until the summer after their junior year, so they call Watson instead. They bother her at all hours, whether it is 2 A.M. on a weekday or 6:30 on a Saturday morning. They approach her at games too. At the Marist tournament, Rhonda Singleton, a Seton Hall assistant, bent Watson's ear for several minutes. The two women go way back, to the days when Singleton's team from August Martin High School in Queens traveled to Paterson, only to get routed by the Lady Knights in front of a nearly packed house at Kennedy. After Watson and Singleton caught up that evening, Singleton peppered Watson with questions about Nicole.

"What is she looking to study? Is Seton Hall one of the schools she's looking at? What kind of kid is she? Is she an easy kid to coach? What's her GPA? Did she take her SATs yet?" Watson generally doesn't have too much trouble painting a glowing portrait of her star: She is an A student involved in several extracurricular activities; a smart, personable kid: a veritable coach's dream.

This process is tiring for Watson, who has been suffering from walking pneumonia since the beginning of the season. But she understands that it is the job of the recruiters to find the best talent. "They have to go wherever to recruit, whether it's Argentina, China, or New Jersey," Watson says. "If that means you have to travel out of the country, then that's what you have to do."

Watson, like Falisha Wright, tries to teach Nicole the same valuable lessons Coach Bonora has imparted: Look at more than just a program's basketball accomplishments when choosing a school. Find out if they have the field of study you are interested in, which for Nicole is communications. Make sure you have several schools to choose from. Find out whom else they are recruiting at your position. Perhaps most important, make sure that if your basketball career ends tomorrow, the school you choose is still a good fit.

* * *

In many ways, Nicole is an inspiration to her coach. Watson still harbors dreams of making the WNBA. Having Nicole around is a constant reminder of the potential that exists for young female basketball players in this day and age. For a time, Watson trained with Nicole under Evans at the YMCA. Now she isn't afraid to ask Nicole about the new crossover dribble move she has learned.

"I'm still learning from her," Watson says. "She's a ballplayer. She has a very keen eye as to what's going on in the gym."

Despite her pneumonia, Watson tried to compete in a women's club tournament at Manhattan's Riverbank State Park in mid-January. She had been looking forward to the tournament for several weeks because she knew there would be several WNBA scouts in attendance, and she was hoping one would notice her and invite her for a tryout. She felt fine during the warmups, but no sooner did the first game begin than her lungs closed up and she couldn't breathe at all. As the game went on without her, she sat off in the corner of the gym, sipping tea, while Nicole sat next to her, comforting her.

"It's frustrating not playing," Watson said. "It's so frustrating. And after this, the next thing that's gonna be open is in April. And everybody's gonna be there. I gotta start all over. I'm not making an impression sitting on the sideline. Maybe

this is a blessing in disguise. Maybe it's better if the coaches see me at one hundred percent than seventy percent."

Watson was an extreme long shot to get noticed by a WNBA coach. She had no agent and no professional experience. And as it turned out, none of the players at that tournament ended up making WNBA rosters. Nevertheless, Watson still hopes that she can somehow break into the pro ranks. That possibility lies in front of Nicole like an endless open road.

Chapter 10

Beginning with the Clifton game on January 22, in which Nicole sprains her ankle, Kennedy finds itself in a three-game losing-streak, its record falling to 5–8 with just three games left before the cutoff date for the state playoffs. At that point any school that has won at least half of its games will qualify for the postseason tournament. Kennedy had reached the state playoffs in each of Nicole's first two years, and she doesn't think kindly about the prospect of failing to qualify this season. Things look bleak. Kennedy will have to win three straight games, including one over Ridgewood, a tough Bergen County team that has already beaten Kennedy this season.

Nicole and her teammates easily win their next game, against Passaic, to up their record to 6–8 entering the Ridgewood matchup. For that game, Nicole knows she must put on a special performance. She ends up scoring 50 points, including five 3-pointers, in a 74–71 double-overtime Kennedy victory. It is the highest point total by any girl in the state for the season and will go a long way in helping Nicole lead New Jersey in scoring for the second straight year. It is her highest single-game output since she racked up 60 against Barringer the previous year. She also grabs 18 rebounds, makes 10 steals, and hands out seven assists. Shantay Brown has a strong game as well, finishing with 16 points.

It is games like this that cause Nicole's achy right hip to act up. After the game her hip and lower back are killing her. For a little while she finds it hard to breathe. In a couple of days, the pain gets so bad that Andrea drives Nicole to a local emergency room. Doctors tell Nicole that she is suffering from back spasms. They prescribe various stretches for her, in addition to the ones she is supposed to do for her shins. Nicole ultimately accepts the back and hip pain as part of her litany of injuries. She can never tell when it will act up; but when it does, it hurts like hell.

Opposing fans and coaches don't know much about Nicole's injuries, only that she is perhaps the most spectacular high school basketball player they have

ever seen. After the Ridgewood game, about a dozen Ridgewood fans approach Nicole to congratulate her. Ridgewood's coach, Jim Ross, is one of her biggest supporters.

"I'd much rather see her score fifty against us than sixty against Barringer," he says. "She earned it. She's a great player. She's a great kid too."

The Barringer incident the year before raised a firestorm of comment around the area—and greatly influenced the way Nicole now speaks to the media. In that game, Nicole took 47 shots, a remarkably large number, making 23 of them, including nine 3-pointers, and finished with an amazing 60 points. Watson missed that game because she was attending a class to earn her teaching certificate, but she asked Nicole beforehand whether she wanted to try and break Wright's county record of 57 points in a game. Of course, Nicole said yes. Meticia was no stranger to blowouts of Barringer, which had traditionally been a poor opponent. She had once scored 25 points when Kennedy beat that school, 108–2.

A decade later, Carmela Crawford, coaching in Watson's absence, let Nicole go hog wild on poor Barringer, while Nicole laughed and the Kennedy players cheered her on.

"I wanted it so bad," Nicole later recalled with a laugh. "It was like being greedy. It's like when you have enough food on your plate, and the person next to you hardly has any, and then there's more food, and so you're gonna take that too. That's how it was for me. I mean, I felt badly for the other team. You look over to the sidelines, it's kind of sad. But I wanted it so badly."

When she was 10 points away, one Barringer player told Nicole, "You're not scoring anymore." Then she told her teammates to foul Nicole every time she touched the ball, prompting a slew of knees and elbows thrown in her direction.

"Coach, take me out the game. They trying to hurt me out here," Nicole told Crawford. As soon as Nicole hit the 60-point plateau, Crawford pulled her out

When asked about Nicole's performance that night, a Barringer assistant coach said, "It was humiliating. Our kids lost heart. It was a night to forget. I'm sure whatever it is [Nicole] was trying to achieve was important, but I don't know if it was worth the pain it gave our players. We tried to keep the animosity down, and the one girl that really wanted to go after her finally calmed down. And we were glad about that."

In the aftermath, Jim Brennan, a columnist at the *Herald News*, wrote a piece criticizing the Kennedy coaching staff entitled "Going Too Far for a Record Helps No One" in which he said: "Any high school team that intentionally preys on an ill-equipped opponent for gaudy results is sending the wrong message to its own players, the opposing players and coaches, and any fan who cares a lick

about sportsmanship. . . . The coaches hold the reins in high school sports, and in this age of 'look at me' performances and lopsided scores, the coaches [had] better learn how to tug on those reins good and hard. This is the time to prepare your students and athletes for the rest of their lives, where almost no one knows the word 'easy.'"

After Nicole's next game that season against Ridgewood, she was angry and upset over the column and refused to speak to reporters. Nicole erupted for 34 points in a game Ridgewood won 55–49. Her opponents could not say enough about her, but they also expressed empathy for her situation.

"She's unbelievable, she's probably the best player I've ever come across," one Ridgewood player said. "We geared our whole defense to her, we've been working on that all week. We've been working on double-teaming and she still just dribbles through us all. There's no way to stop her. You just have to work on the rest of the team. I feel bad that [Nicole] doesn't necessarily have the teammates that she might like to back her up," she added. "I mean, they're a great team, but it just seems like she's doing it all."

Jim Ring, the Kennedy boys' coach, later spoke with Nicole about her boycott of the media. A big, gregarious man who revels in the Kennedy tradition and works overtime caring for his players, Ring took over the Kennedy boys' team after his close friend Tyrone Collins drowned in a swimming pool in 1996 at the age of 46. Ring had kept a close eye on Nicole ever since her freshman year, when he jokingly said to her, "I'll stop coaching if you just let me be your agent ten years from now." After the Barringer incident, he had a few words with her about the press boycott.

"Nicole, one thing you cannot do is fight the press," Ring told her. "These are the people who vote for all-county and all-area nominations. These are the people who make those decisions. To turn yourself off to them, you're making a mistake." As it turned out, Nicole's decision lasted only a game or so, and she was soon speaking to reporters again.

On February 5, two days after scoring 50 against Ridgewood, Kennedy avenges its earlier loss to Clifton by knocking the Mustangs out of the first round of the county tournament. The win sets up a showdown with top-seeded Pompton Lakes the following weekend and automatically qualifies the Lady Knights for the state playoffs.

The Kennedy-Pompton game is supposed to feature a matchup between the two best players in Passaic County, and two of the best in the state. The Cardinals 6'2" senior center, Lauren Fleischer, a soft-spoken, polite girl, is the most dominating big girl in North Jersey. She is headed to Fordham on a full athletic scholarship. Like Nicole, she is closing in on 2,000 points for her career.

The Lady Knights have no one near Fleischer's height, but they beat Pompton in a preseason scrimmage, largely because Nicole so rattled the Cardinal point guard that she fouled out of the game. Many people expect the Kennedy-Pompton game, the last of the four quarterfinals scheduled for that day, to highlight a one-on-one showdown between Nicole and Lauren Fleischer. After scoring 50 points against Ridgewood, there is no telling what Nicole might do in a packed gym with county hardware on the line.

Meanwhile, two days after the Clifton game, Kennedy is set to host Eastside and Delfiah Gray in a rematch of the earlier game won by the Ghosts. Before the game, Nicole sits on the trainer's table in Laura Judge's office icing her still tender right ankle. With the game approaching, Judge prepares to give Nicole what she calls her "mack daddy football player tape job." She supports the ankle with Elastikon, a stretchy tape that helps lock the heel in place. She also adds layers of moleskin to support Nicole's ankle. As Nicole sits on the table, her mind skips over the Eastside game to the big showdown with Pompton Lakes on Saturday.

"I know if Shantay step up and play and AJ [Antoinette Johnson] step up and play against Pompton Lakes, I know we gonna win," she says. "I don't think, I know. If we get fifteen out of each of them, that'd be thirty." Nicole figures she can score 30 or 40 points herself, and that will be enough for the win.

As Nicole ponders the possibilities for Saturday's big showdown, she plays a game with herself in which she points to each of her bare toes and gives it a name corresponding to some big-time female basketball star. Laura Judge and Daeshon Moore, a friend of Nicole's from the STEM program and a rising star on the boys' team, look on somewhat bemused as Nicole counts off the digits on her left foot.

"Tasha Pointer, Shea Ralph, Sue Bird, Helen Darling, and me," she jokes. "And the whole foot is UConn." Shea Ralph and Sue Bird play for UConn, Tasha Pointer is Nicole's hero on the Rutgers team, and Helen Darling attends Penn State. When she shifts to the right foot, she names those digits as well. "Falisha, Sheryl Swoopes, Coop . . ."

All the talk of UConn prompts Nicole to discuss her long-held dream of playing for the Lady Huskies.

"Everybody in my family wants me to go to Connecticut," she says.

"Everybody in your extended family too," adds Judge, who is busy dispensing advice and medical supplies to various athletes coming in and out of her office.

"Connecticut's a lot closer," says Maria Colon, the former Kennedy assistant who has arrived for the game from Eastside, where she now teaches. "You can jump in the car and go to Connecticut. You can't jump in a car and go to Tennessee."

Nicole hardly has time to savor thoughts of attending Connecticut or Tennessee. In the Eastside game, injury strikes again. She steps on an opponent's foot, reinjures her right ankle, and has to be taken to St. Joseph's Hospital. Kennedy goes on to win the game, but the sprain is serious enough so that Nicole has to walk on crutches for several days. She will miss the big county quarterfinal against Lauren Fleischer's team. It is the only time in her high school career that an injury prevents her from playing an entire game.

"I'm disappointed but there's not much I can do," she says after visiting the hospital and realizing the extent of the injury. "Of course I want to be out there all the time, but if you can't do it, you can't do it. I have to look at the bigger picture. I don't want to make the injury worse and then be out for states."

Despite her words of reason, on the day of the county quarterfinals, Nicole is so distraught by the latest injury she doesn't even want to come to Passaic Tech, the site of the games. But she ends up accompanying her team, wearing jeans and a gray sweatshirt. When her teammates jog around the gym during a warmup lap, Nicole moves out onto the floor to take a few shots. A school official, not knowing who she is, tells her she isn't allowed on the court so close to game time. If this doesn't add insult to injury, Nicole doesn't know what will. Exasperated, she tells the woman that this is her team warming up and that she belongs on the floor as much as any of them.

In the stands, a couple of teenage boys wonder as the game gets under way if Nicole might throw on a uniform and enter the game like Superman.

"You think Louden brought her uniform in the bag," one asks the other. "If it is still close at halftime?" Then he yells in Shantay Brown's direction, "Take your uniform off and give it to Louden."

Pompton, too, lacks a star player who has been injured. Shirah Odeh, its starting point guard, turned her ankle the same day as Nicole. With both guards out of the game, Shantay Brown and Antoinette Johnson combine for 23 points and Kennedy is within four points of Pompton going into the fourth quarter. Nicole watches from the bench, urging her team on with shouts of, "Box out, box out." But it is agonizing for her. Here her team is playing a competitive game against the top-seeded team in the county without her. What if she were out there? Kennedy probably would have a good chance at the upset.

Instead, Lauren Fleischer takes over down the stretch and Pompton Lakes advances. But Pompton Lakes' Coach Olive knows he is lucky to move on.

"If Louden and Odeh were both here, I think we would have won a close game," he says. "If Louden is here and Shirah isn't here, we'd have been in trouble."

The loss means another year has gone by in which Kennedy has not excelled in the county tournament, another year in which Nicole has not put a banner up on the gym wall the way Falisha Wright and Meticia Watson did.

"I don't even want to talk about it," a frustrated Nicole says several days later. "I'm ready for this season to be over."

* * *

But the season isn't over, and things only get more bizarre. Nicole is back on the floor three days after the Pompton Lakes game for a routine victory over Barringer. Two days after that, on February 17, Kennedy is set to host the Academy of Holy Angels. One of the toughest teams in Bergen County, the Angels features Nicole's AAU teammate, a 5'5" guard named Tobi Petrocelli, and Nicole is particularly keyed up to play them.

She may be feeling lingering effects from her sprained ankle, but it is hard to tell. Nicole scores 11 of Kennedy's first 15 points as the Lady Knights take a 15–14 lead after one quarter. Once the second half begins, Nicole steps up her one-woman campaign, erupting for 17 of Kennedy's next 23 points as the Knights seize a 53–47 lead with about five minutes remaining. During that span, she hits three 3-pointers and makes several remarkable plays. On one, Nicole blocks an Angel shot on the perimeter, trails her teammate Litza Roman upcourt, and then puts Litza's miss back in for a layup.

With Kennedy seemingly on the verge of an upset of the Bergen County powerhouse, the small group of Kennedy fans, including Nicole's family, looks on with amazement at her performance. If they win, this would be the biggest win of the Lady Knights' season, and possibly of Nicole's career.

With Holy Angels up by three points, 56–53, Nicole attempts a 3-pointer from the left wing that would tie the game. A defender comes flying at Nicole from behind and the ball falls short of its target. Nicole motions to the referees that she has been fouled. Usually she gets the star treatment from referees, many of whom call her by name, but not this time. No whistle is blown.

After Watson calls a timeout, Nicole starts walking back on the floor, but the coach motions her back to the bench. This is a rare move by the coach. Often in similar circumstances, she and Carmela Crawford, the assistant coach, would tell the team to get the ball to Nicole for the last shot.

Most of the players buy into this, understanding that Nicole is undisputedly the team's most potent player. But Shantay Brown doesn't always like it. Shantay is a taciturn girl who has twice been left back in school. Her mother works as a security guard at Kennedy. By all accounts, they live in an especially bad part of

Paterson. Sometimes Shantay comes off the floor during practice saying, "She's not all that anyway."

In her more diplomatic moments, Shantay says, "You just gotta know how to work with her. You gotta know how to play with her. Once you get to know what she do, you'll learn. On fast breaks, you gotta look for her passes. [But] it depends [on] if she pass the ball. Sometimes she don't pass the ball. She'll just come down and shoot it. I got used to her now, so it really doesn't matter."

But without Nicole and her 39 points on the floor, the Angels proceed to hold the ball and run the clock out for the 56–53 victory without once getting fouled by a Kennedy defender. A foul would have stopped the clock, forced the Angels to shoot free throws, and given Kennedy possession of the ball. Instead, the game has ended in an anticlimactic fashion.

Hardly anyone knows what to make of Watson's decision. Why did she take Nicole out of the game? Why didn't she tell her team to foul to stop the clock?

Coach Watson quickly disappears into the athletic office after the game in order to call the game in to the local newspapers. Even Crawford is mystified.

"I don't know what Meticia is thinking there," she says near the Kennedy bench. "I think we probably could have either gone into overtime or possibly won the game. It's one of those things that's a misfortune for the kids because they came out and played so hard today."

Nicole is inconsolable. She wanted so badly to beat Tobi and have a quality opponent, and she can't understand what the coach was thinking. She sits on the end of the long metal bench and cries while Judge, Andrea, and Joan look on, not quite sure what to say.

"I hate this school so much," Nicole screams in between tears. "I can't believe my mother let me go here. I wasn't being disrespectful [to Watson] or rude or nothing."

As people slowly filter out of the gym, Nicole moves over to the stands opposite the team benches and sits with her family. Now she is calmer and her words are not as harsh.

"I guess I just didn't run the play the way Coach wanted or she thought I took a bad shot," she says, looking for some kind of explanation for the coach's decision. "[Once I was out] the only way I could have come back in was for us to foul, and she didn't tell them to foul so I knew I was going to stay on the bench. It's all right. Coach is doing what she feels is in the best interest of the team, so if she thinks my mind isn't focused on the game and she needs to pull me out, well, that's just her judgment. There's nothing I can do about that. I'm the player, she's the coach."

Watson seems confident that she has made the right decision, but is somewhat overwhelmed by the criticism she knows she is sure to get. She says she wanted Nicole to drive to the basket and either sink a layup or kick the ball out to Antoinette for a 3. Although Antoinette is capable of hitting such a shot, she didn't make one against the Angels, whereas Nicole made six. Still, Watson felt she was sending a message to her entire team by pulling Nicole from the game: "There's a particular play that we run, which is very effective if they run it correctly," she says. "And a lot of those shots that were being taken were forced shots, although they just happened to go in. I don't want the kids to get in the habit of taking shots they don't necessarily have to take. The last three-pointer was one of those types of shots."

Watson is in a difficult situation. On the one hand, she is trying to instill discipline and fundamentals in the younger players. She is trying to teach team basketball. On the other hand, she has this special weapon, this one player who can seemingly dominate at will, and she isn't quite sure when to let her loose and when to rein her in.

"It is definitely a game we could have won if I had kept her in," she adds. "But we need discipline. We need to run and play our game, not always depend on Nicole for everything."

* * *

While Kennedy is struggling, Eastside is thriving. Delfiah Gray is playing like a woman possessed. Unlike Nicole, she has a strong supporting cast. In the county quarterfinals she runs up against her old teammate Dakita Trapp, the star of Passaic Tech. Dakita notices that Delfiah has dramatically improved her handle since her days at Kennedy, and she has become much more confident as well. Dakita, 5'2", covered by 5'9" Delfiah, feels as if she has a "big giant" draped over her.

During the game, whenever either one takes a free throw, the two girls joke about old times, something that doesn't sit too well with Dakita's teammates.

"She was here before y'all, so y'all gotta get over it," Dakita tells them. Delfiah outduels Dakita in the battle of former Kennedy players, scoring 18 points to Dakita's 5.

"I gotta give it to her," Dakita says of Delfiah. "That's my friend and all, but she does good things against all teams."

In the semifinals, Delfiah continues to play as if her team is destined to win the championship. She scores 26 points and grabs 14 rebounds as Eastside,

seeded eleventh in the tournament, narrowly upsets second-seeded DePaul to advance to the final.

"For me, it's a first," Delfiah says excitedly after the game. "Whether it's at Eastside, Kennedy, down south, wherever, it's my first time ever going to a championship. We've made it to the counties, we've made it to the states, but we always lose in the second round. This time we're going to the championship and we're gonna win. We didn't make it this far for no reason." Eastside is playing well, but there is no question in anyone's mind that Delfiah is the primary reason the Ghosts are headed to the Passaic championship for the first time since 1985.

Nine days after Kennedy's loss to Holy Angels, on February 26, Passaic Tech hosts the Passaic County championship game. As expected, Pompton Lakes has advanced behind the dominant play of Lauren Fleischer and the steady contributions of its guards. Lauren and the Cardinals ultimately prove too strong for Eastside, ending Delfiah's dream of winning a championship. But once again, the folks at Kennedy are left to wonder: What might have happened had Delfiah been wearing the black and red of Kennedy instead of the orange and blue of Eastside?

Despite all of the trials and tribulations that Nicole, Watson, and the rest of the Kennedy crew have undergone, the team is actually playing some of its best basketball entering the state tournament. Shantay has stepped up as a reliable second option, and several other players—Litza Roman, Jennifer Esteves, and Antoinette Johnson—are contributing as well. Since their three-game losing streak almost cost them a chance at postseason play, the Lady Knights have won six of nine games as they prepare to face North Bergen in the first round of the state playoffs on February 28.

Kennedy is seeded tenth out of 10 teams in the draw, and North Bergen seventh. Oftentimes in games like this, Nicole will spend the first portion trying to get her teammates involved, sacrificing her own shot attempts so that Shantay and Antoinette can get into a groove. But once the second half begins, Nicole asserts herself. She scores 27 of Kennedy's 31 points in the second half, finishing with 39 in a 52–41 upset victory. Aside from two baskets by Shantay, Nicole has scored every one of Kennedy's points in the decisive second half. Once again, a college coach witnesses Nicole's performance. Assistant Coach Betsy Yonkman of Rutgers is in the stands for this game, evidence that the school is still actively interested in Nicole.

Nicole is used to the scouts by now. She is more concerned with the victory, which is especially satisfying because she alone can remember the loss to North Bergen two years before in which she, Dakita, and Coach Jonah fought so badly

that the team ended up losing by almost 30 points. Now, as she peels the tape off her ankle and celebrates with her family and teammates in the stands, she considers the team's latest victory in the context of that loss.

"This win is certainly special," she tells reporters. "Beating them by ten on their home court, it feels great. They played great but I think we wanted it more. We see that any given team can win on any given day. It's all about heart. You can teach defense, you can teach offense, you can teach anything you want to, but you cannot teach heart."

As Nicole walks out of the school with her mother and other family members, the Kennedy players are laughing and joking in the hallway. Suddenly, all the problems and rifts they have endured over the year are forgotten. They have just knocked off a team seeded above them in the state tournament, and in two days they will play in the state sectional quarterfinals. All seems right with the world.

"Mommy, I'm tired," Nicole says as she exits the school with her entourage of family members. "And I have homework."

Chapter 11

On the morning of Monday, February 28, Kennedy's principal, Richard Roberto, comes to Coach Ring with an anguished look on his face. He is sorry, he tells Ring, but Michael Cleaves, the Knights' all-state shooting guard, will have to miss the big state playoff game that Wednesday against Passaic. He is being suspended for three days for cutting classes.

Cleaves, 5'11", transferred two years before from Paterson Catholic and is now widely regarded as one of the best players ever to don a Kennedy uniform—if not the best. His ability to elevate over opposing defenders and throw down a dunk with a flourish has already become the stuff of legend in Paterson.

"He dunks now without even walking," Evans's friend John "Nooney" Benjamin says. "He just flies."

Ring isn't happy, but he accepts the decision. He feels that some in the school are out to punish his star player, to make an example out of him. Ring tells Michael that it would be best if he stays home on Wednesday so as to avoid commotion in the gym.

The Knights have already beaten Passaic three times during the season, including four days earlier for their third straight Passaic County championship. Kennedy is 23–1 entering the game.

Without Michael, James Lattimore, his spindly, flashy, backcourt mate and fellow all-state selection, goes on a scoring spree and finishes with a game-high 37 points, but not before fouling out of a game Passaic wins 85–71.

With under two minutes remaining in the game, all hell breaks loose in the Kennedy gym. Michael Cleaves's brother, Troy Brown, and his mother overhear Kennedy's vice principal, Robert Diaz, saying something about Michael near a gym exit. They take exception to the comment and Troy levels Vice Principal Diaz with a punch, sending him sprawling on the floor. Order is restored, but not before Diaz gets up to retaliate. A calm Troy is escorted out of the gym and ultimately arrested and charged with aggravated assault.

After the game, James Lattimore, crying because his high school career has come to an end, is called from the locker room amidst the turbulence. His girlfriend may be going into labor, and the two are whisked off in an ambulance to St. Joseph's Hospital.

"Some night," Ring tells a reporter. "The season ends. His [high school] career is over. He left everything out on the court. And now he's going to maybe have a baby." Pretty heady stuff for an 18-year-old. (James's girlfriend gave birth several days later to his second child. The first was with a different woman.)

Later, around midnight, James calls his coach and asks, "What do I do now?" Basketball has always been a haven for him, a way, by his own account, to stay off the streets and out of jail. Now, his high school career is over and he can't let go. He is still wearing his uniform when he calls.

"A lot of things have been done in that uniform by me," he says. "No one else needs to wear it."

"The season's over," Ring says. "You're emotional. Tomorrow you have to get up and go to school. Go to bed and enjoy your new pair of pajamas."

James Lattimore is a smart, thoughtful kid, but he has had a troubled life. His mother died when he was young. His best friend was killed one day when he slipped trying to climb into an apartment window at CCP. He is drawn more to the street and the praise of his dealer friends on Twelfth Avenue, than to the classroom. He has never learned how to take notes, or perform other basic skills in school. Some blame an educational system that simply has passed him on from grade to grade without much care. He spent his last two years at the Great Falls Academy, an alternative school for kids who experience difficulty in the mainstream. Several Kennedy teachers say he has always believed he would end up playing pro basketball regardless of his grades.

In the weeks following the end of the boys' season, Coach Ring makes arrangements for both James and Michael to receive scholarships to Notre Dame Prep, a private coed school located in Fitchburg, Massachusetts. Despite skipping classes prior to the state playoffs, Michael remains on schedule to graduate from Kennedy in June. For him, the idea behind going to a prep school is to gain exposure to college coaches and ultimately join a Division I program. For James, the plan is to earn a high school degree, and then possibly move on to a junior college or maybe a four-year institution. Still, some junior college coaches advise Ring that maybe James should earn a Graduate Equivalency Degree (GED) instead of pursuing his course work. That way, they figure in their cynical analysis, he will be immediately eligible to play in junior college. But James opts for the prep school.

"As far as schools go, it is either there or nowhere," he tells a reporter. "This is my last chance, and I want to leave [Paterson], but I don't want to leave. Then, I think about it, and I want to leave again."

On March 25, the day before Coach Ring is to drive Michael and James to the train station for their trip to Notre Dame Prep, both players are scheduled to compete in New Jersey's North-South All-Star Classic, an exhibition that features the best players in the state and allows participants to display their skills one more time for college scouts. Michael puts on a show at the game, scoring a game-high 28 points to win Most Valuable Player honors and winning the slam-dunk championship during halftime with a dunk so vicious he hurts his elbow on the descent. James, meanwhile, never shows up for the game. Instead, he stays home, saying that he didn't have a ride to the team's practices and didn't want to sit the bench during the game as a result of missing practice. Ring is shocked.

"Right now, I think James has lost his focus, because if he was focused he would've been here," Ring says. "He missed a ride, he missed a ride, but how bad do you want to be here then? As a high school kid, I'd break my legs to get down here. Seventeen-year olds will be seventeen-year-olds. Maybe whatever it was James had to do was more important than playing here. For his sake, I hope that James can handle the challenge that's now in store for him. It's not a basketball challenge, it's an academic challenge. And hopefully he'll take advantage of the opportunity that's gonna be given to him up at Notre Dame Prep."

Both players make the trip to the prep school, but only Michael lasts. He remains on track to finish his time there. Lattimore lasts less than a week before returning to Paterson. He says he felt "caged in" in Fitchburg.

"If there's anyone I worry about it's James," Ring tells a reporter. "The gravitational pull of the street can be very strong, especially for him. I've seen stronger kids get pulled in. You have to get out of where you are, you have to get out of Paterson."

Nicole finds it difficult to sympathize with James. She thinks he is a tremendously talented basketball player who simply can't get his act together and is wasting his God-given talents. She knows from firsthand experience that athletes at Kennedy can get away with more than the average student because they know the security guards and are popular. She often saw Michael and James wandering the halls when they should have been in class. But on the night of the boys' loss to Passaic in the state tournament, her thoughts are about as far away from Michael and James as possible.

* * *

While the boys are losing in dramatic fashion in Paterson, the girls are playing perhaps the best game of their season in Kearny against the second-seeded team in their section. Shantay has scored 14 points and Nicole 28 when the game is tied at 53–53 midway through the final period.

The Kearny gym is small and constructed in such a way that the stands are right next to the basketball court. On this day, the gym is rocking in support of the home team. After Kearny's best player, Vanessa DeFreitas, misses a 3-pointer, Nicole dribbles downcourt, thinking to herself, "The game is zero–zero. You know you have to go down there and capitalize on this opportunity."

She makes a stutter step move to lose her defender and then calmly hits a pull-up jumper at the top of the key to give Kennedy back the lead at 55–53. After another Kearny miss, Nicole grabs the rebound, gets fouled, and drains two foul shots to make it 57–53. With less than two minutes remaining, she fires a full-court pass to Litza for a layup that extends the lead to a virtually insurmountable 59–53. When Kennedy wins 62–58, Nicole extends her right hand into the air and holds up her index finger to signify that the Lady Knights are No. 1. They aren't there yet, but back when the team was 5–8 and struggling to qualify for the playoffs, no one could have predicted such a finish to their season.

Nicole has racked up 33 points, 19 rebounds, and seven assists. Shantay has scored 16 points, one of her best games of the season.

Shantay, like Nicole, wants to add a banner to the gym wall and she senses that the team is very close now. One more victory and Kennedy will play in the state sectional championship.

"We want [a banner] too," Shantay says after the game. "When I have gym ninth period, I think about how I want one so I could have something in the future to tell my kids or my friends that [in the year] 2000, I was playing in the state championship [and] we won it."

Nicole, who sees the states as the team's last chance to make a significant statement, feels redeemed now that the team is coming together.

"I think our team just needed a lot of confidence," Nicole says. "I think when we won that double-overtime game against Ridgewood, that gave us a lot of confidence. That's when our team started stepping up. They all know that this is do-or-die, so we might as well just lay it all on the floor, bring our A game and try our best."

But now that Kennedy will face Ridgewood for a third time this season in the sectional semifinal, something else is bothering Nicole.

She has begun to feel acute pain in her left knee and it is becoming more and more difficult to play without suffering. It feels like a creaky car door that needs to be oiled. Nicole believes one of Kennedy's assistant coaches aggravated

the problem recently when he teased her by repeatedly pounding his fist on her knee despite her protestations. Doctors will eventually diagnose it as patella tendinitis (inflammation of the tendon in the knee), yet another injury on Nicole's long list.

Nicole's knee injury isn't the problem in the third meeting with Ridgewood, though. Ridgewood's size is. The Lady Knights simply don't have anyone who can match up against the three six-footers in the Maroons' frontcourt. Nicole has a strong game in which she accumulates 33 points and 10 rebounds; Antoinette adds 14 points, but Ridgewood prevails.

Still, Coach Watson is extremely proud of the effort. "A lot of people counted us out, and we proved those people wrong," she says. "I'm happy, I'm very happy."

* * *

Watson knows something none of her players does. She is pleased because she knows she will be leaving Kennedy on a positive note. Unbeknownst to the team, Watson submitted her resignation about two weeks before the end of the season. About two weeks after the season-ending loss to Ridgewood, she makes it public. Her resignation means that Kennedy will have to hire its third coach during Nicole's career.

Watson cites several reasons for her decision. She says she feels she hasn't gotten enough support from the administration, which, she adds, favors the boys' team over the girls'.

"We didn't get any respect when we were doing well," she says. "That's a little bit frustrating. You would think after all these years. Then to get smacked in the face with disrespect is very hard to deal with." She says she enjoyed support from some fellow teachers and administrators, but didn't get the full commitment she was looking for.

She also feels she hasn't gotten the commitment from the team that she wanted. She is tired of dealing with the petty jealousies she feels the girls sometimes bring to practice.

"I think guys wanna win," she says. "The competitive nature of being a guy is they don't wanna lose, especially teenagers. There's this whole image thing with the guys. They wanna win, they wanna be the best. They wanna score the most points. Coaching girls is different. More attitudes you have to deal with. If they have a fight with their boyfriend, the whole practice is blown. I think the family is more involved. Maybe they have to go home and babysit or cook dinner. I find that coaching girls, you can't really scream at them. If you scream at them,

they get an attitude or they roll their eyes. There is a lot of that on the team. You could scream at Nicole, Nicole's a different player. She works out with guys, she plays against the guys. I think that kind of helps with her mentality of the game."

Watson also wants more time to devote to her own basketball career, which she feels had taken a hit after her illness.

"I think it's realistic that I'll be playing this summer," she says. "I'll be playing whether it's professional or semiprofessional. Rome wasn't built in one year. And if I never get picked up, then I never get picked up, but that exposure is what I need."

By June, Kennedy announces the hiring of Lou Bonora, the renowned coach who led Meticia Watson and Falisha Wright during their glory years. Over the past couple of years, he has gotten the itch to coach again. His daughter Lauren has been keeping the clock for the Jefferson High freshman boys' team, and when he took her to the games he began to miss the sights and sounds of the gym. Periodically during the season, he has come and watched Nicole and her teammates play.

"I'm thrilled," Bonora says when hired. "I love coaching basketball and working with the kids. I'm looking forward to it. It's the shot in the arm I need."

Nicole doesn't know anything about Coach Bonora, other than that he coached Wright and Watson and put all those banners up on the gym wall. What she does know is that she will now be playing under her third coach in four years. The more things change at Kennedy, the more they seem to stay the same.

"You tell me," she says, "three coaches in four years, does that sound like a good situation to you?"

* * *

Once the high school season ends, Nicole can really use a month off to rest her aching body. Her ankle is feeling better, but with two sprains she still needs a brace to protect it. The tendinitis in her left knee continues to bother her, and it isn't likely to subside given her hectic schedule over the next several months. Several of Nicole's advisers, including Mos, Coach Watson, and Evans, suggest she take time off.

The Monarchs, Nicole's AAU team, begin practicing in late March and compete in several tournaments throughout April and May. In mid-May they win the New Jersey state AAU championship in the 16-and-under age group.

Tobi Petrocelli, Nicole's friend from Holy Angels, and the majority of the Monarchs get a three-week break after the state competitions, but not Nicole.

She has been invited to try out for the U.S. Junior National Team in Colorado Springs, Colorado, in mid-June. If she is one of 12 girls selected, Nicole will compete in the Junior World Championship Qualification Tournament later in the summer in Argentina. Geno Auriemma, the University of Connecticut coach, will lead that team, providing any girls who qualifiy instant access to one of the highest-profile coaches in the land. From Colorado, Nicole will return home for a day before flying to France to compete with the Philadelphia Liberty Belles, a highly regarded Amateur Athletic Union team run by Mike Flynn, the recruiting expert. The tournament will feature teams from France, Poland, Byelorussia, Hungary, Slovakia, and the Czech Republic. After that event will come AAU Nationals in Tennessee, the Nike camp, and the U.S. Junior Nationals. Nicole's play during the summer months will be critical in determining how highly she is ranked among guards in her class, and ultimately which schools pursue her.

On the eve of her trip to Colorado, she pays a visit to Kesha to have her hair done. Nicole never goes to any important event without visiting her cousin the hair stylist.

On this night, she sits in a chair in the living room facing the computer and checking her various e-mail accounts while Kesha stands behind her patiently braiding her hair into a zigzag pattern. Nicole has known about these trips for several months, and now that she is on the brink of going, she can't wait to face the competition.

"In the past three years so much has happened," she says, a look of wonderment sweeping across her face. "I went from playing girls in the neighborhood to girls in the county to girls in the state to girls across the country to girls across the world. In three years."

Despite her injuries, Nicole isn't concerned about how she might perform. After a Kennedy season in which she rarely competed against players near her level, she is eager to test herself against the best.

"If you take care of your body, I don't think it's too much," she says of her busy summer schedule. "When I get to college, it's gonna be the same rigorous workout day after day. You can't say you're tired, you have to keep on going. I know what I can do. I think I can run up against any guard in the country. I'll see how I do in France, but as far as nationally, I think I can compete."

* * *

Neither the Colorado nor France trip turns out to be quite what Nicole hoped. She had her moments at the Junior National Team tryouts—like when

Auriemma congratulated her on a defensive sequence in which she made her opponent turn the ball over—but she was not among the players selected. At times, she believes, she tried too hard to impress the selection committee, which included Teresa Edwards, a hero in the women's game who would later this year be competing for a record fifth time at the Olympics, in Sydney. At others, she thinks, she was too nonchalant and didn't play the way she was capable of. Her old friend Cappie Pondexter is among several guards picked. Nicole's roommate Laurie Koehn, a 5'8" guard from Moundridge, Kansas, is also chosen, as is Loree Moore, a highly ranked 5'10" point guard from Harbor City, California.

Still, Nicole doesn't seem overly upset by her failure to make the team. "You learn from situations like these," she says. "I didn't go there with high expectations."

The trip to France is another adventure. Other than vacations to Jamaica and to Canada to visit relatives, Nicole has never been outside of the United States. But since Flynn's organization has offered to pay for the transportation, she and Mos both figure it will be a great opportunity. They are also aware that Flynn is an extremely influential person within the world of women's basketball. If he likes a player, he can recommend her for *Street & Smith*'s All-America team.

Flynn has developed a reputation for being extremely knowledgeable about girls' basketball, but also fairly unorganized. He has seemingly left many of the details of the trip to the last moment and allowed the girls great freedom for parts of the trip.

For someone like Nicole, who craves order and structure, it is not a good match. Nicole, Andrea, and Mos didn't figure on Nicole's having to stay with a host family in the city of Reze who don't speak much English. Flynn didn't tell the girls' parents beforehand that they would be staying with host families, and Nicole and her teammate Seimone Augustus are petrified that the family might be killers or the father a child molester. The 6'1" Seimone, from Baton Rouge, Louisiana, made national news the year before when, as a 14-year-old, she appeared on the cover of *Sports Illustrated for Women* under the headline THE NEXT MICHAEL. Of course Nicole and Seimone's fears about their host family are silly, but Nicole still has trouble getting used to French food. She dines on a steady diet of bread and pasta.

"That's the only thing I liked," she says. "That's the only thing that tasted good, American."

She isn't thrilled with the situation on the basketball court either. Nicole has to compete for playing time with Cherisse Graham, a highly rated point guard from the class of 2000 who has already committed to Purdue. Flynn believed that Graham was physical and talented enough to jump directly from high

school to the WNBA if the rules allowed. Nicole only plays a few minutes in most of the games and is especially upset because she knows the Monarchs are competing in a tournament in Albany, which she considers the best of the AAU season. Needless to say, Nicole doesn't deem the France trip a success. She thinks the best thing about it was seeing the Eiffel Tower.

Part 3

*Summer 2000:
Recruitment*

Chapter 12

Less than 24 hours after returning from her hectic trip to France, Nicole's phone starts ringing as if it were Super Bowl Sunday at the local Domino's. Beginning on June 21, college basketball coaches are permitted to call rising seniors once a week between Sunday and Saturday. Recruits may call coaches as often as they like.

That day, a Wednesday, Jolette Law, Rutgers's chief recruiter, telephones Nicole to touch base and express interest. It is Law's first phone call of the recruiting period. The previous March, Rutgers advanced to the Final Four of the NCAA Championship, falling to Tennessee 64–54. Coach Vivian Stringer of Rutgers became the first coach, men's or women's, to lead three schools to the national semifinals (the other two were Cheyney State and Iowa). Two players from that team, Shawnetta Stewart and Usha Gilmore, were then selected in April's WNBA draft, joining the former Rutgers star Sue Wicks as Scarlet Knight alums in the pros.

Now Stringer is casting about for players who can help her club get past Tennessee and Connecticut. In the final, the Connecticut Huskies had beaten the Tennessee Volunteers to win their second national championship since 1995. After Law speaks with Nicole for a few minutes, she puts Coach Stringer on the phone for the hard sell.

Nicole, aware that Rutgers already signed three guards the previous year, expresses concern about the logjam at her position. Nicole also has reservations about having to compete for playing time with Cappie Pondexter, whom Rutgers is actively recruiting, and who is a former high school teammate of the Rutgers freshman Kourtney Walton; many coaches consider it a foregone conclusion that Cappie will sign with Rutgers. Law and Stringer envision the 5'9" Cappie as a shooting guard, not a point guard. They know that in order to compete

with the taller athletic guards featured by teams like UConn and Tennessee, they need big guards who can post up as well as score from outside. Stringer has heard that Nicole also wants to be a two guard in college, but Nicole tells her this isn't the case. She wants to play the point.

"You know you've been my point guard from day one," Stringer tells Nicole. "If you say right now that you want to come to Rutgers, we have a scholarship for you, no questions asked."

Nicole has dreamed of playing at New Jersey's state university for several years, and that comment takes her aback. After almost an hour on the phone, Nicole has to leave to meet a friend. She isn't prepared to commit yet. She wants to see what other options are open to her. As badly as she wants to play near home in the Big East Conference, in front of friends and family, she also wants to go someplace where she is needed.

Coaches from Penn State, Michigan State, Pittsburgh, and the University of Nevada Las Vegas also call on Wednesday. Other than Rutgers, Nicole is seriously considering only Penn State. Perennial contenders for the national championship, the Lady Lions had advanced to the Final Four the previous spring, falling to UConn. The flood of telephone calls is ongoing the following day, despite the fact that Andrea has recently gotten a new phone number. She had disconnected her old one because Nicole had run up the long-distance bill talking to friends she has made on the basketball circuit.

The new service limits long-distance calling, but it also has the unintended effect of preventing some coaches from reaching Nicole. Her old number is listed in the Nike camp handbook, and some coaches have been sent scrambling for the new one.

The next day, Coach Jim Lewis of Fordham calls and wakes up Andrea, who sleeps in the daytime after working her graveyard shift. Groggy and dressed in one of her T-shirt nightgowns, Andrea slowly releases the phone cord from her upstairs bedroom so that Nicole can catch the phone at the bottom of the stairs. Andrea tells her daughter to move the phone away from her bedroom so that she can get some rest. Sometimes Nicole's celebrity takes its toll on Andrea. Once, when she took her daughter downtown for a dentist appointment, she ended up waiting an hour because Nicole was surrounded by fans curious as to why she wasn't in school. "I tell her I will never go downtown with her again," Andrea said in a moment of exasperation. Now, all she knows about the recruiting process is that it is interrupting her sleep.

Nicole isn't seriously considering Fordham, but Lewis coached Meticia Wastson at George Mason and he wants Nicole to come for a visit.

"I'll speak to Coach Watson and hear what she has to say," Nicole tells him, trying to be polite. "I don't think it should be a problem, it's just a matter of a ride."

Depending on her level of interest, Nicole tells college coaches different things. She goes so far as to tell some, like those from Michigan State and Southern California, that she can't really envision herself at their schools. Some of these coaches appreciate her honesty; at least now they know not to waste their energy. In other cases, such as the University of Pittsburgh, she enjoys speaking to the coaches and keeps the window open, though she doubts she will go there. She likes those coaches because of the honest way they communicate with her. For example, Pittsburgh's coach, Traci Waites, tells Nicole that even if she doesn't choose Pitt, she should feel free to call her if she ever needs someone to talk to.

"I really liked that," Nicole says. "When I go to college I would like to have a relationship like that with my coach."

Other coaches don't charm Nicole as much. "Make sure you're by the phone on June 21," Kristy Curry of Purdue wrote. In Cherisse Graham, Nicole's teammate from the France trip, and Erika Valek, Purdue already had two point guards from the class of 2000. Whether that was why Curry never called, Nicole doesn't know. But she never did.

* * *

The recruiting, coming on top of the trips, is making Nicole's life hectic. At times, it seems as if her entire summer and fall will be consumed by the recruiting process, making it difficult to enjoy her senior year of high school. Sometimes she cannot resist the temptation to look ahead to college and imagine what her new teammates and coach will be like. Lord knows, her time at Kennedy has been full of disappointments.

"It's tough, it's stressful," she says of the recruiting process. "But at some point or another you try to push it all back into your mind and just go out there and have fun, whether it's playing basketball or hanging out with your friends or whatever." The Monarchs are scheduled to practice this evening, a Thursday, for an upcoming tournament, but Nicole needs time off. So Mos told her it was okay to skip it.

Nicole is carefully considering all of the schools courting her, trying to come up with the right choice, taking into account a number of factors.

They're asking me what I'm looking for in a school, and I said I'm looking for a good academic institution, looking at the team's graduation rate, she says

one day over lemonade and a meat-loaf sandwich at a Boston Market near her home. I just told them that I'm still wide open, I haven't made any choices. I don't even have a top five.

"By September I should have a top five, and I'll start taking my visits. In October, after I visit, I should definitely have two or three schools in mind. And in November, I'll make a decision."

Chapter 13

Nicole and her friend Tara Walker are sleeping in their hotel room after the second day of the 16-and-under AAU National Championships in Chattanooga, Tennessee, when the phone rings. It is four in the morning, and Nicole answers. It's her mother, calling to tell her that her grandfather has died.

Kenneth Richman has been in the hospital suffering from diabetes for several months, so his death is not unexpected. But it hits Nicole hard. Euphemia's husband has lived in the same house as Nicole for much of her life, and though he has been ill for several years, he is one of the few men permanently around. She cried the last time she saw him. The doctors had amputated one of his legs because the disease was eating away at his body, but Nicole wasn't prepared for that. He was so skinny and weak Nicole thought he looked like someone from Ethiopia. Nicole didn't like hospitals to begin with, and that experience scared her even more.

When the phone call comes, Tara is scared to leave Nicole alone but she trudges downstairs to tell Coach Fu the news. Mos hears the commotion from her own room and walks down the hall to see what is going on. The rest of the night she comforts Nicole, who is unsure whether to stay at the tournament or return home. Mos shares with Nicole the story of how she was at an AAU tournament in Texas when her aunt died, and how she felt terribly guilty as a result. A Catholic with strong faith, Mos also tells Nicole that the hurt she is experiencing is really pity for herself and a sadness that her grandfather is gone. The truth, Mos believes, is that Kenneth has gone to a better place.

Euphemia wants Nicole home in time for the funeral, but has told her granddaughter to stay at the tournament and finish what she started. Ultimately, Mos advises Nicole, the decision to stay or go is up to her. Nicole feels as if she and her team have worked too hard for her to go home now. She isn't sure when the funeral will be, but she decides to stay. She manages to remain focused enough to run the offense and average about 20 points per game. But it is clear

that both she and the Monarchs are affected by Kenneth's death; the team is not at its best.

Coach Waites from Pittsburgh consoles Nicole at the tournament and sends Andrea a letter expressing her sympathy. "Ms. Richman and Family: My staff and I would like to take the opportunity to extend our condolences to you and your family with the loss of your father and grandfather. We have seen Nicole and she seems to be keeping her spirits up and staying strong. Our thoughts and prayers are with you and your family at this very difficult time. With deepest sympathy, Traci Waites." So touched by the letter are Nicole and Andrea that they tape it to a door in their hallway.

Nicole returns to Paterson in time for the funeral the following Saturday. Euphemia has lost her best friend, but she tries to be strong nonetheless. For three months, Kenneth had been unable to speak much to his wife, but on the Friday before he died he told Euphemia that their son Daniel, who had been shot to death years earlier, had visited him and told him everything would be all right. Kenneth also told Euphemia that he didn't want anyone crying at the funeral. When their son Joshua does cry, Euphemia makes him step outside because she doesn't want anyone else joining him.

About 30 family members, including some who have come from Canada, attend the open-casket funeral. It is painful, but Joan videotapes the event, just as she does all the others involving her family. She works part-time at a print shop and has arranged for an eight-page booklet to be made for the occasion. On the front, under the words IN LOVING MEMORY, is a picture of Kenneth. Below that it reads, SUNRISE: SEPTEMBER 4, 1931, and SUNSET: JULY 9, 2000. The pamphlet gives a brief history of Kenneth's life; he is survived by his wife, five daughters, two sons, twenty-five grandchildren, eight great-grandchildren, three brothers, five sisters, three sisters-in-law, and seven brothers-in-law.

In a light rain at the Laurel Grove Cemetery in Totowa, members of the Richman clan shovel dirt onto the casket as it lies in the ground. Nicole, wearing a black dress, takes her turn.

When they leave the cemetery, Euphemia and her clan go to Paterson's Bragg Funeral Home, and then to the Jesus Christ Church of Apostolic on Haledon Avenue. The church has been Euphemia's second home ever since she came to Paterson. Every Sunday, a predominantly Jamaican group of worshipers comes to pray, share its faith, and listen to music. Every Thursday night, Euphemia attends her missionary meetings, where sometimes a dozen or so older women (only a few men attend) listen to lectures on topics like "Conquering Self, Our Greatest Enemy." As a missionary, she visits sick people in hospitals and nursing homes "preaching the Word to the people." She also attends members' meetings

on the weekends in which the group deals with church business. Now Euphemia retreats there once again to pay her last respects.

Before those assembled, Nicole and Kesha read a poem entitled "Our Grandfather." They alternate the first two verses and then share the reading of the third.

> Our Grandfather who we hold most dear
> Will never truly leave us;
> We lived on the kindness he showed
> And the love he brought into our lives
> Although you are out of our sight and touch
> You are never out of our memories and hearts.
> He shared our troubles
> And helped us along
> You sang to us Bible songs
> That kept us from doing wrongs.
> On Earth you toiled
> In heaven you rest
> Unselfish and true
> The kindest and the best.

> You always sat all us Grandkids around the table and fed us well,
> While we listen to your jokes and stories you always tell
> Then after awhile we asked what's that smell.
> Then you laugh
> Oh dadda we know you so well.
> Grandad how can any of us ever forget you
> When you were always the reason of our do
> We sat with you and talked with you,
> Told stories of other people lives that's true
> Grandad without you what are we gonna do
> But we will try to stay strong just for you.
> You're gone now Grandad so sleep well and rest
> But always remember you are the best.

> **WE LOVE YOU DADDA**

Euphemia eventually makes a small photo album commemorating the day. Pictures show the entire family dressed regally in black. On the first page of the album, Nicole's grandmother places a copy of a prayer from St. Francis:

Lord, make me an instrument of your peace
Where there is hatred . . . let me sow peace
Where there is injury . . . pardon.
Where there is doubt . . . faith.
Where there is darkness . . . light.
Where there is sadness . . . joy.
O Divine Master, grant that I may not so much speak
To be consoled . . . as to console.
To be understood . . . as to understand.
To be loved . . . as to love, for
It is in giving . . . that we receive.
It is in pardoning . . . that we are pardoned.
It is in dying . . . that we are born to eternal life.

After the readings, the family feasts on curried chicken, curried goat, fried fish, coffee, and tea. Nicole is ambivalent about leaving to go to Nike camp. She isn't sure whether she should skip the crown jewel in the summer recruiting circuit. She has worked for years to get a scholarship, and she knows that every college coach in the nation will again be in Indianapolis. This year they will be scrutinizing her more closely than ever before. She feels awkward about leaving her family during this difficult time, especially her grandmother. But Euphemia believes in finishing what you start. She knows that basketball is important to Nicole and that she has made a commitment to attend the camp.

"You don't cry, because I want you to be strong," Euphemia tells Nicole. "Just try to be strong and make a positive out of a negative. Go out there and play." It is difficult, but Nicole gets on a plane and heads to Indianapolis.

Chapter 14

The scouts and recruiting gurus debate the talent level at the 2000 Nike All-America Basketball Camp. Several top girls—including Cappie Pondexter, Kara Braxton, Laurie Moore, and T'Nae Thiel—are absent, competing for Coach Auriemma on the U.S. Junior National team. Others are showcasing their talents at the inaugural Adidas Top Ten Camp in Pittsburgh. Still others are playing in the under-17 AAU Nationals in Tennessee.

Nicole was invited to the Adidas camp, but there was no way she was going to miss Nike for that. "It's the same time as Nike camp, and I'm not giving up that," she said. "I like Nike."

Because the Adidas camp is going on at the same time, some head coaches choose to split their staffs, sending one or more assistants to Pittsburgh while they watch the action in Indianapolis. Later, some coaches will argue that there was superior talent at Adidas, but the general consensus appears to be that Nike remains the top draw.

"They probably have seventy-six of the top eighty kids here," says Dave Krider, a sports reporter at *All-Stater Sports* magazine. "That's still pretty great." Twenty-one of the players later named to the Top 25 in the nation by *USA Today* commit to Nike; of them, 17 are in attendance at the camp. Nicole is not listed among the Top 25.

This year's Nike contingent includes four players from the Garden State: Nicole; Tara Walker, Nicole's friend and AAU roommate; Kelley Suminski of Mendham High; and Jessica Simmonds of Columbia High. Among the other girls being analyzed, examined, and measured from every possible angle are Shawntinice Polk, a 6'4", 270-pound player, and Sade Wiley-Gatewood, a 5'7" freshman guard with pigtails who compares herself to the two-time WNBA Most Valuable Player Cynthia Cooper.

As a sophomore at the first Nike camp, Nicole was relatively unknown. But the invitation to Nike in 1999 gave her a national name; at the same time, all the

coaches knew she had a year to mature and develop her game. Though the coaches eyed her for a possible scholarship, they didn't have to make any immediate decisions.

On the eve of her second Nike camp, Nicole is in shaky emotional and physical condition. She has just buried her grandfather and feels badly about having to leave her family while she plays basketball. The tendinitis in her knee nags. She also struggles with persistent shin splints and a tight quadriceps muscle that feels as if it might pop. She has been playing ball virtually nonstop since the previous November, but hasn't been able to work out recently because of her injuries. She carries a few extra pounds. Her upper body is bigger from weightlifting, but she is up to about 155 pounds, five to 10 more than her ideal playing weight.

This time Nicole is more comfortable with the competition and the surroundings. Nike spells her name correctly in the handbook, and, in an odd coincidence, she is given her favorite No. 11 jersey instead of the No. 72 she wore as a sophomore. More important, she believes her ball-handling and floor awareness, perhaps the two most critical elements of a point guard's game, have improved. Nicole has evolved into a much more vocal floor leader, at least in part because she has become accustomed to directing her inexperienced Kennedy teammates around the floor.

Before any basketball is to be played, Nicole and the rest of the Nike All-Americas have three hours of classes to attend. Nike maintains that the classes are based on life skills for leaders. Because these players are leaders in their own communities, the classes are intended to develop those leadershp skills. On July 16, 2000, a hot summer Sunday, Nicole and the other girls wear Nike shorts, T-shirts, and sandals into the morning's activities.

Among Nicole's first stops is a class about understanding DWI, driving while intoxicated. At the front of the classroom stands Detective Mitchell Davis, who announces to the small group of girls that he had been a narcotics detective from Chicago's South Side. He tells them that during his career he had done it all, from undercover drug buys to working with SWAT teams. He once busted someone in possession of 100 pounds of marijuana and half a kilogram of cocaine.

Davis explains what a blood alcohol content (BAC) is and what it takes to impair one's ability to drive. He then has several of the girls put on "fatal vision goggles" and attempt to walk a straight line while saying the alphabet and touching their nose. Wearing the goggles is the equivalent of having six beers in an hour, a BAC of .15.

Nicole is feeling pretty loose and free throughout the class, laughing and joking with the other girls. While her classmates—some of the best high school

athletes in the country—bumble and stumble in their attempts to walk the line with the goggles on, Nicole navigates the stretch more or less undisturbed.

As she hands the glasses back to Davis and heads for her seat, she delights in saying, "No, I do not drink, people," which draws laughs from her classmates.

With that class completed, the girls then shift to one entitled "Values Clarification." The instructor, Valeria Davis, first asks the girls to stand up in the middle of the room and pick two adjectives they feel best describe them. There is just one catch: the first letters of those adjectives have to correspond to the initials of their names. As the girls move around in a circle touting their various qualities, Nicole announces with a smile, "I'm Nicole Louden. I'm nice and I look good."

On the four walls of the room are handwritten signs that read, NOT TRUE, SOMETIMES TRUE, VERY TRUE, and NOT SURE. For the next activity, Davis reads a statement and the girls are supposed to stand under the sign they feel best corresponds with their beliefs. When Davis reads the statement "I'd rather have good friends than a lot of money," everyone in the group shifts over to the VERY TRUE sign without thinking twice. Everyone, that is, except Nicole. She alone has moved near the sign reading NOT TRUE. Davis asks Nicole to explain why she has made this choice. "I stand alone," she says with a big smile, as if enjoying her continued ability to be different. "Guess I'm money-hungry, huh?"

Whether "money-hungry" is the best description for it is unclear. What is clear is that Nicole probably has very different ideas about both friendship and money than many of these girls. She does not buy into the notion that friends are more important than money, at least partly because she doesn't see the need for a lot of friends. She has a supportive family—siblings, cousins, aunts, and uncles—all of whom make friends almost superfluous. Euphemia Richman has always encouraged a tight-knit family, one that doesn't rely too much on outsiders. Nicole has two good friends, Justine and Sakina, and doesn't feel the need to cast about for any more. "Friends are not something that I need," she has said several times.

Nicole also has a different standard of living than most of these other players, some of whom are suburban girls who probably didn't grown up wanting for basic necessities like food and clothing like Nicole at times. Her mother used to give her $80 a month in allowance when she had a "better job or less bills or something," Nicole recalls later on. "Now I get no money, I'm broke. But what am I gonna do, say don't pay your bills?" Later, when analyzing the question even more, Nicole asks: "What's the use of having a whole lot of friends if you're broke as hell? I just wanna be well off where I'm living comfortable."

Precisely because she has never had very much of it, money has become very important to Nicole. She is arguably hungrier for a college scholarship worth about $100,000 than many of these other girls. Some of them would no doubt find their way to college even without one. But for Nicole, a scholarship is the only way she can avoid strapping herself with massive loans. She has always felt that an academic scholarship was within reach, but in the past few years she realized that she could get an athletic one without having to make her mother struggle. Her play here, and in other summer tournaments, is absolutely critical to obtaining a scholarship. She would leave it up to others to say that friendship is a higher priority than money.

All in all, Nicole enjoys these classes. They are certainly more enjoyable than the ones she takes at Kennedy. "Classes are cool," she says. "Nike camp is not only for basketball, but also for life lessons in terms of what you wanna do. You can only play basketball for so long before you go on and do something else with your life. And that's basically what they're teaching. Communication is key, listening skills and things of that nature."

* * *

Nike issues 92 media passes for the four-day event, and any reporter who wants to interview a player has to fill out a form in advance. At lunchtime the players are shepherded from the players-only cafeteria into an interview area decorated like a locker room. The athletes sit on wooden benches in front of oversized lockers designed to look like those the professionals use.

On the first day of camp, before she has even played her first game, several reporters want to interview Nicole. Wendy Parker from the *Atlanta Journal Constitution* is on hand because she knows Georgia is interested in Nicole. A reporter from Purdue University is also present. The first question Nicole fields is about her health. How is her body feeling?

"I'm feeling pretty good," she says. "Not quite rested, but good enough to play. I'm just gonna go out there and give one hundred and ten percent and just leave it all on the floor and see what happens. I think [the summer] put a wear and tear on my body going nonstop. Since early June until nationals in Tennessee, it really put a wear and tear on my body. Now I realize the importance of rest." As she makes that last comment, her voice rises slightly, as if she is hearing the advice of Mos and Fu in her head.

Then come the questions about recruiting.

"You guys know what schools need what kind of talent," Parker says. "I mean, Georgia's gonna need a point guard after next year. How much have they been recruiting you compared to the other schools and have you ranked at least in your mind the ones you're thinking about right now?"

"I'm really interested in Rutgers, you know that's our state school," Nicole says. "And Georgia and Penn State. I spoke to Coach [Andy] Landers just before I came. We had a pretty good conversation."

"What are your impressions of him and his program?"

"Before I even spoke to him I had a tremendous amount of respect for the program in terms of what they've done in the past. If I decide to go there, I want to carry on the torch, to give them more successful seasons, Final Fours, and championships and so forth."

"Do you feel like you're in a pretty good situation then with a school like that that needs someone at your position?"

"Yeah, because if they recruit two or three point guards, you're going head-to-head with people from your own class so it makes your job a lot easier than to trying to battle a senior to get playing time, you know?"

"And then what sorts of things are you thinking about with all of your different schools? In terms of the whole shebang?"

"Well right now distance, location, isn't key for me. I wouldn't mark out a school just because it's in California, or in the Midwest or the South."

"Does Penn State having gone to the Final Four, did that kind of open them up more? It looks like every year players like you, they all have Tennessee, UConn, Georgia, Louisiana Tech on their list. What do you think it's gonna take for players like you to take the lead and go for a different school? Is it kind of hard to say no to those other schools?"

"Yeah, it is definitely. But I think once you have a connection with a college coach and you believe in their vision, then you're more prone to go to that school. I mean, Natasha Pointer and Coach Stringer. Rutgers wasn't that good but Coach Stringer explained to Natasha about the vision that she had, and Natasha bought into that. And Coach Stringer brought in a great recruiting class, and now they're on the map. It is kind of hard to turn down all the big-time schools, but by the same token, you also want to look at the smaller schools that are rising."

"So Rutgers would be in the picture whether or not they got to the Final Four just because they're back north? I know they're recruiting another point guard too, does that kind of factor into your decision?"

"Yeah it does because I know they have a few guards, I know they signed Mandakova Clarke as a point guard, and Nikki Jett, so they have a lot of point guards. So that'll be a big factor in my decision."

"They're [also] recruiting Cappie from Chicago," Parker says.

"When I spoke to Coach Stringer, she was just saying that everyone thinks Cappie wants to be the one, but in college she wants to play the two. That's what they're recruiting Cappie as, they're not recruiting her as the one."

"And what about Tennessee?" Parker later asks. "They need a point guard?"

"I have nothing against Tennessee," Nicole says. "I don't know anything about their program aside from watching them on TV. I'm not attracted to Tennessee, I guess. I just have no clue why I'm not interested."

"So, it doesn't sound like you're really thinking about too many schools besides Penn State, Rutgers, and Georgia?" one reporter asks.

"No," Nicole says. She also wants to use the interview to dispel a rumor she has seen on the Internet. Before camp, someone posted that Nicole had verbally committed to Rutgers, something that is, of course, not true.

"The rumor was that Rutgers had a lock on me already, that I was pretty much going to Rutgers. I don't know if that's the lowdown in the recruiting process on me or whatever, but that's not true. I mean I really like Rutgers and I'm definitely considering them, but that's not true at all."

* * *

Ninety-two coaches are on hand the first day, and more are expected later in the week. For Nicole's first game, they sit five rows deep in the bleachers. It is a virtual Who's Who of high-powered women's coaches: Vivian Stringer, Stanford's Tara VanDerveer, Muffet McGraw of Notre Dame, Wendy Larry of Old Dominion, Theresa Grentz of Illinois, and Chris Dailey, Auriemma's chief assistant at UConn, are just a few of the scouts on hand. This game features not only Nicole but a number of other high-profile players, including her teammates Shanna Zolman, a 5'8" sophomore guard from Syracuse, Indiana, considered by some to be the best pure shooter at the camp, and Cisti Greenwalt, a 6'4" center from New Mexico considered to be one of the top post players in the class of 2001.

These coaches have known each other for years, and they have an extensive information-sharing network—some would call it a gossip network—whereby they give each other the lowdown on various players. It is hard to keep a secret in this sorority.

Because Nicole is a black player from the state of New Jersey, many coaches simply assume she will wind up at Rutgers. It is unclear how many have read that Internet post Nicole is worried about. But this much is clear: Coach Stringer is known for recruiting athletic, physical players like Nicole, so why

would she let this one slip away from her in her own backyard? It is also hazy how many coaches are aware that Nicole has been suffering from tendinitis, shin splints, a tight quad, and a sprained ankle. Some do notice her added pounds.

As the game begins, Nicole looks confident running the team. She sinks a 3-pointer from the left wing. She throws a bounce pass to her teammate Ashley Earley for a layup. She throws a no-look pass to another teammate who gets fouled. But on a later possession, she turns the ball over by traveling. Still, her team, named "Staley" after the WNBA star Dawn Staley, wins the game.

After an hour-and-a-half dinner break, Staley returns to the court for its second game. Nicole's knee is killing her. It feels like a creaky hinge, and it's painful for Nicole to run up and down the floor.

She is hesitant to drive the lane against big players for fear of having her shot blocked. Better leave the paint to the post players, she thinks. So she plays on the perimeter, passing into the taller girls and shooting from long range when she has an open look. She sinks a 3-pointer from the left side, then misses a second one to start the game.

"She shoots well off the pass," says Coach Gary Blair of Arkansas, seated in the top row of the stands. "She has a tremendous future in the game. She handles well. She has good size for that position. I'd like to see her penetrate and dish and create. And how can she do the little things as a point guard?"

Blair, whose team reached the NCAA Final Four in 1998, cautions that sometimes a kid can hurt her chances by trying to do too much at this camp.

"Too many kids get selfish and they start shooting for a scholarship," he says in his southern drawl. "Some of them shoot their way out of a scholarship. You can come here and not score ten points and still be the greatest player in the country. As long as a kid knows how to play the game and has the ability to defend and see the ball, that's all you need to do."

Nicole certainly isn't afraid to shoot. During one stretch, she lofts 3-point attempts on three of her team's five possessions, sinking one of them. She isn't on fire.

Later, when she nails a 3 from the top of the key, Blair exclaims, "Wow, she's filling it up. Somebody better guard her."

At the end of the game, Nicole attempts a no-look pass to a teammate that results in a turnover, and her team loses 62–57. It will be their only loss of the event, but more than an hour later Nicole will still be angry at herself for that play.

"I'm mad 'cause we lost," she says. "I had a turnover at the end of the game. That was a big possession too."

* * *

After the second game of the day, Nicole and her teammates head into an upstairs auditorium to listen to a lecture from three WNBA players, Vickie Hall of Cleveland, Carla McGhee of Orlando, and Gordana Grubin of Indiana. Each woman tells a little about herself and how she came to play in the WNBA. Hall emphasizes her work ethic, how she used to be in the gym at 6 A.M. shooting 300 shots and would then return at lunch and in the evening. She makes sure to emphasize that a pro career is by no means certain for anyone at this camp.

"Out of this whole camp, maybe five, six, or seven of you will make it to the WNBA. Education," she emphasizes, "you have a big commitment toward that."

If she were an NBA player speaking at the boys' camp the previous week, the message would be the same. But the reality would be different. Some of them could consider jumping directly from high school to the pros.

When Dajuan Wagner, a senior at New Jersey's Camden High, competed at the Nike boys' camp a couple of weeks before the girls' camp, scouts from all 29 NBA teams were in attendance. But as Nicole strutts her stuff here, not a single WNBA scout is in the house.

Wagner scored 80 points in a game the previous season and is widely considered the top rising senior in the nation. For him and his fellow Nike All-America Tyson Chandler, a 7'1", 209-pound center from Dominguez High School in Compton, California, jumping to the NBA is a real possibility. But for Nicole, making that leap is not yet an option. According to WNBA regulations, players generally must be 22 years old to join the league, have completed college basketball eligibility, graduated from a four-year institution, or played at least two seasons for another professional league. "On the guys' side, it's 'Who Wants to Be a Millionaire?' and on the girls' side it's 'Who Wants to Get a College Scholarship?'" says the recruiting expert Mike Flynn, who holds court with the reporters all week.

"I think the rule is great that you can't jump from high school to the WNBA because the salary is a lot less and education is key," Nicole believes. "If I was a guy and a pro coach offered me ten million dollars for five years coming out of high school, I'm gonna jump on it. But for girls it's different."

Many think it's only a matter of time before a young woman challenges the legitimacy of the WNBA's policy.

"If you had a great player who didn't have the grades, she could take it to court and say they're impeding my ability to make money," says Dave Krider, the recruiting expert.

Arkansas's Blair adds: "All it's gonna take is some Jerry Maguire–type agent or lawyer to take it to court and they'll win. It's going to be that real good junior college player who doesn't have the grades to go Division I and doesn't want to go to Europe. I think that will happen and I hope I'm out of it by then."

* * *

During Monday's games, Coach Stringer continues watching Nicole, but she doesn't seem impressed. At one point, she arches her eyebrows when discussing Nicole, indicating she isn't pleased with her play. Whether it is Nicole's conditioning or her shot selection that has turned Stringer off is unclear. The coach is restricted from commenting about specific players, and all she will say is that she wants to recruit the best players possible.

"I would like to just own the whole northeast, but we'll go anywhere," she says. "We're gonna do our best to recruit New Jersey, but it will not be at the expense of getting the best players. We want a national championship. We're looking at the players who are going to Tennessee and Connecticut, and we want to compete with them."

Nicole's second game of the day is of particular interest to Stringer and her staff. That is when Nicole's team takes on the "Holdsclaw" team that features the 5'8" point guard Saona Chapman of Voluntown, Connecticut, Stringer is increasingly considering making Chapman her point guard of the future.

She watched Chapman at the AAU Nationals in Chattanooga and liked her intelligent, fundamental style of play. A cross-country runner, Chapman led Norfolk Free Academy to an undefeated season and a state basketball championship as a sophomore. As a junior, she was named all-state. Everyone around her raves about her work ethic. Stringer and her staff have been sending her bundles of mail both at home and at school for the past several months.

Meanwhile, Andy Landers, the Georgia coach, is also shopping for a point guard. An outgoing man who wears his thick hair slicked back, he seems to be following Nicole everywhere. There is no telling whom else he is looking at, though. At one point he sets his folding chair next to the coaches-only bleachers in order to be noticed.

"I'd put my chair out at midcourt if I could," he says.

He, too, cannot talk specifically about Nicole, but skirts the issue by saying, "There's a definite major college point guard in New Jersey. There's no question that we have to have immediate help, someone who can come in and help in our backcourt."

Meanwhile, Kristy Curry, the Purdue coach whom Nicole never heard from, is eight months pregnant and sitting in the last row of the bleachers to support her back. She mentions that she already has two point guards.

"But, if I didn't have those two, I'd recruit her," she says of Nicole.

Nicole's team wins both games on Monday, including the one over Chapman's team, but the consensus seems to be that she—like a lot of players at the camp—hasn't stood out. Flynn, who stands off to the side talking to reporters, says, "Nicole needs to do something interesting every fourth time down the floor. I've seen Nicole Louden do things in other venues and succeed. If you see three or four three's in a row, that's gonna get your attention. If you see three or four layups in a row, that's gonna get your attention."

She may not have blown anyone away, but Nicole's second win of the day has clearly put her in a good mood. As she lopes off the court wearing her red Nike shorts and black T-shirt, she smiles and shadow boxes with an acquaintance before heading back to the hotel.

* * *

In the lobby of the University Hotel, Nicole and the other girls are in relax mode. Tall, athletic girls, exhausted from the day at the cattle show, move through the plush hotel in sweats and shorts. Some are with their families; others hang out in groups.

Nicole, typically, is by herself when she plops down in an oversized recliner in the lobby wearing green plaid shorts, sandals, and a red PATERSON ALL-STARS shirt.

"I was ballin' today, man," she says with a big smile. "I was in the flow of things." Then she rubs her creaky joint and adds, "My knee was botherin' me."

When Nicole is informed that lights-out for the boys' camp is 11:30 P.M., half an hour later than for the girls, her voice perks up.

"Some double standards going on here," she announces to any Nike personnel who might be listening. "What's going on?"

Then she turns serious again, turning her attention back to the matter at hand: recruiting.

"I did a lot of research on Georgia yesterday on the Internet, so when I go home I'm gonna do research on Penn State and Rutgers," she says. In one of the morning classes, an instructor told the girls to locate the Web pages for their top college choices on the Internet. Nicole looked up the size of Georgia's enrollment, its tuition, and information about its programs in communications and

broadcasting. At home, on her aunt Joan's computer, she will do the same for other schools.

Pausing briefly and arching her eyebrows slightly, as if all the talk of recruiting and college has inspired her to make an important proclamation, she adds, "I'm gonna verbal soon." In recruiting parlance, "verbaling" means to make a verbal commitment to the school of your choice. It signals to all other interested programs that the recruit is now unavailable to their school.

Chapter 15

On the eve of the last tournament of Nicole's summer season, Euphemia sits in her kitchen waiting patiently for her family to get ready. Every year the Richmans rent a van and drive to Washington, D.C., to watch Nicole and the Monarchs compete in the U.S. Junior Nationals, a five-day event run by Mike Flynn and considered one of the most prestigious of the summer circuit. Nicole and her teammates left earlier in the evening so that they would get to Washington in plenty of time to rest for tomorrow's games. The Richman entourage planned to depart by 10 or 11 P.M., but now it is almost 11 and Euphemia's patience is running out.

On this warm summer evening, Euphemia's sons Joshua and Prince and several friends are playing dominoes, drinking, and listening to reggae music at a card table in the driveway, just outside the kitchen door. It is dark, so the young men play and talk by a combination of the house light and streetlights on East Twenty-sixth Street.

Inside the house, Andrea is busy packing and getting Alex ready. The family all came together for the funeral a week earlier, and now five of Euphemia's six children will make the trip to watch Nicole play. All told, 11 people will cram into a van meant for eight: Euphemia, Andrea, Joan, Alex, Prince, Joshua, Nicole's aunt Esther, Kadeem, Junior, Joshua's daughter Starinda, and Kennedy's assistant coach, Carmela Crawford, whom they plan to pick up on the way.

As a light rain begins falling, Joshua ventures inside to pass the time with Euphemia. Starinda, who had been playing with her cousins outside, accompanies him. The Richmans' kitchen is a small, homey space with a colorful map of Jamaica on the wall above the sink and assorted pots, pans, and storage items in between the sink and a refrigerator covered with magnets and notes.

"I'm taking her to California, she wants to be a movie star," Joshua announces to his mother while smiling and gesturing toward his daughter, a

tall, thin, attractive girl several years younger than Nicole. Joshua details cars in California, but his daughter remains in New Jersey.

"She has to go to school," Euphemia retorts in her motherly tone. "Have to have an education."

Joshua, Prince, and their friends have been drinking something called Tiger Bone, a Taiwanese brew that mixes wine and crushed tiger bone and, by the looks of things, has given them quite a buzz. Their eyes are slightly glazed and they all look rather pleased.

"It's like a tonic," Joshua tells his mother with exuberance. "This is good for you. It's good for the bone." Then, as if performing an impromptu advertisement for the product, he adds, "Tiger Bone, it's good for the bone!"

It was Joshua whom Euphemia made step outside the church at his father's funeral because he was crying. Now he wants to be near his mother so they can comfort each other.

"I'm spending some time with my mommy so she don't get stressed," he says laughing, standing with his back up against the sink.

"I'm stressed," says Euphemia, seated at the kitchen table wearing a light-green shirt and matching skirt that resemble hospital clothes. The death of her husband and best friend has made her so, but she remains strong and composed in the face of her loss.

"Me and my father had planned to go to Africa but he got sick," Joshua says. "I was gonna take him to visit Mandela in South Africa. We was gonna come up to Egypt."

"The River Jordan," Euphemia adds as if praising the river at a church gathering.

In the background, Alex and his cousins are playing and screaming, but Joshua is not fazed by the horsing around—he keeps talking about his parents.

"She the Don Mama right there," he says, pointing to his mother. "My brother have another name for her. Mary."

"Are you the mother of God?" asks Joshua's friend Michael, who has also moved inside from the dominoes game, where he has just taken a beating.

"I'm the Mary, that's right, man," Euphemia says with a slight chuckle.

It is hard to imagine the Virgin Mary going to a theme park, but Joshua asks her anyway. "You want to go to Great Adventure August twelfth?"

"I hit the boardwalk but not the casino," she says. "I don't gamble."

Joshua's game and Tiger Bone buzz have made him less concerned about when the trip to Washington will begin, but now even he wonders when they will leave. Euphemia lets it be known that she has been ready for some time.

"I came back here around twenty to eleven. But it's eleven-thirty and nobody's ready. When they going anywhere they're not in no haste. They drag their feet."

Andrea isn't dragging her feet. She is folding Alex's clothes and making sure he has what he needs for the trip, including his GameBoy.

"Where your game is?" she asks him in an annoyed voice.

"I left my game upstairs," he answers. Alex, a solid boy with his mother's round, open face, seems always to be smiling, even when he has forgotten something.

"Where is your toothbrush?" Andrea asks. "Where's your sneakers? You just gonna wear your sandals?"

Now Prince has entered the kitchen to find out what's going on and to second the virtues of Tiger Bone.

"It's Tiger Bone," he says. "It goes straight to your bone. I tell you it's strong. That Tiger, Mama. It's strong." Euphemia doesn't wholeheartedly approve of her sons' drinking, but she doesn't overtly criticize them. Instead, she gives them an occasional stare that mixes disapproval and bemusement.

On top of making sure Alex has all of his things together Andrea is also looking for directions to the tournament. The family plans to drive all night, then stop for breakfast before watching Nicole's first game. But Joan has not been able to find directions on the Internet, and Andrea, who will share the driving with Euphemia, wonders how they will find the event.

"Last year we went and some police give us the wrong directions," Andrea says. "And then we asked some junkie men and they said, 'Go down the street,' and there it was."

Just then, at about midnight, when it looks as if everyone is finally ready to hit the road, directions in hand or not, the phone rings. Nicole is on the other end.

"We were just talking about you," Andrea says. "What exit do I take this morning?"

By the time the family finally picks up Carmela Crawford—who hardly ever misses an opportunity to watch Nicole play—it is almost 2:30 A.M. After driving through a mild rain, the Richman clan pulls into Washington at 6:45. Nicole's first game is at 9:30.

* * *

A stocky woman with glasses and short, spiked blond hair, Coach Fu looks something like a female version of Bart Simpson. During the school year, she serves as the athletic director at Belleville High School. But in the summer months, she leads the Monarchs on trips throughout the country, always trying to mix historical or educational sights in with a basketball tournament. According to Fu, Tamecka Dixon, who now plays in the WNBA, was the best player

she ever coached; perhaps Nicole is not as natural and smooth as Dixon was at this age. But she also says Nicole is ahead of where Falisha Wright and her sister were when they were teenagers.

"She has the ability to keep getting better and better," Fu says of Nicole. "She can be as good as she wants to be."

Nicole is the point guard on a Monarch team filled with stars from a variety of New Jersey high schools, but because the team is more talented than Kennedy's, she does not have to freestyle as much. Fu trusts Nicole to call all of the team's out-of-bounds plays because she "has such a high IQ" and such a developed understanding of the game.

She has such implicit trust in Nicole's decision-making that she has given her "free rein to do whatever she wants." Fu believes this will help Nicole develop into a leader at the college level. But far from running wild with that freedom, she credits Nicole with setting a "businesslike" tone on the team.

Still, Fu had spent two months in the spring trying to transform Nicole from the "streetball" type of player she had become at Kennedy into a more disciplined, polished AAU performer. It took time, not only for Nicole, but for the team to develop into a cohesive unit.

At the Monarchs' first tournament of the season, the Boo Williams Invitational in Hampton, Virginia, in early April, the team had been so out of sync that Nicole had trouble directing the offense. According to the rumor mill, a few college coaches in attendance wondered what was wrong with Nicole. Why was she trying to do too much? Why would she sometimes drive the lane, taking on five defenders at once instead of passing when everyone knew she was already a top player? One AAU coach said he saw at least one big-name college coach leave the game in disgust. Nicole knew it wasn't her best performance.

"I was hampered by my knee and it wasn't a good tournament for me, period," she would later say. "I wasn't in the flow of things. You can tell a team that's in sync. They know where they're supposed to cut and pass. I wasn't in sync with my teammates. I was very unsure when to shoot, when to pass, when they were gonna post up. I needed to relax. I wasn't feeling it. I try to do too much sometimes because I just wanna win. That's basically the reason. I wanna win."

Mos believed that Nicole tried to do too much at Boo Williams because she still wasn't convinced that she was a top player, and she felt intense pressure to perform well in order to enhance her chances of earning a scholarship.

* * *

For the U.S. Junior Nationals Tournament, the large gym at the Raymond A. Dufour Athletic Center at Catholic University in Washington, D.C., is divided

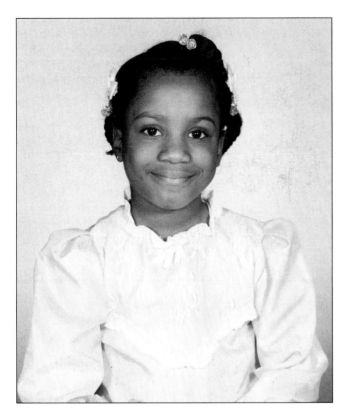

Nicole as a young girl, before she discovered her handle.
Courtesy of Nicole Louden and family

From left to right: Nicole's grandmother, Euphemia Richman, with three of her daughters: Esther; Nicole's mother, Andrea; and Joan. October 2000. Courtesy of Nicole Louden and family

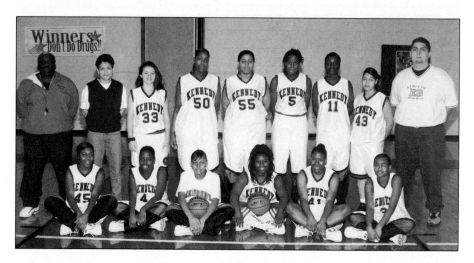

The Kennedy Lady Knights, winter 1997–1998. Nicole, No. 11, stands to the right of Delfiah Gray, No.5. Dakita Trapp, No. 4, sits second from the left. Jody Foote, Nicole's cousin, sits third from the right, a ball in her lap. Head Coach Donovan Jonah and Assistant Coach Maria Colon stand on the left, and Assistant Coach John Zisa is on the right. **Courtesy of John F. Kennedy High School**

Nicole was also a star on Kennedy's volleyball team until chronic injuries forced her to choose between the sports. **Courtesy of John F. Kennedy High School**

Nicole and one of her role models, Rutgers point guard Tasha Pointer, at the 1999 Nike All-America Basketball Camp, where Pointer was also Nicole's camp counselor and assistant coach. Courtesy of Nicole Louden and family

Nicole's AAU coach Joann Mosley, flanked by Lakeysha, left, and Falisha Wright. August 1999. Courtesy of Nicole Louden and family

Nicole is dressed for her 17th birthday party at Aunt Joan's house. January 2000.
Courtesy of Nicole Louden and family

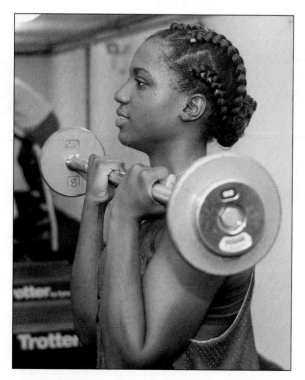

Nicole trains for basketball by lifting weights at the Paterson YMCA. September 2000. Photo by Warren Westura/ Copyright by the Record

Kwan Jonson, left, and his father, Milton Evans, Nicole's friend and trainer at the YMCA.
Photo by Clarice Featherson

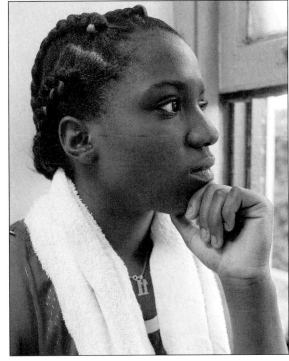

Cooling down after a workout at the Paterson YMCA, Nicole contemplates her last season of high school basketball and the momentous decisions she still must make. September 2000.
Photo by Warren Westura/ Copyright by the Record

Nicole gets a kiss from her grandmother on the day of the press conference announcing her intent to attend Auburn University. Surrounding her, clockwise from the left, are Kennedy coach Lou Bonora; Kennedy athletic director Bob Gut; Nicole's mother, Andrea; Kennedy principal Richard Roberto; Nicole's aunt Joan; and Nicole's brother, Alex. November 2000. Photo by Warren Westura/Copyright by the Record

Andrea Richman gives her daughter a bear hug after Nicole breaks the Passaic County girls' scoring record. She scored 39 points in the game, including two foul shots in the waning seconds to give Kennedy the win. January 2001. Photo by Ellie Markovitch/Copyright by the Record

Nicole wipes her eyes as her friends and family celebrate the new scoring record. She is surrounded by Assistant Coach Carmela Crawford on her left; her brother, Alex; and her mother, Andrea. January 2001. Photo by Warren Westura

The author, second from left, is one of several reporters interviewing Nicole. By the time she broke her first record, handling the media had become as routine as handling the ball. January 2001 Courtesy of Nicole Louden and family

Nicole recovers after a collision during the Group 4 state semifinals. March 2001. Photo by Norm Sutaria/Copyright by the Record

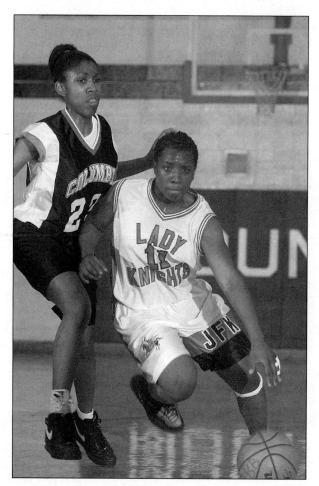

Nicole drives past a defender. She scored 40 points in this game, her last in a Kennedy uniform. Her No. 11 jersey was retired by John F. Kennedy High School earlier in the year. March 2001. Photo by Norm Sutaria/Copyright by the Record

into four courts by large red screens. The gym is so hot and clammy on this summer afternoon that its doors have been propped open to let air in. Girls who are not playing during this round congregate on concrete steps outside the gym, socializing and enjoying the fresh air. College coaches not currently watching the action take the time to make phone calls to their favored recruits.

"We really want you in our program," one male coach who has found a bench all to himself tells a recruit on the other end of his cell phone. "But there's a difference between wanting you and needing you, and we need you. You are a special student athlete and I would like to do everything to get you all the information I can on our school."

Unlike Nike camp, where there were large stands on the sides of the hardwood, there is not much room around the perimeter of these courts. College coaches, parents, and fans jockey for position, and those fortunate enough to find one of the few plastic chairs available are smart to hold on to them. Out in the lobby, some teams have placed packets identifying each player on their roster and supplying pertinent biographical information, such as SAT scores, athletic and academic achievements, and high school coach's name. Nicole's bio indicates that she has a 3.7 GPA, is a member of the National Honor Society, and averages 31 points and nine rebounds per game.

A racially diverse team, the Monarchs will face an all-white team called the Long Island Sound in their second game. In the Monarchs' first contest, Nicole poured 46 points into the team's victory, much to the delight of Carmela Crawford and Nicole's entourage. The Monarchs enter the gym single file wearing white-and-powder-blue uniforms. Some say NEW JERSEY, others MONARCHS on the front. Nicole also wears a black knee brace on her left knee, a pair of black-and-blue Nikes, and a black hair tie around the end of the cornrows Kesha has lately styled her with. She has pumped herself up for this game by listening to Lauryn Hill on her compact disc player. The Monarchs take a lap around the court where they will play and then take up position under one basket for a series of stretches.

Sometimes when Nicole plays against all-white teams, she has been known to think to herself, "We cannot let them beat us. I am not gonna let some rich white girls beat us."

White high school girls' teams tend to play a slow, half-court–oriented game, while inner-city, predominantly black teams tend to prefer a faster, run-and-gun style. These broad differences sometimes inspire a sense of inferiority in white players. Once, during a high school girls' game in Passaic County between whites and blacks, the best player on the floor, who was white, said after her team won that she had had to calm down her teammates before the game because they were

nervous about the opponent. "Black people are a lot faster than white people," she said rather matter-of-factly. The truth is debatable, but black and white alike tend to believe it to varying degrees.

Not all the white teams Nicole faces during the regular season are patsies. Kennedy often loses to Ridgewood and Holy Angels, all-white teams known for strong fundamental play.

"I think some white girls play better than black girls," Crawford says. "I be wondering how they got so much skills and we supposed to be more able athletically than them. . . . I try to figure out why they play so much better than [us]. But I know where they get it from, they start out early."

Now, despite their easy first-round victory, the Monarchs are without four of their players, including Tara Walker, who is dealing with family matters at home. Only nine girls have made the trip to Washington.

"I'm missing four; all I know is it hurts," says Fu before tipoff.

The absence encourages Fu to rely more upon Nicole. Thus her 46-point outburst this morning.

Not all of Nicole's Monarch teammates think Nicole should be encouraged to take over games. Tobi Petrocelli, the best player on the Holy Angels, plays Kennedy during the year, and so she is intimately familiar with how Nicole must shoulder the scoring burden during the regular season. She and Nicole are friends and fellow point guards, but on this team she thinks Nicole tries to do too much.

"When she drives against four people in that game, she can score," Tobi says of Nicole's performance in the first game. "When she drives against four people in a better game, she gets into trouble. That's her mentality in her high school team. It's like, 'Nicole, here's the ball, do what you can to win.' When one person scores, we don't win. Today the other team wasn't decent enough to stop anybody." Tobi thinks Nicole would be better off playing a two guard in a college, not a point. "She's a shooting guard," Tobi says. "She's not into calling plays."

Like Meticia Watson at Kennedy, Coach Fu had a dilemma. If the other team was going to let Nicole score 46 points, why should her own coaches hold her back?

"We like to go with the hot hand," says Assistant Coach Jill Fischman, known to the players as Fisch. "Generally you like the scoring to be balanced but they weren't stopping her. If that team was smart they would've stopped her."

Now with the second game about to start, Fu, wearing tan pants, a cream-colored shirt, and a beeper on her hip, gathers her team in a circle, telling the players an inspirational story about El Cid, the Spanish warrior who fought the Moors. By the look of things, the Monarchs should overpower the Long Island Sound. Nicole drives past her defenders for several explosive layups early in the

game. She also tries to get her teammate Ashlee Burgess, a 6'2" rising freshman who will attend Paterson Catholic, involved by driving and then passing off once the defense has committed to her.

Meanwhile, Fu is storming about on the sidelines yelling at her team, "Triangle and two," and "Deny her, deny her. Keep it in front of her."

As an extension of her coach on the floor, Nicole is also quite vocal. When one of her teammates doesn't step into the lane to deny an oncoming player with the ball, Nicole frowns and shouts, "Yo, take an offensive charge."

Meanwhile, Nicole's family has arrived after a short break from the basketball tournament. Andrea sits in a chair on the side of the court wearing a gold necklace that forms the word JAMAICA and a gray T-shirt that reads BASKETBALL MOM on the front, and I HAVE A GREAT LIFE—I'M A BASKETBALL PARENT on the back. Euphemia sits leaning on her pocketbook.

Behind one baseline, in a corner not far from the Richmans, sits Coach Andy Landers of Georgia, who seems to shadow Nicole. Looking well pressed as usual, he wears a red shirt, off-white shorts with a Nike swoosh, and black-and-white sneakers. His thick black hair is neatly combed, and his green eyes are carefully observant of both Nicole's game and one on an adjacent court.

Landers has five scholarships to give and is in dire need of a point guard. Every day he and his assistants move 16 names around a big clipboard, pushing some girls up the list and others down, wondering all along what the devil they were thinking the previous day. Eight of those 16 are guards, and six of the 16, including Nicole, are at this tournament.

Just a couple of days before, Terri Flournoy, a Georgia assistant, had telephoned Nicole. When Nicole told her Georgia, Rutgers, and Penn State were her top choices, Flournoy said, "That's what we want to hear." Now Landers, a veteran of 26 years in this business, is doing his best to be seen by Nicole and his other targets.

"Most of the girls have seven or eight schools left," Landers says. "We know what we want a lot more than they know what they want. At this point, nobody's driving. When some of these other guards start acting like they want to come, somebody will be driving. That's when somebody's at the wheel, when somebody says, 'Yes.'"

Landers isn't the only coach paying close attention to Nicole. Nicole has spotted a young woman in a University of Nevada–Las Vegas pullover watching most of her games. "Who is this lady?" Nicole wonders, before learning that it is UNLV's assistant coach, Brenda Pantoja, "Coach P." UNLV has been sending Nicole letters repeatedly, but she never thought seriously about attending the school.

* * *

After Nicole has scored 18 points and gotten her teammates more involved in the team's second victory of the day, Fu has a strict protocol for what happens next. The girls return to the hotel, a Marriott in Silver Springs, for showers and a brief rest before dinner. Anyone who needs to ice a body part, like Nicole and her creaky left knee, can take care of it then. Over the years, Fu has assembled a list of 20 "Rules and Regulations" for these trips, a list she distributes to players and parents at the beginning of the season. Among them are practical guidelines like "You should conduct yourselves like young adults both on and off the court, " and "Be polite . . . good sportsmanship is essential. College coaches watch attitudes." Others target teenage girls specifically: "No Pay TV," and "Do not fraternize with the local male population."

After her shower, Nicole's post-basketball outfit includes tan pants, athletic sandals, and big hoop earrings. When it comes time for dinner, a dozen or so girls pile into two vans driven by Fu and the assistant coach, Jill Fischman, a young woman just a few years out of college. (Mos has not made the trip, leaving the team in the hands of the others.) Fu takes the team to a busy family-style restaurant, where all the girls gather around one rectangular table. The coach encourages them to avoid carbonated beverages. As usual, Fu will foot the bill out of the dues she collected at the beginning of the season, but warns, "I'd prefer that you stay away from the higher-end items."

Tobi, a talkative, precocious girl who is considering Harvard and Yale, has worn her pajama bottoms into the restaurant, a source of humor for her teammates.

"I've been wearing them for five days," she says, before turning her attention to dinner. "I hate this, why can't someone just bring me a salad?" By her own account, Tobi has been somewhat spoiled by her parents' lifestyle. Her father's electrical contracting business is successful enough for him to drive a BMW and consider sending his daughter to an Ivy League school. "I'm used to the high life," Tobi likes to say. "I'm used to the good stuff." Alas, because there is a salad bar, Tobi will have to get up from her seat.

Fu, as always, tries to steer the discussion toward something educational, so she tells the team the story of how female athletes at Yale tried to get the school to enforce Title IX in the early 1970s.

"They weren't getting the same things that the men were, and every time they tried to get a visit with the president, he wouldn't see them," she says.

"The President of the United States?" one girl asks.

"Of Yale . . . So they sneak by the secretary, they have sweats on, they go into his office, they take off all their clothes."

"Get out," Tobi yells.

"And they had painted on their bodies," Fu continues, "Y-A-L-E, Yale, and demanded that equality go for all of the people at the school."

"I probably would do that," someone says.

"I would do it in a heartbeat," Tobi exclaims. "I'd do it right now for money."

"She wouldn't even paint things on her body, she'd just pull up her shirt," a teammate adds.

After dinner, the team piles back into the vans, with Nicole choosing the green Dodge driven by Fischman. Music is always Nicole's first priority when she steps into a vehicle, and now she can't abide the Billy Joel playing on the stereo.

"That's why I hate this van," she says, barely masking her disgust.

"We put on the 'ghetto mix' sometimes," says a teammate, Janet Ust, in a hopeful tone.

"Are you putting on the ghetto mix number two?" asks Ashlee, who is seated next to Nicole in the middle row. Soon the van is humming through the darkness of the summer night, vibrating to the cool sounds of Dr. Dre instead of the uncool Billy Joel.

"Why my sister wrote 'ghetto mix' I'm not really sure," says Fischman from the driver's seat.

Nicole and Ashlee then strike up a conversation about another of their favorite topics—boys.

"I get bored easily," Nicole tells her younger friend. "Don't call me three times a week. Don't call me."

"You have to play sports and stuff like that," adds Ashlee.

"You gotta be good, all-league or something," Nicole says. "I don't want you rotting on the bench. Call me once a week." Nicole pauses. "That's not good. I think I need some counseling. That's because I want a boyfriend to have one [for company]—not feeling it, really."

"A lot of people say girls mature faster than boys," Ashlee offers.

"But we're not on the same wavelength or whatever," Nicole says before discussing the plight of one of their black teammates who had been cheated on by a white boyfriend. "My grandfather told me if I married a white man, he wouldn't come to the wedding."

After covering music and boys, the girls then shift to basketball, their third area of interest. Ashlee says that she wanted to attend Paterson Catholic since the seventh grade when that school won the Parochial B state championship and its third straight Passaic County championship. Lately the gossip in the Paterson girls' scene is about Essence Carson, a lithe, athletic eighth-grader who

has come close to dunking for the Pioneers on the AAU circuit and has drawn interest from every high school in Paterson. She is deciding between Paterson Catholic and Eastside. Carson is so smooth and talented that she is already drawing comparisons to Nicole at that age. Nicole, for one, doesn't like the analogy.

"How can you compare us? We play two different positions," she says to Ashlee in the darkness of the van. "I heard Mr. Black was spreading a rumor that I was coming to Eastside. If I'm gonna transfer somewhere, it's gonna be somewhere where I can win something. [At Kennedy] we got to the semis of the states and look at the team we had."

Then Nicole talks about how she dislikes playing with people unless they have a "passion" for the sport, and how she came to develop her own love for it.

"I'm glad that I didn't have a person in my family playing the sport, putting it down my throat. I just did it on my own." Nicole, it seems, is constantly analyzing things, a quality that, in the eyes of many coaches, makes her an ideal point guard and conduit to her teammates

When the van pulls into the hotel parking lot, it is time for the team's end-of-day meeting in Fischman's room. The room is littered with bags of potato chips and popcorn; there's also a stack of freshly washed blue uniforms and a crate of Poland Spring bottled water.

Slowly, the girls wander into the room, reclining on beds, chairs, and the floor as Fu sits on the bureau next to the television, facing her troops.

"Lights out at eleven," Fu says. "That means in your rooms at ten-thirty if you've gone visiting. You should be so exhausted there shouldn't be much visiting, though.

"No phone calls late tonight. Tomorrow up at seven. Breakfast at seven-fifteen. If cereal's not enough, I have wheat rolls, too. We're gonna wear our white uniforms tomorrow if I have time to do the laundry. Nine-twenty is game time so I'd like to be there thirty minutes before."

"What time is it?" interjects Tobi.

"We're not impressed that your boyfriend's calling and that you have a hickey on your neck," someone says. Tobi is known for her busy social calendar.

Fu continues with her speech despite the interruption.

"Bring dry clothes. You didn't play great today but you did a great job. You played really hard and aggressive."

Meanwhile, spontaneous conversations have broken out among the players about their roommates.

"I'm having a blast," Tobi says to Nicole, who is seated near her.

"You have a question?" Fu asks her loudest player.

"At least Tara talks on the phone," Nicole says of Ashlee. "Baby wants to watch TV all night."

"Be considerate of your roommate," Fu adds.

With the meeting over, Fu asks Tobi about the team's plans to attend Mass in the morning, an optional routine on road trips. "This is a Baptist Catholic church? Oh, it's St. John the Baptist? All right, get to your rooms."

While her coach worries about church matters, Nicole is focusing on something more immediate.

"Where's the ice on this floor, because my knee is terrible." Then she lopes out into the hallway with plans to find ice and continue reading *Murder at the Watergate* by Margaret Truman, a book Mos gave her. "I just finished reading *Gone but Not Forgotten*," she says while filling two plastic bags with ice from the dispenser at the end of the hallway. "It's about this guy who treats women like animals. He makes them lick themselves and roll over. This book is the bomb, though."

* * *

At eight in the morning, Fischman is moving about her cluttered hotel room while the animated movie *The Iron Giant* blares on the television set. It is less than an hour and a half until game time, and all the troops aren't even out of bed yet.

"Is Tobi up?" Fischman asks Tobi's roommate, Jackie Buttitta, who has come in to pick up her uniform. "Tell her to get her butt out of bed before I come over there and kick it."

"She's up, she's just in bed," Jackie replies.

Fischman goes about the more mundane duties of an assistant coach—handing out uniforms, rousing players from their beds, and generally making sure everything runs smoothly—with an optimistic fervor. One day, though, she dreams of becoming a head coach. She says she learns more and more from Fu and Mos each day about how to talk to players, parents, officials, college coaches, people at the scorer's table, "everybody around the game."

"I treat it like a salad bar," she says. "Take what you like from different coaches and what you don't like, leave there."

Now, as Fischman ponders her future, a droopy-eyed Nicole drifts into the room wearing a red KENNEDY BASKETBALL XXL shirt over her uniform.

"My back hurts. I'm tired, man," Nicole announces to Fischman.

"Your lower back?"

"No, my whole back," Nicole says as she dives on top of one of the beds.

"Well, you were spending a lot of time on the floor yesterday."

"I'm losing sleep. I'm starting to get bags under my eyes. I was sitting up watching cartoons."

"Do you need water?" Fischman asks, looking around the room gauging her water supply for the day.

"I refilled my water," says Nicole, who always keeps her personal water bottle at her side.

"We need to get some granola, guys," Fischman says to anyone who might be listening. Nicole, by now, has tuned her out, favoring Lauryn Hill on her CD player. "We're going through granola withdrawal."

Finally, after most everyone on the team has eaten granola or fruit for breakfast, Tobi manages to make her way into Fischman's room, where she promptly falls on a bed, exclaiming, "Oh, God." Meanwhile, Ashlee and Janet have retreated into their own private musical worlds, just like Nicole.

As the troops move outside, Nicole stands with her back up against Fischman's van, singing along with the lyrics to one of her favorite Hill songs, "Lost Ones."

> *"Now, now how come your talk turn cold*
> *Gained the whole world for the price of your soul*
> *Tryin' to grab hold of what you can't control*
> *Now you're all floss, what a sight to behold*
> *Wisdom is better than silver and gold"*

After Fischman arrives at the van, the players momentarily jockey for position inside, each looking for the best place to resume sleeping.

"Please don't take my seat, please," Nicole says to Ashlee. Not a second later she leans her head forward on a pillow, her right hand covering her face and her headphones still on. Ashlee and Janet quickly follow suit.

"Is all my precious cargo here?" Fischman asks in a maternal tone from the front seat. As the vans move out toward the game in tandem, Fischman and Coach Fu are connected by walkie-talkies.

"Hey, Fu, we need to go a little bit faster," Fischman says over the walkie-talkie. "A little bit faster." Fischman has been joking all weekend about how slowly Fu drives, and now it may be costing them.

"Start putting your sneakers on, please," Fu tells the girls on the walkie-talkie.

As the vans move closer to the gym, the girls are stirred from their slumber. Janet tapes her ankles in one seat, while Nicole puts her black ankle brace on in

another. Noticing that the van's clock says 9:07, Nicole observes in a sleepy voice, "We have a nice thirteen minutes. Do we have a grace period, an extra five or ten minutes before the game? We better do our stretching in the car."

"You decided to join us?" Fischman asks the heretofore dormant point guard.

"Yo, I was tired."

"No kidding, the snoring was shaking the van."

"That was you driving," Nicole shoots back. "You drive like you're drunk."

Just then, Fischman notices a sign directing passersby to the U.S. Junior Nationals. Today the Monarchs have been moved from the Catholic University campus to Mt. Vernon High School in Virginia.

"Plenty of time," Fischman jokes as she speeds toward the school. "We like to arrive fresh." At 9:15, five minutes before the game is slated to begin, the van pulls into the parking lot. The girls hurriedly take their jewelry off, throw their athletic bags on the floor, and stretch out. "We got about two minutes to get on the court, girls, okay?" says Fu, who has walked over from the other van.

The gym houses three courts, and the players take up seats in a row behind one of the baskets. Nicole lies on the floor, stretching her legs and grabbing the ankles Fischman just taped in the van. It doesn't look like too many college coaches will be in attendance at this location. They will stick to the action at American and Catholic universities, where the majority of the teams are playing. The Monarchs will play their first game against the Vermont Spirit, a smaller team made up entirely of white girls, in relative obscurity.

When the game starts, the Monarchs look somewhat sluggish, but it's clear they are the superior team. They take a quick 12–5 lead. Then, after a turnover, Fu starts screaming from the sidelines, "What the hell is that? Where are you? Where are my wings? Set up your offense. Run motion. Let's go!" The opposing coach, a middle-aged white man with gray hair, seems exceptionally mild in comparison.

The game is an erratic one with lots of turnovers and missed shots. Nicole lofts a 3-pointer that doesn't fall. On another play, she has the ball stolen from her by an opponent who runs the other way for an uncontested layup.

"That's disgraceful," Fu yells. "That's disgraceful."

Later, Nicole is called for a turnover when she fails to inbound the ball within the required five seconds. "Did you call anything?" Fu screams at her, her face turning a hot pink color. "What did you call?"

When Nicole says something to the effect of "I didn't call anything," Fu's voice reaches new heights. "Well, then, it's your fault."

On the next inbound play, a teammate takes the ball out of bounds and feeds Nicole cutting toward the basket for a layup. With the ball in her hands

on virtually every possession, Nicole now tries to get Ashlee involved. She feeds her once successfully for a layup, but on a second attempt, Ashlee bobbles the ball and loses possession.

"It's too low for her," Fu says, holding her arms up to Ashlee's height. "She's up here." The Monarchs take a 23–13 lead into halftime, but Fu is not pleased. In a nearby hallway, she gathers her team in a circle, using a felt-tipped marker and a board to diagram plays. Fu sits on a chair while the players recline on the floor, flanked by soda machines and trophy cases.

"We're not communicating on the court," Fu tells her charges. "We need to communicate. We need to talk. Listen, that's a high school team out there. That doesn't mean we have to play down to their level. Ashlee, use those hips. Put those arms up. You're like a Boeing 747 if you put your arms up."

"Nicole, that was great, unselfish play," Fu adds, referring to a pass Nicole made to a teammate, Meghan Jent. "You were open but we'll take it because Meghan was open."

The Monarchs go on to dispatch the Spirit in the second half despite the fact that Nicole has to sit out part of the game after knocking her right knee—her good one—on an opponent while driving the lane. When she returns, it looks like the injury hasn't fazed her. She makes a steal and then feeds Tobi a behind-the-back pass that results in a layup.

When the game is over, the players look forward to sleep. Their next game is not until 6 P.M. Now, they file out and mingle with family members in the school's entryway. Tobi's parents are in attendance, and Nicole's family has finally arrived after getting lost.

Nicole, realizing that her wardrobe of clean clothes is diminishing as the days go on, tells her aunt Esther.

"I only got two more shirts and one more socks. Don't got no drawers. I thought I was coming home Tuesday."

As the team and its supporters move into the sunshine of the parking lot, Mr. Jent tells the girls, "Keep those victories coming."

Fu, noticing Nicole's private ensemble of a dozen friends and family members, says to Andrea and Euphemia, "What do we got, the Paterson contingent?" There are more members of the Richman clan than there are Monarchs at this event.

Nicole must part ways with her family to be with her team. But she checks in with them first.

"Y'all gonna go eat?" she asks her mother. "Y'all gonna be back at six o'clock?"

"I don't know where we're gonna go eat," Andrea says, a singsong tone in her voice. "There's nowhere around here." The night before, the family had gone to Kentucky Fried Chicken and McDonald's for dinner, but that was in a different neighborhood.

"Bye, Alex," Nicole says, turning to her younger brother, who is fooling around with his cousins. "I love you." Then she adds in an aside, "He listens to me, which is a plus."

As the team heads off in the van to shower and get ready for another lunch at another family-style restaurant, Aretha Franklin's "Respect" blares on the radio. The Monarchs go on to beat the other teams in their pool before dropping two in a row to fall out of the tournament. But for the time being, all is well. Apparently this is a song that everyone can agree upon.

"What you want, baby, I got it," Jackie shouts from the passenger seat, her right arm flailing out the window as the other girls join in.

> "What you need, do you know I got it
> All I'm asking, is for a little respect when you come home
> Just a little bit
> Hey baby, just a little bit
> When you get home
> Just a little bit
> Just a little bit
>
> "I ain't gonna do you wrong
> Ain't gonna do you wrong
> Cause I don't wanna
> All I'm asking for, a little respect when you get home
> Just a little bit
> Baby, when you get home
> Just a little bit
> Just a little bit
> Just a little bit."

Chapter 16

Every August some of the best basketball players in the world come to Paterson for a weeklong event in which they reunite with old friends and display their dribbles and dunks for the city's many fans. NBA players like Tim Thomas of the Milwaukee Bucks and Anthony Mason of the Miami Heat compete alongside high school, college, and older players on teams with names like Prime Time, Crash Crew, and Inner City Blues. Hosted by Tim Thomas, the Tim Thomas Playaz Ball was founded by him when he entered the NBA in 1997.

During his junior year at Paterson Catholic, the 6'10" Thomas received a scholarship from the Tri-County Scholarship fund to help defray his high school tuition. During his acceptance speech that night, he told a roomful of 800 people, many of whom were businessmen and -women from New York and New Jersey, that his goal was to play in the NBA and then return to Paterson and help the people who had helped him. In 1997, Thomas signed his first multi-million-dollar NBA contract, but Thomas and his mother, Dorothy, did not forget their promise. Through an Adidas connection, Thomas purchases athletic uniforms and gear for a number of teams at Paterson Catholic, as well as local AAU teams. He founded the Paterson Catholic Education Fund, which helps needy students afford tuition at his old high school. He purchases tickets to Milwaukee Bucks games for school kids who participate in the Drug Awareness Resistance Education [DARE] program in Milwaukee.

In 2000, the summer before Nicole's senior year, the Tim Thomas Playaz Ball is scheduled to begin on August 6. Back in the early part of the summer, Nicole has promised her doctor that she will take off the month of August to rest her knee and shins and give her body a break. With the AAU season over, Nicole has a month to relax and lift weights at the Y, which she does daily. But her world is not completely serene. A few days after the Playaz Ball begins, Penn State's assistant coach, Jennifer Price, leaves a message on Nicole's answering machine saying that the school has gotten a verbal commitment from another point guard and is no longer recruiting Nicole.

"It was great recruiting you," the message says. "Good luck, and if you have any questions, call us." Less than two weeks earlier, Penn State had told Nicole it still wanted her. The other point guard turns out to be Jess Strom from Munhall, Pennsylvania, who is ranked much lower than Nicole with the national recruiting services.

Ever since Junior Nationals, Nicole has been worried about the recruiting process and is having trouble sleeping. She lies awake wondering whether she will attend Pittsburgh, which doesn't have a big name but whose coach she likes, or Rutgers, which has the big name as well as a coach she admires. She wonders which college really wants her, and which might be a good fit. She has told Mos she is considering taking sleeping pills, but Mos flatly told her no, advising her to develop other relaxation techniques.

Penn State's news shakes Nicole perhaps more by the way it is conveyed than by what it means. Penn State was one of her top three choices, along with Georgia and Rutgers, coming out of the summer tournaments, so she must now strike the Lady Lions from her list. The fact that Penn State had Price leave a message on her machine instead of having its head coach Rene Portland call her directly upsets Nicole. Again, she confides in Mos, who has been through all of this before with the Wright twins, and that has at least given her perspective.

"The recruiting process is absolutely frustrating," Nicole says one day at the Playaz Ball. "It's just a weird process. At the same time, you don't just recruit somebody and then drop them like a bad habit. What if it's the school you most want to go to but you're eighty percent sure? You want to check out someone else. Say I want to go visit Georgia just to make sure Penn State is the place I want to be? Then you're just left out to dry. Your only other option is Georgia, and what if you visit it and don't like it?"

The Playaz Ball is under way, but Nicole isn't intent on going to the sessions every evening at Eastside, largely because the $5 admission charge is too much. On Sunday she goes with her family to watch Kwan Johnson, who is playing for a team called Nationwide Bail Bonds. On Thursday, she wants to see him again, but will have to either charm her way in or sneak past the security guards, who know her as a quasi-celebrity. She combines a little bit of both approaches.

As she walks in the gym for the 7 P.M. game, Nicole once again stands out from her environment. Most of the teenage girls are dressed in tight shirts and shorts. Many scope the crowd to see who's there, some carry babies. The boys wear baggy pants, tilted baseball hats, and BRYANT and IVERSON jerseys. Nicole is dressed in loose-fitting athletic gear and looks nothing like the other girls.

Hip-hop culture dominates teenagers in Paterson. For many, wearing the jersey of a pro athlete is a way of attaching oneself to the image of money, fame,

and success—a means of identifying with athletic superstars, many of whom are scarely older than these high school kids. Every time a Kobe Bryant, Tracy McGrady, or Kevin Garnett jumps straight from high school to the NBA and earns millions of dollars, thousands of teenagers imagine following in their footsteps. "If they did, why can't I?" goes the thinking. Danny Trapp, the brother of Nicole's old teammate Dakita, dreams of a big-time college and pro career, even though he has yet to be recruited by a single Division I school. Still, he hopes attending a junior college will lead him down the path of his dream. "If this basketball thing doesn't work out," he says, "then I might go to medical school."

At the Playaz Ball, Nicole sees her friend Nick Johnson, a physical education teacher at Paterson's School 6, whose daughter Nicole has worked out with at the Y. With the cell phone at his waist, the sunglasses perched on his forehead, and the way he greets people passing through the gym doors, Johnson looks like a well-connected man.

Nicole is still reeling from the Penn State phone call when she sits down next to him. She seems to be in a stream-of-consciousness mode about her fears regarding recruiting. "Get me to a school, I don't care where," she says. "If you payin', I'll be there. That's where I'm at." Suddenly, it's as if she no longer holds the power in the recruiting process. It has shifted from her to the college coaches, and now she's afraid of being left behind. Where she once dismissed schools like so many ugly boys inviting her to the prom, now she hopes that someone, anyone, will ask to be her date.

Meanwhile, Johnson notices his old Eastside teammate Tony Murphy standing at one of the gym doors. Forty-two years old, Murphy was drafted by the Kansas City Kings 1980 and tried out for several teams, including the Knicks and Nets, but never caught on in the NBA; he spent his years playing in Spain, the Continental Basketball Association, and Harlem's Rucker League. On this day he wears a white AND 1 shirt, blue shorts, and a Yankees baseball cap.

"Tony Murphy, nobody in Paterson could touch him back then," Johnson says while pointing out Murphy to Nicole. "He scored about twenty-eight points a game and you weren't allowed to shoot three-pointers. And he was a guard. Put it this way. Remember you and I came to see Horace? People used to come here to see him." Nicole saw Horace Jenkins, William Paterson University's star and a potential NBA player, the other day at the Playaz Ball. So she had a sense for what Murphy was all about.

"He's got two sons named Tony and Toney," Jackson adds laughing. "His rationale was that one day there'd be someone in the NBA named Tony Murphy."

"So, he got a lot of money now?" Nicole asks. Just then, Murphy, a burly 6'3", joins Nick and Nicole in the stands.

"I'm your PR man over here," Johnson says. "I've been telling [these people] about you."

"How much I owe you?" Murphy jokes.

Eventually, Nicole moves to lean against the wall because her back is acting up. A friend of Johnson's, Jackie Carter, seated behind him in the stands, points to Nicole and says to another man, "That girl, best thing in this county, boy. That girl is good."

Meanwhile, Carter's attention has turned to the entourage now walking across the sideline in front of them. Dorothy Thomas, a large woman with glasses, enters wearing a purple Bucks jersey with, NOTORIOUS T.I.M. on the back (Thomas has recently adopted this nickname). Flanking her are four large men and two others filming a documentary about Thomas's Milwaukee teammate, Rafer "Skip to My Lou" Alston.

"Tim gotta be playing tonight," Carter announces. "His whole family is here." Indeed, Thomas's team, the host Playaz, whose coach is Darryl "Jellyroll" Jacobs, is slated to take on Darryl's All-Stars in the second game of the evening. Rumors have swirled that Thomas might sign with the Chicago Bulls when his latest contract with the Bucks ended, but he has just signed an extension with Milwaukee worth close to $67 million.

"She's gonna eat real good now," Carter says, motioning to Dorothy Thomas.

"Yeah, ain't no more McDonald's," Johnson says with a laugh.

"Unless she want it."

"'Skip to My Lou' is here," adds Nicole. Famous in the New York basketball scene for his uniquely deceptive handle, the 6'2" Rafer Alston came out of South Jamaica, Queens. He got his nickname from an announcer at Harlem's Rucker Park after he started skipping with the ball during a game. Nicole and her friends watched highlights of his moves from Rucker spliced together with rap music on a tape put out by And 1, the sneaker manufacturer.

"Where?" Carter asks.

"The one with the fine-ass woman," Johnson says. Alston is standing courtside next to an attractive woman wearing tight leopard-skin pants. She is hard to miss.

"Sixty-seven million," Johnson, who still can't comprehend the size of Thomas's contract, says again for emphasis.

"Can I get an entourage with that?" Carter asks.

"It depends how much you want. You want a two-man entourage, four-man entourage?"

"I got an entourage," Carter says, pointing to the friend seated next to him.

"But they like you," Johnson answers. "You only got a real entourage when they don't like you. When they laugh at your corny jokes, you know you got an entourage."

Anticipation for the main event of the evening is now on the rise. On nights when Thomas has not been competing, the crowd has been spotty, but now the stands are beginning to fill. The parking lot is overflowing with cars and sport utility vehicles, the nicer ones presumably belonging to Thomas's entourage. It is a hot, muggy evening, and people fan themselves with a colorful cardboard party invite that features pictures of Thomas on both sides, and reads, THE OFFICIAL PLAYAZ BALL TOURNAMENT AFTERPARTY. Rap music with a heavy bass plays loudly over the sound system. Adidas banners hang on the scorer's table and on the wall at either end. Jim Salmon, Thomas's former coach at Paterson Catholic and now his Adidas contact, sits on a stool in the corner of the gym surveying the action. A little girl walks around wearing a shirt that reads, MILWAUKEE LOVES YOU on the front and THOMAS NO. 5 on the back.

As Thomas and his teammates run a layup drill to warm up, children scurry gleefully around the court, ignoring the older men at work. Michael Cleaves, Kennedy's standout guard who missed the state playoff with Passaic after cutting classes, warms up for the Playaz.

"Nicole's the female version of Timmy," Johnson says rather boldly in the stands. "She's probably the best female player ever out of Paterson. She has the game, and she can't get enough of it."

When the action begins, the Playaz seize an early lead behind showy moves from Thomas and Alston. This is no place for fundamental basketball. When Alston throws a pass to Thomas a third the length of the floor for a dunk, the crowd can hardly contain its excitement.

"Poster child," Nicole exclaims, referring to the gentleman on the other end of Thomas's dunk.

It is Alston's ball handling that most impresses her, though. Like Nicole, he wears No. 11, and so, ironically, does the man guarding him in this game. At one point while dribbling, Alston extends the ball over his defender's shoulder to make him look. When the defender bites for the fake, Alston spins around and drives to the basket.

"That's too funny," Nicole says. "That's funny as hell. That's hilarious. He spun all the way around."

Later, when Darryl "Jellyroll" Jacobs, the Playaz coach, takes Alston out of the game, Johnson clamors for him to be put back in.

"Hey, Jellyroll," he yells across the noisy gym, "stop coaching. Put Skip to My Lou in. We paid to see Skip to My Lou. Hey, Skip, put yourself in."

Nicole wants the guy wearing No. 11 on Darryl's All-Stars, whose name she does not know, back in the game so he can cover Alston.

"Put Number Eleven back in," she yells. "It ain't a game without Number Eleven. That's what I'm talkin' about. You gotta put Number Eleven back in. Make things interesting."

Now, with both coaches giving in to the fans' call to put both No. 11s back in the game, Nicole and Johnson are appeased.

Anytime someone hits a jump shot, a burly announcer whose microphone is turned way up, shouts, "Stop, pop, and drop." It gets a little old after the first few times.

Nicole loves to analyze other players' games, and this event is no exception. She is a staunch believer in aggressive defense, and after Michael Cleaves gets scored on, she proclaims, "I ain't never seen Mike play no defense in my whole life."

When the game is over, Nicole wants to get Alston's jersey so she has a famous No. 11 for her collection. She approaches him, patiently waiting for him to sign a few autographs and talk to his people. Then she steps up to the NBA guard and calmly says, "Skip, Skip. My name is Nicole Louden and I wanted to know if I could have your jersey."

"After the tournament," Alston says.

"Number Eleven right here," Nicole says, proudly pointing to the necklace she wears around her neck with NO. 11 emblazoned on it. Laura Judge had given it to her.

"What about Horace?" she asks, inquiring about Alston's opinion of Horace Jenkins.

"I don't got no respect for him," Alston says. "He play D-Three [Division III basketball]. He plays against guys this big," he adds, pointing to a small boy nearby. "Who is he? That's the million-dollar question."

Satisfied that she will get the jersey when the tournament is over, Nicole departs for the evening. On the drive home, at about 11 P.M., a drug dealer stationed on the corner of Tenth Avenue yells in Nicole's direction, "Yo, what up? What up?" Nicole laughs off the incident. For the moment, she isn't worried about drug dealers. She isn't worried about recruiting. She seems to have put Penn State in the back of her mind. She is simply a teenage girl excited about getting a new athletic jersey for her collection.

* * *

Three days later, Nicole is back in the Eastside stands for the finals of the Playaz Ball. This time her younger brother is with her. In September Alex will turn 10 and he has just begun playing organized basketball. He doesn't exactly show his sister's polish yet, but he is eager to play. He seems to idolize his sister. And Nicole wants her brother to become the best player he possibly can.

Nicole notices Keith Davis approaching. Davis coached Nicole on a team called the Knights in the Paterson Midget Basketball League back when she had the beginnings of a jump shot and the first glimpse of a handle.

"Yo Keith, what up?" Nicole says playfully. "My brother right here. When you gonna get him on a team?" Davis and another coach move over toward Alex and Nicole.

"What's up, Big Dog?" he asks Alex. "What's your name?"

"Alex."

"How old are you?"

"Nine."

"You want something to drink? We own the concession stand." The last comment comes with a laugh and seems intended mainly for the benefit of the other coach, who presumably will be contending to land the younger brother of the famous Nicole Louden. "You gonna be going through all the same things Nicole did." Davis then leans over toward Nicole and whispers in her ear, "Tomorrow, seven o'clock. School Four."

Now that Nicole has settled her brother's situation, her focus returns to her own. Taking a month off is difficult and has her itching to get back on the court.

"I gotta get my skills up," she tells Alex, who is only half listening. "I gotta get my jump shot, run faster, run harder, play better defense. I gotta get my skills up." And with that, she takes her ball out onto the court to shoot. The finals are still a few minutes away and the court is filled with about 20 nine- and 10-year-olds chasing one boy with a ball around the court. Many wear PLAYAZ shirts, indicating that they compete for one of the younger AAU teams sponsored by Thomas. As Alex looks on from the stands, anxious to get his burgeoning career started, a friend of his approaches and the two boys high-five.

"Yo, I'm having my game Monday," Alex tells the friend with a smile.

"Who you play for?" asks the friend, whose shirt reads RIMROCKA.

Alex, not sure what the real answer is, says "School Four." Now Nicole has given up shooting and is back sitting next to her brother. The friend, unsatisfied with Alex's answer, asks, "What team he play for?"

"He about to find out tomorrow."

"What team you play for?" Alex asks, as if the friend knows something he does not.

"Marty Barnes," says the boy, announcing a team named after the Paterson mayor.

"Well, he ain't playing for Marty Barnes," snaps Nicole.

Impatient with the boys' conversation, Nicole grabs her ball and walks down to a corner of the gym where she can dribble and shoot away from the army of

small boys. There she dribbles the ball back and forth between her legs and shoots at an imaginary basket on the wall.

When she comes back to join her brother, he takes hold of her ball, prompting her to give him a lecture on the importance of basketball.

"Yo, lemme have the rock," she says. "When you play ball, the rock is your life. You can't live without it."

Now she surveys the players warming up, the crowd assembling, and listens to the rap music playing. It seems to inspire her to imagine a tournament of her own like this someday.

"Yo, I hope when I get to college, I blow up my senior year and go to the pros. Keep working hard, blow up. It's over. Then I'll have an event like this. But for the girls. All the pros gonna be there. Sheryl Swoopes, Cheryl Miller, you can't have an event without her. She's the ambassador of the game. You gotta bring Meek," she adds, referring to Chamique Holdsclaw. "And you gotta bring the people in my class. Kara Braxton, Shyra Ely, Cappie. And Usha Gilmore," one of her old friends from the Rutgers camp.

After the tournament is over, and Thomas, Alston, and the Playaz have captured the championship, Nicole is intent on getting that No. 11 jersey Skip to My Lou promised her.

She sidles up to him by the victorious bench, and waits for a moment while he accepts congratulations. Behind her, Milton Evans stands with his arms draped around Alex's shoulders. He came to watch Kwan play and is now spending time with his "adopted" children.

"I don't mean to rush you, but I gotta go," Nicole says to Alston.

"Somebody already got it," he tells her.

Somehow, Alston manages to find another No. 11 jersey and then softly tosses it to Nicole, symbolizing some kind of transfer from pro to high school player.

"Yo, she got the jersey," a teenage boy says in amazement to two of his friends.

Now that she has gotten what she came for, Nicole meanders through the crowd and heads for the door. There an older man stops her briefly to make conversation.

"I haven't been to a girls' high school game ever, but I'm gonna go this year," he promises.

Out in the parking lot, Nicole is excited about the jersey, her latest acquisition for the No. 11 collection. But she is ready to go. "Get my black ass outta here," she announces.

On the drive home, she is still inspired by Thomas's event and what it all means. "I'm gonna get my game up, man. I'm gonna lift. At events like these you see how people have made it. It makes you want to work so much harder."

Chapter 17

The Internet has not only transformed politics, education, and the economy, but also radically altered college basketball recruiting. With the development of cybertechnology, anyone, anywhere in the world, can obtain results and analysis of a player or team's performance almost instantaneously. With the evolution of specialized chat rooms devoted exclusively to women's basketball, anyone can post an opinion of a player, sometimes sparking lively debate about his or her pros and cons. Because all universities now have Web sites featuring vital information about academics, athletics, and student life, recruits can learn a great deal about a school before ever making a visit. Perhaps most important, players can communicate with college coaches on an unlimited basis. The NCAA regulates telephone contact but has yet to limit the amount of e-mail contact a coach can have with a recruit.

As August moves along, and Nicole wonders what her future holds, she spends a lot of time on the computer at Joan and Kesha's house. On August 21, anxious to know where she stands with Georgia, she sends the following e-mail to Coach Andy Landers:

Hello Coach Landers,

I hope all has been going well when you receive this e-mail. I was just writing to you in regards of UGA recruiting me as a student/athlete. I haven't spoken to you or your staff in awhile, and I just wanted to know if you guys were still recruiting me or not. If so that's great, because I am still extremely interested in UGA, and would like to take an official visit, however, if your staff is no longer recruiting me then can you please reply to this e-mail ASAP, and let me know; I would greatly appreciate it. I've enjoyed talking to you and your staff and I've done a lot of research on your program, both academically and athletically. I

hope to hear from you soon and please tell Coach Flournoy I said hello. Thank You. I hope you have a GREAT day.

Thinking about becoming a Lady Bulldog,

Nicole Louden #11

In the meantime, Landers has spoken with Coach Fuccello and Fu has laid out her case for Nicole: she can score, rebound, and pass, and she possesses great vision. Landers explains that he and his staff are deciding between Nicole and another guard, who he thinks might be quicker. They will get back to Nicole.

* * *

The Rutgers women's basketball chat room and the UConn "Boneyard" messageboard are two of the most active Web locations in all of women's college basketball. In the Rutgers chat room a hardcore group of fans regularly chat with one another about everything relating to the Scarlet Knights, from a current player's latest injury to who the hot recruits are for the following season. Throughout the summer of 2000, fans have regularly posted opinions and updates on where Rutgers stands with various recruits.

One of the hottest topics is whether Coach Stringer and her staff will go after Cappie Pondexter or Nicole, or both. Many of the people posting messages are intimately familiar with Nicole's game because of her experience at Stringer's camp. Rutgers fans regard Nicole highly, both as a player and person, but there are many who feel that Cappie is simply a better player. A few days after she sends the e-mail to Coach Landers, Nicole decides to post a message to the Rutgers site, a fairly rare move for a prospect.

This is Nicole Louden and a friend of mine told me about this interesting forum, so I decided to share some ideas/comments. The recruiting process has been hectic, however, I am still EXTREMELY interested in RU, among other schools, which I choose not to mention at this point. As far as UCONN goes, I am not sure what happened along the line. I haven't spoken to the staff, so I suppose their interest has faded which is fine, because they might be looking for a guard they feel can fit their style of play. I wish them lots of luck in the future.

By sending this message, Nicole is clearly signaling Stringer and the Rutgers coaches that she is still available. But to the Rutgers fans, the post is a sort of

honor. Here is a player many of them admire taking time to communicate with some of the most ardent fans in the game. Nicole's post prompts several responses like this one:

> If you look at the thread which is titled cappie and louden, someone claiming to be nicole posted that she is still very interested in ru and some other schools, which she did not mention, and what happened with uconn. Of coarse [sic] we can not be sure that this is nicole, but if it is, it would be so awesome. I responded to her post, saying that we'd love for her to come to ru and that if there was a way she could prove she was nicole, we'd love for her to do it. Nicole, if that really was you, please post again!

Another person followed with this post:

> I'm 99% sure that it was Nicole, not an imposter . . . if so, I hope she ends up at RU, because it sounds like she'd really like to stay home. We currently have just 1 NJ player on the roster (Amber will make 2 when she arrives) and I would like to see more.

Amber Petillion, a 6'4" forward from Brick High School in Brick, New Jersey, has recently made a verbal commitment to Rutgers.

Nicole is also fond of checking in with New Jersey Online, a forum devoted to discussion of the state's high school sports. Its fans tend to be more blunt than those on the other sites.

On August 27, one fan provokes Nicole's ire by writing the following on the girls' basketball forum:

> There are no solid all-around players in NJ right now. Most of them are too slow, shoot too much or can't play defense. Lots of mid-level d-1 [Division I] players in this state.

Someone else has added:

> Louden is a good player, great by NJ standards, but there are many guards her size at this point in their careers [who] are far more advanced. Same for the other players. I'm not on crack. They lack serious ability that it takes to play at a major d-1 school. Guess what, if you are not already being seriously recruited by a top ten d-1 school and I mean just about ready to give your verbal, you ain't going there. The Tenns and UConns already have their players lined up.

> Jersey girls' basketball is way behind the rest of the country when it comes to developing a lot of good top d-1 players. Jersey coaches and parents should try to figure out why that is. The talent is here. It's just not going anywhere. Before you all start attacking me just make a list of the players from NJ who have contributed to a top ten d-1 program in the past five years. It will be a very short list.

Whoever posted this was correct about several things. The Tennessees and UConns of the world long ago targeted their recruits for the class of 2001, and now it is a game of chicken. In September, college coaches will have a 21-day window in which they can pay visits to recruits at their homes. Players are allowed to make a total of five official visits to campuses between September 9 and 29. In the days and weeks to come, there will be a flurry of commitments, with virtually all of the top players expected to choose a school by the November 15 deadline.

The author was also correct in that historically New Jersey has not been considered a hotbed for girls' basketball as much as states like Texas and California.

On August 28, Nicole, feeling the need to defend herself to her critics, writes the following response:

> Nicole isn't great by NJ's standards?...she's good by the country's standards...She works hard and can run with the best of them...Have you seen her play? Her team has a couple of good players on their team besides her, but she puts that team on her back every game and plays her heart out...D-1 ball isn't all about physicality, it's about heart and what you believe you can do, and then going out there and working hard for it...

When someone responds to this post questioning Nicole's play over the summer, she answers.

> For your info, she was seriously injured...with THREE injuries, but I suppose you failed to see that...she's been competing against the same people for 3 straight yrs. in AAU, so do u really think it was that much different? NO...Need I remind she went to the Jr. Olympic Try-Out, then the very same day she came home she had to go to France...upon her return she had practice that night, a tourney the next day and it was off to TN. She PLAYED through the PAIN...other players would of probably cried about the pain and opt not to play but she did...too bad you don't know the kid then you would understand...

Whether the person who had attacked Nicole on the Internet was familiar with her play over the summer is unclear. Nicole's injuries did hamper her mobility. Still, it is Coach Landers's response on September 1 to Nicole's e-mail that begins to confirm her worst fears:

Thanks for your recent e-mail and it was quite timely as I had just talked to Coach Fuccello the day before. Just as you have narrowed your list of schools, we have been in the process of narrowing our list for prospects. I want to congratulate you on all that you achieved to this point and wish you the best as you continue forward in your selection process. I do, however, [think] that it would be in your best interests to consider schools other than the University of Georgia. I know that you are an outstanding young lady, very good student, and terrific basketball player and that you will do well at the next level. We have decided for various reasons to pursue other options at the point guard position. I hope that our paths cross often in the future, as I am and always will be a big fan of Nicole Louden.

Sincerely, Andy Landers

When Nicole receives this message, she can hardly believe it. "Wow, just like that they're dropping me?"

Landers was perhaps Nicole's most visible fan at the Nike camp and Junior Nationals. After Penn State fell through, Nicole was so confident that she would attend Georgia that her sister Karen opted to transfer from her Army post on Long Island to one in Augusta. "I figured somebody gotta be close [to her]," Karen said. "That's where she really wanted to go."

Nicole does not know why Landers is pulling out. He clearly needs a point guard. Perhaps he has seen something in Nicole over the summer that has turned him off. But what was it? Her weight? Her injuries? Her attitude? It certainly wasn't her grades. In recruiting parlance, Nicole is what is termed a "full predictor," meaning that her academics are so strong they leave no doubt about her freshman eligibility.

Unfortunately for Nicole, there is no way of finding out why Landers backed out. When coaches recruit you, they tell you everything they like about your game. But when they pull out, you never get a full explanation.

Nicole just can't understand it. First Penn State withdrew, now Georgia. She continues to have trouble sleeping. Her future seems to be at stake and it appears that she may be a has-been before her senior year has even begun.

Landers does take the time to send Coach Fu a two-page letter explaining that he felt the other player brought something to the table that Nicole did not, a gesture that Fu finds extremely classy. The identity of the other player is unclear. Landers was heavily recruiting Courtney Young, a highly regarded combination guard from Ventura, California. In the end, though, Young chose Tennessee over Georgia, and Landers signed only one guard, 5'11" Whitney Law, during the early period. In December 2000, a former Long Island star, Nicole Kaczmarski, a 5'11" guard, will transfer from UCLA to Georgia, alleviating the Bulldogs' backcourt situation somewhat.

* * *

As the various recruiting services make public their rankings throughout September, it becomes obvious that Nicole's stock has fallen in the eyes of the so-called experts. Mike Flynn's Blue Star Report, which had listed Nicole as the top guard in the nation as a junior, now ranks her the No. 4 senior guard in the country behind Cappie Pondexter, Loree Moore, and Ashley Allen. Joe Smith's Women's Basketball News Service previously ranked Nicole the twenty-ninth best junior overall, but now puts her only among the top 50 seniors. Mike White's All-Star Girls Report listed Nicole as the sixteenth best senior prior to the summer recruiting circuit; now it lists her as No. 47.

All of them eventually say that Nicole's weight gain worked against her, and that her knee injury slowed her. Some cite additional factors as well. Flynn, who has had the most contact with Nicole, says some coaches may have perceived Nicole as being "difficult" to deal with.

"You gotta be very congenial, you can't show a lot of ego and personality in your play and you have to have fun," he says. "I can see from being around Nicole, I can see where she is very hard on herself. And because she's used to doing so much herself, people may get the wrong impression of her as being somebody that's not gonna blend in."

He also says some players in New Jersey "just didn't like her." "I heard a group of players thought she was moody, selfish, thought she was a bitch and that she wasn't that much fun to play with." He won't say who those players are. How much credence coaches give to this type of commentary is unclear, but Flynn acknowledges that once a rumor starts, it is hard to stop.

Flynn further suggests that some coaches may simply have had trouble getting in touch with Nicole because her phone number had changed over the summer. A coach from George Washington University called him for her phone number. "That's a silent killer," Flynn says. "If you're not accessible, people move on."

Joe Smith does not know Nicole as well as does Mike Flynn, but he was at the U.S. Junior National trials in Colorado Springs in June and says she simply did not play well there.

"She tried to do too much," Smith says. "Geno [Auriemma] told all the players just to play basketball, not to do more than they're capable of. She definitely looked slow and did not play well. When you come to those trials, you have to be in the best shape of your life. They're not in their season shape, and a lot of them don't understand what work is. A lot of them are not prepared."

Smith also says Nicole's height may have worked against her. "She's small yet she lacks the quickness and the fundamental game to get away with that."

Bret McCormick of the All-Star Girls Report, a big fan of Nicole's, believes she is still probably one of the top 25 or 30 players in the country, but says that other girls simply played better over the summer. "We know she's a great player, but she's not higher because of her performance this summer. She put on a few pounds. That doesn't mean she still can't play about anywhere in the country."

He suggests that if Nicole were to wait until the spring signing period, "everybody will be knocking down her damn door. When they don't get the player they want, they'll come looking for her. Wouldn't you?"

* * *

Nicole initially resisted the idea of signing in the spring primarily because she wanted to be someone's first choice, not relegated to the late signing period when only the "leftovers" would remain. But now that Georgia has lost interest, Nicole is reevaluating. She is considering waiting until the spring to see if other schools become interested. Publicly, she says she understands Landers's decision.

"I'm very aware that it's a business and they're trying to get ahead just like the next person," she says. "By the same token, I can see where they're coming from. They're giving out a scholarship worth fifteen, twenty, twenty-five thousand dollars, and if they feel another guard can give them what they want, they should go for it. If I was in his position and I felt someone else could do the job better, of course I would take that person."

But privately, she is becoming more and more disillusioned by the recruiting process. In a looseleaf notebook she writes:

> This is the way that I feel. Can you tell? Of course you can't tell. I prance around seeming to be happy and delightful, trying to be what everyone expects of me, but inside people just can't see. The hurt and pain which dwells in my soul.

> *No people to hear me vent or express my fears. Lately this is the way I've felt inside, the hurt and pain I've tried to hide. No one to talk to and no one to see all the problems which are aching me. And when the pressure is unbearable I put my head in my hands while the tears begin to flow, and while this is going on no one seems to know. And when everything around me seems to be going wrong, something inside me says, "Nicole, be gone." So as the days go on I stay to myself, not daring to look or speak to anyone else. And when people say, "Nicole, are you O.K.?" I just look at them and say, "Yeah, I'm great." While all the while I feel like a fake.*

At the end of her sophomore and the beginning of her junior year, the recruiting process was fun, with coaches sending her letters, cards, and FedEx packages on a daily basis and every school in the nation seeming to want her talents. But now, the cold hard world of recruiting is coming down on her full bore.

"I love the game, but I don't like the game," she says one day over lunch. "People take it so serious. Everyone takes it so seriously, schools, the paper. As you get older, it gets more serious." She seems to be looking forward to college—"I'll probably be more in the background than I am now."

She confesses that perhaps she shouldn't have told all those schools back in July, the USCs and Michigan States, that she wasn't interested. Maybe she should have left her options open just in case. "All the schools I've turned down, maybe I shouldn't have turned down," she thinks. At the time, Nicole figured she would have many options to choose from—Penn State, Georgia, Rutgers, Purdue, and so on. She didn't have any intention of attending certain schools and she thought it best to tell them so. That way she wouldn't waste their time, and they wouldn't waste hers.

But now, as schools slip from her grasp like sand through her fingers, she realizes it wouldn't have hurt to have remained in touch with those coaches, just in case. She is hurt and she is beginning to sound like a battle-tested veteran, warning younger players to be wary of all the letters and promises.

"It don't really mean much until a head coach gives you a call," she says. "They're sending like three hundred letters out per week. Don't get a big head if you start getting letters. They're looking at fifty other players for your position."

As she rolls over and over in her mind the various critiques of the recruiting experts, the reasons why her stock seems to have plummeted, she tries to make sense of them. Tries to make sense of the notion that she is somehow "difficult" and isn't coachable.

"Until they've coached me as a player, then they really can't say whether I'm coachable or not," she says. "I think I'm coachable. My job is to go out there and

do my job. If my coach says go out there and get such and such number of assists, then that's my job. If she says, 'Nicole, we're not gonna win this game unless you score thirty points,' then that's my job." And, in fact, scoring 30 points a game has been Nicole's job for the better part of two years.

As far as her injuries and conditioning are concerned, Nicole felt she had no choice but to play over the summer. She desperately wanted to obtain a college scholarship and knew that the summer recruiting circuit was the only way to ensure that the top colleges would see her.

"I was in a no-win situation," Nicole says. "If I hadn't played, the coaches wouldn't have seen me. They could have come to Paterson to watch Kennedy play, but that is not national competition. I did what I had to do in terms of getting a scholarship to college."

The whole process seems to be making Nicole increasingly suspicious of the so-called recruiting experts and others who may want to bring her down.

"People are always quick to assume something negative," she says. "People are always ready to bring you down. You always gonna have haters whether you Michael Jordan or some bum on the street. Rankings don't really matter to me. You don't know the reason why I didn't play well at nationals. You can't change people's way of thinking, you just have to live with it and get over it. Last summer I had a dynamite summer. This summer I had a bad summer. In the fall, if I play good, people will wonder, 'Oh, what did she do to improve her game?' My thing is to show them. In my heart, I think I'm one of the top players in the country.

"My main goal is to become healthy. The way I played this summer, I had limited success. When I'm healthy, there's no telling what I can do. As long as I have my friends and family and the Lord by my side, what I can do is limitless. Everyone can doubt me if they want to, but I have confidence in myself and confidence in my ability. My main goal is to go out there and do what I like to do best—play basketball, try to make my teammates look good, and produce W's [wins]."

Part 4

*Fall 2000:
Decisions, Decisions*

Chapter 18

Back in the spring, when Georgia and other top-ranked schools were sending Nicole Priority Mail packages, she never would have considered a place like the University of Nevada–Las Vegas. One day when she got letters from 10 schools, including UNLV, she opened only a package from Georgia. "I just throw away the ones I'm not interested in, like UNLV," she said then. The UNLV men's team had gained national recognition ever since it captured the NCAA Championship in 1990 behind the future NBA players Larry Johnson, Stacy Augmon, and Greg Anthony, but the women's team never garnered much national attention.

Now, like a jilted lover looking for a rebound fling, Nicole is all too willing to consider UNLV. Las Vegas Head Coach Regina Miller and Assistant Coach Brenda Pantoja have watched Nicole during the summer tournaments and then stayed in touch in the weeks afterward. Nicole noticed Coach Pantoja tracking her at Junior Nationals.

"Dear Nicole," said one card written in late August by Assistant Coach Kristin "Kit" Cole. "Hello from beautiful Las Vegas! I hope that you are doing well and getting excited for your senior year to start. I am really looking forward to meeting you and having you here on campus! I know once you come and visit, you'll want to stay and be a Rebel! See ya soon."

Coach Miller led a remarkable turnaround entering her third season at UNLV. After inheriting a program that had won only four games in the three seasons prior to her arrival, she posted two straight 17-win seasons and opened up international recruiting lines that landed some prized recruits. She led UNLV to its first appearances and victories in both the Western Athletic Conference and Mountain West Conference tournaments. The school had such confidence in her that it gave her a two-year contract extension in August.

In Nicole, Miller sees a smart, athletic player who would fit her run-and-gun, up-and-down-the-floor style. Miller and Pantoja have been remarkably

persistent with Nicole. When many other coaches would have given up, assuming they were not high-profile enough to land her, the Vegas coaches have been able to arrange the first visit of the September period with Nicole. They are scheduled to come to Kennedy during the first week of her senior year.

* * *

With the recruiting process now taking up a large part of Nicole's time and thinking, she discusses volleyball with Laura Judge several times during the first days of school. Judge does not want her to play. Charlie Bell, the volleyball coach, does. Nicole considers her options, and ultimately decides that playing volleyball is not worth the risk. She needs to rest her body and prepare for basketball season. Bell knows he will be without his best player, but eventually agrees that Nicole's decision makes sense. "You might be better off just sitting out volleyball and taking care of your legs," he says.

On September 11, just a few days after school has begun, the two UNLV coaches arrive at Kennedy to meet with Coach Bonora. It is something of an odd situation for Nicole and her coach. Bonora has only returned as Kennedy's coach during the summer and has yet to coach Nicole in a game. He is familiar with her talents, having followed her career during his absence from the program, but he certainly isn't in a position to talk extensively about her strengths and weaknesses. What he does have going for him is an easygoing personality and experience with players and recruiters. Over a 30-year career coaching baseball, basketball, and football, Bonora has won league and state championships, has coached future pro football and basketball players, and has helped almost three dozen athletes earn grants or full scholarships to college, including Falisha and Lakeysha Wright and Meticia Watson.

Coaches Bonora and Miller are ahead of the game because they have known one another since the days when she was an assistant at Old Dominion and had unsuccessfully recruited the Wright twins. Prior to her coaching career, Miller had spent two years as a point guard at Old Dominion in the early 1980s, helping the Lady Monarchs to the NCAA Final Four. Now, Bonora greets Miller and Pantoja, both wearing white-and-red UNLV shirts, and walks them down a school hallway toward an empty classroom where they will watch a couple of videotapes. As he guides them through the hall, he points to an Athlete of the Week plaque mounted on the wall. "There's Nicole," Bonora says proudly, gesturing to Nicole's likeness on the plaque.

Bonora supervises an In-School Suspension (ISS) class for two periods each day in addition to his social studies classes, and that is the classroom to which

he takes the coaches. It is located across the hall from the School Based office where Nicole and her friends congregate. A television set and VCR are positioned on a stand in the corner of the room. The three coaches take seats nearby. Just then, Coach Ring, who also supervises ISS classes, sticks his head in the door wearing his trademark red Kennedy sweater over a white shirt.

"This is Coach Ring, the head boys' coach," Bonora says in a friendly tone to the women. "This is Regina. She used to recruit the twins for Old Dominion University."

"Oh, you're here to see Nicole," Ring says. "Good luck. You got a great kid on your hands. I don't have to tell you that."

"I've always been a mentor to the twins," Miller says, trying to connect with the Kennedy coaches. "They still call me."

After Ring leaves, the coaches pop in a UNLV highlight video intended to show Bonora the style of play the Lady Rebels favor. The video depicts the team's best players, showing a series of exciting fast breaks, layups, and steals. It also draws attention to the Thomas and Mack Center, the 18,500-seat arena in which UNLV's teams play. "What do you have, four of the five starters coming back?" Bonora asks.

"This year we don't graduate anyone," Miller answers. "Next year we graduate four." That, of course, spells good news for Nicole. Should she decide to attend the school, she would have an opportunity to earn playing time early.

After watching the UNLV video, Bonora inserts one of Nicole's game tapes. The coaches have already seen her on several occasions, but this gives them an opportunity to discuss her skills in context. The tape shows Nicole as a virtual one-woman gang, scoring on drives to the basket and 3-pointers from well beyond the arc. As all three coaches look on with amazement, Bonora narrates: "I assume we're gonna see all box-and-ones and triangle-and-twos," he says of the defenses he imagines Nicole facing. "She can just come down and pop one. She's got such range. She's got great range. I haven't coached her for one minute."

When the tape finishes, Miller and Pantoja tell Bonora they are planning to head back to their hotel before going to Nicole's house for dinner and a home visit this evening. The courting of Nicole has begun.

* * *

On their way to Nicole's house, Miller and Pantoja get lost on Route 46 before calling Carmela Crawford and Nicole to come meet them. The Richmans have been looking forward to the first visit by a college coach to their home, and Euphemia cooks curried chicken, jerk chicken, and a host of other specialties

for the occasion. Joan, Esther, Lorna, Kesha, and several of Nicole's younger cousins are in attendance, as are Mos, Crawford, and Milton Evans. Between the adults and the kids coming in and out, there are about 15 people in Nicole's living room for the visit.*

By all accounts, Miller makes a strong, compelling presentation to Nicole, her family, and advisers. She explains that Nicole will be expected to maintain a high GPA to compete, and that tutors and laptop computers will be made available during road trips. She tells Nicole how the team's offense is suited to her style of play, and that she can spend time at both guard positions. She likens a basketball team to a fist, and says that just as you can't make a fist without a thumb, you can't have a basketball team without a point guard. "Think about the things you couldn't pick up without a thumb," Miller says. She tells Nicole she can be the one who puts UNLV's women's program on the map. Pantoja, who played point guard at Arizona when Falisha and Lakeysha were at San Diego State, once again emphasizes that both women know the Wright twins from the old days, and remain in touch.

When it comes time for questions, Nicole's relatives and coaches have several. Crawford wants to know whether Nicole is Miller's No. 1 recruit at point guard.

"That's why we're here," Miller says, making Crawford feel as if she hasn't gotten a complete answer.

Evans asks whether Miller is definitely going to be at the school for the next four years, prompting the coach to explain that she has just signed a contract extension.

Joan wants to know whether there is a sprinkler system in the dorms. The question may seem odd to the coaches at first, but it is on the minds of many in Paterson. A fire in a Seton Hall University dormitory the previous January killed three students and injured 58 others. Two of the students most badly burnt were Kennedy graduates, including Dana Christmas, a resident adviser who went through the dormitory warning fellow students and suffered burns to over 60 percent of her body.

Andrea asks how often Nicole will return to the Northeast for games. Miller says the school might attempt to schedule a game with St. John's in Queens or another Northeastern team, but that basically the Rebels play on the West Coast.

*NCAA regulations specify that "an institution's coach may not permit a media entity to be present during any recruiting contact made with a prospect," so I was not present for the home visits. The rule is intended to prevent one school from obtaining a competitive advantage over another by bringing its own media contingent. This account is based on interviews with those who were present.

Andrea is primarily concerned with education and medical care. "They tell me stuff that I wanna hear," she says. "Their medical staff was excellent. I don't want when she get injured they take two to four hours to get to her. And the academics. If she's not going to get a good education, I don't see why she should go there. And suppose something happens to her. She needs to have a career. She needs to have something to live off of. If I was a millionaire or a billionaire, it wouldn't matter to me. But I can barely make it."

All in all, everyone agrees the meeting went well. "We had a lot of fun," Euphemia says. Nicole and the coaches decide that Nicole will make an official visit to the school in late October. Crawford wants to accompany her.

So, the visit is set. Nicole likes both women, but she isn't convinced UNLV has a high enough profile for her. And she is concerned about how far the school is from her home and family.

A few nights after the UNLV meeting, when Andrea is at work and Nicole and her grandmother are sharing a moment alone in the kitchen, Nicole asks, "Mama, what you think of me going that far?"

Euphemia doesn't know too much about college basketball, but she knows if something makes her granddaughter happy, it is probably a good thing.

"Well, honey," she answers, "if that's where your destiny lies, go there."

* * *

On Thursday, September 21, Coach Joe McKeown of George Washington University in Washington, D.C., is scheduled to come. It will be Nicole's second home visit. The Colonials went 19–9 the season before and finished thirteenth in the nation. They are not exactly UConn or Tennessee, but they are one of the better teams in the nation. GW reached the Elite Eight of the NCAA Tournament in 1997.

American University's head coach, Shann Hart, is to come the following day. Nicole has no intention of attending American because it is not a high-profile basketball school, but she feels indebted to the coaches who have expressed such strong interest in her.

As she sits in her chemistry lab class on this sunny afternoon with blond streaks in her hair thanks to Kesha, she doesn't appear too high about McKeown's upcoming visit or too low about her prospects. Instead, several Bengali friends are taking the opportunity to talk to Kennedy's best-known female athlete about her potential career in the WNBA.

"You better learn how to dunk because WNBA be boring with those layups," says Nicole's friend Saiful, a tall, talkative boy wearing glasses. "That's like the most highlights you get.

"Who had the buzzer beater last year?" he asks, referring to the game-winning shot that went two thirds the length of the court in the WNBA Finals and was then replayed over and over on highlight shows everywhere.

"Teresa Weatherspoon," Nicole says before taking up her friend's comment about dunking. "Women don't play close to the rim. You have to realize, a six-five person in the WNBA is a center, a six-five person in the NBA could be a point guard."

"They should make the court a little smaller," jokes Salah, another member of what Nicole calls the Bengali clique.

"The ball a little smaller, too," adds Saiful, who clearly doesn't follow women's basketball enough to know that they already play with a smaller ball than men.

Nicole, the only girl in the small group of friends whiling away time in chemistry lab, later turns her attention to her need for a date for the senior prom at the end of the year. As she sits on top of the radiator near a window, she yells toward another friend, "Anthony, you wanna take me to the prom, Anthony?"

"I'm not going," says the boy in the green shirt sitting quietly in the front of the room.

"I got shut down by Mr. Anthony Valli," Nicole announces with a laugh to everyone, including the teacher working one-on-one with a student at the front of the classroom. "He's not taking me to the senior prom."

"Ask Salah, he needs a green card," interjects Monojir, the third member of the Bengali group.

"I'll just have to go to my second option," jokes Nicole, who has no alternative in the works.

After discussing the latest High School Proficiency Test, the boys shift back to basketball. They are well aware that Nicole is a star, but they're not quite in tune with the specifics of her recruitment.

"Nicole, you know where you wanna go?" asks Salah. "Tennessee? Connecticut? Rutgers?"

Nicole quickly shifts the discussion away from herself and back to the boys. "You wanna go to Rutgers, Salah? All the Bengalis go to Seton Hall, Rutgers or NJIT."

"NJIT for math," responds Salah, referring to the New Jersey Institute of Technology.

"I thought that you weren't feeling math," says Nicole, meaning she thought Salah didn't enjoy studying that subject.

"You know what I'm thinking?" asks Saiful, intent on plugging Nicole's career. "If she make it to the WNBA and I become a physical therapist, she could come to my team and I could work on her."

"You don't want to be a trainer," Nicole says, laughing. "You have to come to those boring games. Hey, Lisa Leslie's mom is a truck driver. Every time when she took her shipments or whatever, she took her kids with her."

"Who won the finals this year? And who's that lady that retired?" asks Saiful, intent on improving his knowledge of the WNBA.

"Cooper, Cynthia Cooper," says Nicole in answer to the second question.

"How many championships she won?" Saiful asks.

"Four, that's her fourth," Nicole says.

"Everybody in the WNBA is old because they started late," posits Salah, speculating on why Cooper retired after winning four straight titles with Houston.

Then, as if the college conversation has suddenly sparked this thought in her for the first time, Nicole announces brightly, "Yo, next year we'll be freshmen in college."

After this class and a U.S. history discussion on the French and Indian War and mercantilism prompt Nicole to doodle on her book, Nicole heads to her locker. Inside are taped pictures of Falisha Wright and an autographed photo of Teresa Weatherspoon.

As she walks through the crowded halls, Nicole explains how her philosophy regarding the recruiting process changed after consulting Mos and her other touchstones. She is trying to make the best of the situation.

"People helped me realize you gotta go with what you got instead of what you don't got. I'm at ease, I'm just going with the flow. I'm happy with Rutgers, GW, and UNLV. I'm satisfied with what I have." She says Rutgers hasn't pursued her recently, but, "They know me. They have my number. If they want me, they know where to find me." Then as if trying to minimize Rutgers's importance to her, she adds "Rutgers is just like UConn and Tennessee. They're loaded at the guards. They don't really need another guard. Plus they just wanna keep all their in-state talent here."

* * *

The Rutgers coaches have led Nicole to believe they might want to make a home visit but cancel those plans abruptly, telling her that Tasha Pointer's eye surgery has forced them to delay some meetings. Pointer was shot in the eye by a boy with a pellet gun while she was home in Chicago over the summer. No permanent damage was done, and the surgery was expected to be routine.

At any rate, Coach Stringer and her staff never do set up a home visit with Nicole. They have other plans in mind. They are fairly confident that they can land Cappie Pondexter, who is taller and considered more athletic than Nicole. UConn also badly wants Cappie, but the Chicago native has close ties to Rutgers.

Cappie teamed with the Rutgers freshman Kourtney Walton and played AAU ball with Pointer.

Stringer and Law figure that they will use Cappie as their shooting guard, and then go after Saona Chapman as their point guard. The decision to pursue the 5'8" Saona is somewhat surprising. She doesn't fit the profile of the typical "athletic" Rutgers player, in part because she is white.

Even the knowledgeable fans in the Rutgers women's chat room haven't seen the recruitment of Saona coming. Most of the talk on the site is about the debate between Cappie and Nicole, who they assume is being considered because she lives in state.

"We'll only be able to get one of them because they're both point guards and might not want to go to a program that already signed a top girl at their position," reads one typical post on the site in early September.

> *If we sign nicole first, will cappie now not want to come to ru, even though her former teammate is here and her idol tasha pointer came here? If we sign cappie first, will nicole not want to come even though she has said she'll always be an ru fan and we have excellent academics? I would LOVE to get both of them, they would definitely complement each other and jolette law always does wonderful things with our guards!*

But the Rutgers staff considers Saona more of a natural distributor than either Nicole or Cappie. Most recruiting experts assume Saona will attend either Virginia Tech or George Washington. But when Law schedules Saona's visit to campus the weekend after Cappie's, Nicole is the odd woman out.

"After we pretty much knew about Cappie, we needed someone that was gonna be a little taller and that was gonna be pure strictly dribble, dribble pass, not someone that wanted to come in and score and see their name in lights and be a star," Law will later say. "And Saona just wanted to come in and just be a distributor, a point guard. Nowadays, a lot of people get the definition of point guard mixed up. In some sense you have the ball in your hands means you can do whatever you want, create, dribble, shoot as many times as you want. In our system it doesn't work that way. You distribute, you distribute. When the ball comes back in rotation, then you knock down the shot. Today's point guards don't understand that. They wanna know, how many points can I score? How many shots am I gonna get?"

Law has followed Nicole's career ever since she was a freshman. She likes her, and she thinks she is a great player. She just doesn't think she fits into Rutgers's plans.

"Nicole's a great guard," she says. "She's more of a scoring guard. She can play the point, but I just see her as a scoring guard. She's been putting up numbers, she's been doing well. That's my interpretation. Some people might think totally different. We were looking for someone willing to distribute and when the ball comes back in their hands, they may not shoot the ball first. And a little taller. Like I say, we were looking for a taller guard."

In late September, the *Herald News* publishes an article about Nicole headlined RECRUITING 101: KENNEDY'S LOUDEN HAS COPED WITH UPS, DOWNS OF DREAM. It explains that Nicole is frustrated by the hectic process, and reveals that she has played injured over the summer because she felt she had no other option.

The article draws tremendous sympathy from Rutgers fans, many of whom have seen Nicole play and feel they know her.

"I feel for Nicole," one person writes in the chat room.

It's nice to have options, but the confusion must be killing her. What to do? What to do? I think because she seems like such a nice person and is a really good student I feel for her even more. She's the kind of kid anybody would want to represent their school.

No matter what happens, I'm confident that her smarts and her character will lead to success. If the injury and lack of healing time is the main problem, maybe she should wait, get rest, play her senior season, and I'm sure schools will jump back on the Nicole bandwagon.

Another comments:

I agree on the injury thing. It doesn't matter how much talent you have to offer, when you are sitting on the bench in street clothes. Part of being a valuable recruit I would think, is to be injury free. Who wants to sign a kid with a bad knee if you can get another kid who's healthy? The potential talent had better far outweigh that liability plus the other recruits' talent.

Chapter 19

Ever since he was kicked out of the Y in spring of 2000, Milton Evans feels as though he has lost his reason for getting up in the morning. Vanessa Paynter, the new YMCA program director and a former Eastside basketball star, allowed Evans to work with Nicole until the spring. But all that changed one day when a couple of his young cousins were found inside the Y without guest passes. Evans insists they were not playing basketball and were only bringing him some coffee. Paynter insists otherwise. Whatever the case, Evans was kicked out of the building and told not to return. In Paynter's view, he isn't a member, he isn't certified to teach there, and he violated the rules by having his cousins inside.

Evans has never seen eye to eye with Paynter. Before she replaced Wiz Richardson in 1998, Evans could come and go as he pleased. No one enforced the rule about visitors having to pay a fee each time they came; large groups of men would enter to play basketball and not pay the required five dollars. Once they were inside, not much was done to prevent those who wanted to from vandalizing equipment or walking off with basketballs and weights. Some even walked in with guns and knives, occasionally getting into fights. On at least one occasion, Richardson and Evans broke up a fight involving men carrying Uzis. No one enforced the rule that said you had to be certified to teach basketball, and that teenagers had to be out of the building by early evening. Evans and Richardson often stayed until nine or ten at night working with Nicole.

But all of that has changed under Paynter. She and Larry Gutlerner, the Y's executive director, believe that the way to make people take better care of the Y is to encourage membership by making sure that visitors pay the fee. If you have a stake in the facility, they reason, you are more likely to look out for it. So all visitors must pay the five-dollar fee and obtain a guest pass. All those entering the Y must now keep all their bags in the locker room, to prevent foreign objects being brought into the gym. And, most important for Evans, no one can teach

within the building without the proper certification. This last regulation relates to concerns about liability. "If we don't have staff people here and someone gets hurt, you know what the papers would say," Gutlerner says. His fears are not groundless. Several years earlier, a boy died in the Y's gym owing to heat prostration after performing a dunking drill. Evans, who desperately tried to get help to the boy, was the last person to see him alive.

For Evans, whose primary source of identity and pleasure comes from coaching Nicole, Paynter's decision has been devastating. With her August sabbatical from the game over, Nicole has now returned to her daily workouts. But Evans cannot be a part of them. His frustration has gotten so acute that after four months of negotiation with Gutlerner and Paynter, he is threatening to take them to court so that he can get back in.

"[The children] are the ones suffering, not Vanessa or me," Evans says one September day outside the Y. "It's the kids who need to learn how to make a layup or shoot a jump shot."

At times, Evans says he will quit this coaching business after Nicole goes off to college. But now that her senior season is approaching, all he wants is to help her improve her game. He knows that she is on the verge of great things, but he thinks she could be that much better with his help. After all, look how far she's come with his pushing and prodding.

"Being with Nicole, it was a reason to get up," he says. "It was a blessing to see her. I put all of me into her. No matter how I talked to her, whether it was nice and soft or hard and mean, that's my baby girl. I will be with Nicole in November and December no matter if we have to go to another gym. I want her to be Passaic County's all-time leading scorer, and I'm gonna get that ball [when she breaks the record] because that's our own hard work. With the new crossover that's at least ten to fifteen points a game. Nobody gonna stop her. Nobody. They ain't no girl in this town or county or this state that's gonna stop her."

Nicole has included Evans in her visits from college coaches. He was there when the UNLV coaches came, and he'll be there when the George Washington scouts arrive. Evans has heard the stories about Nicole's stock dropping, and he has opinions about that, too. Strong opinions.

He believes she should have given her body a break after Kennedy's season ended last spring. "Even when you're young, you gotta give your body time. Because of her love for the game, she played AAU basketball. This is where her stock went down. I know she wasn't one hundred percent. She was playing injured. A lot of people were seeing her, how many of them knew she was injured I don't know. She was afraid that if she didn't play, people would forget her."

But the real blame doesn't lie with Nicole, he says. It lies with the people at Kennedy who didn't take proper care of her when the knee injury first happened. Evans often views things through a racial prism, and in this case, he is quick to blame Kennedy's athletic director, Bob Gut, who is white.

"If this is the girl bringing the people into Kennedy, why did Gut wait so long?" he asks in an angry voice one day on the front stoop of his apartment. "She's doing the work in the classroom and on the court, why didn't they take care of her? If the girl was in Wayne Hills [a predominantly white school in nearby Wayne], they would've taken care of her. To Gut and them she's just a piece of meat because they didn't let her get healthy. She should've been taken out of games but she didn't want to let her teammates down. She stayed in games because she's a warrior. She never healed properly. Do you know what can happen to you if you keep going?"

In fairness to Bob Gut, he had nothing to do with how long Nicole stayed in games. Nicole wanted so badly to win she played hurt on many occasions. Meticia Watson offered Nicole the chance to sit out during parts of practice when her presence wasn't absolutely required, but when it came to games, Nicole played just about every minute of every one. Once the knee injury was diagnosed, Nicole probably should have taken time off to rest. But again, her busy AAU schedule didn't permit her much time to relax.

It was a double-edged sword for Nicole. Her stock would have dropped had she skipped certain camps and tournaments to rest her knee. But it dropped anyway because she played hurt, fearing that her absence would damage her chances for a scholarship.

If Nicole had been a boy, if she had been James Lattimore or Michael Cleaves, would the school have gotten more involved in her treatment? Perhaps. But in the end, the responsibility fell on Nicole's mother and Laura Judge, who volunteered to make doctor's appointments. Judge would beg and plead Nicole to get treatment, but a combination of financial and insurance problems and Nicole's busy schedule slowed her rehabilitation.

* * *

Now, two days before the George Washington coaches are to visit Nicole, Evans is hanging outside the Y waiting for his protégée. He likes to stand out front and talk with anyone who passes by. He especially likes to flirt with the ladies. "You got a beautiful smile," he told Justine, Nicole's 16-year-old friend, a few days earlier when she arrived with Nicole.

It is about 4 in the afternoon and Nicole is coming from school, approaching Evans on the corner of Ward and Prince Streets.

"You miss me?" Nicole says with a smile as she hugs Evans.

"You crazy," Evans says, trying to sound cool. "People think you know me."

As they talk, Evans takes the pager Nicole has in her hand. He wants to see what kind of phone numbers are programmed in it.

"I be checking her out," he says. "Probably a lot of boys in there. Boys I gotta check out." Evans enjoys playing a fatherly role with Nicole.

Now he turns the discussion to her workout routine, a routine he cannot supervise.

"What you gonna do today?"

"I'm gonna do my three miles, then I'm gonna lift. Then I'm outta here."

"So who's telling you what to do when you're upstairs?"

"Mike," Nicole says. Mike Evans is Milton's younger brother. A quiet, well-conditioned man, he, unlike his brother, is a YMCA-certified strength trainer.

"I knew you were gonna do three miles," Evans says. And with that they hug good-bye, but not before he teases Nicole once more.

"You crazy," he jokes. "People think you know me."

Nicole changes into her workout gear, shorts, a knee brace, and a red, white, and blue USA Basketball shirt and moves into the new weight room Paynter has helped develop; she is ready to run. In one room stand a variety of treadmills and bicycles opposite a television that generally features reruns of *Martin* and *The Fresh Prince of BelAir* at this time of day. Various benches and free weights are arrayed in a row under the television and along a nearby wall. In the inner room are the state-of-the-art weight machines Nicole has used over the years to develop her physique.

As she walks in, she checks in with Mike Evans, who sits in a plastic chair in the corner with an impassive expression.

"What'd you say, two miles?" Nicole says jokingly.

When Mike holds up three fingers, it is clear he isn't biting. "You bring your swimming stuff?" he asks. Milton and Mike have been encouraging Nicole to swim regularly to soothe her knee and ankle injuries.

"No, I forgot it," Nicole says.

"I don't get no respect," Mike responds.

"Well, if they allowed me to run in my shorts and sports bra . . ."

Soon Nicole has taken up her position on a treadmill. But she runs for only a few seconds before stopping.

"Why you stopping?" asks Mike, who has been watching Nicole's pace.

"I got a cramp, but you won't believe me."

"You know why," Mike offers, "because you're too heavy."

"Well, I'm working on that, aren't I?" Nicole then grabs her right leg, stretching and rubbing her right calf, before starting and stopping again. Noticing Nicole's contorted face, Mike brings her a towel to stretch her calf with. When her face again bunches up in pain, it isn't clear whether she's upset about her injury or his approach.

"I'm not gonna hurt you," he says. "Calm down."

Everton Kelly, a musclebound trainer who also works at the Y, joins the conference on Nicole's injury. There are several adult men in the room, but Nicole is the only high school kid. It has been that way practically every day since Nicole began coming here the summer after eighth grade.

"Do this," Kelly tells her, and he elevates his toe onto one of the machines several inches off the ground and pushes off repeatedly to stretch his quadriceps muscle.

After following his advice, Nicole lies facedown on the floor and stretches her quad even more. A song by the rapper Eminem is playing over the sound system, and Nicole sings along, "I am whatever you say I am . . ."

After running some more, Nicole asks Mike, "Can I play?" If her workouts are the equivalent of eating vegetables, the routine she must go through to build strength, playing basketball upstairs is dessert.

"Soon as you done with that fat-burning exercise, okay, heavy?" Mike says. When Nicole gives a disapproving look at that comment, Mike adds, "Let me explain. If you go on the court like that, you're more at risk for an injury. You've got to lose about twelve pounds. You sat around for a whole summer, now you got to work that off."

Then, with Nicole back on the treadmill running hard, he whispers to another person standing nearby, "You notice that since I called her fat her leg isn't hurting anymore."

But Nicole's silence doesn't last long. With Kelly running next to her, she screams out, "It feels like it's getting worse to me."

"You don't have muscles there," Kelly says. "It's the muscles surrounding it. If you don't take care of that, the pain won't go away, baby. You gonna have that forever." Kelly wants Nicole to strengthen the muscles on both sides of her leg so that the pressure on her calf is relieved.

"She's running flat-footed and heavy," offers Mike. "You hear her breathing?"

Soon Nicole has hopped off the treadmill and is dribbling her orange Wilson basketball on the carpet in front of the machines, working on her crossover dribble against some imaginary defenders. In between bounces she puts her palm completely underneath and hesitates before releasing it again.

"If you make a person believe you gonna go one way and then you go the other, they can't recover in time," she says, making a face of pure pleasure as if she has just juked some poor defender out of her shoes.

The discussion turns to Kwan Johnson and how he "works out hard as hell," according to Mike. But Nicole is still concerned about her quad.

"That's the only stretch you got?" she asks Mike.

"No, do this one," he says, suspending his leg in front of him for a moment. As Nicole mimics him, he sympathizes, "I know you feel like your leg about to fall off."

"Damn yo," Nicole shouts by way of agreement.

Finally, after completing her three miles on the treadmill in fits and starts, Nicole decides it's time to go. She looks at her hair in the mirror and frowns.

"I can't come Thursday or Friday because I have college visits," she tells Mike. "I can't come tomorrow because I'm getting my hair done. It looks busty. I had it for two weeks already."

As she walks out, Mike looks at her feet and pronounces, "You need to get new sneakers."

"What kind of sneakers should I get?" she asks. "I'm not saying I have that kind of money, but what should I get?"

"I'll get them for you," Mike says. "Just remember that when you go pro."

Pausing for a moment to take in the comment and consider how she might return the favor, Nicole excitedly says, "Man, if I go pro, the Y gonna get hooked up!"

* * *

On days like this, Nicole loves to go up into the gym and get some run with the boys. Though they offer her the best competition, she sometimes gets frustrated with their lack of organization and dedication.

As a group of high school–age boys gets ready to play half-court with Nicole, a heavyset boy with dark skin named Chucky says to his friend on the sidelines, "You got money on you? I got fifty dollars you can't beat her."

"I'll foul her ass every chance," the other boy says.

"She scored sixty-three points yo!" It was 60, but to these guys that matters little.

The game can't start because one team is lacking a player, and Nicole takes it upon herself to find someone from among the handful of people on the sidelines.

"Hey, you wanna sub?" she yells at one boy about her age. "You wanna sub?"

When the action starts, Chucky, who is sidelined on crutches, begins to heckle Nicole and her teammate Phil, who plays on the Kennedy boys' team; they are having their way with the opposition.

"Kennedy sucks so much," Chucky yells. "Y'all came at the Metro Classic at nine o'clock and you left by ten-fifteen. The first Metro tournament, y'all lost all three games." He is referring to a summer tournament in which Phil and his teammates struggled. "Kennedy ain't shit. Kennedy sucks."

Eventually, Nicole has had enough. She turns toward Chucky and, trying to be cool yet cutting, says, "You talk so much and you still in Paterson."

That shuts him up for a while. Later, when Nicole steals the ball from a player on the opposing team, even Chucky must give her her props—her due credit.

"Call the cops, call the fucking cops," he yells excitedly from the side, his big face breaking into a smile. "You just got robbed. Call the fucking cops. She robbed you."

Chapter 20

MaChelle Joseph desperately needs a point guard. As the chief recruiter for Auburn University, she is in charge of making sure Head Coach Joe Ciampi has all the tools he needs to compete in the Southeastern Conference, the toughest conference for women's basketball in the nation. After LaRita Spencer graduates, the Lady Tigers will have only Carol Smith, a junior, and the freshman walk-on Mollie Smith to replace Spencer at the point. Joseph had been counting on Tanesheia Thompson to be Auburn's floor general of the future, but lately Joseph has been wondering whether that will ever happen.

Ever since she was a scrawny freshman, Tanesheia, who grew up in the shadow of Auburn in Roanoke, Alabama, has told her AAU coach that she wanted to attend Auburn. It didn't take long for Joseph to know she wanted the 5'6" Tanesheia. Watching her sink 3-pointer after 3-pointer against players three years older, she knew Tanesheia was something special. By her sophomore season, Joseph had gotten her to verbally commit to the school. And by her junior season, Tanesheia was averaging 36 points per game for Handley High School. The All-Star Girls Report ranked her as the second best point guard and the eighth best prospect in the nation. Mike Flynn's Blue Star Report listed her as the forty-ninth best player in the nation and the tenth best guard. By contrast, the most recent All-Star Guide Report ranked Nicole as the forty-seventh best prospect in the nation, and the Blue Star report listed her as the fourth best guard.

But by mid-October of Tanesheia's senior season, she was considering another option besides Auburn. Coach Landers of Georgia, also in the Southeastern Conference, had apparently been recruiting Tanesheia hard. At one point, Tanesheia, who often visited Auburn but had also taken two unofficial visits to Georgia, told Joseph, "I think I'm leaning toward Georgia."

The SEC rival isn't Joseph's only concern. Tanesheia has yet to earn the required ACT score for incoming freshmen, and there is a serious question as to

whether she will be academically eligible to play anywhere. Thus it is that, about a month before the fall signing period will conclude, Joseph has to scramble for a point guard.

She calls her friend Bret McCormick in Florida, who works for the All-Star Girls Report. If anyone can help her find a point guard, she figures he's it.

"Do you know anybody that didn't sign early that's good enough to play in the SEC?" Joseph asks.

"You're not gonna believe this," McCormick tells her, "but Nicole Louden is only looking at George Washington, UNLV, and American. Nobody's recruiting her. They need their heads examined."

"What?" Joseph screams through the telephone, hardly able to believe it. "Bret, what's the problem?"

"I don't know, but I think she's awful good." McCormick allows as how his colleague Mike White had seen Nicole over the summer and thought she had put on a few pounds. But he still thinks she is one of the best players in the country.

"I think she's awful good, too," says Joseph as she pulls out her 1999 Nike handbook, the one in which she has written "scoring machine" next to Nicole's name. "She can score. Are we talking about the same Nicole Louden from Paterson, New Jersey?" Joseph paid only brief attention to Nicole during the one day she attended Nike camp the previous summer. She heard the stories about Nicole's injury, but that didn't put her off as much as the assumption that Rutgers's Vivian Stringer simply wouldn't let a player of this caliber out of her backyard.

"You know what," McCormick says, "Texas called here and I told them that they needed to get on it. And I told Louisiana Tech, too. Now I'm telling you."

An attractive woman with long brown hair, Joseph is a fierce competitor. When she finished her playing career at Purdue University in 1992, she was the holder of 33 school records. A three-time first-team All–Big Ten selection, Joseph set the all-time Purdue and Big Ten scoring mark with 2,405 points—the most ever by a man or woman. After graduating, she spent one season as a graduate assistant and interim assistant coach at Illinois before returning to Purdue as an assistant, where she recruited the class that would eventually win the national championship in 1999.

But her time at Purdue was not without incident. An NCAA investigation of the Purdue women's program in 1995 disclosed 11 secondary infractions, including allowing a recruit to use a cellular phone to call her home, providing a recruit with a 120-mile ride to her home, and picking up Purdue players—and high school athletes already committed to play for the Boilermakers—at the

airport. Joseph and Head Coach Lin Dunn were initially restricted from recruiting for two months. Purdue then fired both Dunn and Joseph in March of 1996 shortly before an anonymous letter was sent to the media alleging violations within the men's program.

But Joseph landed on her feet. She joined Coach Ciampi's staff at Auburn, where she dreams of following in the footsteps of Mickie DeMoss, now the Tennessee assistant coach, and Carol Ross, the Florida head coach. They both assisted Coach Joe Ciampi and are considered among the five best recruiters in the nation. Joseph ultimately wants to be a head coach and knows that Ciampi is a great person to study under.

Joe Ciampi began his coaching career at West Point and has been a fixture at Auburn since 1979. He is widely respected not only because the Lady Tigers have won eight SEC championships and advanced to the NCAA Final Four three times but also because 91 percent of his players have graduated. They say he cares about them as people as well as athletes. After games, his wife and children can often be found in the locker room socializing with the players.

He calls himself a "prostitute" of the recruiting system that forces him to be visible and attractive to the attendees of the Nike and Adidas camps and puts too much pressure on the girls. He says the players are out on the summer recruiting circuit too long, and he favors a simpler system and a reduced recruiting window to cut back on player injuries as well as the influence of the AAU types.

When Joseph learns that Nicole is still available, she doesn't waste a minute. She hangs up the phone after talking to McCormick, calls Kennedy, and leaves a message for Coach Bonora. After that, she walks into Auburn's staff meeting in the plush conference room overlooking the basketball court in Beard-Eaves-Memorial Coliseum and explains the situation to Coach Ciampi.

"I want to know what you want me to do with it," she says. "Do you want me to act on it or do you want me to sit on it?"

Ciampi was in the stands at Nike camp in 1999, Nicole's first year, and her explosiveness and ability to create off the dribble caught his eye right away. But he is understandably skeptical about her availability at this late date. If one of the best point guards in the nation has yet to sign, well, there must be a logical reason why everyone is backing off.

"MaChelle, come on now, there's gotta be some problem," he tells her. "We know she's one of the top twenty players in the country. Does she not have scores?"

"Well, I just think everybody thought she was going to Rutgers," Joseph says. "That's why we didn't recruit her."

Later that day, Coach Bonora returns Joseph's call. He knows full well that Nicole wants to attend a high-profile Division I program, and that she isn't satisfied with having to choose between UNLV and George Washington. Just recently, Nicole, desperate for options, gave him a wish list of several programs, including Texas, Texas Tech, North Carolina State, Clemson, Illinois, USC, and others. Bonora began calling those schools, probing to see if any might be interested and offering to send videotape of Nicole. Now, as Joseph talks to him, she can sense how protective he is of his star.

"Why is Auburn coming in late?" he asks. "What do they know about her? How many point guards do the Tigers have? How many are they gonna sign?"

Joseph tries to be as upfront and honest as possible. She explains that the school has already signed one of the top point guards in the country, and then fills him in on Tanesheia's status. Bonora seems to appreciate Joseph's honesty. He says he will speak with Nicole and get back to her.

In the meantime, Joseph buys a plane ticket to Paterson and sends Nicole a FedEx package with a letter. Written on Auburn women's basketball team stationery, the note lists the school's impressive résumé: three NCAA Final Four appearances, six SEC championships, four Kodak All-Americas, and three Olympians, including Ruthie Bolton-Holifield, who won gold medals in 1996 and 2000.

"Hi Nicole," the note reads. "I want to apologize for not contacting you before now. My only hope is that we aren't too late. Auburn is one of the top women's basketball programs in the nation. We have one of the Top 10 programs in the nation. Our last three recruiting classes have been ranked in the Top 5 in the nation. I really am excited about having the chance to talk to you about Auburn. I saw you play last summer and I thought you were one of the Top 10 guards in the nation. We need a point guard who can swing over and play the two. I like your size and strength. I honestly think you have an SEC body. You know the SEC is the toughest conference in women's basketball. Nicole, I hope you don't sell yourself short. I hope you'll give Auburn a look! We have the best of both worlds—a great academic school and a first class basketball program. We are trying to get back to the Final 4!! And win a national championship!! I'm looking forward to sharing Auburn University and our basketball program. War Eagle! Coach Joseph"

* * *

When the packet arrives, Nicole is getting set to make her official visit to UNLV, October 19 to 22. Two days before Nicole is to fly out, Coach Pantoja faxes Bonora a two-page schedule highlighting what the school has planned for

her. The inventory is standard business in the recruiting game, but still a person can't help but feel special. Nicole will meet with everyone from the school's strength and conditioning coach to an urban affairs professor to Dr. Carol Harter, the university president. The meeting with Dr. Harter will take place during a football game between UNLV and Wyoming. Football games are almost always the centerpiece of a recruit's trip to campus.

On October 18, Nicole has a busy evening ahead of her. She needs to visit Kesha to get her hair done, pack, and find time to speak with MaChelle Joseph, who has finally gotten Nicole's number from Coach Bonora.

As Nicole leaves a team weight-training session, Bonora makes sure to show the UNLV fax to the team's younger girls. "You see, girls, this is what takes place on an official visit," he says while flipping through the fax outside the Kennedy gym. Wearing jeans, a gray pullover, and her key chain draped her neck, Nicole walks away from the gym and toward the School Based office. She is in a buoyant mood. Trips always make her feel good.

"I'm about to go get a sandwich and then I'm gonna get my 'do done so I can look tight tomorrow," she says to some of her teammates with a big smile.

Inside the School Based room, Justine and the usual after-school crew are hanging out, taking advantage of the free sandwiches, chips, and drinks that are on a table. Off in a side computer room hangs a sign that reads VOTE FOR JACQUITA ALEXANDER, CLASS PRESIDENT OF 2001. NICOLE LOUDEN FOR VICE PRESIDENT. Jacquita and Nicole won the election, and Nicole is now the class vice president, although she never mentions it. After saying her hellos, Nicole fills up a plastic plate with a sandwich and potato chips and comments on her weight.

"Dag, I wish I could drop some pounds yo," she says to no one in particular.

Justine and Nicole often enjoy verbally jousting when they get together and it doesn't take much to get them started.

"Justine, put some plain potato chips in here for me," Nicole says when she's finished with her first round.

"Dammit, I ain't going back up there again," says Justine.

"Justine, you could put some potato chips on here?" Nicole asks in a friendly voice a second time. After Justine obliges, Nicole wonders where the third member of their trio has gone.

"Justine, Sakina had to go to work?"

"Patricia had called me and asked me where she is," says Justine. Patricia works in the office along with Debbie Tillman, the AAU coach, and Raheem Smallwood, Sakina's father.

"Lemme find out Sakina got an extra job," Nicole says with delight. It is a running joke among the girls that Nicole doesn't work because she is too busy

with basketball, whereas Sakina has been employed at the Lady Foot Locker in the Willowbrook Mall, and Justine, after filling out 20 applications there, has lately landed a job in a card shop.

Recently much of the girls' talk has centered around Justine and her relationship with her mother. Justine is angry with her mother for reading her diary and overregulating her life. The two simply do not see eye to eye, and Justine's mother has asked her to move out by the first of November. Nicole and Sakina have offered support, advice, and their own homes as safe space. Somehow the girls have managed to find humor in the whole situation. "You could do like Macaulay Culkin and just disown your parents," Nicole joked during a recent breakfast at International House of Pancakes. "You could get emancipated."

"I thought about that but if I tried and she didn't contest I would be so hurt," Justine had said.

Now, after spending a few minutes with Justine, Nicole decides it's time to head over to Kesha's house. As she moves toward the door, she grabs two paper bags filled with chips and juice, trying in a not-so-subtle way to make off with some free groceries while a big smile covers her face.

"Nicole, you taking those bags with you?" Patricia yells from behind her desk across the busy room. On the basketball court, Nicole makes steals all the time, but she won't get away with this one.

"Oh, these are the ones with nothing in it," Nicole jokes. "I'm taking them to the garbage."

After Nicole puts the bags down, Patricia adds sarcastically, "Nicole, you not gonna clean up?"

"Damn, they got a sister working," Nicole says.

"You don't gotta clean up, Nicole," adds Roxanne McCurdie, the resident den mother of this group and the program coordinator for a group called Future Leaders. Among her many duties, Roxanne counsels teenage girls about safe sex and pregnancy, parenting and life skills. Currently, she is helping lead the "Baby, Think It Over Program" in which high school girls volunteer to take a computerized doll home for a week, feed it, change it, and generally care for it as if it were a baby. Anytime the baby starts crying, it is registered on a computer chip in a main terminal at the school. Last year alone, McCurdie counseled 33 teenage girls who were pregnant. "And that's just what's reported to me," she says.

Now, Nicole is engaged in a verbal joust with Patricia. "I know I don't gotta clean up," she says.

"You better clean up," yells Patricia.

"Yo, she act like she grown already," Nicole says.

She is trying to leave, but she just can't resist talking to Justine about at least one more topic.

"You buying a class ring?" she asks her friend. It is that time of year when seniors can purchase a permanent remembrance of high school, for only several hundred dollars. "I can't afford one."

"I can't afford one either," Justine says.

"Save up them nice checks you got," Nicole says. "You the one with the job. Not my black ass."

Now it is really time to leave, and Nicole, poking fun at the stereotype of the angry African American, barks in her deepest voice, "Open this door before I get real black."

At five o'clock, Nicole is sitting on the steps of Joan and Kesha's home on North Sixth Street waiting for Kesha to style her hair. While she waits, she walks up the street toward her old house. When a crowd of boys approaches Nicole on the street to say hello, they do so with a sense of reverence for they know she may someday make everyone in Paterson proud.

"They loved me, I was their star," Nicole says after she walks back to wait for Kesha. "Not one of them a day in their life tried to sell me drugs. They looked out for me. And all the drug dealers out here, you know what I'm not even gonna come out here and knock their hustle. Because if they wanna get a job, they could get a job. If they feel like selling drugs is the thing for them to do, well, by all means go ahead and do it.

"And people say, 'Do you want them to sell it to your kids in the neighborhood?' and all this and all that. If the kid is brought up right to begin with, they know better. I've never a day in my life touched drugs. I haven't even thought about taking any drugs. That's just my mentality. When I see kids out here smoking or whatever, I can't understand it because that's not me. I can't even comment on anyone else's life. I don't know because I've never really been there."

* * *

After an hour of teasing out one side of her hair while waiting on Kesha's front step, Nicole has ended up with a curious, uneven hairstyle. The hair on the right side of her head remains in tight braids, while the left side flies off in all directions. Combined with the big smile she flashes occasionally, this look has made her resemble her mother somewhat. Andrea's hair isn't quite this wild, though.

Frustrated that Kesha hasn't shown up and knowing she has a homework assignment due the next day, Nicole decides it's time to drive back to her house.

There Euphemia is sitting in a chair in the hallway outside her bedroom reading some paperwork. Nicole is scheduled to leave from Kennedy Airport tomorrow evening, and she is hoping her grandmother will drive her.

"Mama, my flight is at six o'clock tomorrow."

"Six o'clock when?" asks Euphemia, still reading her form. "I have a meeting from five to six, I don't know if I can take you."

"But Mama, you told me you would take me," Nicole says in a whiny voice.

"I just found out I have a meeting." If she doesn't attend tomorrow's meeting, she'll have to go to another one on Saturday. "I want to go tomorrow because I want to go to Dameon's [football] game Saturday. He said no one is going to his games."

Now the discussion turns to how Nicole has wasted the last hour waiting for her cousin.

"Kesha made me so mad," Nicole says. "I'm leaving tomorrow at six o'clock."

"You're not going to school tomorrow?" Euphemia, always concerned about academics, asks.

"I'm going but I'm leaving early. I'm getting out of school at two o'clock. . . . I need a suitcase. I don't even have a suitcase, Mama."

"We have a suitcase you could use," Euphemia says, trying to calm her granddaughter's fears.

"I was waiting over there for an hour. Me and Kesha had plans. I even reminded her last night."

Nicole's and her grandmother's rooms are next to each other on the first floor of the house, and this conversation takes place outside on the landing. On the door to Nicole's room, surrounding the giant black letters spelling KILLA COLE, she hangs whatever items have inspired her lately. This week a piece of paper reads, "Nicole, Greek origin meaning 'Victory of the people.'" Another cartoon features a woman sitting at a desk, with the caption, "I'm not 100% sure what I want to do when I finish school. I may be a doctor, a lawyer, an engineer, a star in the WNBA . . ." Another note sent from Georgia reads, "Success lies in doing not what others consider to be great, but what you consider to be right."

Euphemia has turned her attention back to her yellow form, which tells Home Care Option employees that the company will begin doing criminal background checks on them.

"They're gonna find a lot of people with criminal backgrounds," Euphemia observes. "I can tell you that."

The black Nissan Sentra Nicole shares with her mother is currently blocking Euphemia's car in the driveway, but when Euphemia has to leave, Nicole can't find her keys.

"Just don't play, man!" Euphemia says. A few seconds later, the crisis is averted when Nicole finds her key chain.

Euphemia leaves and Nicole settles down on her bed. The phone rings. It is Coach Joseph from Auburn.

"You guys are in the SEC, right?" Nicole says in response to something Joseph has asked about Nicole's knowledge of the school.

When a call comes in on the other line from Coach Bonora at the same time, Nicole asks if she can call Joseph back later.

Now she is checking in with Bonora on his results from cold calling schools.

"Anything from Texas Tech?" she asks. Nicole then updates her coach on the Auburn phone call before closing the conversation. "Thanks a lot. I'll try to see you tomorrow because I'm leaving early."

The Richman family has so many members that someone is almost invariably dropping by to check in with Andrea, Euphemia, or Nicole. Lorna sometimes leaves her kids there to play with Alex, or to have her mother or grandmother watch them while she is at work. Now she, Junior, and Kadeem have stopped off to visit. Nicole has become so famous, Lorna tells her as she stands in the doorway to Nicole's room, that a friend of hers in prison in Philadelphia sent Lorna a newspaper article about her.

"She be ballin'," Lorna had told her friend proudly. "She score sixty points in one game."

Now that Lorna has had a moment to study Nicole's unrestrained hairdo, she says seriously, "I try to do my hair like that. That's the new style. It look nice like that."

Nicole's family members don't advise her much on the recruiting process largely because they know much less about it than she does, and they trust her judgment. But that doesn't stop them from asking visiting coaches direct questions. When American University's head coach, Shann Hart, visited, she presented Nicole with a plaque that was meant to foreshadow Nicole's career at the school: NICOLE LOUDEN, 2,000 POINTS, 1,000 ASSISTS, 500 REBOUNDS, 500 STEALS, FOUR-TIME KODAK ALL-AMERICA.

"Just to put that together, I found that amusing," Nicole thought. "It was cool, without a doubt." But Lorna, unaware of the program's uneven history, asked Hart, "Cut to the heart. What's your rank?"

"At the moment we aren't ranked," said Hart, who had only recently come to American University. "We are a new staff and have been on the job three weeks. But we will be ranked Number One. With Nicole's help we're gonna be Number One."

"So you guys are not even in the Top Fifty?" Lorna said dismissively.

Now that Nicole is on the verge of traveling to Las Vegas, Lorna, a pretty, outgoing woman wearing an I LOVE JESUS key chain around her neck, chimes in on that possibility as well.

"Las Vegas," she thinks out loud. "I be lost over there. I would be in the casino. I wouldn't go to college in Las Vegas. I think I would go to NYU or Georgia."

"Coach Landers straight-up played me," Nicole says in response to Lorna's comment about Georgia.

"What he do?"

"Recruited someone else at my position," Nicole says, although she doesn't know this for sure.

"What about Connecticut?" Lorna asks.

"That's definitely not happening. They got too many guards."

"What about California, Arizona, and these other places? New Orleans?"

"When I went to New Orleans," Nicole says, referring to a basketball trip she once made, "there was nothing there. You could only go there so many times before you get bored. I feel sorry for the people who live there."

"What school is Number One?" Lorna asks after covering every other major part of the nation.

"UConn," Nicole says.

"Oh, you can't go there, too many guards. Who's Number Two?"

"Tennessee."

"What about Nebraska? Their football team is Number One in the country."

Soon the recruiting part of the conversation is halted by Lorna's major news of the day, her announcement that Junior's uncle has married a white woman.

"I don't have no problem with people of other races as long as you marry within your own kind," Lorna tells her sister.

"Kadeem," Nicole says, turning to her small nephew standing in the hallway, "if you ever marry a white person, more power to you."

"Too much different values," Lorna repeats. "It's too different."

Now the conversation turns back to recruiting.

"You just gotta pick a school in the Top Twenty," Lorna advises.

"I just could pick a school and bring them back to the top," Nicole says, thinking of a place like UNLV.

"Nicole, when you go to college, it's totally different. You can't carry the team yourself. You can't play like you do now."

"You'd be a good basketball player," Nicole adds, studying her sister's frame. "You got a good basketball body."

"Who'd wanna recruit a thirty-year-old right now," jokes Lorna, who is actually 27. "They'll be like, 'Child, you better be the water girl.' I'd love to play volleyball in the Olympics, I can't play nothing no more. My legs are messed up."

After hearing from Kesha that she is back at her house, Nicole drives back to get her hair done. Finally. When she walks in the door, Kesha is standing in the living room in bare feet, working on her boyfriend Mark's hair. She is dressed casually in tight black stretch pants and red tie-dye tank top over a white T-shirt. Mark wears Timberland boots and black jeans with his underwear hiked high, the current hip-hop style. Ricky and Daniel are running around the apartment playing with a football. Daniel, who is naked, periodically breaks into cartwheels. He has more energy than 10 Nicoles.

Nicole checks in with her cousin Jody, who is lying on a bed in Kesha's room watching a movie.

"What's up, nigga?" Nicole asks playfully.

While she waits for Kesha to finish working on her current customer, she points to the letter Joseph sent her sitting next to the computer.

"To make me feel better, Coach Bonora probably wrote it and put it in an Auburn envelope."

Nicole takes up a position in the corner of the room, laying out her homework on top of a large cylinder that Joan and Kesha plan to use to send food to family members in Jamaica. Daniel continues to bounce off the walls.

"You go take a shower, Daniel," Mark instructs in a thick Jamaican accent.

"Daniel, you take your little behind in the bathroom," Kesha adds. "Nobody wanna look at your little naked wee-wee."

After picking up her cousin and playfully pinning him to the ground, Nicole wants to talk about the look she will present when she travels to Las Vegas, and whether she can borrow a pair of Kesha's sneakers she has her eyes on.

"Maybe I should go there with the baller look," she announces. "Hold up, baller on campus. Kesha, you gonna let me rock those baller kicks?"

Soon Kesha is ready for her cousin, and Nicole takes a seat in front of the computer where she can perform several tasks simultaneously: play spades on the computer, do her homework, talk to her cousins, and have Kesha tease her hair out, separating it with black rubber bands.

Finally, with her hair situation settled, Nicole decides it's time to return MaChelle Joseph's call. She picks up the phone and dials collect.

"Hey, Coach Joseph," Nicole says enthusiastically.

"What's happening with your hair?" asks Joseph, whose job includes remembering the smallest details of a recruit's life.

"It's still getting done. I'm getting the front braided and waterfalls in the back."
"What do you know about Auburn?"
"Nothing at all besides it's located in Alabama."

Joseph then fills Nicole in on Auburn's tradition. The school plays in the SEC, it regularly qualifies for the NCAA Tournament, the last four recruiting classes have been ranked in the Top Five nationally, and several former players have gone on to careers in the WNBA, including Bolton-Holifield.

"Ruthie is the bomb," Nicole proclaims.

Now that Joseph has laid out Auburn's résumé, she moves in for the kill.

"Can you come for a visit?" she asks. Joseph believes that if she can get a recruit to visit Auburn and experience its southern hospitality and charm, it will be hard for her to say no.

"All the weekends are booked until the signing period," says Nicole, who is playing hard to get.

"You don't have to sign until that Wednesday, the fifteenth is the last day to sign. What about the ninth, tenth, and eleventh? What else do you have doing on the other weekends?"

Joseph then feels Nicole out on how she feels about her scheduled visits to UNLV, George Washington, and American University. Nicole says she likes Coach Miller at UNLV because she "keeps it real" and doesn't "sugar coat it," but that she doesn't plan on verbaling during her trip.

As for George Washington, she says of Coach McKeown, "I really wanna go there just to feel him out. I don't know."

"They're only about four hours away," Joseph adds.

"My family, they all wanna see me play."

Then Joseph turns the conversation back to Auburn, mentioning that the Lady Tigers compete against Georgia, Tennessee, and LSU—three of the Top 25 teams in the country.

"It's unfortunate that you don't know more about Auburn because it's a great program and I think you would be more excited," Joseph says. "If you really wanna be in the WNBA, it really would help to play against top players and get TV time. What would it hurt to come and see us?"

"I think you're correct," says Nicole, who is beginning to get turned on to the idea. "I would like to come out there and see what you're all about."

Joseph then segues into Nicole's interests off the court and in the classroom. Nicole allows that she thought she wanted to be a writer, but is now considering a career in communications.

"If you wouldn't mind forwarding me some information about your communications program," Nicole asks.

Content that Nicole is interested, Joseph now wants to make sure that her recruit doesn't make a verbal commitment while in Las Vegas.

"Are you serious about not verbaling?" she asks. "They'll probably try to make you."

When Nicole again assures Joseph that she won't verbal while on her trip, the two begin talking about how Joseph became interested in Nicole. The coach explains that she saw her two years before at the Nike camp, and that since then she has simply assumed Nicole was going to Rutgers.

"Where did this get started from?" Nicole asks, her voice dropping in frustration. "I don't understand. I never said I was verbaling to Rutgers."

After some more talk about Nicole's injuries, Joseph asks where Nicole would go if she had to decide today.

"If I had to decide today? It's a tough question," she says, laughing. "I plead the fifth on that one."

Joseph wants to know who will help Nicole make her recruiting decision, who holds the cards. She has already decided that Nicole is an extremely astute and thoughtful person, but she wants to know who else is involved in the process.

"Do you know Falisha Wright or do you just know of her?" Joseph asks.

"That's my girl," Nicole says proudly.

"Tell her you talked to MaChelle Joseph. Me and Falisha go way back. I've known Falisha for a long time." In the interconnected world of women's basketball, Falisha Wright and Joseph had numerous ties. Wright's college coach, Beth Burns, recruited Joseph to Colorado before Joseph changed her mind and decided to attend Purdue. Joseph also coached against Wright in the NCAA tournament one year. Lin Dunn, whom Joseph worked with at Purdue, later coached Wright on the ABL's Portland franchise. Wright and Joseph then spent time together at the Nike camp in 1999. And on top of all that, Wright and the Auburn assistant, Lauretta Freeman, played together for the ABL's Nashville Noise. So, Joseph is well acquainted with Nicole's friend and heroine.

"What about your mom, what role does she play?" Joseph asks.

"My mom, she's involved in a way but she doesn't really know anything about basketball. She knows nothing about the schools, so it's kind of hard. My family will play a part and my assistant AAU coach, I'm pretty close with her, Joann Mosley. She's a lot older, of course. I'll get Falisha's advice and hear what she has to say. She's like my little adviser. She puts the bugs in my ear. And then I'll decide from there."

"What does your AAU coach think?"

"She honestly thinks I should sign late. But I think if I visit a school and I'm one hundred percent sure that I wanna be there for the next four years, I'm going with it. That's just me. If I'm not sure, if I'm a little skeptical, then I'm gonna wait.

"In terms of the academics, I am looking at the graduation rate. I do want to attend a good academic institution because my mother, she's Jamaican, she has her values and what have you, so she really wants me to go somewhere that's academically sound.

"And in terms of a team I wanna be with ballers. I'm so sick of being on teams where Nicole is this, Nicole is that. I'm not a selfish player in any way. And I don't care about all the hype. I'll take the backseat without a problem. So, I wanna go to a place where I think I can get playing time. Because you know you have to go in there and battle it out with whoever there and try to earn your spot or earn playing time. So that's just my thing."

By now, Joseph is so impressed she cannot believe this kid hasn't been gobbled up by someone. But she understands that UNLV has the inside track, so she addresses that with Nicole.

"I would be a little intimidated if I was them and then all of a sudden Auburn came in. I mean they've been recruiting you for a while."

"UNLV has been here since the beginning of the summer and GW came in at the end of the summer and they'll probably say, 'Well, where were they?' but I'm prepared to answer questions like that."

"Do you feel like you owe them anything?" Joseph asks.

"I feel that I owe them something, some kind of loyalty, but Mos said you don't owe anyone anything. We're always arguing, we have different opinions about the recruiting process. She knows more and she's had players who have gone through the process. I'm just taking her advice and deciding whether to use it at all. UNLV, I do feel like I owe them something. They've been with me. Even in the beginning when I told them I was interested in Georgia, in this school and that school, they were still there, beating down the door. And now all those schools went away and they're still there. I really respect that. I honestly do.

"We'll see. I just want the cards to fall into the right place. We'll see how everything goes."

Soon, Nicole asks the question that she has been dying to ask the whole time.

"How come you guys weren't recruiting me before?"

Joseph again explains that she had assumed Nicole was going to Rutgers.

"That's totally understandable," Nicole says. Still, she cannot get her mind around why everyone else backed off. "For everyone to back off like that it just don't make sense. I don't know."

After almost an hour-long conversation, Joseph tells Nicole that she wants to fly to Paterson to visit her next week and that she wants to set up an official visit the weekend of November 9.

"I have to speak to my mom about that," Nicole says. "That kind of annoys her when I have to miss school."

"I would like to speak to your mom. How do you feel about her calling me collect?" Nicole suggests Joseph try her mother at home in the evening, before she goes to work.

After they hang up, Joseph is ecstatic that she still has a shot at Nicole, and amazed at how Nicole seems to be in complete control of her own decision-making process.

"I honestly believed she bounced things off of people but I think that kid was in charge," Joseph will say later. "Sometimes the mother's in charge, the father's in charge, the AAU coach, the high school coach, boyfriend, friend; you never know who's in charge. But in this situation, there was no doubt she was in charge." Still, she remains skeptical about whether she can get Nicole at this late date.

Nicole is pleased that a Top 25 team is interested, a team that plays on national television, but is skeptical about the process. "Honestly," she says after she's hung up, "I feel I am at least one of the top fifteen players in the country and to have those schools interested, that is what I expected from the get-go. I am happy, but as far as being psyched, not at all."

Kesha and Nicole have now moved into the kitchen, where Kesha is treating Nicole's hair with a steam iron she has heated on a burner.

"Make sure this feel mad silky smooth," Nicole instructs her cousin. "Going to school looking GQ tomorrow." Nicole is feeling good. Her hair is shaping up, and now she has a big-time school pursuing her all the way to Paterson. Nicole notices some brown sugar Joan is using to make a Jamaican rum cake, which Kesha calls "black sugar." Nicole likes the concept of black sugar so much she proclaims, "That gonna be my next screen name. Oh, that junk is raw!" When reminded of her previous names, she proclaims in a singsong voice, "I'm gonna always be 'Dark Delight,' as dark as I am and as delightful as I am. People like being around me because I'm delightful. And they also like being around me because I'm a black queen from the Motherland!"

Chapter 21

If Nicole had been a highly regarded boy taking a recruiting trip to UNLV—let's call him Nick—her, or rather, his visit might have been quite different. After Nick was installed in his hotel room at the MGM Grand, he could well have been taken to a party and offered the company of a female student or two. The coaching staff would have shown him the bright lights of the Strip, the celebrities hanging out in the casinos. And if the school's boosters wanted Nick badly enough, they might just have offered to alter his test scores if necessary, or to give him a little money to make the "right" decision.

All these things have been done for male recruits at UNLV. During his senior year of high school, Desmond Herod, the second all-time leading scorer in New York City high school history, made an official visit to UNLV. The 6'4" guard out of Adelphi Academy in Brooklyn stayed in his own suite at the New York–New York Hotel complete with a hot tub and a view of The Strip. He had never seen a hot tub before.

In 1998, when he signed with the Rebels, he looked forward to a promising basketball career, to say nothing of the fast life and warm weather.

"Out in Vegas, you have basketball, campus, fast life, casinos, girls, fun, and then school work," he told the *Star-Ledger*. The summer before his freshman season, he worked as an office assistant for the tennis star Andre Agassi, twice dining with him at the best Vegas restaurants. "He's a real nice guy," Herod said. "I got a chance to see his house. He's got a nice house and a lot of cars. I saw Brooke [Shields], too. She came by."

Once, while walking through the exclusive Bellagio casino, he ran into Michael Jordan sitting at the end of a $5,000-minimum blackjack table. "It was him, the dealer, and his cigar," he said. "That was it."

Herod struggled through his freshman season at UNLV, averaging 5.5 points and 15 minutes a game. He missed home and whenever he talked to his high school roommate Charles Manga, a Seton Hall center, he missed home even more.

But homesickness wasn't Herod's biggest problem. His biggest problem occurred when reports surfaced that he and Lamar Odom, the nation's top recruit who signed a letter of intent with UNLV in 1997, received what was called a "$100 handshake" from a school booster during a recruiting visit. Herod denied the allegations and the NCAA cleared him.

"People will always assume I got a lot of money because I was leaving New York and I turned down a lot of schools to go to Vegas," Herod told the *Ledger*. "To a certain extent, I think I got caught up in the middle of things. Coming out of high school, it's a fast life out there. It's easy to get sucked into it."

Herod eventually transferred to Seton Hall and sat out a year, following NCAA regulations. A broken foot sidelined him for the first seven games of the Pirates' 2000–1 season, but he ultimately worked his way into the lineup.

Odom, meanwhile, first came under scrutiny when a July 1997 *Sports Illustrated* article accused a UNLV assistant, Greg Vetrone, of being able to arrange for altered Scholastic Assessment Test scores in 1994 while at the University of California–Irvine. Vetrone vehemently denied the allegations, but UNLV didn't contest lesser allegations that he had given Herod rides to work and made improper phone contact with Odom. Odom's academic reputation was, of course, damaged by the story, which focused attention on the disparity between his poor academic history and the relatively high score of 22 he scored on the American College Test. The article prompted the NCAA to request a review of the academic records of Odom and another player, but Odom declined to grant permission for his review.

Odom never played at UNLV. He went on to play one year at Rhode Island before going pro and becoming one of the brightest stars in the NBA. But UNLV wouldn't escape so easily. In December of 2000, the NCAA would put the UNLV men's basketball on probation for four years because of violations stemming from Odom's recruitment. The NCAA determined that for two months during the summer of 1997, when Odom was enrolled in a summer school class, a local dentist and UNLV booster named David Chapman gave him approximately $400 to $800 two or three times a week, paying him a total of about $4,000 before the university decided not to allow him to enroll. After Odom left the university, according to the NCAA, Chapman continued to provide him with housing, an automobile, meals, dental work, clothing, and cash. The amount ultimately totaled a reported $5,600.

The Odom affair wasn't an isolated incident at UNLV. Features of Odom's recruitment were similar to that of Lloyd Daniels in the 1980s, which attracted the attention of the NCAA and led to UNLV's probation in 1993. Daniels never played for UNLV, and the controversy over his recruitment led to the forced res-

ignation of Coach Jerry Tarkanian in 1993. Coach Bill Bayno suffered a similar fate after the Odom and Herod situations became known. He was fired only hours after the 2000 probation came down.

Even before that, Bayno's name had surfaced in connection with a racketeering case being brought in federal district court in Atlanta against Steve Kaplan, the owner of the Gold Club, an Atlanta strip joint. According to court documents related to the case, Kaplan enlisted Gold Club strippers to have sex with Bayno at Las Vegas's Mirage Hotel in June 1998 (Kaplan's attorney said, "Any such allegation about Steve Kaplan's involvement is absolutely untrue"). Bayno told *Sports Illustrated* that he met Kaplan several times, adding, "I'm not saying I haven't had sex with girls at the Mirage, but if it was arranged by Steve Kaplan, it was unbeknownst to me."

* * *

Nicole's four-day sojourn in Las Vegas isn't nearly as eventful as Herod's, Odom's, or Bayno's. Coach Brenda Pantoja picks her up at the airport on Thursday and gives her a hug and a big smile. She drives her to The Strip, where the two watch part of a glitzy water show. Nicole is tired because of the time change, but excited about the change of atmosphere. She has rarely been this far from home before.

The next morning Pantoja picks Nicole up at the MGM Grand and takes her to breakfast at a local International House of Pancakes. Nicole meets Coach Regina Miller, who also greets Nicole with a big smile and a hug. The day is filled with a tour of the campus, meetings with various university representatives, and a lunch with the players. It is topped off by a UNLV volleyball game, which the hosts lose to Brigham Young.

Late Saturday morning, the sun is shining brightly and Coach Miller suggests that she and Nicole take a tour of the campus in a golf cart before the UNLV–Wyoming football game. Miller has coveted Nicole as a person and a player for several months now. She believes Nicole can be her point guard of the future, a floor general who might continue to lead the Lady Rebels upward.

Now she is looking Nicole directly in the eye, hoping to gain a verbal commitment from her right there. Nicole is soaking it all in—the campus, the environment, everything Miller is saying.

Nicole knows the pressure is on. "Maybe this is the place for me," she thinks to herself. "I like the coach, the coaching staff is okay, I like the players. Maybe I should come out here. It's so many miles from my family, but you have to break away from the nest sometime."

But something holds Nicole back. She has promised Coach Joseph that she won't verbal while in Las Vegas, and, as much as she likes Miller and the UNLV campus, she wants to see what other options are available. "I did wanna take my other visits and I did wanna give Auburn a chance," she will say later. "I didn't have anything to compare to UNLV, so I didn't really know if that's the place for me."

Still, Coach Miller is so confident that her recruiting pitch has worked that her staff sends Nicole a presigned 2001–2 National Letter of Intent and an Athletic Financial Aid Award form. Including tuition, room, board, and a stipend, Nicole's scholarship is worth more than $17,000.

After Nicole gets home, she rates UNLV on a form Mos has given her entitled "College Rating." On it she ranks various aspects of the UNLV basketball program and the school on a scale from zero to five, with zero representing "poor" and five "outstanding." "The coach as a person" and "the basketball facility" each receive a five, but next to "postseason play" she has written a one. Under the "school" heading, Nicole gives "the campus" and "the school's overall academic reputation" a two and "distance from home" a zero. Overall, the score is 52.

* * *

While Nicole is enjoying the excitement and beauty of Las Vegas, all is not well at home. Early Sunday morning, a 16-year-old Eastside High freshman named Wilken Rodriguez is stabbed to death outside a sweet-16 party in Paterson. The father of a five-year-old son, he apparently got into a dispute with a 17-year-old former Kennedy student. Wilken's twin brother, Wilbin, also involved in the fight, is knocked out with a baseball bat. Wilken is taken to Wayne General Hospital, where he is pronounced dead.

When Nicole returns to Kennedy on Monday, it resembles an armed camp. Many Kennedy students, fearful of reprisals from the Market Street gang on the Eastside, have brought knives and other weapons to school.

"We were finding knives in the girls' rooms and the boys' rooms," Paterson Police Detective Andrew Muckle later said. "Kids didn't know if [the rumors of reprisals] were true or not." The police stationed five additional cars outside Kennedy throughout the week, as well as several motorcycle and bicycle units. On the basis of tips from students, they were able to seize weapons from a number of other teenagers.

In the days that follow, students at Kennedy design a small mural commemorating Wilken, who was apparently well liked, even at Kennedy. Over a

series of articles and pictures of Wilken were written the words, WILKEN, YOU'LL BE MISSED BUT NEVER FORGOTTEN. THAT'S A FACT.

A week after the murder, another, albeit smaller, incident affects the Richmans more directly. While riding his scooter outside the house, Alex is jumped by three boys trying to steal it. His cries bring Euphemia out of the house and she chases the assailants away.

Wilken's murder still dominates discussion in school. One day the incident provokes a debate among Nicole, Justine, and Sakina on violence, the police, and the general state of Paterson. The three girls, as well as Sakina's daughter, Jalea, and several of their friends, are in the School Based room playing a board game called Taboo when the subject of gangs, still on everyone's mind, comes up.

"Yo, you know how many gangs are in this school?" Nicole asks rhetorically. "That's why I'm cool with everybody. I ain't trying to get killed." Nicole adds that she's trying to at least see the age of 20 before something dangerous happens.

Justine says that "everybody [at Kennedy] bring a blade or something to school. It ain't nothing." As for whether the police presence in the school is helping matters, their opinions differ.

"It don't make me feel better," Justine says. "It's not like there's violence on an everyday basis. Ain't nothing happening."

"I think it's a good idea," says Sakina, who wants to grow up and reform the police because she feels that most of the officers in Paterson aren't from the city. "In neighborhoods like mine, you call the police from your house, it's ten to twenty or thirty minutes later by the time they get there. [The Paterson police do not release statistics on response times, but it is not uncommon for them to take an hour or more to respond to a call.] You could be dead or seriously hurt or all the stuff in your home will be gone. Put a certain time limit on when the police should be at your house."

Despite the recent incident, the girls feel that Kennedy and other inner-city schools tend to get a bad rap from the media.

"A lot of people make Kennedy seem so bad, but it's not," Sakina says. "The media makes it seem bad."

"There's a lot more people here," Justine adds. "There are twenty-five hundred people here."

"A lot of it is because we're a minority," Nicole interjects. "You don't hear Clifton getting dogged like that. The media is so ready to project all the negative things that it overshadows all the good things that we get here. . . . Anthony got a perfect score on the HSPT [High School Proficiency Test] math."

"But you don't hear about that, do you?" Sakina asks. Sakina is a youth representative on the Mayor's Task Force, and has learned that the major gangs are

recruiting fifth-, sixth-, and seventh-graders. She has also interviewed people in Paterson to learn about the various gang rivalries.

"We talk to a lot of people on the street [and ask], 'Why would you be East Thirty-first Street against East Thirty-second?' It don't really make sense because we're all in the same community and we're all making the community look bad. Whether you know it or not, Tenth Avenue is Bloods. They not Tenth Avenue. They Bloods. They be having their meetings ten-thirty to four in the morning."

"I feel so naïve to Paterson," Nicole says sheepishly. "I don't know anything about gangs."

"The detective say the founder of Dark Side is a white kid from Totowa," Sakina says.

"We should form a gang," Nicole adds.

"You have a gang," interjects Raheem, who is walking past the discussion to his corner office. "It's called the Kennedy girls' basketball team."

Sakina and her friends have long decried the absence of alternative forms of entertainment for young people, and believe that contributes to the gang problem.

"There's nothing to do in Paterson," Sakina says. "No arcade, no movies, no computers, not even a rec room if you want to just go on the computer."

"Other people tell us we're boring because we don't smoke weed," Nicole adds. "How we look like we boring? Cause we don't smoke weed or nothing?"

"People in general need something to do," Sakina says. "You have a whole bunch of black and Hispanic kids that don't have nothing to do. There's nothing positive to actually do around here. They have nothing but negative things to do. If they enforce some kind of curfew, you'll have so many pregnant girls walking around here."

"Everywhere you turn it's another pregnant girl," Nicole says. "What they need to do is hand out some condoms around here. There's a lot of people don't buy condoms around here. We need to have a health fair and people need to hand out condoms. I know you embarrassed buying a condom but you gonna be more embarrassed walking around with a child your whole life."

"You know how gym is a requirement?" asks Justine. "We need to have some kind of class where you talk about stuff."

Finally, with the board game and discussion over, Nicole heads for the door, slapping her hand on her pager. "Hit me on the hip if y'all wanna do something later."

Chapter 22

On the day after Nicole returns from Las Vegas, and in the wake of the uproar over Wilken's murder, MaChelle Joseph of Auburn arrives in Paterson. It is Monday, October 23, part of what the NCAA considers an "evaluation period." During these periods, "Coaches may evaluate the academic standing and playing ability of prospects . . . but may not make any in-person, off-campus recruiting contacts." Essentially what this means is that Joseph may visit the school and speak with Coach Bonora. She may watch Nicole work out, but she is not permitted to make any face-to-face contact with her.

When Joseph comes to Kennedy, she and Bonora meet in his In-School Suspension class for about an hour. Behind closed doors she lays out her case once more. Auburn has come to need a point guard because of its uncertainty over Tanesheia Thompson's status. The coaches have extremely high regard for Nicole and probably would have pursued her all along had they not assumed she was interested primarily in Rutgers; Nicole never returned a questionnaire sent by Auburn after her sophomore year at Nike. Joseph can envision Nicole playing several positions at Auburn—point guard, shooting guard, and even some small forward. And Joseph doesn't want to see Nicole sell herself short by going to another school that doesn't offer the tradition, exposure, and competition that Auburn does.

During their conversation, Joseph's cell phone rings. What a stroke of luck, Joseph thinks, when she sees the 503 area code displayed on her phone. She knows it is Falisha Wright returning a call she had placed to ask about Nicole, and she hands the phone directly to Bonora before answering. She believes Wright will tell Bonora that Joseph is a straight shooter.

Nicole had already spoken to Wright about Auburn, and Wright told her Coach Joseph was "good people" and that "she'll take care of you." Now, Wright and Bonora talk informally. "How you doing?" Bonora asks. "Make sure the next time you're in town, you come and see me." When Wright asks her old

coach about the status of Nicole's recruiting, the Kennedy coach mentions that UNLV has offered Nicole a scholarship; this comment is intended at least partially for Joseph's benefit.

After they emerge from behind closed doors, Bonora takes Joseph on a brief tour of the school, past all the Athlete of the Week plaques. "You've had some great athletes come through here," says Joseph. "That's for sure."

Soon Coach Bonora and Coach Joseph arrive back at the School Based room to watch a videotape of Nicole. Most of the students have gone for the day, but Raheem Smallwood, Sakina's father and the head of School Based, is still there.

"This is Coach MaChelle Joseph from Auburn University," Bonora tells him. "She's interested in Nikki for Auburn. They said they'd sign her early and everything."

Joseph remarks to Bonora that she has been recruiting for nine years, and she has never seen a situation like this where so many schools back off an elite player, leaving her available at this late date.

"Nobody would've guessed it," Joseph says.

Soon the two coaches are watching a game from the year before in which Nicole exploded for 45 points, including the game-winner on a drive through the lane in the final seconds. When Nicole fires in a 3 from well beyond the arc, Joseph says, "That's unbelievable."

"That was pretty far back," Bonora agrees. "That's almost out of bounds."

Eventually, knowing that the tape speaks for itself and that Joseph must catch a plane, Bonora says, "I think you've seen enough. She's strong, she's got great range, she's got handle."

"She's unbelievable," Joseph says. "She can get twenty points a game. I just gotta talk her into coming and visiting."

"She's gotta learn to come off a screen," Bonora, always the coach, adds.

"I'm sure you'll set her some screens," Joseph says. "Then she'll probably average fifty points."

As they make their good-byes, Joseph leaves this thought hanging in the air: "I hope she doesn't sell herself short." As if her comment weren't crystal clear, she will later send Nicole a preseason basketball poll that ranks UNLV No. 100 in the nation, and Auburn No. 14.

* * *

The coaches from UNLV haven't heard Joseph's characterization, but it doesn't take much to put two and two together. Two days after the visit, Coach Pantoja calls Bonora three times before school is out. Where was Auburn

before? Has Joseph talked directly to Nicole during her visit? Now, the tone of the phone calls and letters from UNLV become pressing, more desperate.

"Nicole, you are a perfect fit for UNLV and UNLV is a perfect fit for you," Coach Miller writes. "Don't hesitate! Become a Lady Rebel! I look forward to working with you during your college career."

In conversations with Nicole, Pantoja asks questions designated to plant certain doubts in her mind. "Are you worried about how many players are filling your position?"

"It depends on who those players are," Nicole, ever confident, says.

"Are you willing to sit or do you want to contribute to a team's success right away?"

"I want to contribute right away, without a doubt."

"It depends on who the coach is. If there are players that are more experienced, like a junior or senior, you'll probably have to sit."

These questions are obviously intended to make Nicole think twice about Auburn, and for a brief period they have the desired effect.

"I know that experience had a major part to do with it but I thought it would be who could put the ball in the hole or contribute to the team in a greater way," Nicole confides one day.

Bonora has seen all this before, and he isn't going to be swayed by anyone's pressure tactics. On the Wednesday after Joseph's visit, as Nicole is leaving the gym, Bonora asks her to come back so they can talk for a few minutes. Sometimes it is hard to pin Nicole down these days. He confides that Coach Pantoja called. "I gotta tell you we didn't have the best discussion," he says. "She said Mrs. Robinson was offended that Auburn was coming in so late."

"Mrs. Robinson?" Nicole asks with a laugh, grabbing her coach on the shoulder. "You mean Mrs. Richman."

"I'm sorry, I'm thinking of the movie *The Graduate*." Bonora adds that he asked Pantoja whether Nicole had verbaled in Las Vegas. She didn't, of course.

Nicole tells her coach how she had almost made a commitment, how the mood was right in the golf cart, but something held her back.

"Are you a religious person?" Bonora asks. "Are you familiar with the Bible at all? Are you familiar with what the Devil said to Jesus in the Book of Matthew? As they looked out over a mountain, he said, 'All of this could be yours if you give me your soul.' Don't forget, recruiters are like car salesmen. They want you for something. They get a commission if they sell you a car."

Bonora repeats to Nicole what he told Pantoja on the phone: "If it was my daughter, I'd encourage her to take three to five visits and see what she likes. Don't commit early. Take into account the academics as well as the athletics.

What else do you have lined up besides UNLV, George Washington, American, and Auburn? Where else would you like to go? What if Louisiana Tech says they want you to visit?"

"Well, tell Louisiana Tech I'm coming on down," Nicole says, her voice rising in approval of the thought. Louisiana Tech has produced several WNBA players, including Nicole's heroine, Teresa Weatherspoon, and Vickie Johnson, also of the Liberty.

"What weekends do you have available?" Lou asks. "This week is GW, then you have American, then open, and then Auburn."

As Nicole walks to her black Sentra parked presumptively in an illegal space in front of the gym, Bonora yells, "Don't commit. Don't commit."

Nicole hardly has time to take this latest conversation in before Joe McKeown, the George Washington coach, calls to tell her the school has received a commitment from a point guard who lives in Maryland, Greeba Outen-Barlow, and is no longer recruiting Nicole. Outen-Barlow is the eighty-sixth best senior in the nation, according to the Blue Star Report. "It just didn't seem like Nicole was ready to make a commitment," Nicole reports McKeown telling her.

"I didn't have a huge interest in GW like I did in Georgia, so it was okay," Nicole says. But as she thinks about it, she sees this as another example of a college coach doing her wrong. Because the notification from George Washington comes just a couple of days before she is scheduled to visit, she has no time to arrange a visit to Louisiana Tech or someplace else.

* * *

Nicole and her family visit American University in Washington, D.C. Nicole has no intention of going there, but she feels indebted to the coach. She changes her mind several times about whether to spend one of her five official visits on the school, ultimately deciding to make it unofficial. During the trip, money is tight, so Nicole ends up declaring it official, meaning that the university will pay for it. She and her family eat almost $300 worth of Italian food at a dinner with Coach Hart. The decision also means that she has only three official visits remaining.

As October ends and November begins, other schools such as Texas and the University of Southern California become aware that Nicole is still available. They hurriedly send off FedEx packages and make last-minute phone calls. Aware that Nicole is still making up her mind, a local lawyer one day hands her his card, and says, "You're probably gonna need some help in this process," adding for good measure his connection to Paterson's most famous star: "I helped Tim."

During the summer, Nicole told USC she wasn't interested in traveling that far. The school backed off and attempted to recruit Cappie Pondexter. Now, its coaching staff is trying to make up for lost time.

"Dear Nicole," USC's head coach, Chris Gobrecht, writes, "As I said on the phone, sometimes the gifts that drop from heaven are the best of all—having the opportunity to recruit you is a gift from heaven.... USC is far and away the best of all the Universities you are considering and can offer you the best in every thing from internships during your school years to National and International networking after your school years. It is a private university with a pricetag of $40,000 per year for each one of our players. To tell you the truth; Cappie wanted to come here but we were having problems getting her admitted, so she opted for Rutgers. You are a much better student and probably a better fit for USC.

Second reminder; it is likely much easier and much cheaper to fly to L.A. direct then [sic] it is for you to go to some of the small towns or places you are considering. If you have to get on an airplane to go to the school of your choice, USC in Los Angeles is more accessible than any of the others!

We would love the chance to sign you in April and would have shot for this week if there was time."

But Auburn is way ahead of the curve. On November 2, when these other schools are still writing Nicole letters, Assistant Coach Lauretta Freeman visits Kennedy just to watch Nicole practice. She recently sent Nicole's mother a letter, addressed to "Angela Richman," about the same time Coach Joe Ciampi sent Nicole one explaining that the point guard plays a crucial role in any team's "offence." Nicole and Justine have had a good laugh at these spelling errors, but Nicole is still buoyed by Auburn's persistence.

Freeman's visit comes at a time when Nicole is swamped with exams, and when she and Laura Judge are again dealing with Nicole's knee problem. A few weeks before, Dr. McInerney had repeated his recommendation that Nicole get orthotics. Once again, the cost, $300 and up, is prohibitive.

In another meeting, with one of McInerney's colleagues, Nicole is told that she may need a cortisone shot, or perhaps even surgery, if the tendinitis in her knee does not abate. The doctor wants a magnetic resonance imaging exam (MRI) performed on her left knee; he fears that she may have torn a portion of her patella tendon. She does not appreciate the cold, flat way this doctor gives her the news, as if the future of her entire basketball career were something that could be discussed without any compassion whatsover. She doesn't like this doctor and wants to see McInerney instead. But he is not available. For days afterward, she complains to Judge about how this doctor spoke to her. She decides to get the MRI done, but not to pay much heed to what the doctor said.

Now, after Nicole misses a 3-pointer during a warmup session, Auburn's Freeman jokes to Coach Bonora, "I told her she could brick five in a row, we still want her!"

By now, an official visit to Auburn for the following week has been set up. In the meantime, Coach Ciampi calls Andrea to touch base. He is aware that coaches from other schools have visited Nicole's home and met her family. He knows he is at a slight disadvantage because he hasn't had the same opportunity. During the phone call, he tries to make up for lost time, hoping to tell Andrea all that he can about Auburn and how Nicole will fit into the program. Andrea thinks he sounds nice, but he speaks very quickly.

On November 3, Bret McCormick, the recruiting expert who first turned Joseph on to Nicole, arrives at Auburn for the team's preseason game against Athletes in Action, a club he coaches. When he and Joseph discuss Nicole, Joseph says, "We've got her coming in for a visit."

"Oh really," McCormick says. "You'll probably get her then."

Chapter 23

On November 9, when Nicole arrives at Auburn, Alabama, on an Auburn University jet flown by an Auburn University pilot, two things strike her immediately. The first is that there aren't many black people on campus—about 7 percent of Auburn's 22,000 students are African American—yet 8 of the 14 women on the basketball team are black, as are many of the school's service workers.

Almost simultaneously Nicole notices that everyone is extremely friendly. Everywhere she goes, students wearing shorts and T-shirts in November's mild weather take time to speak with her and show interest in her.

"Everyone knows the South is generally known for its hospitality," she later says, "and I experienced that firsthand walking down the street. Everyone was like, 'Hey, how are you?' Where are you gonna find that in Paterson?"

Auburn is about as far from Paterson as one can get, and not just because one third of Paterson's 149,000 residents are black and just 17 percent of Auburn's are. Founded in 1856 under the name East Alabama Male College, the school opened three years later with an initial enrollment of 80 white students; in 1960, after several name changes, it became known as Auburn. It started admitting blacks in 1964. Unlike UNLV and George Washington, which are located in the middle of two of the most vibrant cities in the world, the town of Auburn would likely just be another stop along Interstate 85 if it weren't the site of the university.

Auburn ranks as one of the top 50 academic institutions in the nation, according to a recent survey by *U.S. News & World Report,* but it has gained much of its fame because of the success of its athletes. Rising out of the center of campus like the Roman Coliseum is Jordan-Hare Stadium, where Bo Jackson won the 1985 Heisman Trophy before becoming a two-sport star in professional baseball and football. Across the street sits the Beard-Eaves-Memorial Coliseum, where Charles Barkley earned the nickname "The Round Mound of Rebound"

before going on to a Hall of Fame career in the NBA. It is where Ruthie Bolton-Holifield played for Lady Tiger teams that reached the NCAA Final Four in 1988 and '89 and contributed to a 68-game home winning streak. Completing the triangle of magnificent athletic arenas is Plainsman Park, Hitchcock Field, where the baseball team plays. The university has an athletic museum devoted to showcasing the careers of Jackson, Barkley, Bolton-Holifield, and other stars. Seventeen athletes from Auburn, including eight in track and field, participated in the 2000 Sydney Olympics.

When Nicole enters the women's basketball wing of Beard-Eaves-Memorial Coliseum, she notices the framed pictures, trophies, and basketballs commemorating Auburn's rich basketball tradition under Coach Ciampi. As she walks around campus, she sees signs announcing $100 tickets for sale for the upcoming SEC football championship, in which Auburn will take on Florida. Nicole's busy schedule doesn't permit her to venture downtown, where the sidewalk of fame honors stars like Bolton-Holifield and Vickie Orr, a 1992 basketball Olympian, the way entertainers are honored on Hollywood's Walk of Fame. Restaurants and bars downtown feature framed photographs of Auburn's many football and basketball players and other athletes hanging on the walls.

If Nicole wants the big time, this is it. Joseph and her colleagues go to the usual lengths to make Nicole feel as if she will fit right in. Before she arrived, Joseph and Assistant Coach Craig Kennedy compiled a highlight tape of Nicole in action, set to the song "Eye of the Tiger" from Rocky III. While making the tape, they were amazed at the skills Nicole possessed, how she could change speeds on the dribble, power through post players on the way to the basket, and step back and drain 3-pointers. Now, as Assistant Coach Kellie Jolly Harper escorts Nicole into the Coliseum, the highlight reel plays on the large screen hanging over center court. The team stands off to the side as a stentorian voice slowly announces, "Now presenting from New Jersey, Nicole Louden." At the end of the video, images flash of what Nicole's career might hold: AUBURN ALL-TIME LEADING SCORER, 2,333 POINTS; LEADS AUBURN WITH 20 POINTS PER GAME; 3-TIME ALL-SEC ACADEMIC HONOR ROLL; 2004 ALL-AMERICA; 4-TIME ALL-SEC.

The coaches take her to the locker room, where there is a jersey with her name and number; perhaps thinking it might be valuable, someone has stolen the LOUDEN name tag over one of the lockers. They present her with a basketball that reads, AUBURN 77, RUTGERS 68, signifying a hypothetical game in which Nicole's potential new school defeats her old favorite. They introduce her to Ruthie Bolton-Holifield, who is on hand to welcome Nicole and a fellow recruit.

"Yo, doesn't Nicole have guns on her?" one of the coaches asks the 5'9", 150-pound WNBA star, referring to the size of Nicole's biceps.

Bolton-Holifield, known for her impressive physique, kids, "No . . ." Apparently, she thinks Nicole's muscles don't compare favorably to hers.

At the men's and women's basketball double-header that evening, Nicole imagines what it would be like to take the floor in the Coliseum. She sees the Auburn cheerleaders, the dancers nicknamed the "Tiger Pause," and the "Dunkin' Darlings," a predominantly white group of students who are the official "Hostesses of the Basketball Team." She notices the basketball teams wearing sneakers provided by Nike and having a choice of three different types of uniforms provided by the firm Russell Athletic, headquartered in nearby Alexander City, Alabama.

Nicole's doubts about the size of the school's black population are alleviated somewhat when she attends a party at one of the school's black fraternities on Friday night.

"On campus I saw like five black faces," she says. "At the frat party it was all black heads. It was on, you could feel some love in the room. Oh, my goodness, so many guys trying to talk to me."

When Nicole meets with Auburn's trainers, they don't delve too deeply into her medical history. It is not standard procedure during a recruiting visit, and they are not fully aware of the history of Nicole's various injuries. Nicole doesn't volunteer much information, saying only that she has had injuries "here and there." In any event, it is likely that she will receive the best medical treatment of her life should she attend Auburn. The school features a fully equipped training room, including various leg machines, bike ergometers, stimulation units, ultrasound, and a whirlpool so that Nicole can soothe her back, knee, and shins after games. She won't have to worry about getting a ride to rehabilitation because it will be within walking distance of her dorm.

Everyone who comes into contact with Nicole seems tremendously impressed with her poise, charm, and intelligence. "She wowed Coach Ciampi," Joseph later says. "You bring an easterner in, they're so much more aggressive. I loved it. I'm that way, he's that way. I loved the conversation. I told Coach Ciampi, 'This kid's unbelievable, Joe, it's too good to be true.'" Ciampi—who likes to say, "You don't win with offenses or defenses, you win with special people"—agrees.

The players like her, too. Spencer, the starting point guard and Nicole's host, is impressed that Nicole wants to see everything, including the "Tiger Walk," in which throngs of students and supporters line up to cheer on the football players as they walk from their pregame meal at Sewell Hall toward Saturday's football game with Georgia. She thinks Nicole could fit in well at Auburn. "Just being around her, she's SEC material," Spencer says. "Most girls come out of high school and they haven't been in the weight room. They're just not ready for the game. But she reminds me of Ruthie Bolton."

During the football game, Nicole finds herself standing up and singing with the 86,000 other fans, "It's great to be an Auburn Tiger."

* * *

When Nicole returns home Sunday night, she is so excited about her trip, so sure Auburn is where she will spend the next four years of her life, that she tells her mother and family that she has made her decision. Andrea has been somewhat skeptical of Auburn because of its late entry into the process. She has urged Nicole not to sign anything during her visit. Nonetheless, she supports her daughter's decision. She simply wants Nicole to be happy. She wouldn't mind if all of these coaches stopped calling her house, either.

But by Monday, Nicole is rethinking her decision. She doesn't want to rush into anything, and she thinks perhaps she should take visits to other schools. Nicole wants to consult a few people before making her final decision, mainly Mos, Falisha Wright, and Coach Ring.

Over the past several months, Ring has noticed the precipitous decline in Nicole's stock, that the letters from Connecticut, Rutgers, and Tennessee stopped coming to the school, and he wondered what the heck was going on. Now, at school on Monday, he tells her that maybe she wasn't Auburn's first choice, but at this point who cares?

"Nicole, you got what you got for two reasons, because of your GPA and your SAT score. And sometimes that becomes a more important factor than your ability to dribble, pass, and shoot.

"The way major college basketball is these days, they'd rather have the bird in the hand than two in the bush. Nicole, you fell right into their lap. You might not be as good as the girl from Alabama, but the coach would rather take the guarantee that you present than wonder about the girl who would've qualified.

"Unfortunately, right now you're in a situation where you don't have time to visit USC, Louisiana Tech, and Texas. What you have to weigh is when you hold off Auburn, this girl might qualify and then your scholarship might not be available. Nicole, let's look at it this way, you have UNLV in this hand and you have the SEC and Auburn in this hand."

Later in the day, Nicole runs into Vinnie McGill from the boys' team in the School Based room. Wearing black sweats and a black headband around his shaved head, Vinnie sits on a couch and quizzes Nicole on her weekend trip.

"How was it?" Vinnie asks. "That's where you're going?"

"Probably, probably," Nicole says, sitting on the back of the couch facing Vinnie.

"Where they ranked?"

"One poll has them at fourteen, the coaches' poll has them at Number Twenty."

"So how was it?"

"The campus was nice, the people were great."

"All black?"

"The campus is seven percent black," Nicole says. "If you include people of color, it's fourteen percent."

"How many people on the basketball team black?"

"Mostly the whole team. It was tight there. They had an exhibition game. They played this dude on the other team, he was on another level. He came down and bing-bang. Every time he touched the rock, they called him 'Airball. Yeah, Airball.' When he sat down it was like, 'Yo, Airball, you suck.' Crazy fans for an exhibition game. Being there people exhibit all their energies toward athletics."

When Vinnie asks about the women's team, Nicole provides her analysis. "The point guard they got now is five foot six, Carol Smith. Girl got game yo. She got the ball on the wing, didn't even wait for the girl to get there. She just blew by her and shot a floater over her."

"You got a chance to start?"

"It's gonna take some time to learn the system," Nicole says. "I say by the tenth game I should be in there."

Then Nicole mentions that she is still being recruited by USC, Texas, and Louisiana Tech, lest anyone think she doesn't have options.

"You better go see them first," Vinnie says. "You'll probably change your mind."

"I love Auburn, though."

"Yo, how many games they got on TV, on ESPN?"

"They got one on ESPN and one on CBS. My sister live right there and my uncle live down there. My uncle live in Atlanta."

"You gonna come back to visit?" Vinnie asks.

"I'm gonna come back."

"You don't know where you going?" asks Nicole, even though Vinnie is only a junior.

"I don't know where I wanna go. I still got a year left."

On her drive to the Y, Nicole's mind is racing. When she first got home from Auburn, she was ready to sign. Now, she is having second thoughts. She is still flirting with taking her other visits and waiting until the spring to sign.

"There's so many things to consider," she says. "I mean, what if I get injured? What if my performance senior year isn't up to par?" She says she is planning to speak with Falisha Wright and Mos this evening to see what they have to say. Then she repeats a mantra Coaches Ring and Bonora have apparently helped

drill into her head. "If I couldn't play basketball starting tomorrow, is this the school I would want to go to? Is this a place I could go and fulfill my education for the next four years?"

Once at the Y, Nicole, dressed in black shorts, black sneakers and two white tank tops, continues thinking out loud, now while exercising her thighs on one of the machines. "I'm in the worst situation. My senior year I shouldn't be in this predicament." In addition to speaking with Mos and Wright, she has decided to call Coach Joseph and say "I want to take the other visits but still commit to Auburn. And if she says we're not sure if we'll still have a spot for you, then I'll verbal."

That night, over homework and dinner at Mos's house, Nicole and her AAU coach have a frank discussion about the pros and cons of Auburn and UNLV. The size of Auburn's African American population has been the only real con in Nicole's mind, but she figures that she can adapt to almost any situation, so she disregards that issue. When she fills out the same form she completed after the UNLV visit, "the coach as a person" and "the basketball facility" receive fives, but "the basketball program" also gets a five to UNLV's three. "The campus" earns a five to UNLV's two, and "distance from home" receives a two, unlike the zero she gave UNLV. The total adds up to 65, compared with UNLV's 52.

After Nicole comes home from Mos's house, she lies on her bed, looking at the posters on her wall and thinking about everything that has happened in her life over the past several months. Her house is quiet—no music is playing and no one is around to bother her.

"Nicole," she thinks to herself, "you're in a great position right now. You can't ask to be in a better position. The school is a great institution academically. It has a great basketball program. They play in the SEC against the best competition in the country. What more could you possibly ask for? There's nothing else for you to analyze. So, why am I trying to find something negative in a positive situation?"

She prays to God, asking for His strength and courage to make the right decision. At that point, after half an hour of contemplation and reflection, Nicole makes her decision. "My heart is at Auburn, so that's where I decided to go."

On Tuesday morning, Coach Bonora and Kennedy's assistant principal, Robert Diaz, are standing in the main office at Kennedy. The two men aren't aware that Nicole has made her decision and are still operating under the assumption that she is reconsidering signing with Auburn. They clearly think the prevarication is a mistake.

"If she gets hurt, I don't know if she realizes the risk involved," Bonora says.

"She's had physical problems all last year," Diaz adds.

"Someone had to get to her," adds Bonora, who has been slightly skeptical about the quality of advice Nicole has been receiving all along. "Ideally, at the end of last year she should've picked her ten schools, had her five visits and that was that. But at the end of last year there was a coaching change."

"The SEC is probably the best league, this is the best women's league there is," says Diaz. "I don't know what kind of school Auburn is, and the graduation rate is a hundred percent, you said?"

Coach Ciampi's graduation rate is actually listed as 91 percent—still quite impressive.

"I don't know who she's talking to, frankly, whether it's her AAU coach or what," Bonora says. "Sunday night she was excited and now she's changed her mind."

Just then a secretary hands Bonora a fax from Auburn telling Nicole that the coaching staff really wants her and will look after her if she commits. "We make one promise only," it says. "We will take care of you."

Bonora explains that "there's a lot of pressure on" Nicole, before telling the cautionary tale of Tommy Vigorito, a local football star whom Bonora had coached at DePaul High School. "The kid had it all, grades, he was a good football player, good-looking. He gets to Virginia and they hold up a sign for him, he's supposed to be the savior of the football program. Three days later, he's sitting in a Roy Rogers in Wayne, he's quit school. He couldn't handle the pressure."

Bonora spoke with Vigorito and his father and listened to their concerns; ultimately he helped persuade him that Virginia was the right choice. Eventually, Vigorito went on to a pro career with the Miami Dolphins.

By four o'clock, when Nicole is sitting on an exercise bike at the Y, she doesn't look fazed by the momentous decision to attend Auburn—a decision she has told Coach Bonora earlier in the day. As a song from the rapper Eminem plays over the sound system, she doesn't look pleased or contented, joyous or relieved. Just focused.

"It will probably hit me later," she says. "You know what, it's finally out the way, which is a great thing. Now it's time to focus my time and my energy and devote myself to my team. I have to be there for my teammates now. The college situation is out the way. I'm focusing on my last year of high school and helping my team.

"It's time to think about the John F. Kennedy Lady Knights. All my time, focus, and energy is now on my team."

Later that night, alone in her bedroom, Nicole signs a 2001–2 National Letter of Intent to attend Auburn. Andrea affixes her signature as well. The next day, November 15, the last day of the fall signing period, Nicole will mail the letter.

* * *

On a cloudy and gray Wednesday, administrators at Kennedy arrange a press conference for Nicole at the school. By about 10:30 in the morning, Andrea, just coming off of her night shift at work, is taking a shower at the house. She plans to pick up Alex at school and take him to Nicole's signing.

"I'm glad that her mind is finally at ease," Andrea says when she has emerged from the shower. "For a while I think she was worried, when Georgia turned her down. She don't say much though."

Once dressed, Andrea drives to School 21 to fetch Alex. A sign COUNT ON ME. DRUG FREE. THAT'S ME hangs over the entrance to the building. She disappears into the school briefly, returning with her son moments later.

At Kennedy, a smiling Nicole wears a white sweater, cream-colored pants, and tan boots for her big event. More than a dozen people, including family, reporters, and administrators, are beginning to assemble in a conference room near Principal Roberto's office. "I have to beautify myself," Nicole jokes as she puts on some lip balm before entering.

Surrounded by her family, Nicole takes a seat at a large wooden table in the room, a copy of her Letter of Intent in front of her. The actual letter has already been sent. This one is for the benefit of the photographer, the two newspaper reporters, and others assembled. Joan, as usual, is videotaping the event.

Standing in front of the room, Kennedy's principal, Richard Roberto, addresses the small crowd. "We're here to celebrate one of our premier students signing a Letter of Intent to go to a Division I university, Auburn University," he says. "I think it's a fantastic opportunity. It's gonna be a very good challenge. We are very happy for Nicole. We'd like to congratulate Nicole on being a great student athlete and we would like to congratulate her family, all the members of her family, for being such a supportive team and getting Nicole through the educational process. You're to be commended. We are very, very proud of Nicole. Nicole, we wish you the best success academically, athletically, health wise, and we just want you to be a star and represent yourself and your family and Paterson, New Jersey, the best that you can."

"Thank you," Nicole says.

"Congratulations, everybody," says Coach Bonora with a big smile. "As I said, it's all good. It's all jiggy. It's a nice thing for Kennedy High School."

With that, a photographer takes a series of pictures of Nicole with Euphemia, Andrea, Joan, Kesha, and Alex. For one of them, Euphemia leans over and kisses her granddaughter on the cheek.

After the pictures have been taken and the speeches have been made, Nicole and her family venture out into the hallway, spilling out near the flagpole in front of Kennedy. There is a chill in the air, but everyone is so joyous they hardly notice.

"God has sent an angel to watch over her," Joan says proudly of her niece. "And that was the gift he has given to her, Auburn, for the hard work she has done during the past three years."

"I think everything is copacetic, man, beautiful," Euphemia adds. "She don't have to worry about anything anymore. We just have to pray for her that she doesn't get swell-headed and she do the things that are right."

Andrea and Nicole joke that maybe now the phone won't ring quite as often—at least with coaches on the line.

"Nobody ain't calling but the bill collectors because nobody calling for me now," Nicole says, a smile lighting up her face.

"Bill collectors ain't calling for me now," Andrea says with a laugh.

"Then nobody gonna be calling me," Nicole says. "My calling is done."

Epilogue
2000–1: Senior Season

If Nicole's first three years at Kennedy were filled with frustration, her senior season was like a fairy tale—a fairy tale conjured up largely of her determination and desire to win. Or, more precisely, her refusal to lose.

On the eve of the season, Coach Bonora and the Lady Knights suffered a major blow when Shantay Brown was deemed academically ineligible to compete. She averaged about 12 points per game, was the only other reliable ball handler besides Nicole, and seemed on her way to becoming an all-county performer.

In her absence, Nicole generally started alongside Litza Roman and Antoinette Johnson, now both veterans, and two freshmen post players, Crystal Reed and Bridget Hodgson. Nicole's friend Jamie Davis also played a key role on the front line. Bridget, a sturdy girl with glasses and long braids, said she had wanted to team with Nicole ever since she was in the sixth grade. "Now it's my chance to play with her, and I am," she said.

Coach Bonora instilled the most organized and disciplined coaching style of Nicole's high school tenure. He let the girls know in no uncertain terms that he expected them to be on time for games and practices; it didn't always work out as he planned, but penalties were handed out when players didn't show commitment. When Jennifer Esteves, a promising sophomore guard, abruptly quit the team early in the year, only to rejoin it later, Bonora made her play on the junior varsity for several weeks before integrating her into the varsity.

He also rewarded the girls whenever he could, ordering in pizza and taking them to dinner on occasion. He set up more plays than Kennedy had run in Nicole's previous three years. Aware that Nicole was still suffering from tendinitis, he frequently had the offense run its sets without facing a defense during

practice, so that Nicole wouldn't get fouled or injured by an overanxious player. He called that play "naked" because the offense faced no defense.

By the start of the season, the MRI on Nicole's knee came up negative and she was cleared to play. She had obtained temporary orthotics (for about $75), which alleviated much of the pain in her knee and shins. "I wouldn't have made it if I didn't have them," she said. Other than having the chronic tendinitis, Nicole managed to stay injury-free throughout the year, the first time that had happened in her high school career. She also tried to take better care of her body by not playing volleyball or any other sports. "I'm a lot wiser now," she said. "I know I need to look to the future."

As the season progressed, Nicole dominated opponents like a Division I player competing against high school kids. With her hair in Allen Iverson–like cornrows and her eyes supremely focused, she attacked the basket with a relentless fervor, perfecting an almost unstoppable pull-up jump shot from close range. She drew many fouls and often scored 10 to 12 points a game from the free-throw line. Referees called her by her first name, and opposing coaches and fans often complained that she got the "star treatment," such as getting away with carrying and traveling violations that most players would suffer.

Nicole, in turn, cultivated relationships with the referees, often slapping them on the behind or chatting face-to-face about calls. She seemed more aware of the clock, the court, and her surroundings than the majority of other players. Though the gap between Nicole and her teammates was wider than ever, they were now catching her passes more often than not. They were generally making the wide-open layups afforded them when Nicole passed out of double- and triple-teams. Inspired by Nicole's ferocious defensive play, the Lady Knights often smothered and overwhelmed opponents with their full-court press.

On December 19, 2000, in a game against Eastside and its freshman phenom, Essence Carson, Nicole became only the fourth girl in Passaic County history to score 2,000 points for her career. The historic bucket came in typical Nicole fashion. She grabbed a defensive rebound, fed the ball to a teammate as she raced upcourt, and then put back her teammate's missed layup on the offensive end. The victory was especially sweet because many comparisons had been made between Nicole and Essence; Debbie Tillman, Nicole's former AAU coach, had gone as far as saying that Essence was a better ninth-grader than Nicole had been.

Two days later, Nicole scored 37 of Kennedy's 50 points in a loss to Tobi Petrocelli and Holy Angels. In that game, Nicole surpassed her idol, Falisha Wright, to become Kennedy's all-time leading scorer. The next obstacle in the

individual record book was Maureen Garvey's all-time county scoring mark for girls, 2,185 points.

On January 6, 2001, Nicole stepped to the foul line at Clifton High School with 3.6 seconds on the clock and Kennedy trailing 56–55. She had entered the Clifton game needing 39 points to break Garvey's mark, set five years earlier, and now she had 37. Before the game, Coach Alan Carline of Clifton had told Bonora that Nicole wasn't going to break the record against his team. When Bonora repeated this comment to Nicole, she smiled and said, "We'll see about that."

As the crowd looked on with great anticipation, Nicole briefly turned her back to the basket, walked a few paces toward the middle of the court, and told herself these were just regular free throws. She made the first, to tie the game at 56–all and pull even with Garvey's record. Then she calmly spun the ball in her hand a few times and sank the second free throw not only to win the game, but also to set a new girls' scoring mark of 2,186 career points.

When Kennedy won, the crowd erupted, knowing it was a part of history. Bonora hugged Nicole at midcourt and asked her, "Which felt better, breaking the record or winning?"

"Coach, it's all about winning," an excited Nicole said.

Joan and Euphemia were attending a wedding in Jamaica at the time. They had spoken with Nicole that morning. So, Andrea was left to sprint across the floor and bear hug her daughter from behind as an entourage of reporters, photographers, and onlookers surrounded a tearful Nicole. In a scene that was becoming increasingly common, she spent most of the postgame period giving interviews, signing autographs, and accepting congratulations. Several Kennedy teachers, one of the school's former principals, and Nicole's old city league coach, Ronald McLaurin, made a point of seeking her out for hugs and praise. Two white cheerleaders from Clifton approached her shyly and said, "Nicole, we just wanna say congratulations. You're really good." Everyone around Nicole seemed genuinely happy for her.

"I know the girl," Litza said. "When she graduates, I'll ask for her autograph."

The next day, the *Herald News* ran on the front page a large photograph of an ebullient Andrea hugging Nicole, with the headline 2,186! At Joan's job, her coworkers handed out sheets of paper that read, "Nicole Louden made Passaic County History. Way to Go! Keep Up the Good Work! Keep Encouraging! May God Continue to Bless Your Family."

Three days later, in a pregame ceremony at Kennedy, it was announced that the school would retire Nicole's No. 11 jersey, an almost unprecedented gesture considering her career was not yet finished. In front of about 75 fans, including

half a dozen relatives and Mos, Nicole was presented with a dozen roses and a basketball commemorating the breaking of Garvey's record.

"Nicole, you've reestablished the standard not only for girls' high school basketball, but for Kennedy High School," Principal Roberto announced. "Kennedy's always had a rich tradition in basketball and you've kept it going." As Nicole broke the various scoring records, Kennedy honored her in other ways too. In the gym and school foyer hung large posters with an oversized photo of Nicole. The caption read: CONGRATULATIONS NICOLE—THE NEW PASSAIC COUNTY SCORING LEADER. Similar messages were posted on the Kennedy billboard on the school's front lawn.

This acknowledgment of her individual accomplishments was gratifying, but Nicole wanted more than anything else to win something with her team. When the county coaches seeded the Passaic County Tournament in late January, Kennedy was given the No. 1 seed, in large part because of their tremendous respect for—and perhaps fear of—Nicole. The Lady Knights were 11-3 when the tournament was seeded, by far their best start during Nicole's career.

Once the tournament began, Nicole was simply not to be denied. In the quarterfinals, with Kennedy down 10-3 to DePaul early in the contest, Nicole took over the game with a series of knifing drives to the basket and jump shots from everywhere. By halftime Kennedy was up by 12 points, 39-27.

At halftime, as she sat in a chair in the locker room in the basement of Passaic Tech High School, her voice swelled up with such emotion, it sounded like she was about to cry.

"Oh man, I wanna win this game so badly," she said to her coaches and teammates. "You don't know. Let's go. It's not how you start, it's how you finish."

Nicole finished just as she had started, like a hardwood warrior who refused to accept defeat. She finished with 33 points, 13 rebounds, and 13 assists, in the process breaking yet another scoring record. This time it was the all-time Passaic County scoring record of 2,614 points set more than a quarter of a century before by John Gerdy of Passaic Valley High. After the game, Gerdy's father, Steve, congratulated Nicole on the achievement and told her he was most impressed by her passing and unselfish play. The whole experience was thrilling for Nicole.

"My motto is 'I refuse to lose,'" Nicole said once the DePaul game was over and she had autographed a couple of T-shirts for some young men she had played against at the Y. "I refuse to lose, I'm not going home a loser. I told the girls, I told them when we were at Kennedy, I told them when we were on the bus, and I told them when we got here. I'm not going home with an *L*, and they basically just followed along with me. We came out with a *W*, and I'm so proud of them."

Antoinette scored 19 points. But it was Nicole's ferocious play that overwhelmed the DePaul players, many of whom seemed to be genuinely afraid of her.

"My team got scared," said Kristin Emma, who led her team with 25 points. "I can't say anything else, but they stopped playing. I felt like I was the only one that wanted to play the whole game. Nicole Louden's a very good player, [but] a team wins the game, not just one player."

In the semifinals against Wayne Valley, Nicole continued where she had left off, banking her first shot off the glass despite being off balance and having a defender in her face. She scored 34 of her season-high 47 points before halftime and grabbed 15 rebounds as well. It was her highest point total of the season, and the most since she had scored 50 against Ridgewood as a junior. Once again, the opponents seemed overwhelmed.

"I was focused, I was in a zone," Nicole said. "I was just basically ready to play. I worked on my shot before I got here, the things that I need to do because when I'm off, I know when I'm off, and when I'm on, I know when I'm on. And today I was on."

When Kennedy met Paterson Catholic in the Passaic County championship, Nicole took the court with a dislocated pinky on her lift hand, an injury suffered in the team's last regular-season game a few days earlier. She had two fingers taped together, but that didn't stop her from scoring the game's first 10 points. Later, she felt a pop in her left knee, a sensation unlike any she had ever experienced in that chronic trouble spot. As she dribbled upcourt on possessions late in the game, she appeared to be dragging her left leg like an anchor. Laura Judge later diagnosed it as loose cartilage, an injury she said would be chronic but not career-threatening. Despite the injuries, Nicole finished with 33 points in a contest that was never in doubt.

In the final moments of Kennedy's 53–35 victory, a small army behind the Kennedy bench began pulling on white T-shirts specially made for the occasion. Nicole's relatives, 16 of them, donned tops featuring a picture of the Lady Knights, with the legend PASSAIC COUNTY CHAMPIONS 2001. Joan had made the shirts on Friday, and from the time her niece exploded out of the gate, the family couldn't wait to put them on. After the game, Nicole's family members joyously searched out players, coaches, and even reporters to get their autographs on the shirts.

The victory was a long time coming for Nicole and the Kennedy faithful. The Lady Knights had won the last of their five consecutive Passaic championships under Coach Bonora in 1991. Now, after several frustrating seasons, Nicole—dislocated finger, gimpy knee, and all—had won her first.

"It feels absolutely phenomenal," Nicole said, an ice pack wrapped around her left knee. "It's indescribable. It's better than any record you could ever break. People who have been to this point three or four times, they can probably take it for granted. But for someone like me, this is my first time winning it. To get a little bit of glory with my high school, it's great. I'm loving it. And I'm gonna savor this moment as long as I can."

* * *

Great players make those around them better. Michael Jordan led the NBA in scoring for several years before his intensity rubbed off on his fellow Bulls and the team blended to win its first title. Nicole, it seemed, had a similar effect on her teammates.

"I learned from Nicole that no matter how the game goes, always give a hundred percent," her teammate and friend Jamie Davis said. "Don't ever let down, because you never know what's gonna happen. It could be your last game played, just give your all. From playing with Nicole, you have no choice but to be a better player. She makes you look better."

In the locker room after the county championship game, Coach Bonora introduced several former players to his current ones. LaTonya Johnson, Teya Eaton, and Debbie Barrett, the women partly responsible for the banners in the Kennedy gym, stood off to the side as the coach said, "Tradition is very important at Kennedy, and we do have a tradition. Hopefully, it's gonna get bigger and better."

* * *

Nicole and her teammates didn't rest on their laurels after winning the county championship. Kennedy continued its incredible play through the state playoffs. In the first round, the Lady Knights came from 16 points down in the first half to beat Ridgewood and avenge the loss of the year before. Nicole scored 35 points and grabbed 11 rebounds. Jamie delivered several critical free throws in the final minute.

Nicole added 32 points in a thrilling 58–56 sectional semifinal victory over Emerson. Before the sectional final, Bayonne's coach Jeff Stabile said he planned to "make Nicole work" for every basket. "We wanna see those jump shots fall short at the end of the game."

Apparently, Stabile underestimated Nicole's skills and will to win. She torched Bayonne for 33 points, including four 3-pointers. Bridget added 12 points and eight rebounds as Kennedy won its first state sectional title in nine years, 61–50.

"You can't stop her," Stabile told reporters. "Even when she was not scoring, she was assisting. She is the complete package."

Coach Bonora commented, "I'm the only one who can contain her—when I sit her on the bench. You can't contain her, you try your best to keep her in the thirties. That's about it."

A throng of relatives celebrated with Nicole after the game. This was yet another moment she had dreamed of since first walking the halls at Kennedy.

"I'm exuberant," Nicole said. "Oh, my gosh, I'm loving it. I'm loving it so much. This year has been phenomenal. I spoke to Coach Ciampi last night. He wished me a lot of luck. He said, 'Nicole, you're having a great year. Just go out there and play,' and that's what I came out here and did. And we came out victorious. I'm so proud of my team. I love them so much."

Nicole played her last game in a Kennedy uniform on March 8, 2001, against Columbia in the Group 4 state semifinals. The contest featured a little bit of everything. While struggling to gain a rebound, Nicole accidentally elbowed Gayle Nwafili, a Monarch teammate headed to Providence College, in the face, causing Nwafili to cry out in pain and miss several minutes of the game. The 6'1" forward, one of three Columbia players taller than six feet, returned and finished with 25 points. The other Lady Knights were virtually helpless against the bigger team, but Nicole, stricken with injuries and exhausted from a grueling schedule, alternated between knifing through the defense and lofting 3-pointers from far beyond the arc. The successful play of her teammates over the past several weeks evaporated and Nicole was left once again to battle an opposing team alone. She finished with 40 points in a game the Lady Knights lost, 69–54.

She finished the season averaging a New Jersey–best 34 points per game. For her career, she ranks third all-time in state history among girl scorers. She was a unanimous all-state selection and was named the Player of the Year by the *Herald News* and the *Star-Ledger*.

But it was the team's achievements she cared most about. Soon there were new banners in the Kennedy gym. The banners, just like the T-shirts Joan had made, proclaimed Kennedy as the winner of the county and state sectional titles in 2001, not any individual player.

"You can't sum it up in one word," Nicole said of her career after the Columbia game. "Everyone didn't believe in us, besides us, and that's what got us to this point. We had a great year. What more could you ask for? I think I went out my senior year with a bang. I wasn't getting emotional because we lost. I was

getting emotional because it was the end of my high school career. But like coach said, thirty-two minutes, no regrets. I don't have a single regret."

* * *

While Nicole led Kennedy to glory and prepared for a career at Auburn, some of her family and friends stayed in Paterson; others went in different directions.

Euphemia Richman bought a four-story house on Paterson's east side, the first house her family had owned in the city. As of early 2001, Nicole's grandmother lived in the spacious home with Andrea, Alex, Joan, and Kesha.

Dakita Trapp talked about joining the Navy in order to bring more discipline to her life. As of summer 2001, she was deciding between attending a junior college or a four-year college and was living with her mother in Paterson.

Delfiah Gray earned a scholarship to Midland College, a junior college in Midland, Texas, known for the success of its women's basketball program. It took her some time to adjust to the changes in academics, basketball, and her environment. She struggled in the classroom at first, but fared better as time passed. She had always wanted to leave Paterson, but the move wasn't easy. "The hardest part is being in this area, being in this small town," she said. "I come from a big city."

During her freshman year, she did not make many friends at school, preferring to keep mostly to herself. On the court, she had to make the transition from star to role player. Still, Delfiah came off the bench and averaged 7.5 points and 3 rebounds to help Midland reach the championship game of the National Junior College Athletic Association (NJCAA) National Tournament in March 2001.

Meticia Watson is a physical education teacher and assistant girls' basketball coach at Teaneck High School in New Jersey. By the end of Nicole's senior season, she was working out with the Kennedy players and assisting Coach Bonora.

Falisha Wright tried, but failed, to make the WNBA's Sacramento Monarchs during the 2001 season. She currently lives and works in Portland, Oregon.

James Lattimore hoped to earn his Graduate Equivalency Diploma (GED) and play basketball at a junior college. But as of summer 2001, the Paterson police were investigating his connection with a hit-and-run incident in which a woman had been hospitalized. James had been working several jobs to support his two children.

Michael Cleaves graduated from Notre Dame Prep, improving his stock as a basketball player in the process. He received a full scholarship to LaSalle University.

Cappie Pondexter averaged 25 points, 7.4 rebounds, and 2.5 assists during her senior year and was named Illinois's Ms. Basketball for the second straight season—a first in state history. She was also selected Player of the Year on *Parade* magazine's 25th annual All-America High School Girls Basketball Team. She headlined a Rutgers recruiting class ranked No. 1 in the country by the Women's Basketball News Service. As of the spring of 2001, she was waiting for a standardized test result that would determine whether she was academically eligible to play as a freshman.

In December 2000, a joint investigation involving officials from the Drug Enforcement Administration, the U.S. Department of Housing and Urban Developmont, the New Jersey State Police, and the Passaic County Prosecutor's Office resulted in more than 300 arrests at the Alexander Hamilton Housing Development. The 11-month investigation netted 47 arrests for possession of drugs with intent to distribute. Officials also confiscated $125,000 worth of heroin and crack. According to published reports, officials repeatedly called the arrests "just the beginning." As of summer 2001, the police and FBI were monitoring gang activity in Paterson and planning a major bust, which could possibly involve as many as 40 Kennedy students.

The Auburn women's basketball team finished the 2000-1 season with a record of 17–12 and failed to qualify for the NCAA Tournament. Nicole was one of five recruits the Lady Tigers signed for the 2001–2 season, a class ranked among the Top 10 in the nation by several recruiting services. "We are very pleased with this class," Coach Ciampi said. "This has the potential to be one of the best classes in Auburn history. We were able to get two of the state's best players along with the top players in the nation." In early 2001, MaChelle Joseph watched Nicole score 38 points in one game against Clifton and declared that she would likely play major minutes as a freshman. Joseph later left Auburn to take an assistant coaching job at Georgia Tech.

Meanwhile, Nicole's family won't be able to attend all her college games the way they did her high school ones, but a large contingent planned to be there for her first contest at Auburn. Euphemia said the family would sometimes have to choose between going to visit Nicole at Auburn and relatives back home in Jamaica. Nicole says she will miss her family terribly. Her sister Karen and Uncle Prince will be living separately in nearby Georgia.

Milton Evans watched proudly, if not altogether quietly, as Nicole broke the various Passaic County scoring records and Kennedy captured the championships.

"I'm sad that she's going away [to college], but I'm glad that she's beginning to achieve her goals," he said the day of the county final. "Those thousand shots a night, those two five-mile runs a day, those swimming lessons, running in the pool, they're paying off. I'm gonna cry when her high school career is over. That's gonna be sadness, but the joy will be that she's going on."

He planned to attend Nicole's first game at Auburn in the winter of 2001. After that, he will have to follow her results through the Paterson grapevine and the agate print of the newspapers. He vacillates between coaching another child and retiring.

"The question is," he says, "where is the next Nicole? Because you know there's another one out there. That's why I gotta get back to the Y."

Acknowledgments

Many people contributed to this book, but it could never have been written without the ceaseless openness, honesty, and patience of Nicole Louden and her family. From the day I first met Nicole, and especially after I approached her about writing the book, she accepted me into her life, opening her thoughts, her heart, and sometimes even her diary, without hesitation. Even during the most trying times of the recruiting process, Nicole was willing to sit down with me for frank and candid discussions. Her decision to let me follow her during this period was a courageous act aimed at letting readers understand what the recruiting process means to someone with limited means but unlimited potential.

Every member of Nicole's family whom I met was similarly sincere and truthful, but a few deserve special mention. Euphemia, Andrea, and Joan Richman, and Kesha Young opened their lives to me, and put up with what must have seemed my constant questions, my unwavering presence in their homes with a pen and a notebook. They invariably did so with a smile. My life has been enriched by knowing them.

I am indebted, too, to the various Kennedy coaches, players, and trainers who knew Nicole. Donovan Jonah, Meticia Watson, Lou Bonora, and Carmela Crawford allowed me almost unfettered access to the team's games, practices, and meetings, and often took time to meet with me when I had questions. Jim Ring was tremendously helpful in providing background on Kennedy and the history of the boys' team. Oftentimes I would walk into his office unannounced and he would talk with me at length, always teaching me something new. Laura Judge kept me updated on Nicole's complicated medical history, putting her injuries into lay terms. Dr. Vincent McInerney and Nancy Keil also provided valuable medical information related to Nicole's injuries. Two former Kennedy players in

particular deserve special mention. Over a number of years and across several schools, Dakita Trapp and Delfiah Gray both shared their thoughts and feelings about what was surely a tumultuous period in their lives. Dakita's mother, Delores, and her brother, Danny, also generously granted me an extensive interview.

Raheem Smallwood and Debbie Tillman of the School-Based Youth Services Program met with me periodically and offered their insights on a number of topics, from teenage pregnancy to the history of girls' basketball in Paterson to the relationship among Dakita, Delfiah, and Nicole. Sakina Gillespie and Justine Baker accepted me into their world and taught me a great deal both about Nicole and life in Paterson.

A number of Patersonians were tremendously helpful in terms of providing context and background, especially regarding the city's rich basketball history. Milton Evans shared with me not only his passion for teaching and for making Nicole a better player, but also the hard facts of life that forced him to come to terms with the past. Charles "Wiz" Richardson and Arthur Lowery talked with me on several occasions at the Paterson YMCA, revealing much that I would not have otherwise learned. Falisha Wright, Kwan Johnson, John "Nooney" Benjamin, Ed Black, Benjie Wimberley, James Steward, Keith Davis, Charles Thompson, and James Lattimore shared of themselves as well, taking a white reporter into places he might not otherwise have gone. Detective Andrew Muckle of the Paterson Police Department and Al Moody, director of the city's Youth Services Bureau, were extremely helpful in providing context on Kennedy High School and Paterson. Ed Smyk, the Passaic County historian, and Jack DeVries, a columnist at the *Herald News,* read parts of the manuscript and offered their advice.

Larry Gutlerner and Vanessa Paynter allowed me free and easy access to the Y, permitting me to interview Nicole and others without hesitation despite my sometimes probing questions. Vanessa Paynter also shared with me her own stories of growing up in Paterson as a female basketball star and the recruiting process she underwent.

A number of basketball coaches and recruiting experts were tremendously helpful as well. Joann Mosley and Karen Fuccello allowed me to travel with the Monarchs and learn what a girls' AAU team is all about. Despite her ambivalent feelings toward the media, Joann Mosley took time on many occasions to illuminate aspects of Nicole's life and her recruiting course.

Vivian Stringer and Jolette Law of Rutgers and Joe Ciampi and MaChelle Joseph of Auburn opened the door to the inner workings of the recruiting process. For that I am forever grateful. Coaches Ciampi and Joseph made me feel extremely welcome on my visit to Auburn, sharing with me their thoughts on pursuing Nicole.

Several members of the New York Liberty gave generously of their time. Teresa Weatherspoon became involved in the project after meeting Nicole, ultimately authoring the foreword. Rebecca Lobo patiently and humorously answered numerous questions, and agreed to read the finished product. Jason Guy, the team's public relations assistant, patiently put up with my requests to speak with Weatherspoon and Lobo.

A number of recruiting experts provided enormous assistance as well. Mike Flynn, in particular, put up with my questions and badgering for several years as this project came to fruition. On numerous occasions, when I could track him down in his busy life, he talked with me about Nicole and the future of women's basketball. Joe Smith and Bret McCormick shared their thoughts on Nicole's ever-changing status. Smith read a part of the manuscript and helped mold sections on recruiting.

Felicia Hall, now with the Charlotte Sting, and Tony Dorado of Nike provided indispensable background on Nike's involvement with women's basketball and Nicole's performance at the camps.

I was blessed with an agent, John Monteleone, who pushed me to pursue this project when I myself wasn't certain it could work. He believed in me, and in the idea, from the beginning. For that I cannot express enough thanks.

Sam Freedman supported me in the genesis of this project, when I was his student at Columbia University, and then provided invaluable insight in producing the final draft; his questions and suggestions prodded me to work harder than I ever had before. Pat Ryan generously gave of her time, editing several drafts and providing equal doses of support and constructive criticism. My parents, Janet and Donald, supported me throughout the writing of this book, with my mother sharing her own athletic experiences as well as carefully editing the final manuscript.

Darcy Frey inspired me to write a book that I'm sure is only a shadow of his classic, *The Last Shot*. He spoke with me several times to encourage and advise me on my own reporting.

I am also indebted to Jim Brennan of the *Herald News* for hiring me in the first place, and later consenting to my taking a leave of absence to pursue this project. More than an editor, he has been a confidant, sounding board, and friend. Jim McGarvey, the editor of the *Herald News*, was also supportive of the idea, allowing me to stay associated with the paper while on leave. Several of my current and former colleagues at the newspaper helped me with research and advice. Brennan, Art Stapleton, Al Iannazzone, Keith Idec, Jason McIntyre, Dan Rosen, Bill Hughes, Alisa Dornfest, Hilary Burke, Ernie Garcia, and Josh Gohlke did much of the work that allowed me to write sections of this book. Reporting

done by Michael Casey of *The Record*, Greg Tufaro of the *Home News Tribune*, Steve Politi and John Ruyzam of *The Star-Ledger*, Chris Casavant of the *Norwich Bulletin*, Kelly Whiteside of *USA Today*, Steve Lopez of *Sports Illustrated*, and Jeff Schultz of the *Atlanta Journal Constitution* contributed vastly to making this book more complete. *Mollie's Job*, by William M. Adler, provided tremendous background on Paterson.

The people of Andrews McMeel took a risk on this project when many others would not. My editor, Kelly Gilbert, provided much-needed structure late in the process. I am eternally grateful to her and to Allan Stark, who first sponsored the book, for their unflinching support.

<div style="text-align: right;">
ADAM ZAGORIA

New York City

May 2001
</div>